An Aesthesia of Networks

Technologies of Lived Abstraction
Brian Massumi and Erin Manning, editors

Relationscapes: Movement, Art, Philosophy, Erin Manning, 2009

Without Criteria: Kant, Whitehead, Deleuze, and Aesthetics, Steven Shaviro, 2009

Sonic Warfare: Sound, Affect, and the Ecology of Fear, Steve Goodman, 2009

Semblance and Event: Activist Philosophy and the Occurrent Arts, Brian Massumi, 2011

Gilbert Simondon and the Philosophy of the Transindividual, Muriel Combes, translated by Thomas LaMarre, 2012

Contagious Architecture: Computation, Aesthetics, and Space, Luciana Parisi, 2013

Moving without a Body: Digital Philosophy and Choreographic Thoughts, Stamatia Portanova, 2013

An Aesthesia of Networks: Conjunctive Experience in Art and Technology, Anna Munster, 2013

An Aesthesia of Networks

Conjunctive Experience in Art and Technology

Anna Munster

The MIT Press
Cambridge, Massachusetts
London, England

© 2013 Massachusetts Institute of Technology

All rights reserved. No part of this book may be reproduced in any form by any electronic or mechanical means (including photocopying, recording, or information storage and retrieval) without permission in writing from the publisher.

MIT Press books may be purchased at special quantity discounts for business or sales promotional use. For information, please email special_sales@mitpress.mit.edu or write to Special Sales Department, The MIT Press, 55 Hayward Street, Cambridge, MA 02142.

This book was set in Stone Serif and Stone Sans by Toppan Best-set Premedia Limited, Hong Kong. Printed and bound in the United States of America.

Library of Congress Cataloging-in-Publication Data is available.

ISBN: 978-0-262-01895-1

10 9 8 7 6 5 4 3 2 1

For my father, George Munster

Contents

Series Foreword ix
Acknowledgments xi

Introduction: Prelude to the Movements of Networks 1

Looping

1 Networked Diagrammatism: From Map and Model to the Internet as Mechanogram 19

2 Welcome to Google Earth: Networks, World Making, and Collective Experience 45

3 Data Undermining: Data Relationality and Networked Experience 73

Refraining

4 Going Viral: Contagion as Networked Affect, Networked Refrain 99

5 Nerves of Data: Contemporary Conjunctions of Networks and Brains 125

Synthesizing

6 Toward Syn-aesthetics: Thinking Synthesis as Relational Mosaic in Digital Audiovisuality 153

7 The Thingness of Networks: Invasion of Pervasiveness versus Concatenated Contraptions 175

Notes 197
Bibliography 213
Index 233

Series Foreword

Erin Manning and Brian Massumi, editors

"What moves as a body, returns as the movement of thought."

Of subjectivity (in its nascent state)
Of the social (in its mutant state)
Of the environment (at the point it can be reinvented)

"A process set up anywhere reverberates everywhere."

• • •

The Technologies of Lived Abstraction book series is dedicated to work of transdisciplinary reach inquiring critically but especially creatively into processes of subjective, social, and ethical-political emergence abroad in the world today. Thought and body, abstract and concrete, local and global, individual and collective: the works presented are not content to rest with the habitual divisions. They explore how these facets come formatively, reverberatively together, if only to form the movement by which they come again to differ.

Possible paradigms are many: autonomization, relation; emergence, complexity, process; individuation, (auto)poiesis; direct perception, embodied perception, perception-as-action; speculative pragmatism, speculative realism, radical empiricism; mediation, virtualization; ecology of practices, media ecology; technicity; micropolitics, biopolitics, ontopower. Yet there will be a common aim: to catch new thought and action dawning, at a creative crossing. *Technologies of Lived Abstraction* orients to the creativity at this crossing, in virtue of which life everywhere can be considered germinally aesthetic, and the aesthetic anywhere already political.

• • •

"Concepts must be experienced. They are lived."

Acknowledgments

The research and writing for this book were made possible by a "Discovery" project funded by the Australian Research Council from 2007 to 2010. My main collaborator on this project was Andrew Murphie, who has been, before during and after the event of the project's funding, a wonderful friend, a deep and generous thinker, and an inventive instigator of networks. Many of his insights have made their way into these pages, and I consider this book an outcome of our dynamic collaborations from VJing through to sharing meals and networking writing. Our other partners on this project have also been incisive, thoughtful, and generous with their time and resources, and I thank Adrian Mackenzie and Brian Massumi for their participation in many discussions, meetings, workshops, and platforms over the past few years. Additionally Brian Massumi and Erin Manning have been wonderfully supportive in their capacity as series editors for this book, and I could not have asked for better or more considered commentary. I would also like to thank them for inviting me to take up a residency at the Senselab in Montreal during 2008. It provided valuable time away from the normal humdrum of work to begin writing what became this book. Thanks also to the readers of the manuscript for many useful suggestions and to the editorial team at the MIT Press for prompt and professional support.

Thinking through network experience would not have been possible without the networks of friendship that have sustained me, especially over the last decade in both my academic research and my artistic practice. *The Fiberculture Journal* has been a great source and platform for such friendly networking since 2003 and I thank especially Andrew (again) and Mat Wal-Smith for their work there, which has reached into this book. A small and loose cluster of friends who made up our "experience" group—namely Andrew (again), Lone Bertelsen, Niamh Stephenson, Ros Diprose, and Brett Nielson—were very helpful in providing the basis for thinking through how networks do indeed experience. Lone Bertelsen also made a very thorough and considerate research assistant during the final phases of writing this book. I sometimes think the

academic workplace would be better if we networked across our friendships there rather than remaining confined to our silos. Thanks, then, to those friends and networks that help to cross and break free of these, especially to Jill Bennett, David McNeill, and Ross Harley and to my postgraduate students past and present. I would also like to thank the many artists with whom I have had conversations and with whose work I have engaged in order to get at the radical potential of networking: Adam Nash, Esther Polak, Natalie Bookchin, Michelle Teran, and Daniel Margulies all provided extra insights about questions in and of the network. In general, my extended friendship network—close at hand and far away, those I see regularly and those whom I do not get to see—continues to sustain me.

My last thank you goes to my greatest friend and partner, Michele Barker, with whom life has become an ongoing meshwork of joyful thought and artistic practice.

Earlier versions of some of the chapters appeared in the following publications:

Chapter 2, as "Welcome to Google Earth," in the *Critical Digital Studies Reader*, ed. Arthur and Marilouise Kroker (Toronto: University of Toronto Press, 2008), 397–416.

Chapter 3, as "Data Undermining: The Work of Networked Art in an Age of Imperceptibility," in *Networked: A Networked Book about Networked Art*, ed. Jo-Anne Green and Helen Thorington (New York: Turbulence, 2009), http://munster.networkedbook.org/data-undermining-the-work-of-networked-art-in-an-age-of-imperceptibility/.

Chapter 6, as "Syn-aesthetics—Total Artwork or Difference Engine? Thinking Synthesis in Digital Audiovisuality," in *Inflexions* 4 (2010), http://www.inflexions.org/volume_4/n4_munsterhtml.html.

Introduction: Prelude to the Movements of Networks

Asymmetrics and temporality in network topologies

Let's begin with two sides of the network—not the usual approach, as networks do not lend themselves spatially to a projective geometry of dual bounded edges. When we imagine a network these days, it is hard to stave off the flood of visualizations—tangled threads, fractal webs, uneven distributions of interconnected circles and lines—that populate our contemporary connectionist imaginary. To approach the network as a visual form, we might do better, then, to insert one of these conjoined knotted fields into a 3D visualization tool. This would allow us to turn a time slice of a particular network—perhaps of global major internet service providers on June 28, 1999—around on its z axis. As it spins from front to back, we can now see that this image of a network does have a left-right, back-to-front formation. If we look at the network from the front—left to right and then from the back also left to right—we see that the network appears asymmetrical.

This rather simple observation about the asymmetry of network topologies is often overlooked because the seemingly infinite and intricate scales of overlapping connections immediately threaten to seduce and engulf our attention. Such images as the topological map of connectivity between major internet servers produced by Hal Burch and Bill Cheswick for the Lumeta corporation in 1999 are typical of this sublime imagescape of global connectivity (figure 0.1). The scale and iteration of node-and-link relations in such an image beguile us, blinding us to simpler compositional aspects such as asymmetry and unevenness. But it is precisely this clumsy and old-fashioned terminology of composition that I will evoke first to expose some of the problems that beset our contemporary experience of networks. In conjuring "an aesthesia" of networks, I am evoking, in the first instance, the contemporary perception of networks and the relation of their perception to network experience. As I later argue, though, network perception and experience do not belong to humans alone.

0.1
Map of the Internet showing the major ISPs: data collected 28 June 1999, Hal Burch and Bill Cheswick, for the Lumeta Corporation. Patent pending; copyright Lumeta Corporation 2000–2011. All rights reserved.

Visualizations such as Burch and Cheswick's certainly awaken us to the topological nature of networks, and emphasize that relational space is now definitively the habitus of information. A network image can be rendered for just about every aspect of day-to-day life for which data exist, including financial information, organizational data, mapping systems of every variety, social networks, and technical ecologies of all kinds. But such images have become uniform, dominated by links and nodes, visualized as direct lines connecting dots. The very sameness of this rendering, operating across all and any network, creates the idea of the network as infinitely transposable, in spite of what might be specifically visualized. Hence zooming in on an area of a network

visualization of, say, Lufthansa airline's international corporate infrastructure looks remarkably similar compositionally to Vladis Krebs's infamous mapping of the cellular Al Qaeda hijackers' network, which he produced in the wake of 9/11 (Krebs, 2002).

Here networks mirror networks, in a pervasive mimesis barely concealing a visual and conceptual slide into what I call network *anesthesia*—a numbing of our perception that turns us away from their unevenness and from the varying qualities of their relationality. My suggestion—to approach the network from two sides—is really a wake-up call. Instead of simply seeing networks everywhere, perhaps we should look, think, and sense more thoroughly the patchiness of the network field. We need to immerse ourselves in the particularities of network forces and the ways in which these give rise to the form and deformation of conjunctions—the closures and openings of relations to one another. It is at this level of imperceptible flux—of things unforming and reforming relationally—that we discover the real experience of networks.

This relationality is unbelievably complex, and we at least glimpse complexity in the topological network visualization. Yet many such images, which aim to map the relations obtaining among elements while simultaneously admitting their change over time, may have done a disservice to this complexity. Images such as Burch and Cheswick's involve not just hubs, nodes, and links but imply duration. Topological network images require us to think in time, even if we are only seeing the network imaged during one particular moment. Permutations of this one snapshot both precede and proceed from it. But such imaginings land us back in the middle of complexity itself—what came before and what might come after both subject to a dizzying multitude of ways in, through, and out of the threads.[1] Crucially, though, even if a network image is static, imagining it durationally means acknowledging its constitutive dynamism.

This begs the question of how we diagram networks *as* dynamic and temporally constituted and propelled. As I point out in chapter 1, there are places to look for a sense of such diagramming processes and practices within the history of figuring online networks and from outside network analysis. But before delving into network histories proper, I want to draw attention to the importance of various artistic practices that have provided us with network diagrams not so beset with the problems of the link-node format. Mark Lombardi diagrams the "network" as a swirling interplay of historico-political forces, even though he deploys the skeletal format of circles and lines. Lombardi famously diagrammed the financial network that, from the 1970s through the early 1990s, filtered Bush family oil monies from Texas to the Middle East and resulted in the Bin Laden family's attempts to rearm and refinance sectors of Iraq for their own interests. *Banco Nazionale del Lavoro, Reagan, Bush, Thatcher, and the*

0.2

Banco Nazionale del Lavoro, Reagan, Bush, Thatcher, and the Arming of Iraq, c. 1979–1990 (4th version), detail, Mark Lombardi, 1998. Image courtesy of Museum of Modern Art, copyright Photo SCALA, Florence. Copyright Estate of Mark Lombardi.

Arming of Iraq, c. 1979–1990 (4th version) is a large drawing with separate horizontal timelines beginning in 1979 and ending in 1990 (figure 0.2).

As with all of Lombardi's works, key points along the timelines are marked by circles, which sprout interrelated people and events that are circled, dated, and named. These reach out via spiraling lines to their relations with other players and events, forming complex overlapping loops. All of his diagrams trace the financial and political dealings of global members in government and financial institutions, arms- and money-laundering deals, tax avoidance schemes, and drug trafficking, gangster, terrorist, and military alliances, to name but a few. Lombardi's diagrams give us a sense not of the network per se but of *networking*—the processes and operations that join and separate disparate people and events along temporal horizons. Although deploying what we might think of as similar compositional elements, such as "circles" (nodes) and spiral lines (links), Lombardi's work does not seek to formally capture its elements within a network "figure"; rather, he presents us with networking as "topological surface" (Massumi, 1997: 751). He wants us, in other words, not to abstract a

set of ideal spatial relations between elements but to follow visually the contingent deformations and involutions of world events as they arise through conjunctive processes. Lombardi's images propel both our eyes and the images' diagrammatic components toward potential concatenations; we seek out how people's, organizations', and history's relations imply and generate forces at the core of global political events.[2] Lombardi's lines are ones of durational force propelled by the dynamics of relationality. I contend that a range of contemporary artistic practice can best get at the relationality at the core of network experience. From artists who diagram through to artists dealing with online databases and video jockeys (VJs) opening us to the networking of sound and vision together in novel ways, this range of practice is attenuated to that imperceptible opening, closing, joining, and separating that is networked aesthesia.

The experience of networks or network experience?

The confusing aesthetic aspect of link-node network images such as Burch and Cheswick's is that, despite being time slices from a temporal continuum, they nonetheless generate a frozen quality. By mapping thousands of compressed subsets of links and nodes into clusters within one overall "coherent" plane, such an image evokes a sense of both the overwhelming vastness of the data it seeks to visualize and a tidy, repetitive mode of managing quantity. Yet this deadens the sense of complexity by making it appear to be mainly a problem of managing the quantity of connections among elements. Complexity can thus be seen; it can be made perceptible. Here we encounter something crucial for network experience—the slide from perception into the perceptible. To make something perceptible is to make it recognizable, which is not the same as perceiving. Perception, I suggest in arguments based on a reading of William James's work on experience, is a making of the world and of sensing itself, as we go.[3] The perceptible, on the other hand, arises when perception-action has already occurred and is then matched to something already known. To recognize is to see something already seen: a pattern seen in data is an example of the perceptible. Data mining, a computational technique for creating pattern in large data sets and a major facet of contemporary networked cultures, is just such a mode for generating the perceptible. This is a technique for management, for rendering the enormous complexity of data relations as recurring patterns that humans can comprehend.

Perhaps the uniformity of the network diagram—links, nodes, clusters—makes us think that we perceive networks everywhere. Instead, via techniques such as data mining, networks have been computationally rendered as perceptible. Moreover, the frequent misalignment between ideas about human perception and models of computational

learning and pattern recognition—not to mention the place of such techniques in an era obsessed with security—has meant that what is perceptible comes to stand in for what is perceived. This book suggests ways to think through this perceptible experience of networks while exploring the question of how networks might be understood differently. This means asking who or what perceives, who or what is experiencing. But rather than generating a typology of human-machine perception, I believe we are better off inverting the form of questions about perception and experience. It is not simply humans who network with humans; nor is it just computers that are hooked up with one another. As Bruno Latour likes to remind us, humans and nonhumans are in this together (1993: 3). But we are not together in the same ways; that is, our togetherness is also heterogeneous. It is through this heterogeneous togetherness that networked experience arises.

Fields such as human-computer interaction typically pose the question as, How do humans experience computers and networks? We need to recast this. We have assumed that the topology of the link-node network visualizes a generalized experience of connectivity, which can become the ground for more systematically analyzing our experience of networks. We proceed from this to ask the human question: What is our experience of such and such a network, given the general connectivity of link-node relations? How then do we relate to each other and collectively produce ourselves with others in and on the ground of the network? I suggest that we ask instead, *How do networks experience? What operations do networks perform and undergo to change and produce new forms of experience?* By inverting the relations between networks, experience, and human being, I am proposing that we also rethink what we mean by "experience" in contemporary culture.

It seems a little awkward, odd even, to attribute experience to networks. Isn't experience something we humans "have" as part of our humanity? I do not want to suggest that we attribute qualities of humanness to the somewhat abstract and often highly technical infrastructure of the contemporary network. Nonetheless, I want to suggest that we take seriously the proposition that networks do indeed experience. In order to do this we require a rather different concept of experience in order to get at an aesthesia of network relations. This book sets out to build this different conception via the philosophy of William James, in particular focusing on his exhortation to take seriously the reality of relations (James, 1977: 195). I suggest that in order to get at what networked life is like for us—both how we have come to accept anesthetized visions of networks' complexity and how we might attempt to break out of this numbness and reach toward shared projects of fissural joy—we need to first understand networks' experience. It is not, then, a question of doing away with the human but

rather of getting to the human experience of networks as a singular individuation of *networking*. We get to such individuations by first understanding the collective processes of networked aesthesia. These processes engage a technics of conjoining the nonhuman and human through a dynamics of recursion. An aesthesia of networks—or more plainly network experience—joins the heterogeneity of humans and nonhumans into arrays that tend toward both repetition and difference. We find ourselves loosely concatenated with both other humans and with informatic machines, enmeshed in an architecture that depends on the auto- and allopoietic production of massively redundant crisscrossing routes and pathways.

William James and the radical experience of networks

I approach this networked technicity via the nonnetworked and decidedly untechnical theory of experience that we find in the work of William James. James's work helps us find a way out of the now overdetermined and superabundant social and organizational network analyses. Theories of participatory online culture try to capture an understanding of the "shared experience" of networked cultures. But again these analyses begin with the network as a given. Either the infrastructure of computational networks provides the conditions for new social and political formations via software environments such as blogs or wikis (Shirkey, 2008), or sociality qua network provides a model for understanding emerging social and organizational structures (Granovetter, 1973; Mayfield, 2005).

James starts with experience. He does not presume its quality or facticity; rather, he urges us to understand the making of experience at what I will later call, using the vocabulary of Félix Guattari, a "molecular level." James's own vocabulary for understanding experience is scattered with images and processes that are well suited to understanding network relations as diffuse generators and formations of contemporary experience. For James, experience is loosely wrought; hanging together through varying relations of proximity among things as these bump up together, pass into one another, sediment, and change. Relations should not be thought of as ground, as is connectivity in the contemporary figure of the network. Relations are always actively forming: "In radical empiricism there is no bedding; it is as if the pieces clung together by their edges, the transitions experienced between them forming their cement" (James, 1912: 86).

James emphasizes the difference between a substantive and processual approach to experience. For him, relations are the sticky forces that make the world open up to the experience of change—of something passing into something else. Relations

comprise the most immediate aspect of experience; we experience "and," "but," "if" as much as qualities such as "blueness" or blue things (1977: 38). These experienced relations of conjunctive and disjunctive transition "concatenate," generating the stuff and duration of experience. James does not hold such a homogeneous conception of experience as to suggest that everything is simply "connected." Instead, he develops the notion of a "concatenated union," which—like his notion of a mosaic unfolding as its components' edges transit in and between new and differing elements—creates consistency through its very differentiation. Concatenation is "a determinately varied hanging together" (1977: 221). Such a vocabulary is not out of place in contemporary analyses of networks, especially of the web. David Weinberger's 2002 description of the revolution in knowledge, organization, business, and culture that he attributed to the structure of the World Wide Web seems almost lifted from James's philosophy of experience: "The Web is binding not just pages but us human beings in new ways. We are the true 'small pieces' of the Web, and we are loosely joining ourselves in ways that we're still inventing" (2002: xii).

Furthermore, James's deployment of flows and streams—the general liquidity that suffuses his philosophy—knits him together with the by now all too familiar conceptions of data coursing through the networked world. Yet using James's philosophy of experience to make sense of networked experience presents us with something of a double-edged sword. Its rather perfect fit with a flowing universe of information could just lull us into a more prolonged seduction by the "figure" of the network and its anesthetic effects. On the one hand, the Jamesian conception of experience maps neatly onto a networked world of streaming interconnected data. On the other hand, to understand James's notion of concatenation as mere networked connectivity would be a grave mistake. Whereas the current figuration of an interconnected world only offers us yet another connection, another "friend," another "node" in the network, the Jamesian conception of relations as the stuff of experience is concerned with the radically *novel*: "Time keeps budding into new moments, every one of which presents a content which in its individuality never was before and never will be again" (James, 1979: 76).

The point is not to map, model, and systematize the network or experience but to account for, to sense and to encounter, novel network aesthesias. Some words, then, are in order on my use of the concept of *aesthesia* in this context. This book does not attempt to create a new network aesthetics, to systematize network experience, although it is certainly interested in network forces, assemblages, and techniques, such as data mining, that tend toward the model and normalization. I call these collective tendencies the network *dispositif*. But *networking*—processes, proto-formations, and

imperceptible human/machine currents that conjoin social, info-technical, and aesthetic elements in novel ways—is what generates an aesthesia of networks.

Much recent theorization of new media aesthetic experience has returned to Alexander Baumgarten's eighteenth-century rehabilitation of "aisthesis" as sensory knowing of the world. In contradistinction to a conception of the digital as immaterial, the body and its sensorimotor capacities opening up to the virtualities of information have come to be seen as the basis for aesthetic experience of new media (see, for example, Hansen, 2006: 6). While I remain sympathetic to embodied perspectives on new media, I think we need an account of network aesthesia that does not rely solely on *human* capacities for perception. After all, what we need precisely is to account for and encounter novelty in the *relations* between human and nonhuman, where the latter, in the context of this book, involves technical network operations such as recursion. It is not, then, perception understood as a sensory (human) knowing of the world that offers us novelty in networked experience; instead, it is the relation of perception to its difference—the imperceptible.

It is useful to refer to Gilles Deleuze's distinction between the two dimensions of aisthesis (1994: 174–176). One is based on ordinary sensing: there's that blue wall, that piercing whistle, that swaying reed. This is ordinary perception functioning in conjunction with other faculties—knowing that was the same blue wall brushed against yesterday; likening the whistle to a scream; imagining the reed to be a dancer. It is a *common* sensing. But this is not the mode through which novelty enters or through which experience can be radically altered. This comes from another "aesthetic" dimension, which raises sensing to an nth power. For this to happen, the "object" encountered must be a "sign" (1994: 176). This does not mean that we have ascended to a transcendental plane of meaning. The sign here is not something known but a problem bearer. It is what makes the sensible perplexing—even shocking—what unfolds as the genuinely novel. We are dealing then not with ordinary sensory perception but instead with the *ontogenesis of sensibilities* (Deleuze, 1994: 176).

This raising to the nth power is a recursive prehension of the "being" of the sensible; a confrontation with what is ungraspable in the sensible because it is genuinely novel and there are no prior conventions through which to understand it. It is *imperceptible*—an "out of" the given sensibility's realm, which is nonetheless *in* (the) sensible. The imperceptible contributes to the becoming-other of the sensible (Bogue, 2003: 178), to a radical aisthesis. Any sensibility gets its ontogenetic consistency from these radically empirical, dynamic processes of intensive differentiation. The "being of the sensible" is always a *becoming perceptible*, a volatile emergence of sensing from the virtually imperceptible. It is this emergence that is inventive and creative.

The sign does not designate something that signifies but rather something that signals the presence of something else, offering up possibilities other than what is given/recognized/perceived. Novel art, then, never points us toward its source whether that be the aesthetic object itself or the body of its perceiver—it is defiantly nonindexical. Aesthetic novelty is borne on signs that are not yet known or sensed as such, on experience whose ground is only shifting durations and allopoietic loops: what will happen when a sensor is activated in a darkened space; what phase shift will occur as a sound wave oscillates; what can and can't be heard when data is transduced into radically different materialities? Novel art generates an experience, an aesthesia that proffers new sensibilities, and so the possibility that other ways of sensing, relating, and indeed living might thereby emerge.

In a radically or transcendentally empiricist approach, creation and invention in the arts occur as the imperceptible is encountered and differentially actualizes through novel assemblages. For Deleuze, this is precisely what modern art does, by which he means art of his time, the period roughly from the 1950s to the 1970s (1994: 68). Whereas from Kant onward, the discipline of aesthetics is founded on an attempt to locate what of the sensible is able to appear or be *represented* through the a priori categories of space and time (Davey, 2007: 616), for radical empiricism art "making" is primarily processual, nonpersonal, and immediately nonhuman in and of itself. It is a mode of composing immanently, transversally, across a "moveable and moving ground" (Deleuze and Guattari, 1994: 105). As art composes, differentially and relationally encountering the imperceptible (and in so doing transforming itself), it *transacts* novel experience by inventing new sensibilities. In this radical empiricist vein, I want to propose that network experience can be encountered by pursuing this second dimension of aisthesis. I propose that we seek how networks—especially those in which aesthetic inventiveness is a constituent element—relationally prehend what is imperceptible. An aesthesia of networks is a project for generating novel networking sensibilities.

Network metamodelization

The capacity of recursion to return us both to the beginning—to be repetitive and anesthetic, in other words—*and* to inventively diagram new worlds into possibility are played out across the first section of this book. As Adrian Mackenzie has shown in the context of a detailed study of contemporary experiences of wirelessness, James's world is not simply about connectivity; rather, it undergoes constant processes of joining and separating (Mackenzie, 2010). I turn to some of James's own diagrams and

thought images in chapter 1, suggesting that he also offers us ways to creatively critique a world of pure connectivity. James gives us a sensibility that reinserts ambulatory, peripatetic, and transitory movements into understanding network experience. I extract this diagrammatic tendency from James's conception of concatenation and conjoin this with some overlooked early diagramming of the internet. Such diagramming appears alongside the great "cartographies" of the internet, as they first appeared in Paul Baran's images of centralized, decentralized, and distributed communications (see figure 1.3). But Baran's more modest functional diagrams of the technics of network movements show us networking as process. In Baran's arrays (see figure 1.4), a station repeats and conjoins with another not because it is waiting, like a node, to be connected but because it actively diagrams information. Here packets of information *switch*, traversing the network in a nonsystematic manner and depend on the actual conditions under which the network is operating. Ambulatory networked experience, which we can approach both via James's concatenated union of things loosely joined and Baran's recursive arrays, marks networking as the felt force of temporal topoi of looping. Recursion or looping and its redundancies, I argue, is a persistent networked operation, so much so that it lends a flavor to much of both the banality and euphoria of networked encounters.

In chapters 2 and 3, both the repetition and inventiveness of recursion—the network's cartographic *and* diagrammatic movements—are examined across key aspects of contemporary networked socialities and databases. Chapter 2 looks closely at the ways in which one image of the world, Google Earth, has come to generate a very particular self-enclosed, recursively constituted, universe. Google Earth appears to be an image *of* the world. Yet its territory is enclosed, I argue, by dispensing a world *to* users based on the architecture of database search. This is indeed the Google enterprise's worldview; Google uses search as a "utility" to optimize *life as the experience of search*. The kind of world imagined and dispensed by Google Earth, then, is not sociality with all its differential relations but rather a database/network of users constituted through search. Although not strictly social media, Google Earth is nonetheless an exemplary creation of twenty-first-century networked society—a "society" of individual users connected by information architecture.

In chapter 3, I reveal how the database more generally has come to play a key role in concatenating network relations. The relational database, crucial for contemporary information architecture, promotes a form of data organization in which relations become the real stuff of, and in, the network. Oddly enough, we reinhabit a Jamesian universe. If, for James, the barest of relations to be accounted for within a philosophy of radical empiricism is "withness"—"This imperfect intimacy, this bare relation of

'withness' between some parts of the sum of total experience and other parts" (1912: 43)—then the relational database might be considered the technical instantiation of just such a concatenated enumeration of life. The relational database foregrounds the "relations" that organize data, making these the actual *stuff* of databasing. But it also multiplies relations so that we again become lost in the complexity of relations about relations. In this chapter, I follow two responses to this complexity: data mining and what I call "data *under*mining." Data mining, of course, tries to stratify this multiplying data into perceptible, recognizable patterns for humans to experience. But its work also lies in extracting meaning from the topological structuring of data in order to add value. Extracting such pattern from data sets yields the promise of some kind of potential modeling that will forecast future trends or behavior around which more sales, data, and knowledge accumulates. Data mining packages networked relationality into predictions. Data *under*mining, on the other hand, is an ethico-aesthetic response to this modeling of futurity, emerging in a range of contemporary artistic projects. It is a strategy for rationalizing both the complexity of networked data relations and normalizations of "user" behavior. Rather than model, data undermining is a *metamodelization* of networks.

To metamodel networks we must ask how the network as node-link figure or as assemblage for predicting behavior has arisen. Metamodeling networks is a way of thinking networking as process rather than map or figure, taking its cue from the thinking practices of Guattari. Metamodeling, Guattari suggested, aims to critically graft a series of rough working forms/formations together that collectively and heterogeneously diagram the singularity of some experience (Guattari, 1996: 122). Such a process of diagramming should work expressly against the production of universal models, which he believed only served to enforce habitual modes of living. The processual, mosaic, and pluralistic forces at work in metamodeling aim at resisting conventional configurations; in the context of network experience this process can be brought to bear on the link-node figure, for example. My aim is less an alternative figuration of the network and more a critical transformation of the modeling tendencies—of connectivity, of behavior—in network analysis and practice.

The transversality of network experience

Guattari's concept of the molecular and his articulation of the process of metamodelization allow for a different approach to the question of networks that, I suggest, take us into their micropolitics and away from the assertion of the network as a scale-free model.[4] According to network science proponents such as Albert-László Barabási, large-

scale networks—from the web to disease epidemics and those found in genomes—can easily be compared because they share generic mechanisms for growth (Barabási and Albert, 1999). Scale-free networks develop by adding nodes to other nodes or hubs, which are already well connected. This generic mode of modeling networks supposedly facilitates both an understanding of network development and a method for comparative structural analysis across all possible networks. But many networks do not scale up, and a range of large-scale networks are not sufficiently homogeneous to be analyzed by breaking their elements down into smaller topological portions of a larger system.

Chapters 4 and 5 are particularly concerned with how relations actualize at and between these molecular and molar dimensions of networks. They explore ways to shape and bring into experience the conjunctions that transversally conjoin affective, precognitive, and preindividual molecular experience with our contemporary network regime or *dispositif*, that is, the network operating at a molar dimension. These conjunctions sometimes produce novel experience and at other times result in a capture and consolidation into "the network." But an analysis of such conjunctions is where critical network theory should be headed, for it is in these very emergent movements of holding together, cutting, and crossing that we discover networking as process or movement. Chapter 4 explores in particular the network movement of "going viral." I am especially interested in instances of going viral that have not been deliberately orchestrated but rather erupt imperceptibly. The viral catapulting of ordinary, everydayness—babies laughing, children biting each other, bedroom crooners are all examples of this—generates a vague and emergent affectivity. Many have noted the speedy and heightened spread of affectivity itself at work in viral media and networked communications (Gibbs, 2008; Sampson, 2011; Thrift 2008). But I am interested not only in the speed of contagion but also in the qualities of going viral—the affective vitality of viral videos. I suggest that these are shaped by their refraining, repetitive sequences of ordinariness in such viral online videos that compose their affect and make them catch on. This middle section of the book takes its cue from this rhythmic concept and concerns itself with the ways in which refrains trace new possibilities for expression as well as repeat established affective territories.

Chapter 5 crisscrosses between molecular and molar, sketching the ways in which network assemblages reterritorialize microprocesses of perception. I rejoin the concerns of chapter 3, around the prediction and normalization of behavior. As commercial network entities such as Google increasingly move from search to prediction, they mobilize and implement research into "machine learning," and machine learning is indebted to the architecture of neural networks. In chapter 5, we partly shift "offline"

in search of what networks borrow from neural architecture and neuroscience more broadly. But this is not just a "loan"; rather, it is a dampening of what is radical or novel in neural networks. I argue that the shift to prediction as the ultimate goal for Google search is a reterritorialization of the radical experience that distributed (neuro) architectures potentially offer.

It is not just the network corporation that leans on neuroscience. A range of internet and media theorists have wholeheartedly turned toward neuroscience as the substrate from which to garner physical evidence for a number of claims about contemporary media effects. In, for example, Nicholas Carr's analysis of networked media's effects on our neural circuits, he uses a 2008 neurosociological study as evidence of, "what the Internet is doing to our brains" (2010a: 120–126). This signals a panicky flight away from contemporary media and networks into the arms of neuroscientific evidence. We need to steer a rocky course between succumbing to neuroscience as contemporary bedrock and understanding the genuinely novel possibilities for conjunctions between human and machine thought that neural networks offer us; to see the ways in which the potentially radical temporal relations raised by some branches of neuroscience might rejoin the radical empirical tradition of Jamesian thought. Such a genealogy of thinking *thinking*, then, provides an understanding of attention as something a brain does relationally, as it keeps in touch with the forces and capacities of others and other things. Such a perspective on attention gives us something very different from the predictive behavior patterns that are becoming normative in contemporary networked cultures and experience: predictive text, search, and, soon, platforms that can predict what we want to buy, experience, or know before we do.

From anesthesia to syn-aesthetics

Finally, this book carries the concept of networked aesthesia into the realm of synesthesia and traces the networked movement of synthesizing itself. This brings me back to the question of conjunction, of how to think the edge and its forceful movements of meeting, overlapping, integrating, or edging away in networked environments. In the last few years, synesthesia has been used to describe the experience of contemporary audiovisual *digital* spaces, conjoining new media and perception. Their compossibility hinges on the existence of a sometimes implicit and sometimes explicit analogy between the neural and the digital. Prominent neurological conceptions of the synesthetic and models of the movement and flows of data through software and infor-

mation architecture, such as the database, converge. But there is a danger of sliding into a reified model of the brain as fundamentally wired or networked.

How might such multisensorial audiovisual experience be encountered in novel ways, where elements of sound, color, and gesture are given lines that sometimes exchange, cross, yet nonetheless diverge from one another, opening onto new worlds of sensory experience? Must the synthesis of heterogeneous elements collapse into a digitally transcoded world? I propose a syn-aesthetics, which takes seriously the "how" of the join and the relation, the crossing of signal and sensory modalities. Chapter 6 considers a range of cross-processed phenomena in the work of a number of contemporary VJs and audiovisual artists, eking out a syn-aesthesia of networks.

The last chapter considers the creeping connectivity of pervasive media—a creep that increasingly consigns conjunctions between media to ambient "background" experience. "Smart" connected objects are not supposed to make a fuss about their relations to either one another or to humans but instead should quietly and discretely keep track of their place in the world (Weiser, 1991). With the development of tagging, data embedding technologies, and mobile and satellite tracking devices over the last decade, data and things have become increasingly entangled and interchangeable. On the face of it, a smooth synthesis of transactions between humans and nonhuman computational devices seems to be part of the new infrastructure of incessant connectivity. This total networking of life has been both lauded for its radical potential (Sterling, 2005) and criticized for its eradication of human creativity (Lanier, 2010).

But there are other responses to the question of collectivities that such an internet of things raises. A range of experimental aesthetic strategies have sprouted in tandem with pervasive networking, strategies that aim to induce a way of making, thinking, and unfolding relations between data, objects, and humans as a version of Jamesian "concatenated knowing." The point is not to make everything smoothly pulse, transmit, and glow; the point is both to interrogate in a lively manner *and* to invent processes that allow us to follow just that movement in which one thing—data packet, smart object, subjectivation—conjoins with or transitions into the next. I consider modes of art research practice that pay attention to the relationality of networked things, or what I call *the thingness of networks*.

The second approach to networked collectivities returns us to the diagram, which itself becomes a device for thinking through and generating new kinds of collective network "protocols"—"ethico-aesthetic" ones. Here the diagram multifariously operates to catalyze processes, tools, and situations that allow new enunciations of relational experience to emerge. What is at stake here is opening up the network as a

relational field of both techno- *and* biodiversity—a field in which neither things nor humans are accorded primacy and yet neither is experience, *aesthesia*, reduced to the dull and homogeneous world of data administration and blinking wired objects. The diagram returns us both to the felt force of networking, to the very movements that have generated the internet, and to a new image of thought for networking, for enunciating heterogeneous collective experience. The network diagram becomes material process. It diagrams a *networking*, an inventiveness that moves us to experience networks' novel relationality.

Looping

1 Networked Diagrammatism: From Map and Model to the Internet as Mechanogram

Maps or diagrams?

During the freewheeling years of control, cybernetics, and communications research of the 1950s and '60s, the first generation of computer scientists and digital engineers were busy imagining network topologies. This was not just a visionary problem for the future nor an immense thought experiment conjuring what J. C. Licklider (1963) grandiosely dubbed the "Intergalactic Computer Network." It was actually a rather banal exercise in solving the problem of queuing in line to retrieve information stored on a computer somewhere else. The history of the grand design of computer networks unravels to reveal a tangled skein of maps for the future of communication systems mixed together with a lot of hanging around solving problems. This connection between anticipation (imaging a network to come) and tedium (the pragmatics of engaging with online computation) continues to fold into and constitute the duration of network experience. Vanquishing geographical distance *and* watching a download progress bar as files are served across the network; the real-time immediacy promised by holographic video conferencing *and* the stuttering audiovisual freezes in a Skype session—these are just two familiar contemporary examples of this doubled future-present of networking. Yet any effect that comes with enduring this tempo of online networks is usually managed by interfaces, which visually present rotating, animated cogs and steadily progressing blue or green lines. There are even especially designated "anti-waiting" spaces that divert attention away from the here and now—places where bored humans can game away the eternal minutes of data as it gets served up and down the net.[1]

But as any entanglement divulges, grand designs can amount to nothing and the boring bits take center stage, becoming significant actors in unfolding events. The problem of queuing has remained a constant of online experience in spite of proclamations and hype that technological futures necessarily comprise the heady

combination of increased speed, increased data transmission, and decreased costs.[2] In an interesting return to waiting, the explosion of peer-to-peer (P2P) file-sharing networks in the early 2000s, after the dot-com bubble burst, could be seen as a different networking response to the file queue. Here the morphology of the "queue" is dispersed into a "crowd" of simultaneous uploaders and downloaders of files, in effect making the file itself a kind of network. In 2001 Bram Cohen, then a young programmer interested in P2P networks, released a new protocol, BitTorrent, for sharing files between peers across an online network.[3] Network protocols such as TCP allow a file to be accessed and retrieved online by a single client making a request to a centrally stored file (usually on a server) and then sequentially receiving the components of the file at the download location. As I outline below, the routing of the packets that comprise such a file is distributed, contingent, and nonsequentially transmitted; the "client" still fundamentally remains waiting, queuing for packets to arrive. As the files became larger during the early 2000s, first with music and then video files, so too did the queue and waiting times lengthen. The BitTorrent protocol downloads a .torrent file to any peer (user) request for a particular file download—usually made to an indexing website that lists large files currently available (Slyck, 2001–2011). The .torrent file is essentially metadata—data about data—that keeps track of the peer's IP address by connecting the .torrent file to a central BitTorrent tracker. This tracker is also tracking all other peers who are currently online and also have the relevant .torrent file for that large file. The tracker builds a crowd of peer files that distributes packets of the file across current requests. If a peer has completely downloaded a given file, then the peer will become a "seed" for that file and only have to upload that particular file (although they may be downloading others). While a peer is downloading, however, they also already have packets of that file available for other requests and hence, simultaneously become "uploaders."

BitTorrent synchronically disperses the operations of uploading and downloading across the nodes themselves and introduces another morphology for networking—swarming. This is not to say that waiting is wholly resolved for online networks from this point on: swarming needs its swarm. Unless there are sufficient seeds online when a peer makes a request for a torrent file or enough peers to ensure that at least a distributed copy of the file is available, it can take quite some time for the network to "rise to speed" and share the file. As a P2P protocol, then, BitTorrent was generated and continues to be used under the aegis of another kind of protocol—a collective ethics of network sharing: "It is HIGHLY recommended that once you have gotten an archive you leave the BT client running for at least the amount of time that it took you to download the archive to help ensure that others will also be able to get it. Share

Networked Diagrammatism

and Share alike!" (Slyck, 2001–2011). Yet BitTorrent nonetheless revisits the question of the queue that emerges right from the beginning of computational networking.

Both imagining the network as a vast, smoothly operable interconnectivity of resources and intelligence *and* solving the problem of waiting conjoin ontogenetically to individuate computational networks. But it is the foundational cartography of the network as a map of links and nodes that has become the representative image of network design. This cartography not only sets the ground for network visualization but also catalyzes a network logic through which topological imagery amasses. Paul Baran's 1964 memo for the RAND Corporation, "On Distributed Communications," sets out the differences between "centralized" networks vulnerable to attack and take-down, decentralized networks with clusters of nodes that remain open to take-down, and distributed and hence robust networks (Baran, 1964: 1–5; and see figure 1.1).

In countless images—for example, those mapping the topology of server connectivity, the patterns of power and influence in organizations, terrorist cell communications, and associations between users in social media networks—variations of these

1.1
"Centralized, Decentralized and Distributed Networks," from *On Distributed Communications*, Paul Baran, 1964. Copyright RAND Corporation. Image courtesy of RAND Corporation.

network diagrams have come to dominate the "netscape." The distributed mesh, especially, has become associated with networks in action, with the pulse of operations such as data mining as it technically "reveals" the hidden interconnections in data sets. This mesh image promises to give form and to trace the patterns of data relations. It has become a blueprint for laying out the invisible infrastructure that knits networks together.

In his original memo and then in a much later interview, Baran provides a strong sense of the context in which he mapped out these primary topologies (Baran, 1964; 1990). His plan for a distributed communications system was to be the frontline of U.S. defense in the case of nuclear attack. Working for a research institute funded almost exclusively by the U.S. Air Force, Baran, an engineer, was working on first-strike event scenarios at the height of Cold War tensions:

The great communications need of the time was a survivable communications capacity that could broadcast a single teletypewriter channel. The term used to describe this need was "minimal essential communications," a euphemism for the President to be able to say "You are authorized to fire your weapons." Or "hold your fire." These are very short messages. The initial strategic concept at that time was if you can build a communications system that could survive and transmit such short messages, that is all that is needed. (Baran, 1990: 14)

Baran's resulting image of distributed communications is of a net undergoing deformation, as if strong currents were straining its torsions. Its terrain is already modulated by the uneven repetition of links and nodes loosened from their centers of gravity, drifting toward and away from their attractors. While all nodes extend outward, reaching toward their closest neighbors, their edges simultaneously hold taut against one another. The map of distributed communications materializes cybernetic military design—a network of proximate modules for withstanding pervasive attack. But it is simultaneously affectively composed out of the insularity of post-World War II American paranoia—don't get too close to your close or distant neighbors.

But Baran was not the only person working on distributed communications during this period. Leonard Kleinrock's PhD proposal, "Information Flow in Large Communication Nets," was approved by the Massachusetts Institute of Technology in 1961. Kleinrock's research project went on to mathematically prove that packet switching was a viable communications operation (Cunningham, Kleinrock, et al., 1961; 1962).[4] A packet consists of small units of data ("datagrams"), themselves consisting of a "header" and associated data. A header specifies the routing information of the data but gives no information about when the data will arrive or in what order the packet's datagrams will reassemble at their destination. It is the header that changes the nature of communications in the packet-switching network, which embodies a markedly

different idea about "the network" than the circuit-switching networks used, for example, in telephone communications. The telephone call requires a "reservation" of a specific link and line between two parties for the duration of the call. Essentially the next call to the same party has to wait in line, a phenomenon exemplified in ordinary telecommunications phenomena such as "call waiting" or being "put on hold." In packet switching no such reservation is necessary—datagrams route through any available "line" or link. Slightly later than Kleinrock, Donald Davies, Deputy Superintendent of the Division of Autonomies at the National Physical Laboratory in London, also wrote a report titled "Proposal for a Digital Communication Network" that likewise contributed to the early research that made packet switching a different kind of data network.[5] Both Kleinrock and Davies later reflected on their research, commenting that at the time it constituted part of a broader context for sharing and distributing resources, information, and limited bandwidth opportunities (Kleinrock, 2005; Davies, 1986: 10). Kleinrock spoke of this research context of shared interests as a "mosaic" (2005).

A mosaic—rather than a web or the network itself—is an interesting thought image to call upon. It suggests the ways in which concepts and designs for constructing a network might emerge out of a field of research problems that do not so much smoothly connect to form one common problem and more as roughly abutting one another. The mosaic has associations to the artisanal and with a practice of crafting. But the artisanal mosaic has fallen by the wayside as a contemporary image of conjunction. The image of the network as a slick über-design of links and nodes has instead dominated the post-World War II cybernetic era. The mosaic conjures up a worn and scuffed kind of patterning of (somewhat) piecemeal materials—tiles, stained glass windows, quilts. But it is one that we should keep on hand. It plays a role in William James work on radical empiricism, which I will raise a little later in this chapter, and diagrams an alternative path for feeling our way through the conjunctions of network experience.

Nonetheless, it is the map of distributed communications that has become the definitive image of technically inflected networks of communication. Although this model of the network has become the enduring image, packet switching is the *operation* propelling the movement of information into a networked patterning. Which comes first: the network or networking? image or operation? map or diagram? In contemporary cartographic discourse we have become used to the idea that the map is an a posteriori affair, giving us insight into the cultural or political forces at work in the practices of mapping (Crampton, 2010: 9). A map, according to geographical constructionism, is not to be confused with territory; instead, it comprises a mode of

representation that can be decoded, revealing the geopolitical and historical specificity of its makings. But the map of the concept of the internet—Baran's distributed communications image—is cartography ahead of its territory. Is it akin, perhaps, to a blueprint for how to proceed? Or is it a diagram, somehow analogous to the function of circuit drawings, which mark out the routes and impedances of electrical wiring? This depends, of course, on how we deploy the diagram—as a course of action or as inflection of potential movement(s). It is the latter tendency, which I refer to as *diagrammatic*, that I pursue in my discussion of networking as a technics of potential and indeterminate movements. As we move selectively through some of the early history of the internet, networked diagrammatism unfolds as a latent and neglected mode for thinking about how networks experience.

For both Baran and for contemporary networked experience and culture, the image of distributed communications is imbued with cartographic rather than diagrammatic impulses. Baran's distributed communications network has come to possess and project a vector that claims map and terrain simultaneously. Maps are not necessarily or ontologically opposed to diagrams; it is not as if the cartographic must always reterritorialize or the diagrammatic always move away from territories. Indeed, under certain machinic tendencies, the exact overlaying of map onto a territory might describe the de/reterritorializing semiosis: "On a map of an island laid down upon the soil of that island there must, under all ordinary circumstances, be some position, some point, marked or not, that represents qua place on the map the very same point qua place on the island" (Peirce, 1932: 230).

Rather than read these remarks as the ultimate conflation of signifier with signified, we might see Charles Sanders Peirce's overlay of map and terrain diagrammatically. This is tricky because Peirce also brought the diagram under the auspices of the icon. The icon was itself subsumed under the second category of his trichotomous classification of signs, in which signs were to be ordered by the ways they denoted their objects (Peirce, 1932: 243–263). Icons are a kind of sign, which share the qualities of their objects, such as resemblance. Diagrams, then, are a kind of icon that resembles not the object itself but the relations necessary for generating an object, "since a diagram, though it will ordinarily have Symboloide Features, as well as features approaching the nature of Indices, is nevertheless in the main an Icon of the forms of relations in the constitution of its Object" (Peirce, 1933: 531). A diagram of a network, then, does not *look like* a network but maintains the same qualities of relations—proximity, degrees of separation, and so forth—that a network also requires in order to form. Resemblance should here be considered a resonating relation rather than a hierarchy (a form) that arranges signifier and signified within a sign. The point on the map that

Networked Diagrammatism

finds the very same place territorially would not diagrammatically be causally determined by the place (signified). Gregory Bateson asked the same question about the relation between maps and territories and came up with a "resemblance" at whose core lay noncorrespondence. Indeed, for him, this was difference itself:

"What is it in the territory that gets onto the map?" We know the territory does not get onto the map. That is the central point about which we here are all agreed. Now, if the territory were uniform, nothing would get onto the map except its boundaries, which are the points at which it ceases to be uniform against some larger matrix. What gets onto the map, in fact, is difference, be it a difference in altitude, a difference in vegetation, a difference in population structure, difference in surface, or whatever. Differences are the things that get onto a map. (Bateson, 1987: 320)

The point of overlay between map and territory, then, is a fuzzy set of resonating, subtractive, differentiating resemblance relations—the island-map force field.

The Peircean diagram, although iconic, is not strictly speaking indexical. The object to which it refers does not cause its mimetic properties. How would the place on the map and the place on the island share qualities other than via the process that William James calls "translocation," the process of continual change through which things come to habitually "coincide with one another" (James, 1977: 275)? The consistency of resemblance between map and territory lies not with cause but rather in the event of their overlay—an asignifying semiosis of relays between difference and resonance that generates a new relational plane of consistency. The place on the map and the place on the island recursively relate (to) each other, creating a looping topology that describes not simply the nature of the map or the island but generates the "event" of relationality in and through which map and land constitute a field.

In the images of imagined (coming) networks generated by Baran and in the subsequent ubiquitous spread of the link-node networked imagescape, which is the diagram and which the territory? Paolo Virno has suggested that Peirce was attempting to deterritorialize the diagram's mimeticism, freeing it from signification per se and making it into a condition instead for the possibility of semiosis (2009). Indeed, we see in Peirce this discovery of the diagram as a method for moving reasoning away from embodying meaning or functioning as description, model or illustration, toward the diagrammatic as an event that generates novelty: "A *diagram* is an *icon* or schematic image embodying the meaning of a general predicate; and from the observation of this *icon* we are supposed to construct a new general predicate" (Peirce, 1998: 303). Gary Genosko too thinks that Peirce's musings on icons are more diagrammatic than might be assumed if they are simply gathered under the sign of the icon: "In Peirce's work, too, diagrams can be deterritorializing because they are iconic—icons do not lead one away from themselves to their objects, rather, they exhibit their object's

characteristics in themselves" (2002: 179). There is a tension, then, in Peirce between the iconic status of the diagram and its energetics—its tendency to want to generate something else, something novel out of itself. We constantly feel this tug between the diagram as a map that precedes movement and the diagrammatic, which is the generation of movement. This latter deterritorializing movement away from signification—the movement of mapping toward the diagrammatic—echoes throughout contemporary radical cartographic networked projects, which shift away from the encoding/decoding of the map as a representation of culture, identity, and the political toward the precodified potentiality of the diagrammatic. These are projects that work at and upon the virtualities of cartography, or as Brian Holmes (2008: 22) suggests, at the level of opening up energies that are coextensive with yet divergent from the field of social power. I reflect on this point throughout this book in analyzing how some of these projects singularize a dimension of collective networked enunciation.

But, for the most part, Baran's distributed communications image has lost any vibrant diagrammatism with which it once might have shimmered. This is especially the case as it has filtered through the forces of networked modeling via both computer engineering and network organizational theory. What has come to saturate images of networks is a peculiarly engineered visuality—a mode of both perceiving and making the world as if it were at once elastic *and* predictable. Here are the bare possibilities for making connections, such images seem to be diagrammatically suggesting. And this is what the connections will look like, they also predict:

Computer simulations have long been used as an effective tool in engineering, economics, psychology, and a number of other social sciences. Engineers typically use simulations to predict performance of a system that has known dynamic characteristics. These characteristics are typically obtained from theory and are then articulated in the simulation as difference or differential equations. The goal of engineering simulation is then to assess the dynamic performance of a system based on a priori knowledge of the dynamic relationships among the various elements of the system. (Monge and Contractor, 2003: 99)

What we lose in this determination is the felt force of networking, that is, the coming to experience of networks—a becoming in terms of how networks experience and how experience is felt in and across the network. If we want to understand networks' experience, we must look at and inquire into their diagrammatism instead.

From diagram to mechanogram

Baran produces quite a different sketch in his 1964 RAND memo—a diagram that does not conform to the projective geometry inhabiting the models of his various com-

Networked Diagrammatism

munications systems. And, perhaps not coincidentally, this sketch has not circulated as widely as the topological maps of centralized, decentralized, and distributed communications. His procedural diagram, "An Array of Stations," demonstrates how the organization of stations (points through which packets of information "switch" and move through a network) into a system of conjunctions, permits packet transmission even in an event where many stations go down (see figure 1.2).

Baran's procedural diagram feels more generic and less spectacular, positing only the minimum conditions necessary for information to traverse a network. His shot-through array is impersonal, repetitive, and machinic—not a representation but rather shorthand for the possibility of any large-scale networked operability at all. The "stations" (indicated by the small outlines of circles) are arranged in columns and rows. But the switching of packets of information, weaving their way hither and thither, need not follow a systematic course. Packets not only contain data about how to display themselves as a specific kind of content (originally text but now any form of

1.2
"An Array of Stations," from *On Distributed Communications*, Paul Baran, 1964. Copyright RAND Corporation. Image courtesy of RAND Corporation.

media) but, additionally, are accompanied by data about where they need to eventually end up, that is, a computational address that signals some particular station in the array. But they do not have a predetermined route for reaching that address. They might—as Baran indicates by cutting across the diagonal—traverse a network in a nonsystematic manner, depending on the actual conditions under which the network is operating. An array of stations will provide networked infrastructure, but the *networking* of information is only ever emergent.

From "An Array of Stations," we can feel our way back, prehensively, to the diagrammatic of online networks as an intensive field of technical energetics, recursively propelling itself via loops and bounds. A station repeats and conjoins with another not because it is waiting to be connected but because info-matter is in process, is "switching." This "arraying" at once makes and traverses the condensed space-time recursion that will become, that *is* the stuff of, interneting. In "An Array of Stations," we can see arrays—stations that have lined up in relation to one another to form the base frame of networked coordinates—but the "arraying," or diagramming of the network, is nonvisible: "A diagram has neither substance nor form, neither content nor expression. . . . A matter-content having only degrees of intensity, resistance, conductivity, heating, stretching, speed, or tardiness; and a function-expression having only 'tensors,' as in a system of mathematical, or musical, writing" (Deleuze and Guattari, 1987: 162). Deleuze and Guattari have pulled away from the iconic diagram drawing the energetics out of Peirce's observation that the diagram generates something new from out of itself, and they run with the immanence.

It is never going to be possible to "see" networking—to diagram the coming (in)to experience of networking—although we might look at diagrams of the network. But "An Array of Stations" gives us the felt informatic force that is packet switching, the conjugate conjoining, the recursive differentiation of information moving in and as network (see Manning, 2009: 124). Deleuze and Guattari's term *tensors* derives from Riemannian geometry—the differential geometry of topologies. A tensor describes the relation between vectors; for example, a stress tensor is the relation between the directional input of stress deforming along a surface and the eventual directional output of the stress. Whereas input and output are vectorial and are coordinate dependent, the tensor is relational and coordinate independent. There is thus no "form" (coordination) to the tensor but there is function; that is, its function is to generate relationality. It is this abstract or pure functionality that Deleuze and Guattari attribute to the process of diagramming. A tensor can be inferred but cannot be seen; its function is geometrically "felt" in what it does to a basis of reference, such as a coordinate system.[6]

Baran's array is an image that arises out of the functive quantification of stations to the *n*th degree, produced as a network diagrams itself into experience. It is an image composed as its tensors function relationally—*between* and *among* the variable packets, *across* the variable packets' movements to their destination, *against* and *through* the density of network traffic and use. It is these relations that give rise to a multidimensional quantity of arrays. Even though Baran supplies us with a "fact" external to the array—the fact of an almost three-quarters takedown of the network—even so, he does not prescribe the movement of the networking itself. Diagrammatic movement is not yet fact. Or, as Deleuze says of that preconfigured space in which a painting's initial marks onto a canvas stake out only the barest diagram of its lines and zones, "They mark out possibilities of fact, but do not yet constitute a fact" (2003: 101). The diagram is not pure virtuality, pure potentiality; but neither is a diagram some *thing* for something else—a model, illustration or plan determining the contours of an unfolding. Rather, it marks and enables the passage from virtual to actual; it rhythmically prepares the space through which the configured image, the choreographed movement, will have then drawn or danced itself out. Diagrammatic events are engendered as an event's virtualities become rhythmic; in the network this rhythm is recursive. They generate a looping tempo that spatializes, as an array intensively generates from out of the reentry of another array networking. This is networking's general predicate, from which we observe the production of new general predicates—new networkings.

Diagrams that conjugate technical assemblages such as networks are *mechanograms* and are specific to the composition of technics, just as biograms are specific to the composition of bodies (Manning, 2009: 124). If we understand arraying as mechanogram then we get at the mechanospherical, nonhuman, functive, and intensive plane of networked consistency. Arraying is the diagrammatic of computational networks—the rhythmic marking out of the possible fact of the network. But it cannot determine an outcome; it cannot predict that the network will connect in such and such a way. The array is protensive; it generates its next instance because of its virtual openness to the passage of any packet whatsoever. The array as an assemblage—intensive movement, extensive conjunctions—also actualizes through its architecture of openness. The fundamental relations engaged diagrammatically by networking are not links and nodes but indeterminate loopings, the infolding of the general predicate as new instance(s) of itself.

But it would be a mistake to claim that networks are autopoietic machines, if this implies that they are closed to other abstract machines of perception, affection, cognition, power, sociality, economy, and so forth:

Every abstract machine is linked to other abstract machines, not only because they are inseparably political, economic, scientific, artistic, ecological, cosmic—perceptive, affective, active, thinking, physical, and semiotic . . . —but because their various types are as intertwined as their operations are convergent. Mechanosphere. (Deleuze and Guattari, 1987: 536)

It is precisely by returning the online network to its function as mechanogram that allows it to rejoin with all those other abstract machines, which singularize, stratify, and overcode. "An Array of Stations" is, additionally, not solely diagrammatic. It is an image actualized under the rather devastating material conditions of potential full-scale nuclear disaster. It is intertwined with a war machine. There is something crucial about Baran's "Array of Stations" that can be detected by following both its diagrammaticity and this conjunction with the sociotechnical ensemble of a nuclear war machine. It is as if it offers us up the network as a mosaic of interlinked abstract machines—those that function more diagrammatically, multiplying and generating new relations; and those that overcode, closing down, taking out, and taking over this open looping.

For Baran, and during the 1960s, this conjunction materialized as vulnerability to nuclear attack and take down. For contemporary online networks, open architectures have instead paved the way for commercial takeover. This comes largely in the form of networked corporatism that has now saturated online activity, from economies of networked labor through to the attempt to capture all forms of online attention. The array too, according to Mitchell Whitelaw, has conjoined aesthetically with architecture and engineering in postindustrial displays that configure computational technologies as boundless, "The array is a spatial device that says 'and so on'" (2008a). Whitelaw compares the gridded serialism of the array under modernism with the organicist and algorithmic array aesthetics of computation. Grids repeat arrays under horizontal and vertical coordinate forces. Computational arrays instead differentially distribute forces to produce "organic," exponential, deformation series seen, for example, in the Beijing "Bird's Nest" stadium, where the facade and structural arrays repeat, mesh, and differentiate along its curvature. Architects Jacques Herzog and Pierre de Meuron, who worked in a group with the Chinese artist Ai Weiwei and architect Li Xinggang and others to design and build the National Stadium in Beijing, were keen to demarcate the stadium's arraying mesh off from modernism. Instead, they likened its convergence of structure and facade to the Gothic: "We're interested in complexity and ornamentation . . . but of the kind you would find on a Gothic cathedral, where structure and ornamentation are the same" (quoted in Pasternack, 2008). It has become commonplace to delimit contemporary architecture as "net-

worked" and organic in contradistinction to modernist grids. But, as Mark Taylor suggests, much of Frank Gehry's work, for example, also preserves traces of the grid, folding it into a complex network between the building's organicism and the surrounding, often gridded, industrial and urban infrastructure (2003: 41ff). The grid and network, then, are figures through which the arraying diagram, or more precisely the mechanogram, moves, transitions, and transforms itself. The arraying mechanogram intersects with abstract machines of biopower and bioeconomics, the limitlessness of life, economy, growth, and with the concrete assemblages of urbanism, the flows of financial capital across and through a city's industrial infrastructure. Arraying, as Whitelaw maintains, is a space-making device rather than a device that figures in spatialization. Its traits, force, and affect generate space: one more, and so on and so on. It is open (and vulnerable, like Baran's grid arrays) to the exponential vectors of a life machine of limitless technological growth.

"An Array of Stations"—diagram, map, image—teeters on the brink between the diagrammatic and the figurative. It lays out networking as an open operation but, in this very openness, we have the "possibility of fact" that its architecture will bring it into conjunction with other machines: war, biopolitical, and bioeconomic machines. Perhaps, as opposed to the distributed communications series, it has historically failed to acquire the status of network model because it returns "the model" to its chaotic intertwined relations with the social, the technical, the militaristic and so forth. If it does anything, it functions as a metamodel, unfolding the institutional and organizational genealogy of its own production and deployment (Guattari, 1996: 122; Genosko, 2002: 27). It is little wonder, then, that the image of distributed communications with its link-node iconography triumphs instead, as *the* model for the network society and, in the process, strips networks of their diagrammatism. The image of networks as distributed communications system propels their atomizing and segmenting propensities instead to the foreground. The focus becomes all about the individual elements and how in turn these connect. The very relationality that constitutes the force, the ground, and the experience of networking is somewhere else. In the sleek image of the distributed communications system, the mess of conjunctions with networked corporatism or with biopower sit invisibly to the side. We see constituted connections rather than the possible facts of where and how networks actually conjoin. Yet faced with the force of conjunction felt in almost every aspect of networked experience, we need more than ever to reprehend networks' diagrammatism—the becoming-singular-and-heterogeneous of their loops and arrays.

William James and the mosaic of networked experience

In the radical empiricism of William James, mosaics are less images than modes of moving thought and life along. James calls his philosophy of pure experience "mosaic" because it concentrates on the relations that allow thought to conjunctively expand (James, 1912: 42, 86). James's thought wants to replay the movement of pure experience, pushing out from its own edges to conjoin with and separate from the next flow (of) experience. Events transition from one into the next, sometimes continuously and sometimes discontinuously, and it is in these very transitions that both experience and the amorphous, diffuse development of life lies: "Experience itself, taken at large, can grow by its edges. That one moment of it proliferates into the next by transitions which, whether conjunctive or disjunctive, continue the experiential tissue, can not, I contend, be denied. Life is in the transitions as much as in the terms connected" (James, 1912: 87). The image of a mosaic is useful for James because it gets at that sense of bits butting up against one another—bits that might snugly fit together or bits that might jaggedly push away all, moving, via an overall "second-order" process, to form a pattern or a whole (James, 1912: 41–42). Mosaics emerge processually as a bringing-into-relation that traces and delimits the outer edge of one event, conjoining/differentiating it from the inner edge of the next. It is the edge that is the mosaic's force and that drives its patterning, not the pattern or mosaic "bed" determining where the pieces should sit.

The term *edge* also makes an appearance in graph theory, the mathematical backbone of network analysis and networked topological imaging. An edge, more commonly referred to as a "link," is just that line depicting a relation between nodes or vertices. But in almost every topological depiction of networks, the edge has lost its adjunctive, cementing and edging out capacities that it holds in James's mosaic thought. Instead, the edge as link becomes either a vector for the expansionist growth of node-driven additions to the network and/or a dead connector smoothing the flow of traffic between node-things. What we have lost in the model of the network delivered to us via the image and theory of the graph is the *experience* of the edges, the experience of relation, "the relations that connect experiences must themselves be experienced relations" (James, 1912: 43).

Mosaics are of course everywhere in contemporary data visualization. In fact, a standard mode of representing and comparing data sets that depend on another variable or contingency—for example, the number of women compared to men working part time in a call center—is called a "mosaic plot" (Hofman, 2003: 619). Here the mosaic is rendered nondiagrammatic, operating only as, to summon Peircean semiot-

ics, a symbol: "A *Symbol* is a Representamen whose Representative character consists precisely in its being a rule that will determine its Interpretatant" (Peirce, 1998: 274).[7] The mosaic as image in ordinary computational visual culture loses the power it holds in Jamesian mosaic thought—unless it creeps in again, diagrammatically.

Mass Ornament (2009), by Natalie Bookchin, is a video installation made up of downloaded YouTube videos, in which people video themselves dancing in their lounges and bedrooms.[8] It would be easy to call the installation a "mosaic" of online video experience. Rectangular video windows temporally unfold across the screen to reveal rows, indeed arrays, of similarly dancing girls (and the occasional boy), captured by their webcams, creating a rhythmic pattern—a "mass" of display, of "ornamentation." Bookchin acknowledges the influence of the grid or "array aesthetics" of Fordist industrialism, by using music from Busby Berkeley's 1933 film *The Gold Diggers* in the soundtrack. The connection is cemented by Bookchin's references, in both artist statements and interviews about *Mass Ornament*, to the ways in which Berkeley's dancers performed a machine choreography of the early automated factory: "'What was so spectacular about the dancing,' says Bookchin, 'was that it was a perfect reflection of mass production, right? Of the way things move in a factory, and how people lose their individuality in service to this abstraction'" (Bookchin quoted in Willis, 2009).

But to discern the mosaic at the level of visual pattern alone would fail to get at the way *Mass Ornament* unfolds networked diagrammatics. The display of hundreds of YouTube downloads, edited together across the 63 minutes of video installation, creates a twofold rhythm of difference and repetition. The installation carefully sets in place a space-time of sameness as it opens—with eight YouTube videos popping up in line across the screen in no particular order—revealing both a similarity of mid-shot webcam angle onto the ordinariness of contemporary domestic architecture. Throughout the installation we return to these interiors as both backdrops to the dancers and to the empty spaces of mirrors and frames, occupying the same position on bedroom walls. We see multiples of unoccupied lounges, made by the same furniture companies the world over, and computer screens dotted globally on desks, positioned opposite the webcam and all glowing with the same blue-cyan light. So too, as the dancers walk into webcam view to begin their "routines," do we watch their uncannily similar entrances; their gestures that repeat and mimic one another, as if one connected monotonous rhythm were infecting online dancers' performance everywhere.

Yet *Mass Ornament* also distributes and punctuates its amassed choreography, conjoining each separate dancer in rhythms that suggest a dispersed "withness." As five separate girls turn on the webcams and prepare to pose in a sequence that plays out

1.3
Screenshot from *Mass Ornament*, Natalie Bookchin, 2009, single-channel HD video installation. Copyright Natalie Bookchin. Image courtesy of the artist.

across the entire installation screen in a row, Bookchin also has each separate video begin at different moments into the dancer's walk toward the camera, before they turn to face it for their performance. Bookchin deploys this editing technique throughout the installation, temporally staggering and qualitatively differentiating the sameness of gestures performed (figure 1.3).

One movie, one dancer, one "mosaic" tile, is never quite in sync with its conjoining piece. Instead, gesture, dance, and movement "flow" out of one element, infecting the neighbors. Rather than simply moving in a row, the next dancer modulates the last's gesture in a vast relaying of movements across the screen, across bedrooms and continents, never quite stabilizing into "one" style. Our attention shifts from the actual mosaic pieces, the individual YouTube "nodes," to a diagram that relentlessly seeks edges with which to conjoin and makes edges through which it disperses—less the spectacular screen-based experience, as Bookchin notes, than a shuddering pulse of networked relationality:

The videos come from online social networks, which offer exalted promises of creating social relationships and making the world more open and connected, but instead, produce a cacophony

of millions of isolated individual voices shouting at and past each other. What I am trying to do with my editing and compilation is reimagine these separate speakers as collectives taking form as a public body in physical space. (Bookchin and Stimson, 2011: 308)

For James, a relation cannot simply *be* experienced as this or that, be consumed once and for all *qua* experience. For relations only unfold in duration, "[Personal] histories are processes of change in time, and the *change itself is one of the things immediately experienced*" (James, 1977: 198). Relationality is the experience of passage—a vague edging with, against, between, away from—that actualizes the related things. It is experience *as* conjoining/disjoining. To take the edge seriously means to also value the force of relation—its capacity to change the things in relation at the very moment change itself relationally occurs. The book on the table is different from the same book on the bookshelf by being brought into proximity, into a different relation of "withness" with the table, says James (1977: 222–224). It has changed not in and of itself (that is, essentially, although what that may be is also up for debate, according to James) but for something else—the table, the other furniture in the room, whom or whatever is knowing/experiencing the book. This is especially so for the experience of knowing the object, for an object (thing, node) can only be known via its associated milieu, "*To know an object is here to lead to it through a context which the world supplies*" (James, 1977: 156, emphasis in original).

It is not simply that the dancers in *Mass Ornament* are implicitly connected by the internet's infrastructure or by ubiquitous portals such as YouTube, which harbor techniques for soliciting the same kind of templatelike, user-generated content. By drawing on James's understanding of the force of the edge in mosaics, the force of relations generating transitions, we shift away from the pieces—the "tiles"—sitting in their bed or structure. We move instead toward the capacity to connect nonlocally via rhythm, cross-sensory relays, patterning. Bookchin's installation conjures the ways in which globally dancing bodies, intimately performing subjectivations, emerge in the reassemblage of packets of video files. In YouTube, packets, aggregated to eventually display as video files, are uploaded by a solitary dancer in an empty domestic setting, one devoted to home-brewed celebrity. As the files are reassembled in Bookchin's single-channel mosaic work, we sense the way in which this emerging, technically inflected subjectivation is nonetheless a collective refrain.

In *Laid Off* (2009), a work that develops this mosaiclike compositionality, Bookchin collects "vlogs," online video confessionals, mainly from North Americans who have lost their jobs.[9] Each "mosaic" window of an individual vlog recounts and reflects on the moment an employee was told (usually by their employer) that they had lost their job. Using the same strategies of rolling out edited together "rows" of the video

confessions across the scene, the networked diagram here is driven by voice and timbre. On the one hand, the job loss narratives are remarkably similar, signaling the widespread use of "management-speak" to flexibly maneuver through contemporary industrial relations. Video fragments of each individual's working day flow into the others to create a shared narrative of insecurity and job loss in the wake of the 2008 financial crisis. We listen to similar stories as people's jobs are pulled from under them: "one of the larger people in the company and someone from human resources was there"; "'well,' he said, 'this is the part of the job I really don't like'"; "and finally the owner cut everybody's hours down to nothing" (Bookchin, 2009). But the "shared" narrative falls away at the same time as feeble excuses are proffered by managers, and pauses, sighs, and gaps are all they can find to replace their words. A different moment of collective enunciation suddenly crashes through this feeble narrative of excuses. "Laid off" resounds through each tile, as each employee speaks the phrase simultaneously. From a centered window, Bookchin arranges two lines of almost simultaneously speaking tiles of recently unemployed people, fanning out and diminishing in size, as they edge toward each side of the screen. It's a startling moment both because the synchronicity of the editing amplifies the vocal volume and because the very slight temporal delay incurred by visually scattering each speaker/tile across the screen also creates a slight reverberation through the phrase "laid off." The voices speak together but not as one. It is the reverberation that gives the sound its peculiar timbre—a vibrating chorus in which neither unity nor disparity prevails. As if we were listening, not to the same experience, but instead from the inside of (a) collective multiplicity.

Diagram and *dispositif*

To engage diagrammatically with works such as *Mass Ornament* and *Laid Off* is not to deny the spectacular uniformity of globally connected bodies or voices that unknowingly perform similar movements or say the same things. To return, then, to the mechanosphere, *Mass Ornament*, for example, does not escape the overcoding of the network by spectacular aesthetic machines (links and nodes, grids, mechanical dancing). *Laid Off* does not avoid the monotonous tone of protocols and the language used to justify corporate restructuring and job loss after 2008. Both videos slip along the conjunctions of a network that is becoming—generating itself dynamically as relations form and play out transversally across diagram and the network as *dispositif*. We need something like Foucault's concept of the *dispositif* or "apparatus" to continue metamodeling networked experience:

What I'm trying to single out with this term is, firstly, a thoroughly heterogeneous set consisting of discourses, institutions, architectural forms, regulatory decisions, laws, administrative measures, scientific statements, philosophical, moral and philanthropic propositions—in short, the said as much as the unsaid. Such are the elements of the apparatus. *The apparatus itself is the network* that can be established between these elements. (Foucault, quoted in Agamben, 2009: 2, my emphasis)[10]

For Foucault, "the field" is coextensive with "the social" but we might think about the field aesthetically too. The diagram is an immanent tracing of the qualities or traits of relations at play and operates aesthetically across a field—the recursive arraying of networking, for example. The *dispositif* is an actualization of the concrete network or assemblage—the concatenation that joins networks *with* hacker culture, for instance—that is produced as a specific individuation out of the conjunctive work of these traits (Deleuze, 1988: 36–37). The diagram will never simply function demonstrably as "proof" of what exists in the *dispositif*, although it is also always indicative of the kinds of conjunctions that any field will be likely to make.[11] Yet diagrammatically things are always moving, creating more conjunctions as they become, across a *dispositf*, and as the concrete assemblages of the *dispositif* concatenate with new assemblages: "From one diagram to the next, new maps are drawn. And there is no diagram that does not also include, besides the points which it connects up, certain relatively free and unbound points, points of creativity, change and resistance" (Deleuze, 1988: 44).

Aesthetic forms such as representational images of networks or "mosaic plots" or arrayed formations of crowds comprise part of our contemporary network *dispositif*, our "network condition" (Munster, 2009: 4). Tiziana Terranova sees the emergence of network science, responsible for the proliferation of, especially, the ubiquitous maps of networks, as a powerful element of this *dispositif*'s discourses and sets of scientific statements (2007). According to Terranova, the key mechanisms of this *dispositif* are security and the market. But, she argues, it is the relation of these mechanisms to each other that is crucial. Although what needs to be secured is the ongoing life of the population, giving security a biopolitical vector, it is risk—calculated as the series of events that will incur potential economic loss—that must be managed bioeconomically and minimized. What must be secured, then, is not life itself and not the risk to life but rather any potential damage to ongoing growth of the market. The network model and image play a key role in simulating risk events and predicting outcomes, hence their use in both organizational analysis and antiterrorist detection: "The network intervenes in this calculation as a productive machine *and* as a predictive/preemptive mode of simulation. As a mode of simulation, it allows one to model and rehearse possible strategies of preemption. As a productive, concrete assemblage, it

acts as an uncontrollable multiplier and as a medium of diffusion of series of effects" (Terranova, 2007).

But networks are more deeply embedded or engaged in the *dispositif* than just functioning as modes of calculation; they function at the level of the apparatus. Whether implicitly preempting the rise of a networked *dispositif* or not, what Foucault lands on when he spoke of the apparatus as a "network of relations," is the immanence of networking and relationality to the *dispositif*, of the ways in which we are nonetheless returned, in the midst of a regime of power, to the diagrammatic. In fact, we must take into account this relaying between the molar model of the network that Terranova alerts us to and the molecularity of networks as machinic elements in the ongoing ontogenesis of a *dispositif*, to which, I think, Foucault was alluding. Networked experience increasingly comprises these recursive relays across planes and scales—from model and map to diagram and back.

The diagrammatic cannot be reduced to a *dispositif*. It will exceed the particular orientation and imperative that propels the *dispositif* in the latter's work of managing heterogeneity just this way rather than that. But, then again, the diagram does not chronologically or even ontologically exceed the *dispositif*. It does not stockpile "moreness" that requires exposure or can be exploited. Whatever a network diagram will become, whatever its potential, this will only be determinable by the future "event" of the network *dispositif*: "If the potential was not effectively there in the past, there is only one place it could have come from: the future" (Massumi, 2009: 40). Diagram and *dispositif* are therefore neither opposed nor ontologically stratified hierarchically. It is pointless to try to recover the movement of a diagram in order to recuperate something that exceeds a current *dispositif* or to dig down under the assemblage of networked power and find a diagrammatic "pool" of potentiality waiting to gush forth. They are intertwined in temporal relations that Massumi calls "recursive causality" (2009: 40). The event in which managing life as an ever-expanding network that can be ultimately costed out, or borne, by individualized subjects also *invents* new diagrams of networked collectivity. *Mass Ornament* invents (rather than finds) the potential of dispersed choreographies of the self-node as a collective "dancing of the network," just as it also accumulates a mass of similar bodies interacting in similar ways in similar interiors and engaging similar technologies.

Knowledge as mosaic: James and radically distributed experience

So far I have suggested that knowing network experience—the experience of networking as a collective conjoining, bifurcating, routing, rerouting of movement—lies some-

where with its diagramming. James's radically empirical conception of mosaic as edging takes us closer to the felt force of a mechanogram like the network. Here we move along the mosaic, literally living on (the) edge, conceiving of relations as something in the making rather than already made: "In actual mosaics the pieces are held together by their bedding, for which bedding the Substances, transcendental Egos, or Absolutes of other philosophies may be taken to stand. In radical empiricism there is no bedding; it is as if the pieces clung together by their edges, the transitions experienced between them forming their cement" (James, 1912: 86). The problem with so much contemporary network analysis, especially of communications systems and organization, is that the application of sets of relations to entities lies at its core. Peter Monge and Noshir Contractor, for instance, might attempt to understand contemporary media outlets by mapping these as interconnected sets of the relations "provides information to" and "gets information from" (2003: 30). But it is hard to see how this actually signals much of a shift away from models of communication systems that rely on the rather worn-out schema of sender-message-receiver. The relations themselves are not performing the real "work" of the media outlet in Monge and Contractor's network model; instead the nodes/people act as central conduits for the transmission of information. It is not that James disposes of the human as a dimension of the mosaic of experience; rather, he offers us human experience as a direction that might be traced or felt as the mosaic's pattern individuates according to humans and their associated context. Human experience ("ordinary experience") is an ordering, a "punctuation" by things, their qualities and the relations of things to one another. It has a specific and acquired syntax (James, 1977: 215). The human in the network—whether in a media outlet or an online software project such as Wikipedia—is a conjunction and/or disjunction of *networking*. The edge that is human-technics in online networking offers something to be explored. It should not simply be assumed that it is comprehensible either because we "know" what constitutes humanness or we know the parameters of a technical system.

Importantly, for James's radical empiricism, things experienced in the world and a human subject experiencing them are neither pregiven nor separately constituted kinds of experience. They are simply potential vectors for unfolding the one experience. For example: "The paper seen and seeing of it are only two names for one indivisible fact which, properly named, is the datum, the phenomenon, or the experience. The paper is in the mind and the mind is around the paper, because paper and mind are only two names that are given later to the one experience, when, taken in a larger world of which it forms a part, its connections are traced in different directions" (James, 1977: 156–157). Human perception is but one vector in the context of

1.4

Diagram from "The Knowing of Things Together," William James, originally published in *Psychological Review* 2 (1895). Image courtesy of American Psychological Association.

some thing's experience. And this perception is never originary or monadic but always already distributed and collective, made so by the relational movement of things in the world, constantly flowing into and out of one another. He diagrams this early proposition for a distributed cognition-perception, demonstrating the architecture of experience with a sketch (see figure 1.4) that resonates with Baran's "An Array of Stations."

The circular "nodes" are an array of the same object featuring again and again, each repetition also marked by vertically intersecting lines that indicate the object is simultaneously known/experienced by many perceiver-knowers.[12] This recurrence of the object as something cognitively shared by many traces the horizontal line of experience as fundamentally collective. In fact, James remarks, the ways in which objects travel to constitute a shared plane of experience would never be so straight as this diagram asserts. The shared mosaic of collective experience wanders and loops, creating something more nomadic and tangled (James, 1977: 157n18).

James leaves his diagram of collective experience architecturally open and indeterminate. The networked mechanogram is already at the heart of a conception of human experience in James. It makes sense, then, to situate a mosaic, networked diagram as a precondition for, or at the very least constitutive of, "ordinary" (human) experience. This is not in the least to advocate a form of structuralism where "the network" functions like a language, which the human is born into and through which she must acquire operability. Rather, James offers us a processual technics of experience in which the movement—what he calls "the rush" of knowing, of doing, of continuing/discontinuing—generates an indeterminate patterning, a coherent but necessarily incomplete networking as experiencing:

According to this everything in the world might be known to somebody, yet not everything by the same knower, or in one single cognitive act,—much as all mankind is knit in one network

of acquaintance, A knowing B, B knowing C,—Y knowing Z, and Z possibly knowing A again, without the possibility of anyone knowing everybody at once. This "concatenated" knowing, going from next to next, is altogether different from the "consolidated" knowing supposed to be exercised by the absolute mind. (1977: 264–265)

Although an open architecture infuses both the Jamesian network of experience *and* Baran's networked diagrammatism, there is a difference in how relations to knowledge come to develop out of each. It is worthwhile looking at this difference given that contemporary networked experience has become intricately caught up with questions of knowledge, from human cognition understood as an epiphenomenon of neural networks to the moniker of the "knowledge economy" and critiques of cognitive capitalism. As I have suggested, James's experience-as-network begins with human knowledge as always already distributed, "loosely joined" or "concatenated" in the transitions and relations between knowers, known, and knowing. Knowledge is not a project for collecting, analyzing, and categorizing; rather, it is utterly and radically pragmatic, "a world working out an uncertain destiny" (James, 1977: 269). Moreover, the networked making of knowledge as experience is never simply expansionist and unidirectional (continuous growth) for James but always involves ambulatory, peripatetic, and transitory movement. Experience is movement from the "fringes," where the fringe is not so much a place but a plane of consistency, the preindividual virtuality of thought thinking and moving out of itself (James, 1977: 158). Experience-thought (rather than cognitive experience) renews and returns a fringing, pulsing, *and* diminishing knowledge rhizomatics: "A thing felt is fringed by an expanding thought-pool of potential that shades off in all directions" (Massumi, 2011a: 51). Importantly, there is no "place" from which knowledge comes; there is only knowledge-in-the-making, and this making is a collective effort.

This is really quite at odds with most of the vast projects that aim to index knowledge and that subtend computational networked culture: Vannevar Bush's Memex, Tim Berners-Lee's original proposal for a hypertext system that came to be known as the World Wide Web, even the core of Google, the architecture of which was initially conceived as a data structure for scalable indexing of web pages (Bush, 1945; Berners-Lee and Cailliau, 1990; Brin and Page, 1998). In all these cases, knowledge is to be collected, accessed, and distributed via a network technique: indexing, linking, searching. In all cases, knowledge is understood to fundamentally *exist*. It is a pool that the techniques of networking tap into. Online enterprises are married to a notion that resources such as knowledge, and also will and affect, lie in wait for the network to mine. Networked corporatism locates potential as something that exists, must be

located, and will move it forward—not something that is to be invented. The shift from knowledge to affect as a resource to be data-mined is something I return to in chapters 3 and 5, as I chase emerging regimes that twin together the precognitive and the network.

Of course, a vast nonlinear distance separates Bush's early associative memory system and the contemporary culture of search. Google searches, for example, do not simply access web pages or existing "knowledge" on the web. The very act of initiating a Google search generates a return page of results as well. Searching for knowledge generates "knowledge." This data about data—or metadata—figures, in complicated ways, in the life of online enterprises such as Amazon. Here it loops around an initial query by someone, is stored automatically by the networked enterprise's software systems (using, for example, software robots and cookies), and becomes a predictive tool for automatically generating new lists of items to purchase. Importantly, these metadatafied pages are not primarily intended to become, at least on the part of networked corporations, a pool for the future that the shopper, searcher, or user accumulates and stores for their own use, although this might be a spinoff of such modes of prediction. Instead, this relation to potential is severed from the person inputting the data, the searcher, and becomes automatically the property of networked corporations, to be stored in perpetuity in giant server warehouses. Prediction takes down potential. Gone are the "possibilities of fact," the diagrammatics of distributed knowing. And now, occupying that space are results, predictions, and patterns that connect. It is as though the "thought-pool of potential" no longer expands around or fades away from the "thing felt" but rather accrues to the mode and means through which things are cognitively pursued. The technicity of search has recovered and sequestered the thought-pool of networks' potential.

The image of a distributed communications network is, crucially, not just a flattened space, endowed with a logic for laterally expanding its territory; that is, just add more nodes. Of course, flattening and expansionism are problems enough, and both are most definitely at the heart of network science, analysis, and the growth of networked practices and cultures such as embedded and pervasive computing (Mejias, 2010: 611). But the ways in which networks experience, the ways in which they move into and make worlds, may not be inherently cartographic or spatial as such. Ambulatory networked experience, which we can approach both via James's concatenated union of things loosely joined *and* via Baran's recursive arrays, marks networking as the felt force of a temporal topos of looping. The networked mechanogram suggests the peripatetic movement of looping out toward other aesthetic, social, political, and technical machines. The event of these conjunctions will have produced a pool of

potential—that the network will have become a model, or that networking will generate new conditions for collective enunciation. But as it is consolidated into a model, this recursive duration comes to be managed quite differently. The loop closes around the pool, flattening potential into a resource that seems to precede the actual duration of networked events. Potential then becomes some possible set of "things" that might eventuate, there for the taking. In "the network" as model and map, potential has been tamed, at best translated into possibility at worst probability, predictably lying in wait for the future.

2 Welcome to Google Earth: Networks, World Making, and Collective Experience

Between the autoscopic and autopoietic in networked ecologies

Early in the development of its virtual globe, Google Inc. was simultaneously gushing and demure in its visual ambitions for Google Earth: "The whole world is covered with medium resolution imagery and terrain data" (Google Earth Community, 2005).[1] On the screen, and at a variable distance of approximately 40,000 miles to about 50 feet, Google's nonetheless ambitious project for world visualization approaches and stretches out in front of me: zoomable, pannable, and at my fingertips. I can quickly traverse its patchy terrain that, from the extreme distance of a satellite view, seems like agricultural variation. On closer inspection, these color differentials reveal a quilted zeitgeist of composite low- and high-resolution images. I am traversing territory that is Google's—a world that can be accessed from my laptop in my bedroom, from my office workstation, and from my mobile phone on any street corner. A world by which people set their geographical coordinates, globally locating one another's on- and offline activities.

In 2004 the Google corporation acquired Keyhole Corp, a digital mapping firm that had developed a software package, giving interactive access to a massive database of satellite imagery and terrain information of the earth. It also acquired Where2, a software package for digital mapping. In 2005 the first version of Google Maps went live. Like so many events across the history of technologies, this acquisition did not signal technical innovation per se. Geographical information systems (GISs) had already undergone major growth and uptake during the 1980s and were being incorporated into online user-accessible interfaces throughout the late 1990s. What is significant about the Keyhole and Where2 acquisitions is that Google—a search-engine-based company with up to 99 percent of market share in some Western countries—was the buyer. Less than a year after the Keyhole purchase, Google released a plug-in for its search engine that allowed limited online accessing of a satellite and

terrain information database of the earth and a free, downloadable, combined 3D-mapping and search tool—Google Earth. During that same year, 2005, Google released Maps API (application programming interface), which allowed other sites and users' software to interact with and externally embed Google Maps. Significantly, the acquisitions enabled Google to realize and extend itself as a massively distributed online user experience by hooking into what was already an increasing cartographic trend in media culture. At the same time, the "shared" and distributed quality of this online experience is mitigated by an autopoietic renaming of this experience as "Google Earth." Such autopoiesis occurs at the machine level of Google's organization as a networked entity, as cartographic data is updated and increasingly "covers" the world with its imagery. The more Google (re)places and covers the world with high-resolution satellite, terrain and, most recently, 3D models of buildings and landmarks, the more the earth becomes a living actualization of the Google assemblage. Google's acquisitions drill into collective experience, turning networking into a world or environment of Google's own making. And the release and uptake of Google Earth and Google Maps have had more "world-making" effects than Orkut, Google's foray into social networking and a self-conscious attempt to create community via social media.[2]

Google's "earth" cannot be separated from the Google enterprise, and it is increasingly difficult for us to separate ourselves from the creep that has been called "googlization" (Rogers, 2009). William Gibson captures the amorphous state of play that Google has become as it conjoins search and information provision to its relations with its users. We see a networked ecology of "Google-us" emerging:

It [Google] makes everything in the world accessible to everyone, and everyone accessible to the world. But we see everyone looking in, and blame Google. Google is not ours. Which feels confusing, because we are its unpaid content-providers, in one way or another. We generate product for Google, our every search a minuscule contribution. *Google is made of us, a sort of coral reef of human minds and their products.* (Gibson, 2010, my emphasis)

But there is something about Google Earth's world making—the way in which it sustains itself as a "living-image" system—that signals a profound separation between it and collective (human) sociality. If the coral reef marks out Google as a primarily search-based enterprise, then the blue globe image—the most distant view, located some 40,000 miles in space, one can conjure of the world using Google Earth—says more about what kind of "world" is associated with Google Earth's reterritorializing cartographic quest. Google Earth is just that distant planet that seems strangely suspended from the chaos of sociality and life. An odd rift runs through the apparently homogeneous "googlization of everything" (Vaidhyanathan, 2011)—a world made accessible (search), though the terrain has been covered over (mapping); the symbiotic

endeavor that is "accessible" Google search, simultaneously back-ended by its opaque search engine algorithms.[3] Unlike Natalie Bookchin's diagrammatic approach, in which we feel the conjunctive relation between distributed collectivity and cloying intimacy as vital to networked experience, googlization holds its disjunctions at arm's length, pursuing instead a solipsistic quest to make the world "googley." Perhaps this holding apart of Google and the world opens up just enough of a crack in the ground to ward off self-enclosure, making the deep "monism" of googlization ultimately unachievable. As James states, championing noetic pluralism against just such monist figurations of the universe: "Things are 'with' one another in many ways, but nothing includes everything, or dominates over everything. The word 'and' trails along after every sentence. Something always escapes" (1977: 806).

In *Autoscopia* (2009), Justin Clemens, Christopher Dodds, and Adam Nash create search-based portraits for the web and data entities for the virtual environment of Second Life. Both "live on" autonomically, fueling and ever so mildly contributing to an entropic future for search engines such as Google.[4] The web version of *Autoscopia* comprises a simple search field into which a name can be entered, which then generates a composite web "portrait" using the image search results returned for this name. *Autoscopia*'s homepage also lists all the portraits already generated by its engine: Barack Obama, Osama bin Laden, JFK, and Julian Assange, grace the site. Such portraits are generated as both image and list of the first lines of text results returned by the autoscopic bot, which locates shards of online identity gleaned from Google, Facebook, Twitter, and so on. The returned results compose image portraits that are ghostly and multilayered—condensations of double, triple, multiply exposed layers produce a peculiarly web-based portraiture. The greater the online density of standardized images attached to a name on the web—that is, those whose online image has homogeneous, mass distribution either because they have been reproduced repeatedly or because their public domain images are usually ones that have been formally photographed—the clearer and more recognizable are the portraits. Others, such as the artists themselves or this author, return images that appear mutant, nonhuman (see figure 2.1).

In the autoscopic economy of web presence, only those who are seen most often and uniformly by others will be portrayed with the greatest clarity. But the autoscopic in *Autoscopia* involves a shift from the question of identity and its mirrors to how networked ecologies and their relations come to be generated. Each returned portrait is also a unique web page (with its accompanying metadata), which will, in turn, appear in the search results page of an ordinary "google" of the portrayed name. Additionally, these pages return recursively as future pictorial elements in *Autoscopia*-generated images of the same identity: "The identity created will thereafter be

2.1
Screenshot from *Autoscopia* website, 2009, Adam Nash, Christopher Dodds, and Justin Clemens, copyright. Image courtesy of the artists.

reincorporated into future search results. Each portrait also 'Tweets' its existence on Twitter, with both the web pages and Tweets looping back into future portraits" (Clemens, Dodds, Nash, 2009). Using *Autoscopia* literally generates data components for the portrait so that it both visually organizes and maintains itself in a data-based networked environment. Yet the more web pages *Autoscopia* generates and returns to itself, the more it scrambles any coherent web identity and presence. In other words, the autoscopic portrait that the site generates of Barack Obama will become a future element composing his incrementally heterogeneous data self, both in *Autoscopia* and in future search engine results for his name. In returning search to itself, *Autoscopia* turns search astray—allopoietically, differentially.

Online search, fueled by the recursivity of metadata, organized by algorithms such as Google's PageRank and functioning as a mode for generating or composing unities such as online identity, has become machinic. Search is no longer straightforward; rather, it is an entangled, dynamic operation, transversally crossing the human and

nonhuman, the living and nonliving. Googlization—the shift from a network search engine function to a functionality of searching across an entire networked ecosystem, although not a "living system," nonetheless realizes many of the processes that, according to Maturana and Varela's conception of autopoiesis, are characteristic of the living (1980: 78ff; Maturana, 2002). An autopoietic or living machine, a "unity," maintains its composition relationally through interactions with its "medium" or environment. Changes in the medium trigger changes in the unity and lead to adaptation. But in the *living* unity, only those changes that conserve the organization of the living machine (that is, its autopoiesis) are "structurally coupled" with it: "As a result living systems and their nonliving medium change together congruently forming a biosphere as a multidimensional network of reciprocal structural coupling that arises spontaneously *as a result of the conservation of the autopoiesis of the living systems*" (Maturana, 2002: 17, my emphasis). The reciprocity between living machine and medium, the dynamic of structural change between living and nonliving, fundamentally maintains *the unity's* organization in Maturana and Varela's model. In the coral reef that has become the networked entanglement that is the Google-us structural coupling, which is the living and which the nonliving, which the unity and which the medium? In fact, Maturana and Varela suggest that the dynamic interrelationship of unity and medium that generates structural coupling—where structural changes in both living and nonliving generate the sustained ongoing relationality of each to the other—is also a feature of *nonliving* systems: "It is a phenomenon that takes place whenever a plastic composite unity undergoes recurrent interactions with structural change but without loss of organization, which may follow any changing or recurrent structural configuration of its domain of interactions (medium)" (1980: xxi).

Even though, for Maturana and Varela, there is a desire to maintain a clear functional distinction between living and nonliving systems, *at the ecological level* the blurring of this distinction is already present. Increasingly, couplings between living and technical systems mean that we need not only to expand the field of what constitutes autopoiesis but also to transversally approach living-nonliving relationships. The entire Google enterprise as network ecology, for example, is conserved by the ways in which it "selects" its users' interactions and changes—its environment, or what Maturana and Varela call its "medium"—to sustain search as the fundamental kernel of its organization. A search for a title in Google Books will return a page of results, which ranks results on the basis of "signals," such as which popular searches are currently being executed.[5] Typing "the dragon tattoo" into the Google Books search field, for example, returns, as top result, *The Girl with the Dragon Tattoo* by Stieg Larsson rather than the book *The Dragon Tattoo* by Tim Pigott Smith. Google search,

the nonliving assemblage, reorganizes itself according to the habits of its living searchers. That networked corporations have shifted into deploying system-based, coupled, and emergent modes of using data and data-related techniques is not simply borne out in the increasingly sophisticated development of search. This is overt networked strategy, as the declarations of developers, such as Mathew Gray, the leading software engineer for Google Books, attests, "One of the fundamental things we've learned is that the whole is greater than the sum of the parts" (quoted in Madrigal, 2010).

Guattari has suggested that to consider a living system only as a closed, autopoietic unity of inputs and outputs cut off from the developmental events of its entire genetic phylum would fail to account for its liveliness (1995: 39). And for Maturana and Varela *ecosystemically* autopoiesis is always organized and organizing in relation to both other autopoietic processes and a greater ecology of interactions (1988: 43–50). Autopoiesis entails collective activity and collectives always comprise a diverse ensemble of human, nonhuman, institutional, and technical agents. Niklas Luhmann also noted that a more generalized systems approach to autopoiesis might see nonliving systems using a general "system-building" principle of "self-referential closure" (2008: 84). Once we understand generative processes transversally, the distinction breaks down between technical systems as allopoietic (producing something apart from themselves; a factory producing a silicon chip, for instance) and living systems as autopoietic: "Institutions and technical machines appear to be allopoietic, but when one considers them in the context of the machinic assemblages they constitute with human beings, they become ipso facto autopoietic. Thus we will view autopoiesis from the perspective of the ontogenesis and phlyogenesis proper to a mecanosphere superposed on the biosphere" (Guattari, 1995: 40).

It is at this level of a reinvigorated analysis of networked ecology that we need to apprehend the conjunctions and edges of Google's world making. Both Google's making, that is, of a searchable world and its cloaking of that world in data. To do this, we must come at Google from both ends—on the one hand from the viewpoint of what Guattari calls a generalized ecology, "to comprehend the interactions between ecosystems, the mecanosphere and the social and individual Universes of reference" (Guattari, 2008: 29); and on the other hand from the molecular, diagrammatic perspective of microecologies. The former will search out the conjunctions between Google and other abstract machines, asking whether these conjunctions lead to a hardening or cracking of the seamless surface of googlization. The latter will involve feeling out how and where, as with *Autoscopia*, the relations between search engine and the cartographic loosen up, releasing new energies and conjunctions that allow for a new diagram of networks.

Welcome to Google Earth

Images of the world, inscription of what?

From what aspect of networks' experience does a digital mapping application that covers the earth with its data emerge? Does the multiplatform, massively accessible and distributed application that is Google Earth signal the revenge of the map and territory on the skeletal, deterritorialized image of the link-node network? Google Earth's updating, shifting, and composited sets of terrain and satellite images are often referred to as a "virtual globe." Should we therefore understand Google Earth as simulated world? The Google Earth experience could easily fall into a long line of virtual environments from flight simulators through to fully interactive entertainment and art-based experiences such as the CAVE immersive virtual reality environment. Indeed, Google Earth could be thought, pursuing such analysis, as the ultimate of all simulations—a multiuser online map of the world that has become, for all intents and purposes, the reference point for the earth's actual geography. A fulfillment, perhaps, of Marshall McLuhan's prescient 1964 question, asked as he contemplated the meaninglessness of increased data gathering, "So why not use the actual earth as a map of itself?" (McLuhan, 1997: 174). Or should Google Earth be considered more than a map, more than imaging or simulation of the world and instead be treated as a shared, networked environment? In many other multiuser online tools and environments, such as games, social media, and web publishing (blogs and wikis, for instance), the presence and activity of others constitutes the experience to be had and spurs further development of these environments. The term *sociable media*, updated more recently to *social media*, has been used to think through the participatory and networked nature of such spaces.[6] Is Google Earth an example of social media rather than a set of images of the world?

Much of the excitement about social media has revolved around the potential for online networks to be understood as and consist of proto-social and organizational forms. Early text-based and emerging forms of social media, such as blogs or chat, and networking environments, such as Friendster, were not initially image-oriented or visually rich. It is certainly the case that image sharing and networking exist through online interfaces and tools such as Flickr and that these have integrated into or themselves become fueled by social networking. Additionally, the rise of strongly identified social media networks from 2004 onward, such as Facebook and MySpace, have dedicated image features that allow posting of images with status updates as well as Facebook's "Wall," where "friends" can visually interact with each other's image galleries. But what seems extraordinary about Google Earth is that it is a completely visual environment *at the same time* as it is an almost total imaging of the world. If Google

Earth is to be thought of as social media, then its virtual "globalism" should surely elevate it to the ultimate in online social mediation. Google Earth could be conceived as the convergence of image and sociality, where new transformations in visual practice are seen as coemergent with experiments in new social networks.

Yet there is something that needs to be considered alongside this mash-up of the social and the aesthetic as a potentially rich set of entanglements for networked experience. There is something very striking about the Google Earth experience that has gone largely unremarked. It is possible to "fly" around from location to location using Google Earth or Maps, yet the experience of such traversal remains a solitary one. There are buildings, tanks, trees, and monuments visualized but only a muted sense of cohabiting this environment with others.[7] In 2007 Google Maps debuted Street View, which allowed street-level navigation of the cartographic environment at 360-degree panoramic turns through photographic images of streets. The collection of Street View image sets marked a turning point for Google Earth and Maps, as these sets were now acquired not from third-party organizations but by Google itself. Here Google began to call the shots by subcontracting the task of photographing street images to Street View image collectors. But it is precisely this dive into the fully panoramic image of the world that has subjected Google to questions of privacy and citizenship and questions of the constitution of and relationship to mediated social space and visual culture. For as the Street View cameras collect their data sets, they cannot avoid bringing people and their possessions identifiably into Google's world.

Google has developed a privacy policy, or rather technique, that finds identifiable faces and license plate numbers in its Street View images and automatically blurs them. But this has not unilaterally solved the problem of privacy and the limits on visibility. In Germany, amendments to the Data Protection Act in 2009 that allowed citizens to opt out of having identifiable houses in Street View became a condition of its launch there. The European Union has also made demands that Street View images only be stored on Google servers for six-month periods. The higher-resolution and more panoramic Google's world becomes, the more "social" tensions it generates; or rather, the more it generates a tension with sociality.

This distinguishes Google Earth, again, from other online environments, such as blogs, social software networking and tools, and gaming, where the presence of and relation to others assume primary status. The Google Earth environment, then, is one in which there are many "satisfied" individual users in full flight but also one where a tense and difficult relationship to the social prevails. The "population" of Google Earth in fact chooses to reside elsewhere, *adjacent to* the visual virtual globe. An online Google Earth Community site, which runs as a public members' set of forums and

blogs, functions as a beta-testing space, as a discussion about Google Earth's pros and cons, and as a kind of repository for quirky "citings" of visual data located and browsable via Google Earth. In addition, there are a number of unofficial sites—Google Earth Hacks, for instance—as well as a host of creative deployments of and experiments with its visualizations.[8] The point I am making here may seem obvious, but its implication is quite profound. The sociability of Google Earth, as an exemplar of distributed, networked media, lies *outside* the actual visual environment and aesthetic experience that comes with traversing its globe. The relations between aesthetics and sociality that are thrown up by the experience of Google Earth as a distributed simulated environment span an aporia symptomatic of the contemporary online network. This aporia is produced and reproduced throughout networked media and relationships. It resides in networks' offer of both the anesthesia of hyperindividuated, solitary, nodal experience (flyovers, god's-eye views) and an aesthesia of networking, lying with new forms for collective practice, formation, and enunciation.

How does Google Earth negotiate, and how is it used to negotiate, this aporia? Insofar as we consider the Google Earth globe as part of the greater sociotechnical ensemble of the networked enterprise, it functions to create an imaginary projection of a particular kind of world. This "world vision" wants to propel the heaving density of the earth's population and its attendant heterogeneous socialities outside of, or at least adjacent to, the nice clean map of the globe. Instead of producing a heterogeneously populated world, Google Earth produces a world and its peoples as a loose database of individual users initiating and retrieving their individual inquiries bereft of any sociality. What looks like the potentially expanded autopoietic formation of Google's Earth—the self-*organizing* production of a world or system through recursive interactions with an (online) environment—in actuality tends toward self-*enclosure*.

Perhaps it is easier, safer, and ultimately less chaotic to negotiate contemporary socioaesthetic currents of collectivization by overinvesting in the sublime beauty of the power and tools of data visualization. This would seem to go part way to explaining Google Earth's unrestrained excitement in its capacity to wrap the entire earth in imagery. And certainly it is the barefaced beauty and power of visualization (rather than the adjunct sociability it might also spawn) that is promoted by Google as the primary capacity of Google Earth. The issues of heightened visibility and inaccuracy have surfaced as twin responses in both individual user experience and national reaction to Google Earth and Maps. Governments from India, Thailand, and South Korea have expressed concern over the compromise of national security that such high-resolution imaging of military and political installations might encourage.[9] The implication here, then, is that Google Earth, is deadly accurate in its rendering of visual

data and that, coupled with the accessibility and popularity of Google as a search engine, such heightened visibility might make certain geographical regions extremely vulnerable.

But does such augmentation of sight in fact increase visual accuracy? Does the ability to see "targets," using something like Google Earth, actually provide greater visibility for terrorists or the amateur cartographer? In his 1988 film, *Images of the World and the Inscription of War,* the German director Harun Farocki visually explores Paul Virilio's thesis concerning the increasing imbrication of military and visual technologies from the late nineteenth century onward. In a series of scenes repeated throughout the film, Farocki fills the frame with aerial photography of German munitions factories captured by Allied reconnaissance missions throughout World War II, which were targeted to be bombed. In the very same photographs Farocki shows us that there are details of buildings occupied by Nazi concentration camp officials and lines of the camp inmates queuing up to be gassed. Why didn't the Allies use such information to bomb the SS in their buildings and liberate the inmates, the narrator's voiceover persistently asks? The answer is intimated as the film unfolds: the military eye only sees what it has been trained to target. Increased visibility is not commensurate with the capacity to see accurately, if that is not what a militarized field of perception requires. We should not, then, take the appearance of Google Earth or even the rise of digital cartographic applications as evidence that the whole earth is becoming more "visible."

In spite of the visibility Google Earth facilitates, it nonetheless does not offer us an image *of* the world. Or rather, its coverage of the world by imaging data should not be understood in terms of increasing indexicality. Many user sites and blogs that comment on or reuse Google Earth imagery reveal that an uneven visibility comprises its aesthesia. In March 2006, just after Google released an update of higher-resolution images of Germany, a user posted, "I haven't been on GE [Google Earth] for a week or so and was today surprised to find the resolution all over Germany was less patchy. But the area near Munich had been replaced by much older data. The building I work in is now apparently a building site" (AlexK, 2006).

Google acknowledges that its imaging and terrain data is only accurate within a three-year period and is updated on a rolling basis (Google, 2010). The Google Earth visual experience is odd, then, oscillating between temporal glitches and lags and near real-time user interaction. Unlike the high-resolution and fast-reaction-time experience of being in an online multiuser gaming environment, Google Earth is not globally experientially seamless. Google's virtual earth does not function via a one-to-one visual correspondence with the world. But neither is Google Earth pure simulation,

preceding the physical earth and then destabilizing the latter as referent. Rather, it functions via a stretch of the image—the image's deformation provides coverage. Google Earth is the image rendered as purely visible data—at the cost of any claims to representational purity. How are we to understand this new functionality for the digital image in Google Earth and how do engagement with, and experience of, its visual environment have consequences for our contemporary *experience* of the sociality and aesthetics of networking? Although Google Earth is not an image or map of the world, its imaging operations nevertheless signal something important about the world it is making and that its many users redeploy.

A wired and windowless world

"The empty center of neoliberalism is sociality," Geert Lovink and Ned Rossiter warn us (2005). We shall also see that at its center and across its eventless horizon Google is socially bereft. Google is an emerging form of post-neoliberal networked corporation that literally projects its own zeitgeist. This is less an expression of Google than a substitution for the social itself, setting Google free from the latter's seething, struggling, heterogeneous dimensions.

Rather than representing the world from a particular cultural or national perspective or even a specifically located mode of representing, Google Earth presents us with an event—the image horizon. Event horizons form part of astrophysicists' notion of the black hole; they are its space-time boundary relative to an observer. Beyond the event horizon, any events that occur in or to the black hole cannot be detected by or do not affect the observer. Hence light emitted beyond the space-time boundary of a black hole never reaches the observer, and whatever passes through the horizon from the side on which the observer is located cannot be detected again. Google Earth's solitary *and* distributed mapping experience produces the image of the world as an ever-receding horizon for the user. Beyond this boundary—always shifting, updating, and remapping itself—the effects of *making* the world as a potentially massively distributed social project *never reach the solitary user* who is operating within the Google Earth environment. There is emptiness at the center of the experience—the hole left by the evacuation of sociality from this online environment.

Jeremy Crampton argues that distributed GISs share the twin characteristics of being both dispersed and dispensable (2003: 27). But the Google Earth experience dispenses the image of the world on a highly individualized and customized basis, as is the propensity of the entire Google, and indeed much post-neoliberal networked enterprise. The solitary observer/user becomes the locative point from and for which

Goggle Earth events occur. Yet using Google Earth to map the world produces a kind of expansive visual horizon for the user. But this occurs at the expense of all that cannot be observed beyond the image horizon—the capacity to experience the world as one inhabited by the messiness of others and social relations. If there is no sociality in this virtual globe environment, this is because that very dimension recedes, always to be found elsewhere beyond Google Earth's image horizon.

In some respects, the user within the Google Earth environment resembles the Leibnizian monad, whose windowless perspective on the world nonetheless produces a universe of beings as a multitudinous series of intensively "illuminated" individuations. The visual field of the monad is turned in on itself, lighting up from within rather than from a source in the external world. Yet, as Deleuze has suggested, the baroque monad only exists relative to the external universe, which is its series limit (Deleuze, 1993: 51). The monad depends on a constitutive outside, even if it cannot see the totality of this outside. Google Earth inverts this relationship by summonsing a world into existence at the behest of the monad/user. Whereas the baroque world depends on the monad and, equally, the monad depends upon it, the Google Earth monad does not appear to constitutively need a world beyond Google. Google *is* the monad user's image and event horizon.

<AbstractView> (2010), by artists Esther Polak and Ivar van Bekkum, gets at both the monadism and the coupling "us-Google." It recognizes the solipsistic and relational dimensions at the core of the ecological problems of Google's world (see figure 2.2). While undertaking a residency in the Scottish Highlands in 2009, the artists tracked sheep with GPS devices. Out in the remote pastures with local farmers, they were serendipitously being tracked/caught by Google's Street View cameras and made an unsolicited appearance in Google's worldview. The work <AbstractView> that they made about this doubling is a living anemone plucked from the Google-us "coral reef":

We were caught in the act. We found ourselves captured by Google Earth Street View while working on the balloon pieces near Loch Ruthven. We observed while being observed and we decided to play around with our newly exposed privacy. Fly and dive around ourselves, with ourselves and loosing ourselves, using Google Earth as the mobility enabler. Just to find out whom we belong to. (Polak and van Bekkum, 2010)

By embedding Google Earth as a web plug-in in an external site, it was, at the time of making <AbstractView>, possible to play around with its cartography and insert 3D objects, such as buildings, into the world. In <AbstractView>, Polak and van Bekkum created 3D bubbles from their Street View captures—microcosmic worlds that recursively sit in their (external) website version of Google Earth.[10] And, as they suggest,

2.2
<AbstractView> no. 1, 2012. Esther Polak and Ivar van Bekkum, http://www.abstractview.tv, copyright. Image courtesy of the artists.

such recursive gestures touch upon the very rift that courses through the worldmaking impulse at the heart of Google Earth: to whom do we and to whom does Google belong in such an ecology? Moreover, how do we/Google compose this belonging? What relations of "withness" are at work in this mapping-making of world? James again, "Things are 'with' one another in many ways" (1977: 806). It is only by feeling our way in and out, through such a mosaic of looping that takes us and Google alongside each other's edges that we can follow this conjunctive and recursive mode of generating contemporary networks.

What Gibson's coral reef and Polak and van Bekkum's abstract viewing mechanism brilliantly probe is the relational architecture of "Google-us" meshes. Here the production of a "world view" at street level is at stake in which corporation and user, public and private space are all literally glued together in a sticky "withness." This occurs through the microprocesses of visualization that form via relays, captures, and releases and that resonate to compositionally produce emerging sociotechnical ensembles. A coral reef, in which the allopoietic generation of information—sourced from the user and participant—is incrementally folded back to form an autopoietic habitat. Google is made of/by us—the product of our relational, distributed perception-cognition. As

we contribute content, we make a "Google-us" earth. Yet even though we can look into Google's world, probe at it from the vantage of an exterior abstract view, from within Google Earth we cannot look out.

In actuality, no inverse isolation holds between monad and environment in the Google universe, if we understand Google as an entire sociotechnical ensemble. The data queries generated by individual users of Google services *are* accessible but accessible to Google, the corporation. Data queries are routinely stored by Google, which analyzes data patterns to reshape its services. Hence the "outside" has access to the "inside" but the insides never see directly what their outsides are up to. Google users are folded into the (closed) autopoietic production of Google and the data gained through this production cannot structurally couple with another environment/medium to produce new singularities. Yet the separation of visual environment from sociality—of Google Earth from Google Earth Community, for example—holds apart the possibility of forging new aesthetic experiences from emerging traits of collective enunciation *within* Google's imaging of the world.

What kind of exemplar, then, does the Google Earth experience offer for a shared yet distributed aesthesia? I will suggest that it is one in which sociality, as a domain of conflicting, disjunctive, anabranching, and chaotic processes and formations, is not permitted to enter. This, of course, is not the whole story of distributed aesthetics. As I hope to indicate throughout this book, there are many projects and emergent modes of networking in which a vigorous and lively sociality figures as the condition of their possibility and of their distribution. But Google Earth is most importantly an earth coming into being as a result of a particular orientation—the creative networked corporation—the horizon of which binds its users against the messy event of chaotic sociality.

During the late 1980s, Margaret Thatcher proclaimed, "Who is society? There is no such thing! There are individual men and women and there are families" (1987). Google Earth provides an ever-receding horizon of such a society-free world. It displaces online community networking fluxes to a space external to its visual field—the Google Earth Community and various other online sites and forums. The Google Earth environment remains unpopulated by such an unruly meshwork. Hence the image, stretched and deformed as it is within Google Earth, is nonetheless "purified" of networked social relations. In a sense, the Google Earth environment and experience are the imaginary of a coming community—the community of perpetual and solitary foragers, of "exposed privacy," as a condition for living a data-based mode of existence. This coming community is being constituted while the Google enterprise is steering a rocky course through the differential demands of nation-states for data protection,

the increasing sophistication of GIS systems, the geopolitics of "developing" military powers, and the proliferation of radical aesthetic cartography and data projects.

Google Earth and social media may not be so far removed from each other in this respect. Social media—clustering around the rhetoric and schema of friendship networks—operate through an ever-expanding quest for connectivity, contacts, and "friends." They are desperate for and desperately dependent on popularity. Google's infamous reconstitution of search as a popularity contest via its PageRank algorithm associates it with social networking through the economy of linking. Social media per se do not pose an alternative, outside of, or limit to, Google Earth. Both social media and online search are organized around "link value," where the site, node, or "friend" all accrue a perception of value based on whether another site, node, or "friend" wishes to link (Walker, 2002). But sociality also involves the emergence of relations that cannot be erased by reducing everything to the level of nodal units, as Thatcher sought to do for neoliberal society. Collectivities—networks, families, and even individuals—are complex and chaotic forms of organization. Conflict, failure, and dissipation are as much a part of their interrelations as growth and connectivity. It remains an open proposition as to how, or even whether, social media constitute networked social formations. In part, this possibility turns on their ability to move from sociability to sociality, but it also turns on how collectivities are generated under such conditions. In social media and arguably any online networking, collectivities are generated for the main part through the labor of collectively producing, negotiating, and enunciating sociocultural, aesthetic, and sometimes political strategies and projects—networked, creative labor, in all its meshed messiness: chat, discussion, and comment; the ongoing maintenance, development, and generation of software environments and infrastructure for networking; peer-to-peer sharing, carving out of new spaces and styles for media distribution; the "hacking" and mashing up of Google Earth's globe, to name only the most obvious aspects. It is precisely the cognitive labor involved in generating online experience that is displaced *outside* the Google Earth environment.

User, usability, utility

The motto of Jakob Nielsen, the guru of user-friendly web design, has been "Usability comes first even if a site is not trying to sell anything" (2000: 389). Usability was the great instrumentality underwriting Web 1.0. But as the web deformed after the dot-com ripple of 2000–2001, search became one of its new instrumentalities. And in forging ahead with the new instrumentality of search, Google Earth has marked out

a trajectory that stretches toward an atomistic, nodal event horizon rather than indeterminate and chaotic social formations. Instrumentalized search, as a core endeavor of the creative networked corporation, is intricately bound up with a worldview in which sociality can only ever be understood as the aggregate outcome of individual transactions, including the transactions of querying and retrieving information or data. If we begin with search as Google's core business, then, likewise, we need to understand the relation of Google Earth's visuality to the rationalization of online visual cultures in the service of such instrumentalism as we enter ever deeper into networked corporatism.

Around the end of the 1990s, usability discourse dovetailed with web development. Nielsen's mantra of pared down text-based websites that were easy to navigate became de rigueur for serious online corporations (Nielsen, 2000). Pitching an "engineering" against an "art" approach, which resonates with the reign of "model" over the peripatetic diagram, Nielsen convinced a swathe of web designers that their gratuitous graphics had to go in place of the "user" who instead desired straightforward navigability (2000: 369). He landed a consultancy to clean up the software he considered the chief offender against web usability—Flash. Commissioning the Nielsen Norman Group to conduct a usability study of Flash MX in 2002, the software company Macromedia implicitly steered Flash software away from its association with superficial and superfluous presentation and content and married it to the common denominators of Nielsen's usability standards.

But something was missing from this leaner post-dot-com online environment, in which the web had begun to not simply rationalize but shift into what we have come to call Web 2.0. This changed environment lacked "fun." Amid the tussle between usability and play, the Google search enterprise launched itself upon the world. Although Google's search engine architecture was in beta development from late 1998, its characteristic childlike and slim line logo on the website's splash page, surrounded by a spacious sea of clear white serenity, had already become its brand by September 1999. Google was perfectly placed to sail through, and indeed capitalize on, the dot-com crash of the early 2000s. This is not simply because of the nature of its core service—search—but because it fused the usability ethos with the play aesthetic.

Google web design has retained an ongoing faith in usability rhetoric insofar as both its website's homepage and its search result pages continue to be text-based. The addition of Google's advertising program AdWords in 2001—small text advertisements semantically connected to key search words and appearing on the right hand side of returned search queries—hardly detracted from usability standards. In fact, Nielsen himself endorsed the text-based nature of Google's click-through advertising as an

unobtrusive way of both navigating information and satisfying the user's parallel "desire" for online consumption (2001). In a way, Google Earth's rich image-based environment stands in contradistinction to the lean usability of Google's text-centric world. Although the Google Earth experience can be understood in terms of the core Google activity of search, something else also occurs. As suggested by the adjunct formation of the Google Earth Community and other online uses of its maps, the Google Earth experience has become an end in itself. Perhaps, then, Google Earth shares something with massively multiplayer online role-playing games (MMPORGs) in that it builds a Google-like space to simply hang around in and "play," beyond the instrumentalism of search.

However, MMPORGs tend to be extended spaces for hanging around in, moving the actual "task" of playing into something that involves game development, chat, and general gaming sociability (Duchenout and Moore, 2004: 333–355; Jansz and Martens, 2005). Google Earth is neither sociable in this sense nor a space for welcoming the social as a disjunctive, chaotic field. Rather, it "handles" the tension marking the subjectivation of "online user," which is one that is caught in an ongoing oscillation between search/instrumentality and sociability/play. But it comes at this via a different route than those sociable spaces developed via online gaming, the ecology of which is probably a more open and consciously crafted example of the "coral reef."

On the one hand, we might think of search as less an activity than as the *activation of utility*. Like the system software installed on a computer, Google uses search as a kind of "utility" program to perform the tasks it deems most important to its users. This optimizes not only the Google experience but also *life as search experience*. Eric Schmidt, Google's CEO, stated in 2007 that "the goal is to enable Google users to be able to ask the question such as 'What shall I do tomorrow?' and 'What job shall I take?'" (Schmidt in Daniel and Palmer, 2007). On the other hand, utility is a term that comes to us from economics, indeed from utilitarianism, which has become the mainstay of neoliberal economic thinking and rhetoric. Utility, in this sense, is a measure of the satisfaction gained from consumption—usually of commodities. But in the Web 2.0 context, this also includes the consumption of online services. Furthermore, if we understand the Google zeitgeist as an inmixing of computational and economic utility, we can see that it rates search *usability* highly as a measure of *utility*: "Google's mission is to deliver the best search experience on the Internet by making the world's information universally accessible and useful" (Google Inc., 2011). In a way, this solves the issue of the unsatisfying leanness of Nielsen's usability standards. Usability, in the Google universe, transmutes into utility, which is sustained as both a measure of search satisfaction and as a utilitarian outcome (the best search results),

through which the best possible solutions are furnished for the greatest number of users.

In the context of this transmutation of usability into utilitarianism via utility, the Google Earth experience needs to remain a fundamentally solitary experience and not stray too far into sociality. Google Earth is not just the best possible experience of flying over the world but the outcome of the individual user's preferences, producing an optimal experience for her/his own consumption. Uncannily, there is in fact a moral framework that already supports this kind of world: preference utilitarianism. Although I do not want to suggest that the Google enterprise developed with overt knowledge of preference utilitarianism in mind, it is nonetheless the case that preference utilitarianism perfectly encompasses the intersection of contemporary computation, neoliberal culture, and the post-neoliberal networked corporation. At the same time, the preferential aspect of this utilitarianism admits the personal back into the mix, all the while mitigating against the emergence of "a people," of Google Earth as habitus, or of an online massively *relational* collectivity.

Preference utilitarianism developed from the 1950s onward as a framework for moral (rather than economic) thinking in the work of British philosophers such as R. M. Hare (1981). Its basic aim is to make aggregated individual preferences capable of satisfying the requirement of universalization. Taking into account all possible alternative preferences that might deter acting on the rightness of a given proposition provides the grounds to seemingly ensure that all the terms of a proposition become universally moral for preference utilitarianism. This "check and balance" approach to the relation between proposition and action is supposed to analytically refine moral imperatives so that they can be acted upon. Hare sought to bring universal conjectures up against prescriptive refutations—the universal against the particular (individual)—in order to arrive, finally, at propositions that hold morally under any circumstances. The proposition must therefore be the kind on which one universally prefers to act, having taken into account all other preferences that might change one's desire to act. Preference utilitarianism has the peculiar flavor of marrying the contingency of desire with the indifference of logic. It is this quality that is likewise characteristic of the three-way marriage between computational culture, neoliberalism, and networked search as they align and generate the culture of cognitive capitalism. Their union intensifies the conjunction of choice (preference), algorithm (logic), and networked flows.

Utilitarianism concentrates on the consequences that are produced by actions; moral propositions can be arrived at retroactively as those that lead to the best consequences for all. It is easy to see how utilitarianism and neoliberalism intersect through the belief in the idea that deregulated markets produce the best kind of

economic and social formation via the mere satisfaction of consumption. But, somewhat ironically, it is unclear how to configure the individual consumer and his or her *preferences* within the statistical averaging of "the best," to which the mechanism of the free market inevitably gives rise. Preference utilitarianism attempts to resolve the tussle between the universal and the individual, "the good" and personal satisfaction, by producing the universal as the aggregate outcome of individuals' preference satisfaction.

This is precisely the logic of Google search. The best search results are those that take into account the preference of all other web pages (or their developers) to link to another page:

Google interprets a link from Page A to Page B as a "vote" by Page A for Page B. Google assesses a page's importance by the votes it receives.

Google also analyzes the pages that cast the votes. Votes cast by pages that are themselves "important" weigh more heavily and help to make other pages important. Important, high-quality pages receive a higher PageRank and are ordered or ranked higher in the results. Google's technology uses the collective intelligence of the web to determine a page's importance. Google does not use editors or its own employees to judge a page's importance. (Google, 1999)

Here we have an algorithm—seemingly impartial and the very stuff of logic—that sorts and orders the preferences of all web users to arrive at the best possible solution for the individual searcher. Through this logic, both the aggregation of web flows and information (the market, the universal) and the subjectivation of the solitary, satisfied user (the consumer, the individual) are held together without ever having to encounter conflict, differentiation, and the chaos that is the field of networked sociality. Google Earth, then, can be understood as the aesthetic rendering, *an-aesthesia*, of the logic of Google search. It produces the experience of navigating a database world that has been computationally filtered as the best possible, highest-resolution rendering of a world—as an individualized, "satisfying" mode of engagement. Henceforth there really is no online society; there are only users, algorithms, and aggregates.

Will Google eat itself?

In questioning the relation between the aesthetic and the social in contemporary networked cultures, I have suggested that Google Earth functions as more than a map but less than a virtual world. The Google Earth experience both emerges from and is constitutive of an aesthesia of networked corporatism; it is a particular mode of forging a conjunction—in actuality more an aporia—between hyperindividualism and sociability. But there are a number of ways in, out, and through Google's world making—of

approaching an outside to the self-enclosed image horizon that bounds the Google universe. At the very least, the emergence of both software-based and experimental geosocial practices that perturb Google's brand of autopoiesis testifies to the production of other lively, distributed aesthetics. Additionally, I suggest that whereas the logic of utilitarianism is bound to repeat the aggregation of all outcomes as "the best" and "the good," heterogeneity can be discerned in algorithmic logic if it is put to work divergently in networked cultures. Adrian Mackenzie has suggested that algorithms are something more than mere computational commands: "To treat algorithms as pure repetition would be to overlook the inventive variation embodied in every algorithm" (2007: 102). Algorithms, he believes, follow a Jamesian logic of concatenating movement into order, through varying sequences, routes, and pathways of networked data (103–104). Hence an algorithm does not so much prescribe a movement to be performed and repeated as generate specific movement through data as it is executed.

According to Google's press releases about how PageRank assesses the "value" of a web page, it's the "votes" that count—the backlinks that Page B has garnered, for example, from Page A. But in their first technical paper explaining PageRank, Sergey Brin and Larry Page, Google's founders, also underscored the importance of the page doing the linking (1998: 3). If a page were backlinked by a major site such as Yahoo, it should receive a higher ranking than another page, which might have many more but not so highly valued links. It's "who" or "what" votes that counts. But this is not all there is to the PageRank algorithm. What spread of pages or data should the algorithm move through? This field of movement must also form part of the algorithm, and although it is a modeled field (it must be in order for the algorithm to return results and not simply keep computing ad infinitum), for Google it is based on an intriguingly indeterminate personality type: the "random surfer" (Page and Brin, 1998: 5–6). The behavior they attribute to the random web surfer is simply to keep clicking, keep moving. At some point, especially if the surfer finds herself in a closed loop of pages, she will randomly link out to another site. The notion of the random surfer is based on the statistical modeling of random walks on a graph known as a Markov chain, where the probability that another random walk will occur is computed solely on the current state of all known walks. PageRank assigns a limit value to the likelihood of a random link-out occurring in order to provide a distribution spread and limit for the quantity of web pages with back and forward links. It can be seen, then, that the PageRank algorithm (and here we are dealing only with its earliest incarnation), concatenates a number of heterogeneous elements: link value as brute quantity of back and forward links, perceived importance or a differential summation of the ranking of the actual links themselves, and a probabilistic spread of the distribution

and limit of computation that the algorithm should perform. The very heterogeneity of these elements in a *networked* environment means that their concatenation (in spite of all the modeling of randomness that is an integral part of algorithmic logic) will be volatile: "The algorithm engages with and provides an elaborate figure of an unpredictable and intrinsically dynamic environment. It moves to the fringes of mechanical action, where similarity or repetition begins to blur" (Mackenzie, 2007: 98).

The classic example of the ways in which both spread/limit of page distribution and linking concatenated to work against the other supposedly modulating element of PageRank—its summing of the importance of pages being linked to—is the Google Bomb. Prior to 2007, when Google made some changes to the way it indexed pages, tactical media activists, general web humorists, and online commercial interests could elevate a site's ranking and hence return search results via unexpected and disjunctive search queries. This was done by deliberately creating a large quantity and spread of links between the query phrase and the page to be highly ranked. One of the best known examples occurred in 2005, when the phrase "miserable failure" was used on pages which also hyperlinked to the official Whitehouse biographical page for George W. Bush.[11] Typing in the phrase "miserable failure" to Google's search engine then returned the Bush site as the top ranked result. A number of people have commented on the ways in which tactical media uses of Google bombing have struck at the heart of the supposed neutrality of the PageRank algorithm and of search itself (Kahn and Kellner, 2005; Zer-Aviv, 2007). But what is more interesting about Google bombing is that it indicates that algorithms, as Mackenzie suggests, are never simply repetitive, stable executions of code and that their sequencing, their movement in the network means that things can always be "with" one another in many ways. Although the Google universe might seem to have swallowed our contemporary horizon, if we approach the experience of networked aesthesia through James's elaboration of concatenation, we get a real sense of just how loosely joined things can be.

Pushing Google's world making toward recognizing that the "us" in the coral reef ecology is a perturbation involves not simply clever manipulation of algorithms or reverse engineering of software but, crucially, the collective activation of networking. The links need to be created; the "miserable failure" refrain must be distributed. *Google Will Eat Itself (GWEI)* is the title of a piece of collaborative network art produced by the Austrian-based duo UBERMORGEN.COM, Alessando Ludovico, Paolo Cirio, and a *network* of artists, activists, and online denizens.[12] The project piggybacked on Google's AdWords, which has provided the company with a lucrative source of revenue and made it financially successful. To advertise on a page of Google search results, businesses create Google accounts in which they "buy" keyword search terms that

correspond to their products. As a user generates a search query, so too are matches made to advertisers. If a user clicks on one of the text ads—"clicking through" to the product or business website itself—a micropayment is generated for Google from the advertisers' account. A click-through more or less equals a vote for a business and the business only pays for all the votes that are generated in relation to its products. In the world of Google economics, a click-through is simultaneously an execution of a computational command, a flow of potential buyers to a business, and a vote for the product itself. Google builds a form of cultural capital here because the click-through generates a micropayment for whoever is serving the ads. What Google takes from the web, it also gives back—or so the mantra goes. The simple act of clicking, once an experiment in textuality, has now become the execution of an algorithmic sequence that keeps web microeconomics pumping.

GWEI attaches itself to the enclosure that is Google's world, the circularity it deploys in order to (in a limited sense of the word), autopoietically sustain itself (see figure 2.3). The project serves Google ads to a network of open and hidden websites. It relies on both random click-throughs to sites on which the ads are served *and* on a

2.3
"The Attack," *Google Will Eat Itself*, 2005–2007, UBERMORGEN.COM, Alessando Ludovico, and Paolo Cirio. Image licensed under Creative Commons Attributions 2.5, http://creativecommons.org/licenses/by/2.5/.

network of new media artists, tactical media producers, critics, cultural producers, and hacktivists visiting sites and perfunctorily performing multiple click-throughs. Micropayments are then generated for the *GWEI* account using the AdSense aspect of Google advertising—micropayments to those serving the ads. Now the fun really begins, for the money generated for *GWEI* is used to buy Google shares on the stock market. The results of this, *GWEI* declares, will be twofold: first, to place the shares in trust to be given back to the public, who has in fact generated the income; second, to eventually publicly buy out Google through shareholder takeover in a calculated several hundred million years. In 2006 Google censored *GWEI* by removing all pages attached to the site and the domain name from its indexes. Nonetheless, it was via organized networked activities on mailing lists, blogs, and through email that the *GWEI* site continued to be linked to, keeping it active as a server of ads to other sites and keeping it visible to other search engines.[13]

I propose we think about *GWEI* not simply as an example of networked art but as "expanded algorithm," extending the field, possibilities and actualizations of the algorithmic in networked experience. *GWEI* is moreover an investigation of the ontogenesis of the algorithm in computational culture and networked economies. Following Mackenzie (2007: 102–103), we can say that code sequences change and evolve through usage and transfer and exchange across platforms, nodes, and users in online contexts and through their extensive spread and deployment throughout communications systems. For all pragmatic purposes, there is, then, no ideal or pure repetition of sequences of code that algorithms run through when they execute in concrete situations. Algorithms often function because they are able to make use of variation and rearrange sequences of code into different orders, resynthesizing these so as to maintain the associations between sequential events. The immanent variability of the actualized algorithm draws out its potential (virtual) inventiveness.

GWEI exploits the inventiveness of the algorithm operating at the generative basis of Google's search-oriented world. It no longer offers up a repetitive expansion of information, of search, and of the parasitic relation of these to collective action. Instead, as Google eats itself, it becomes something else via *the very same execution of sequences through which it normally sustains itself*. That "something else" is in fact an inversion or reversion of the Google-us coupling: eating itself, Google generates the (auto)production of the collectivity of "we," who will come to take possession of "it." The *GWEI* buyback incorporates a "business plan" for public ownership of the Google corporation defined, in the contemporary corporate terms of pure speculative capital, via a projection for the eventual, complete ownership of Google shares by "the people." Of course, the reality of a meaningful shareholder stake in Google via the

processes *GWEI* puts to work is unachievable. But that is not the point or the real work of such a project. That work lies instead in imagining a networked event—a new relation with a different concatenation of elements that takes us collectively beyond the horizon of Google's self-enclosed world. Here we have artistic practice, which takes us out of the recognizable pattern of Google-us relations and invents an imperceptible, indeed impossible, world where the encounter becomes Us-google.

GWEI reinvents the Google world, based as it is around, and founded on, the Page-Rank algorithm, finding instead difference in the Google loop of repetition—perhaps even, as Gregory Bateson said, of information itself—as the difference that makes a difference (1978: 470). Rather than algorithmic art, *GWEI* produces an aesthesia of the algorithm, drawing out its relational variability. Moreover, the project *does* acknowledge both the social relations engaged in the playing out of web economies and the potential for the formation of different kinds of socialities to be discovered via the networking of distributed media. It is not the click-through that is at the core of the production of value in a project such as *GWEI*; rather, click-through value has itself to be generated by the artistic and cultural networks of people who connect to, distribute, and redistribute information about such art projects via sociable media such as blogs, online magazines, forums, and face-to-face art festivals and symposia. This is where the real work of the project is done—in the gathering of resources to support the project by these disparate and emergent, networked socialities.

Is this kind of aesthetic intervention sufficient in an age and terrain increasingly covered by Google-like imagery? Sufficient, that is, for the enunciation of other kinds of collective experience? Although I want to endorse the aesthetic and cultural work that projects such as *GWEI* undertake, we also need to invent an aesthesia that holds itself apart from yet in relation to the self-enclosure of Google Earth's reef, feeding only itself. How might it be possible, in other words, for "difference," in Bateson's sense, to make it onto the map that is Google Earth, for there to be a "revirtualization" of Google Earth, deterritorializing its mapping energies and rediscovering its diagrammatism? In chapter 1, I suggested that the relay between network diagrams and diagrams of the network in contemporary network cultures had reached such recursivity that it had become almost impossible to extricate the diagrammatic from the network diagram. But the point is not so much to find a world "free" of the map or Google Earth, to resolve the recursions as it were, but to work out instead where one might transversally begin to delimit the diagram/map/world movements as totally convergent, to explore, in other words, the points at which the deformation of Google Earth's "image" really start to stretch and tear, bringing it into relation, into a mosaic, with other perceptive and affective machines, other "Incorporeal Universes" (Guattari,

1995: 4). What are the (transversal) edges of the relationality "Google-us"? As Bateson suggests, if you are interested in what constitutes the "identity" of being a blind person in a sighted world, you had better extend that "self" to the prostheses the person uses to move around and the pathways along which she feels her way in the world, all of which enter into a circuit of relays to produce an "ecology of blindness" (1978: 325). The ecology of networks in the era of Google web hegemony also extends outward to whoever "us" is and all that we cartographically create. For these creations too will "map" Google's Earth. A cartographic mosaic emerges alongside or extends energetically and intensively out from the Google-us coupling: a transversal, autopoietic transformation is in the process of being enacted. Or, rather, perhaps we should call it an autoproduction, in which new territories, alongside the recursive map-world/Google-us coupling are being created: "A process of autopoiesis rather than mimesis, cartography actively enacts, assembles and brings forth concrete existential territories as well as incorporeal universes of reference, without presupposing any static image of the earth to begin with" (Bosteels, 2001: 902–903).

Toward an allopo(i)etics of Google Earth

(How) would it be possible to bring this diagramming in, or extend it out, to Google Earth? As I have argued, much of the networked sociality that accompanies Google Earth sits to one side of the platform; Google Earth continues to turn on its own axis relatively "free" from the crowds, controversies, and chaos that nonetheless bubble up at its fringes. One would have to conjoin and stretch the map/image/Google Earth to its territories/peoples/online networks via another relationality to get the difference "onto the map." In Michelle Teran's performance piece *Buscando al Sr. Goodbar* (*Looking for Mr Goodbar*, 2009), a Google Earth map of the city of Murcia in Spain becomes the centerpiece for investigating, locating, and networking its nodal inhabitants. Teran "visited" Murcia using Google Earth over a period of time to get to know what its inhabitants were up to "in the network." Using Google Earth longitude and latitude coordinates, in conjunction with YouTube video searches, Teran was able to plot people across the city who, unknown to one another, had uploaded videos of themselves—sometimes performing solo, sometimes socializing or playing—to YouTube (see figure 2.4).[14]

She then contacted the video makers and some were included as "destinations" on an itinerary for an actual bus tour scheduled through the city during the *28th ARCO-Madrid* Contemporary Art Fair in February 2009. Inhabitants of Murcia were invited to join a bus tour of the city that followed the route Teran had plotted out of uploaded

2.4
Screenshot from *Buscando al Sr. Goodbar*, 2009, Michelle Teran, mixed performance, online video, cartographic, and software work, copyright. Image courtesy of the artist.

YouTube video makers on Google Maps and a moving image of the video-making map played on a large screen inside the bus. As the bus neared its YouTube destination the videos began to play. An actress from Murcia, Irene Verdú would leave the bus at various points and escort the "tourists" into the homes, clubs, and bars of some of the video makers. Here the YouTube performances were reenacted, bringing the bus tourists "onto" the performing, social media map of Murcia.

In the 1977 film *Looking for Mr Goodbar*, by Richard Brooks, the reserved and dedicated schoolteacher character of Theresa Dunn, played by Diane Keaton, roams the bars of New York looking for sex and drugs. Moving through the city at night, her character seeks ways to extend and cut across the limits of job, gender, and middle-American sensibility that she inhabits by day. But the more she seeks the company of nighttime strangers, the more she becomes embroiled in the underside of New York life. Eventually, she meets a man in a bar with whom she forms a fraught, jealous, and possessive relationship, and she is murdered. There is no Mr. "good bar." Teran's

multimoving, multimovement piece that rolls out through the night across the city of Murcia resonates in name only. *Buscando al Sr. Goodbar* is a humorous and joyful work whose narrative is also shaped by chance and somewhat banal encounters between people meeting in urban night environments. In some cases, the bus tourists switched from audience to performers, "serenading" the original YouTube maker-performer as they met at one of the destinations with a song that they had heard onscreen on the bus. Rather than presenting a seedy "underside" though, these conjunctions crisscross to produce a field of relations among Google Earth map, social media, the urban landscape, and a city's inhabitants, opening onto novel modes of imagining urban socialities as multiply networked and lived events.

Buscando al Sr. Goodbar is impossible to pin down to a particular genre of networked media art. It is at once locative media, performance, social media, psychogeographical, participatory. It flows less as a result of software, interface, virtual environment, and the internet, even though it is wholeheartedly a work in and about networks within the Web 2.0 environment; it functions more as a work proceeding from "enactive networking," to borrow a concept from Varela's "enactive perception," which he envisages as the dynamic relation generated through the coupling of an embodied perceiver and environment that "lays down" a way in the world (Varela, 1999: 12–13). The networking in *Buscando al Sr. Goodbar* is dynamic—an unfolding relation that ensues via the conjoining, the *enacting* of city, media, inhabitants with one another. The Google Earth map is situated via YouTube, which is further situated by a performance, itself resituated as a reenactment of video recordings. The bus tourists begin to inhabit and move through their networked city by being brought into actual conjunctions with the YouTube performers; the YouTube video makers become performer-inhabitants, gaining an actual audience for their media uploads previously performed via solitary screens. Google Earth functions here less as a map, less as a self-enclosed world and more as the condition for the very event of networking as edging—an opening-out-onto. It sets off and is thoroughly entangled with a series of (recursive) relays that become the predicates for novel predicates—emergent socialities inflected by networks that are ecologies of performing, traversing, seeing.

3 Data Undermining: Data Relationality and Networked Experience

Databases and the cognitive labor of data management

During the late 1960s, when Baran's schema for distributed communications was beginning to be implemented by the U.S. Department of Defense's Defense Advanced Research Projects Agency (DARPA) and a tightly knit group of university researchers, a different problem of networked relations was being mulled over in the business world. By the early 1970s, computers were playing an increasingly dominant role in internal company record keeping and logistics as well as in emerging management issues, such as tracking supply chains, for globally dispersed and interconnected businesses. Accordingly, access to and interconnections between stored records also became the business of business. Yet even into the early 1970s, the design for storing computational records mainly took the form of the hierarchical database, modeled on a treelike structure, in which records were organized via parent-child pathways.[1] A "parent"—perhaps an identifier such as an employee number—could have many children, employees with their identifying numbers for example, but each "child" node or record could only have one parent. This structure resulted in a stepped, one-to-many organizational structure for data that, if visualized, would resemble Baran's "centralized" communications diagram with core nodes and spokes emanating from them. Such a structure made sense for unique storage and retrieval queries—say for a social security number lodged in and called up by a census database. But attributes that ranged across a set of variables that might include a number of subsets and may need to be articulated with other attributes, such as "language spoken" *and* "gender" of the person associated with the social security identifier, became increasingly cumbersome to upkeep using these hierarchically fixed database structures. As the military-academic research world had set itself the task of making networks relational by increasing redundant pathways for data, data redundancies in hierarchical database structures were imposing the need for greater relational flexibility in the corporate

sphere. Informatic redundancy became a force shaping the emerging computerized world.

The shift in database operationality that permitted running a sole query relating a set of data variables came to be known as "primary keys." Although seemingly small, this shift betrays a modulation crucial to the coextensiveness of the network *dispositif* and the broader social field. In other words, the intranetworking of database architecture embedded relationality as an organizing force between elements in an informatic assemblage. We can see that Baran's diagram for distributed communications was not just a model, then, for a spatially dispersed form of transmitting information; rather, it was a new mode for "texturing" information as relational. In chapter 1, I showed that Baran's diagrams are caught in a tension between the top-down imposition of "models for a network" and the lateral diagrammatic forces of emergent networking that can be detected in his "Array of Stations" (see figure 1.2). This dynamic is immanent to informatic networked cultures and can also be found in the networking that has made database architecture such a pervasive mode of epistemic organization. This chapter is partly concerned with the ways in which the dynamic between distributed network model and diagrammatic networking shapes both data's hermeticism and its vulnerability. Whereas a growing military-research-corporate atmosphere has come to surround legitimized access to data—pin numbers, passwords, complicated logins, and secret servers, for example—a rather humorous, even absurdist, attitude to the contemporary accumulation and recursive generation of data also indicates the vulnerabilities of database architectures. Such vulnerabilities, torsions, and self-perpetuating redundancies have become the material of a current generation of data artists.

Many data record-keeping structures of the 1950s did the job of government record keeping—the U.S. Census Bureau, for example (Neufield and Cornog, 1986: 183). In these cases, maintaining a fixed relationship between the record and a unique identity was paramount. But in the business world, what was becoming important by the early '70s was the exchange of information between and across elements: how could this part be supplied for x number of products to y number of businesses, and how could its whereabouts be tracked? Standardized "attributes" containing interchangeable variables came to be the sorting and compilation mechanisms for this kind of data; unique identifiers were increasingly relegated to the domain of government bureaucracies alone. Shifts in database design and conception during the '60s and '70s indicate that "business" rather than bureaucracy was to become the basis for modeling how data was to be (internally) networked and organized. If the networked society can be primarily understood as a society of control, then the rise of control "mechanisms" lies

less with governance and its concomitant technologies of the self and more with the banality of rows and columns that comprise the database table, literally contouring the new world of networked business.

As datasets increased due to expanding, dispersed, and internationalized business transactions, queries to databases became increasingly combinatorial. And the actual nature of datasets was also changing. Prior to, and also well into, the 1970s, hierarchical structures continued to be the main, if inefficient, model for database design. These stored their data hierarchically, with the structures themselves providing "pointers" or navigational pathways to the next data "value." Both data records and moving through these were intrinsically entwined and occurred as a level-by-level set of processes. At a certain threshold, then, adding more data or adding different types of data to a dataset entailed major changes to, and potential distortions of, the data structure in order to continue navigating. It wasn't simply data that was multiplying; the structures proliferated as well, generating reduplication and redundancies across the record sets. Data queries would have to "travel" further through and around the database, slowing down the query returns. In many cases, too, the hierarchical database was matched to one application or software program. If a number of programs wanted to access the same data, a new query would need to run for each application. Sharing data across applications (between different specialized branches of one enterprise, for example) was time-consuming.

It might seem that packet switching, as the new design for a many-to-many communications network, and the problems of database design were at opposite ends of the networking spectrum, even though they arose during roughly the same time frame in computational history. Whereas packet switching makes use of network (organizational) redundancy, the hierarchical database structure was beset with multiredundant and nonrelatable data as its organizational issues. But the conceptual solution for how to deal with both the speedy movement of data through computational networks *and* the fast retrieval of information from databases is strikingly similar. This similarity lies in the *unlinking* of data as package in the network or as stored record in the database from either's infrastructure. Prior to the packet switching model, data communications had been based on the idea of the traditional telephone circuit between two "stations," with a telephone call reserving a dedicated circuit for the duration of the communication session. During a phone call, then, the network link and the data being transmitted between the two stations were bound together. Packet switching instead treated the data and network (infra)structure independently, allowing whatever communications links not in use at the time to provide the actual network for the packet. The packets themselves had attached data, metadata, directing where they were to end up

and how they were to reassemble at their destination rather than being guaranteed preassigned or reserved routes.

In David Child's original technical report of 1968 on a new theoretical model for database design based upon the mathematics of set theory, the same idea of independence as an organizational principle for dissociating data from its infrastructure can be detected. Importantly too, "meta" structures make their way into this new design as a way to implement this independence:

> Each set in an STDS [set-theoretic data structure] is completely independent of every other set, allowing modification of any set without perturbation of the rest of the structure; while fixed structures resist creation, destruction, or changes in data. An STDS is essentially a meta-structure, allowing a question to "dictate" the structure or data-flow. A question establishes which sets are to be accessed and which operations are to be performed within and between these sets. (Childs, 1968: iii)

A database becomes a structure for describing structure: that structure is not *pre*scribed over the entirety of the database but rather is generated or, in computational language, is "declared" by the question or query. Just as Baran's arrays designate a shift from an *infra*structure of networks to a kind of "edging" force that propelled the networking of packets as they switched processually, so too was the database changing from an underlying informatic "infra" to a networked *meta*structure. Or perhaps we can say that infrastructure in networked information no longer takes the form of underlying structure but is rather a recursive and propulsive force. This declarative method of performing database structure as query specifies only what needs to be done, leaving how this is to be accomplished to the program or software itself (Abiteboul, Hull, and Vianu, 1995: 29–33). Similarly, packet switching specifies that *n* packets of data need to be transmitted and arrive at *x* address but not how they should get there. At the machine or network level, then, data storage and communication links should not be of concern to the human user or retriever of networks and data. At the machine or network level data is implicitly allowed to run amok, so long as at the program, interface, and human readability levels its descriptions, values, queries, and reassemblies conform. We should keep this relative "anarchy" of data movements *occurring at the machine level* in mind when thinking about how relational networked experience accretes differentially for machines or humans. But it is also this differential between the machinic movement of data and human interfaces that is reconsidered in experimental ways by contemporary data artists who work in and under data regimes.

Child's set-theoretic thinking about databases influenced the design of the relational model of databases that Edgar Codd, a computer scientist working at IBM, first laid out in his in-house IBM report of 1969 and published later as "A Relational Model

of Data for Large Shared Data Banks."[2] The orientation of the relational database as a metastructural mechanism, which was conceived during this period, continues to underwrite the contemporary organization of data even if we have moved on from these earlier designs. Even as new paradigms for data access, storage, and retrieval such as cloud computing become pervasive, even as data exponentially multiplies and is increasingly distributed across databases and data centers, some fundamental decisions and design principles deriving from the relational database continue to affect our current networked data experience.[3] It is crucial that we try to inhabit the world of the relational database in order to understand the contemporary experience of networked data and of networks' experience of data. This will also assist in understanding how the shift from hierarchical to relational data is tied into the development of a general network *dispositif* coextensive with an entire social field of "the network."

Indeed Codd's separation of human experience/relationship from the machine's experience of data is more explicit, for he situates this split at the level of cognition and conflates this with epistemic access: "Future users of large data banks must be protected from having to know how the data is organized in the machine (the internal representation)" (1970: 377). Codd reasoned that if the data could be organized in a way that manipulations upon it, or changes to it, did not change the ways in which both users and other application programs accessed and read it, then this would lead to more efficient databases. His method was to separate the datasets from the software that *managed* the database: "The relational view (or model) of data . . . provides a basis for a high level data language which will yield maximal independence between programs on the one hand and machine representation and organization of data on the other" (1970: 377). Hence his model was not simply a new design; rather, it created a new functionality for the database software—management. The relational model implemented both a design for and an administrative method of dealing with the relations of human users to and with data. As the artist and activist Graham Harwood has commented in a contemporary context, Codd's initial separation of dataset from data management system resonates with changes that signal the coming of the networked *dispositif*: "After Codd's idea of relational database management systems, data sets and the code that process them are separate. So, the DBMS becomes an engine for the production of knowledge and power, changing conduct from processing the sets of information" (Harwood, quoted in Fuller, 2010). By separating the dataset from the program/structure that manages it, Codd accomplished two things. First, he facilitated the addition of more and more data to sets without necessarily disturbing the data structures. Second, he ensured that the work to be carried out on the database took place primarily *at the level of management*. The "design" of a database involves

modeling the sets to which data will belong and selecting the kinds of operations to be performed upon those datasets. Here the database designer implements what is known as the *physical*, or internal, level of the database architecture. Here—at the machine level of the database—the complete details of data storage, access paths for the database, and how the data is to be retrieved or placed in the database, are produced.

But what develops, after Codd's new model took off in the wake of the wide-scale implementation of relational databases in business during the 1980s, is the creation of a "middle layer" of architecture requiring increasing attention. This middle level—known as the "conceptual" or sometimes the "logical" level of the database's architecture—describes the database in its entirety across the different database users and applications accessing it. The conceptual schema hides the details of the physical and internal storage levels but maintains a "view" of the organization of the database as a whole: its different entities, relations, and constraints. The conceptual view becomes part of the modeling of relational databases: "A conceptual data model depicts a high-level, business-orientated view of information" (Mullins, 2002: 106). It is the database *administrator* who most often views this middle layer. This is the level at which the work of attending, in an ongoing way, to the overall organization of the database's relationality takes place. The differing user's views, known as the "external level," are only partial and produce a (specialized) view of data required by a specific user group. A database administrator may also work on the physical level of the database, depending on whether, in the organization for which the database is used, that person is also involved in database design. But the administrator's main task is to manage the middle layer.

Both the middle layer of management and the design of databases produces a conjunction in which we find a particular form of labor tied to the database—the labor of attending to, of administering the ongoing organization of information as smooth flowing transactions between sets. This is the labor of *databasing*, and it could be said that in this very labor we also have the initial conjunction that forges a relation with the social and economic machine of cognitive capitalism. The mechanogram—that is, the diagrammatic force of relational networking—becomes the mechanism that helps to conjoin the informatic with the social. Henceforth, database architecture and the role of creating and administering data overlap and fold into one another. This functionality is quite different from using a database, which is "external" to the database itself. The database administrator's and designer's roles become constitutive of and concur with the role of cognitive worker in post-Fordist, or cognitive, capitalism. Their function is not to work on or with data itself but to select the opera-

tions and decisions that enable data to be put into informatic exchange: "The work of the worker is a work which increasingly implies, at various levels, the ability to choose between different alternatives, and thus a responsibility in regard to given decisions taken" (Lazzarato, 2004). Data has become not simply organized but organizational. It must be consistently tweaked, reset, normalized; it must be managed. As databases become more and more a part of contemporary organizations though, it is also the case that ordinary users become subsumed into the cognitive tasks of managing data and of managing data about data. The relational database is as much a diagrammatic force of contemporary networking as are "visible" networks.

Data as relation of relations

Alternatively, as we shall see later in this chapter, the newfound flexibility of the relational database—its capacity to apply ever-varying operations to data—suggests a whole new life for data, one in which relations become the real stuff of and in the network. In a strange way, we have come to reinhabit a Jamesian universe in which "any kind of relation experienced must be accounted as real as anything else in the system" (James, 1912: 43). If, for James, the barest of relations to be accounted for within a philosophy of radical empiricism is "withness"—"This imperfect intimacy, this bare relation of *withness* between some parts of the sum of total experience and other parts" (1912: 47)—then the relational database could be said to be the technical instantiation of just such an enumeration of life as bare concatenation. For what Codd's proposal does is to make the internal "relations" that organize data—that conjoin, disjoin, and synthesize data—the actual *stuff* of the database.

Indeed this relationality goes further, for Codd organized datasets *as* mathematical relations, drawing on Peirce's work on relational algebra. Peirce had sought to find a notation that could express predicates across two arguments: "A term multiplied by two relatives shows that THE SAME INDIVIDUAL is in the two relations" (Peirce, 1870: 11). A mathematical relation in this domain of algebra is a way to logically express relations such as "is next to," "conjunction," "is greater or less than," and so forth. Here relations are themselves "objects" selected out of a set (a defined context of ordered elements) or sets. An example of an elementary relation is the Cartesian product, in which, for instance, the ordered pair collection (or relation or "object") of all coordinates from the x axis and the y axis—$\{x_1, y_1; x_2, y_2; \ldots\}$—is generated. Mathematically, the "relation" here is both the pairing-selection operation performed between the sets of x and y coordinates and the object (set) generated by the operation.

3.1

Christopher Martin, *Relational Database Terminology*, 2008. Wikimedia Commons, public domain.

Codd took this algebraic relationality into the database creating, at its simplest, the relational model for database design, which consists of tables comprised of unordered columns (attributes) and rows (tuples). The order in which a row or set of attributes occurs in the table has no bearing on the entity itself. The table is an object or relation, R, that contains the contents (the data), and constitutes these contents as (mathematical) relation. R maps rows/tuples to columns or attributes/values (see figure 3.1).

R, then, is an object that is the product of relating sets and attributes in some particular way. R is a relation of relations. Values as well as data domains are constrained and enabled in various ways by the algorithms of the database; data domains are named—the domain of all employee numbers of an organization, for example—and how domains combine together are specified in the database programming (Codd, 1970: 379–380). The combinatorial flexibility of the relational database lies in it being also able to combine and specify the relation of relations R to other Rs by defining certain kinds of "keys" that declare a relationship between tables/Rs. So, for example, in figure 3.2, if one were to use the key "mark" to run a query, data could be returned in the same query, in a "relational" fashion, about both the real name associated with the login "mark" and the phone number of Samuel Clemens.

It turns out that relation itself is not simple in a database, since R is already the relation comprised of all the relations in the table; or R is the predicate of all the predicate variables specified by the table; or, as Adrian Mackenzie puts it: "R is a set of sets, since a tuple (typically embodied in a 'row' in a database table) itself is a set that possesses some order (for instance, a row of a database table might include a name, an age, gender and address). The relation R allows set making to become recursive" (2012: 226).

Or we could say that R is not a relation between things or even representations of things or data; rather, R is a relation that specifies its relationality in this or that way.

Data Undermining 81

3.2

Lion Rushton Brock Kimbro, *Relational Model for Databases, Highlighting the Key*, 2004. Wikimedia Commons, public domain.

If structure had become the runaway redundancy of hierarchical databasing, then the recursive generation of relation becomes the fundamental architectural generator of the relational database.

After the relational database, strictly speaking, *there is no more data*. The *content* of the database at any given moment in time is a set of relations for each variable/attribute of the query. But then this is also and exactly what a relational database *is*. Content and relationality are one: there are now only data relations. Databases, like networks, are propelled by a twofold movement immanent to such relationality. They extensively overcode insofar as they incessantly accumulate, sort, compile, and *manage* data. And they intensively generate a recursive energetics of relation. This intensive relationality has now generated so much data about and between data that much of this now needs to be partitioned off from the applications that send queries to the database. One type of partitioning, for example, is known as data warehousing, which stores, centralizes, aggregates, and reports on data sourced from one or more databases, usually performing these operations on a server location separate from the database itself. The separation of data and structure immanent to the design of the relational database has led to further separations, dispersal, and distribution of data. Data as data*based*, quite aside from any movement through packet-switching networks, ontogenetically generates a networking. Recursively, its relationality declares that it be conjoined. Importantly, this multiplying, intensive relationality of data sets the stage for the emergence of a class of software. This software exclusively queries what new data can be derived from the superabundance of data relations themselves. During the

1990s, this software emerges as an entirely new kind of knowledge about data—data mining.

The perceptible and imperceptibility

The more data multiplies both quantitatively and qualitatively, the more it needs to be managed, regulated and interpreted as patterns that can be comprehended by humans. The labor of extracting pattern and order from data is rarely visualized for screen display in daily life. This kind of management of data is undertaken by sophisticated sampling, tracking and automated techniques; that is by software. Both knowledge about, and analysis of, these techniques are frequently sequestered to become the sole property of corporations and institutions. What we see as patterns, visualizations and diagrams of data are its *perceptible* end. To make something perceptible as a data visualization is to make it recognizable, which is not the same as *perceiving* something.

Perceiving is a making of the world (and of perception itself), as we go (Noë, 2004; Massumi, 2002; Manning, 2009). Perceiving draws on neuroaffective processes that we barely see or know are there; microperceptions and sensations that might be felt and indeed even made by our sensory-motor systems but are nonconscious. We might go so far as to say that perceiving arises out of the *imperceptible*—from what has not yet been understood, recognized or determined. The perceptible, on the other hand, arises after these nonconscious processes have already occurred and when a percept is correlated with or to other percepts. This correlation makes something recognizable. To recognize is to see something already seen. A pattern seen in data is an example of recognition, albeit machine recognition. Something is made perceptible here rather than perception occurring. Data mining is a computational technique for creating pattern from large datasets—datasets that have mathematically become "objects," which are relational sets. But it is not simply a technical operation. It is a technique for managing data perception, by making data into *the perceptible*: data recurring as particular formations for us to see something in the already seen.

But what we do not regularly perceive in these perceptible visualizations are the processes, both conceptual and computational, that render pattern and relationships among data. Even when data flows are not sequestered from everyday view (that is, when they become private property), their remixing and recombination in, for example, the web through the operations of search engines, digests and feeds such as RSSs (a group of web formats for publishing streams of frequently updated online information such as blogs and news) increasingly makes this *manipulation* of data

invisible. These mounting reserves of data about data, the software used to extract and analyze these and the social and cultural techniques used for extraction results in a generalized state of data *nonvisualization*. This is not to say that techniques for aggregating and deciphering data do not use visualization methods. In the area of data mining particularly, visual environments can be modeled to make sense of patterns detected in sets. But the parameters, relations and arrangements that organize and make sense of data are not visualized. These nonvisualized processes have become the imperceptible of data visualization. They are machine microprocesses, out of which the visualization of data arises.

However, unlike what the imperceptible for human perception comprises—that is, the barely registering, indeterminate, dynamic spectrum of microsensations that comprise perception's virtuality—the imperceptible processes of data management are highly determined via computational techniques of information analysis. This disjunction-inversion between the perceptible and the imperceptible in humans and computational machines—and between the techniques of data management and dissonant aesthetic directions in network cultures—has opened up as a sphere for experimental artistic investigation. A number of projects such as *ShiftSpace, MAICgregator*, and *TrackMeNot* traverse the disjunctive synthesis of data perceptibility and imperceptibility, deploying what I will call data-*under*mining approaches.[4] In chapter 7 I will revisit this disjunctive synthesis, when I examine the imperceptible relations drawn out by differentially conjoining datasets with both hardware and corporeality in the collaborative media artwork of YoHa (Graham Harwood and Matsuko Yokojiko).

Collectively, these data-undermining projects have generated a way of conducting experimental research into how data comes to be aggregated and managed in contemporary networked cultures. The practice of making art in networked contexts—both in the area of intensively networked data and in the online networking of databases—must take serious heed of data's coextensivity with a now military-academic-industrial complex and of its relational complexity (Knouf, 2009b). And yet a poetics persists. A poetics of data *under*mining as a contemporary approach to diagramming an aesthesia of networks can be detected in the ways in which artists deploy browser extensions, aggregators and plug-ins in their humorous, absurdist unraveling of current data logics. There is also a poetics generated when such artistic endeavors create networked spaces where alternative congregations and gatherings of sociality might be invented. Such spaces cut across the predefined arenas for online interaction that the bulk of social media platforms have become. The poetics at work here lies in the way artists and others involved in forging emergent socialities are working against the dominant trend toward perceptibility, which can be found in the craze for data visualization.

From this perspective we can see how a range of artists work with both strategies for making what is currently not perceptible in regimes of data management *perceivable*; that is, how data is amassed through social, financial and research relations between military and academic institutions and corporations. Such conjunctions are often lost amid not only the mounds of information but also amid techniques that have become overlaid and automated with respect to data management such as aggregation. Later in this chapter I will look at the ways in which artists extend the functionalities of web browsers to render data management techniques perceivable. But there is also a poetics that can be found in obfuscating; that is, in working against the forces of visibility which are so powerful in network cultures and which amass around visualization. So I will also be paying attention to artistic strategies of making data navigation and data agents imperceptible. Together I call these interventions into contemporary data regimes of management and visualization, data *under*mining.

Data undermining, as a mode of aesthetic investigation, rides the swirling tide of ebbing and flowing data, sometimes providing a serious line of sight into the increasing obfuscation of imperceptible data processes. At other times, however, data undermining is also imbricated in an expanding web of information that resides within a different realm of perception—that of the network and database. Deploying the very sources of data and techniques produced and developed by data mining processes, undermining data traverses the terrain of machinic perception, generating a sense of how networks experience. Data undermining must use the very data and network structures produced by the machine it aims to seriously investigate or critique. It must try to render the data and relations produced *visible*, in order to poetically render the interests at stake. Hence this form of aesthetic research negotiates a tremulous set of interconnections between perception (where aesthesias remain open to making and unmaking), the perceptible and imperceptibility. What data undermining has to do is remain inventive—open to the flux and flow of machine perception, greeting it with humor and/or poetry. But at times and within the current context of cognitive capitalism, data undermining might also have to find ways of becoming imperceptible. I take up this question of becoming imperceptible at various intervals throughout this chapter, asking what becoming imperceptible indeed might entail in a culture infused with such strong trends toward perceptibility.

Data mining engages the dynamics of the perceptible and imperceptible in a different direction from data undermining. The former smoothly travels between state, military, academic institutions and the corporate world, all of which have stakes in the governance of knowledge economies. It is both situated within networked information *and* is determining of information as networked patterns of linked nodes.

Data Undermining

To data-*under*mine on the other hand, then, is to enter headlong into the sticky webs and precarious voids that comprise just such interconnected topologies but with the hope of resurfacing differently and perhaps of shifting the conjunctions along the way.

A selective genealogy of data mining

The imperceptibility of the techniques for managing data—for extracting pattern from data using data mining, for example—is perhaps unsurprising given their genealogy. As a large and complex facet of the technics of contemporary network cultures, data mining has a number of different lineages. Its techniques are intimately bound to: the rise of large scale datasets; the history of statistical analysis in the twentieth century; the development of artificial intelligence (AI), especially boosted by rapid increases in computing power during the 1980s; and the development of machine learning, which through methods such as the application of neural nets and decision trees to datasets, conjoined statistical analysis with AI.[5]

These techniques and disciplines depend upon certain more general computational conditions that really only became technically and economically feasible in more widespread ways from the 1980s onward. Enormous quantities of data must be able to be stored; that is, both databases as forms of media organization and their hardware—initially supercomputers but then servers—are prerequisites. Simultaneously, the processing capacity to run queries, compare and analyze reserves of data so large must exist quantitatively and qualitatively. Not only, then, must CPU power increase, as it rapidly does during the 1980s, but many data mining techniques require the qualitative shift to parallel processing in order to conduct the exponential combinations involved in analyses of data that involve computing variables.

Importantly, it is also the *relations* among data, invoked in the analysis and storage of variations about a data source in relational databases, that provides the condition of possibility for data mining: "Databases are increasing in size in two ways: (1) the number N of records or objects in the database and (2) the number d of fields or attributes to an object" (Fayyad et al., 1996: 38). Thus large amounts of data are not simply stored but rather are arranged relationally; no longer are we dealing with data as "stuff" but rather we have entered the domain of data as a topology. Topological arrangements of data produce data as a relational field, and this field becomes the "object" of analysis as well as the ground for the production of more data about data. Or as I suggested earlier, data becomes a relation of relations. This arranging of data as relational or topological via relational databasing can also be understood, as I have

already suggested, as a *networking* of data. The discipline and discourses of network science have grown around just such topological analysis of networking data (for example, Barabási, 2002). So although some relational databases use computer networks to distribute their data to other databases or to other computer users, this is not the primary sense of the network I am invoking here. Rather, organizing data *as* relational, subjecting it to deformations and transformations by other data and to machinic processes such as algorithms, comprises the *primary* relational design genealogy of data. Networking understood in this primary relational sense is the precondition for data mining. If data mining, "is a process that uses a variety of data analysis tools to discover patterns and relationships in data that may be used to make valid predictions" (Edelstein, 2005: 1), then it is also a process whose precondition is the network *dispositif* through which information is relationally generated, arranged and conceived. We need to revisit briefly my discussion of the *dispositif* in chapter 1, where I suggested that it could be understood as the concrete (social, technical, aesthetic, political, institutional) actualization of the diagrammatic forces of conjunction or relation of networking. What I am suggesting is that it is not the internet per se that makes contemporary databases and data cultures possible. But rather that the relationality of data and the internet are socially, politically, epistemically and aesthetically coextensive. They belong to a mechanogram of recursive diagramming. The implication is that if we want to understand networked cultures and societies then we also need to understand the diagrammatic forces that similarly organize data as relational. In the history of computing, data mining develops out of the availability of corporate and scientific datasets, which began to be increasingly hoarded in massive reserves during the 1970s and '80s. But it is not until the 1990s, when networks, AI and statistical analysis converge, that the term "data mining" sees the light of day.[6] And, not coincidentally, larger convergences are at work: the global, although uneven, growth of the neoliberal knowledge economy underpinned by, as Lazzarato has described it, the value added by immaterial labor, and subtended by the technological developments of networked and multimedia communications: "The various activities of research, conceptualization, management of human resources, and so forth, together with all the various tertiary activities, are organized within computerized and multimedia networks. These are the terms in which we have to understand the cycle of production and the organization of labor" (Lazzarato, 1996: 138).

AI research, unsurprisingly in this broader socioeconomic context, thrives in the context of discovering "knowledge" (read: applying statistical techniques to data) about market-based information reserves. The work of data mining, then, does not simply lie in making something perceptible but also in using knowledge science to

extract meaning from the topological structuring of data *in order to add value*. Wherein might this added value lie? How do we get to value-add, as the marketing execs might say? Here it is important to understand the second aspect that necessarily conjoins with data mining—the power to predict. Extracting pattern from data sets is only a worthwhile knowledge endeavor, if it is going to yield some kind of potential modeling that facilitates forecasting future trends or behavior around which more sales, data and knowledge might accumulate: "In marketing, the primary application is database marketing systems, which analyze customer databases to identify different customer groups and forecast their behavior" (Fayyad et al., 1996: 38). If corporations can make visible unknown patterns amid data that reveal how people behave in terms of potential future expenditure, then what future "value" might be foretold and indeed added back into datasets? But the risk involved in prediction is great. Pattern modeling simply reveals *existing* relations, not future ones. The slide that takes place in data mining from the perceptible or the recognizable into the *predictable* delineates the speculative imperative lurking at the core of data mining.

Yet this is where data mining gets its feet. At the end of the '90s, the U.S. military began to get excited about the feasibility of commercial data mining. In a fascinating interview between the journalist Jacob Goodwin and Anthony Schaffer, a U.S. military intelligence operative working during the late 1990s, the origins of the antiterrorist Able Danger operation in data mining are revealed (Goodwin, 2005). In this interview we see how the U.S. military's approach to intelligence began to be driven by data mining approaches. The conjunctions between military and commercial interests were being forged. Such thinking shows the ways in which operatives such as Schaffer and operations such as Able Danger shift from data analysis—looking for what is hidden but present—to prediction. By the late 1990s, then, the U.S. military began to believe that data mining techniques drawn from commercial data analysis could reveal the future movements of Al Quaeda terrorists:

SHAFFER: . . . J. D. Smith [a former contractor on Able Danger] talked about some of this in *The New York Times* [on August 22, 2005].

He talked about the fact that they were going to information brokers on the Internet who were getting information about the mosque system from overseas locations. Nobody else found that to be reliable. That's why nobody was looking at it. The problem was that nobody was looking at it regarding the right type of vetting. J. D. Smith and company were using these advanced [software] tools to ferret out patterns within that information.

GSN [Global Security News]: You're talking about lists of where mosques were located geographically.

SHAFFER: No, individuals who were going between mosques. Who were they? Who were the contacts? Looking down to the individual level.

GSN: Did they say, for example, "Here's Abdul and he's showing up at a mosque in Pakistan and, lo and behold, he's showing up at another mosque in the Sudan a week later"?

SHAFFER: Yes.

GSN: How did they get down to the level of who's walking in and out of a mosque?

SHAFFER: Because apparently there are records of who goes where regarding visits to mosques. That was the data that LIWA was buying off the Internet from information brokers.

This interview lays bare the bones of data mining as an activity that extracts meaning via a complex set of analyses—and importantly rests upon the financial conjunctions between the U.S. military and commercial knowledge brokers. This is a sociotechnical assemblage propelled by increasing levels of recursion, which conjoins knowledge production in the form of techniques of data analysis to military interests and commercial brokering of data from the 1990s onward. Any artistic investigation of contemporary networks—indeed any attempt to open up networks toward an aesthesia—must contend with the cementing of the network *dispositif* via such extensive institutional ties and relations *and* with the intensive technical relationality of networked data.

Relational data aesthetics after the relational networking of data

The first phase of web development and design, from 1995 to 2001—Web 1.0, as it is sometimes retrospectively called—required designers and artists to be versed in at least a basic level of HTML, the then broadly used scripting language for displaying information online. During the early phase of web design there were no prepackaged methods for formatting the way a web page was displayed. All graphic and stylistic elements had to be laid out in HTML, which "told" the web browser how to display the formatted page online. For a relatively short period, both artists and designers had a measure of access to the source code of the web, and this resulted in a lot of play with HTML aesthetics. This was the atmosphere in which, for example, the artistic duo of Joan Heemskerk and Dirk Paesmans, known as jodi.org or simply jodi, became infamous for their collapse of the visual levels of web display into the underlying HTML level of source code.[7]

But after this HTML "phase" of web engagement with source and code, web design and use moved toward less visible interaction—certainly for the everyday user—with the underlying architecture and flow of data through its various nodes and mechanisms. Web 2.0 is built on an aesthetics of templates, which obfuscates the relations between play and work, user and informatic/networked corporations. Search engines, blogs, and social media provide a prescribed space where users can play around and have a good time. In this movement toward the automation and templatization of search and design, we can also see, as Olia Lialina suggests, the insertion of a layer of professionalization of the web (2007). This is inserted *between* the machine level of coding and the user. It follows from and folds into the administrative and management layer that databases acquired when they became relational. So although with Web 2.0 user content and user generation become a catchphrase, the management of web processes and the actual labor of web design become increasingly separated from everyday web interaction.

"Web 2.0" denotes the many changes that have taken place in the online environment after online cultures, commerce, and everyday users regrouped in the post-dot-com context. At the core of the concept of Web 2.0 is the understanding of the network as an expanded field of interaction, interrelation, and semantic generation between users, online infrastructure, and software (see O'Reilly, 2005). Web 2.0 has become mainly associated with a human-centered experience of the web; it's all about social media and how "you" can get "your" content online. But how does the *network* experience under Web 2.0 conditions? Increasingly via automated techniques for producing pattern and "behavior." That is to say, it is not simply the case that networked operations are automated or that automated network operations produce a pattern that we can describe as behavior; rather, the network increasingly becomes a filigree of soft, behavioral automata doing the experiencing.

Although social media have made the most noise in this environment, other "quieter" and more mundane software operations are at the heart of this production of the automated extraction of pattern, and the modulation of such experience so that it is deemed "behavior." Aggregators, for example, are a common feature of the information landscape of Web 2.0. Interestingly, they assemble a number of the aspects of networking that I have been discussing in this chapter. They automate what had previously been carried out by human labor in Web 1.0, and hence they pass aspects of cognitive work on to the automated technical operations of network design itself. Aggregators are also methods for dealing with the explosion of online "chatter" that followed the growth of blogs from around 2002 onward. They are able to easily link

and function in relation to the straight-to-web environment that has become the mainstay of contemporary online interactions. Users deploying aggregators are usually not aware what the parameters are for extracting and determining the stream or "pattern" of information brought together. The processes of making the data meaningful—that is, what holds this data together in an aggregate—are not immediately available to us. Automatic aggregation tends to perform operations that reduce the relations between data to commonalities rather than to recognize differences. This may be of crucial importance in the aggregation of news data, where conflicting rather than similar perspectives about an item actually comprise its semantic levels. But techniques such as aggregation smooth out these differentials and present us instead with a flattened landscape of information. The sources, processes and, most importantly, the *relations* that provide context and formations for data are rendered invisible.

How have artistic practices responded to this imperceptible mode of generating data? Data undermining, as one such practice, follows a kind of inverse engineering mindset.[8] To invert the engineering of such software/hardware is not simply to rediscover the technical principles that structure and allow a technical artifact to function (reverse engineering). It is also to turn these principles inside out in the hope that by doing so something different—indeed, a different kind of knowledge production, even in the midst of the broader social field of cognitive capitalism—might take place. A contemporary generation of artistic inverse engineers has applied a similar attitude toward knowledge, systems, and technical objects designed in and for networked spaces. *MAICgregator*, for example, a Firefox extension developed by Nicholas Knouf, deploys a news aggregator that searches government databases, private news sources, private press releases, and public information about the trustees of U.S. universities and college for information about where U.S. military funds have been spent in the American university system. As Knouf suggests, opening up the conjunctions that make up contemporary knowledge techniques not only generates a different knowledge base but also forms a proposal for a "radical cartography" of knowledge production (Knouf, 2009b). In the screenshot of a *MAICgregator* pass on the University of Southern California's website, information about funding provided by the U.S. Department of Defense to research projects undertaken by the university's researchers has been aggregated and redisplayed on the official "News" page of the university's website (see figure 3.3). Instead of the usual list of achievements gracing the increasingly corporatized websites of neoliberal tertiary institutions, we see a literal view of the costs, partnerships, and priorities at work in the current production of academic knowledge. The inverse engineering of the university's website is made possible not by an outright "hack," which would pit the hack against the authentic site and would

Data Undermining

3.3
Nicholas Knouf, screenshot of a *MAICgregator* pass, 2009. License copyleft.

see the university shut down/out this "alternative" information. Instead, *MAICgregator*, as a plug-in, extends the data relational capabilities of the browser. As browser extension, *MAICgregator* must be downloaded and installed in order to extend what can be perceived. It adds a kind of metalayer to, rather than intervening directly into, the official university website. Similarly, *MAICgregator* extends the uses of aggregators by overlaying aggregated information in the unexpected context of the official university site rather than, say, streaming the information about military support of academic research to, say, an email or social media feed. Data undermining here amounts to extending the software behavior of ordinary data mining and of web display, deploying the metastructures immanent to data technics. Yet as it does, it immediately renders disjunctions between the proprietary of the web site/space itself and the data being displayed. If we wanted to consider this in Jamesian terms, we might note that *MAICgregator* allows data and its "base," its "site," to no longer be seamlessly conjoined but rather to be "with" each other in a pluralistic manner, "some path of conjunctive transition by which to pass from one of its paths to

another may always be discernible" (James, 2008: 140). *MAICgregator* undertakes the work of data undermining in order to multiply the possible discernible paths of "conjunctive transition" between data in contemporary knowledge economies.

Becoming imperceptible in an age of perceptibility

Some data-undermining practices also move beyond rendering visible the data management processes at stake in the contemporary assemblages of data. Extensions such as *MAICgregator* or *Ad-Art*, developed by Steve Lambert, produce novel spaces online that both affirm and challenge the trends in Web 2.0 design and culture. *Ad-Art* is also a freely available Firefox extension that, once installed, replaces web advertisements with revolving, curated artworks.[9] What such projects demand is a socioaesthetic domain for data in which users, techniques, and flows are not appropriated by automatism and in which the labor of all elements is not rendered imperceptible and, inevitably, irretrievable. But they do more, or at least provide the potential for something quite other—they facilitate alternative social-political spaces in which knowledge can be generated collectively rather than merely (re)discovered and accumulated proprietarily, as it generally is through data mining.

One example of such collective knowledge generation is the *ShiftSpace* project (figure 3.4). The *ShiftSpace* Firefox extension allows a layer of graphics and text to hover over the top of any website, forming a kind of metadisplay layer. The layer of text is made up of annotations and comments about the site over which it sits, and which anyone with the plug-in can generate and share with others. The metalayer displays a conversation occurring both within and about the site and yet extraneous to it. The plug-in literally *shifts the space* of online authoring, supplementing what has been privately designed and authorized web space with visual discursive space that is shared. Begun in 2006 by Dan Phiffer and Mushon Zer-Aviv, not only has the *ShiftSpace* team grown to 12 people (in 2012) but the *ShiftSpace* site also hosts an entire networked subculture of bloggers, plug-in developers, and so on. Although a data mining application or method has not been used here, the ethos of collective knowledge generation via online activity that such a project provides connects it to the current of data *under*mining I have been noting. If, for instance, aggregators pull together disparate threads of information and present them as digests, streams, and flows of information, *ShiftSpace* indicates how knowledge spaces, organization, and production can continue to be both multilayered and resistant to such forms of compression. In the demonstration of the "Notes" feature of *ShiftSpace*, we see how an article published online on a site owned by a magazine *and* the further discussion and blogging that

3.4
Dan Phiffer and Mushon Zer-Aviv, screenshot from the *ShiftSpace/Notes Space*, demonstration video, 2008. Image courtesy of the creators.

this item has generated in other sites might be brought together (see figure 3.4). Pinning a "sticky note" to the original article that directs people to where the other discussion might be found, at a metalayer level, *conjoins* rather than aggregates the different sites. The metalayering both preserves the differences between the article and the discussion—each online space is preserved, rather than mined, digested, and restreamed—and concatenates them so that "some path" of "withness" might be discernible.

Projects such as *ShiftSpace*, *Ad-Art*, and *MAICgregator* have a "cosmic" dimension to them—in the sense that Deleuze and Guattari invoke. They suggest that the cosmic is a pulsation toward making (a) world: "but becoming *everybody/everything* is another affair, one that brings into play the cosmos with its molecular components. Becoming everybody/everything is to world (*faire monde*) to make a world (*faire du monde*)" (1987: 307). In an informatic climate in which everything must be reduced to bounded, determined, perceptible data—data that is authorized, data that is owned, and data that already contains the known but just needs the right techniques to uncover knowledge—we need ways of generating new spaces, new worlds for generating "data" differently. Deleuze and Guattari's cosmic dimension to world making provides an ethico-aesthetic approach to data aesthetics. This "worlding" means entering into the relationality they set up between "indiscernability," "impersonality," and "imperceptibility" (1987: 307). It is to become a trait rather than an "author"—to enter a zone

in which one is not distinct as some "one" but joins with others to make a world instead. To leave only traces, comments, marks that only show up with and through others in networked space is to enter an indiscernible zone of web-world-becoming. It is to work at and through the mosaic edges of data as it diagrammatically networks.

Becoming imperceptible in an age of imperceptibility

The last area of contemporary networked aesthetic practice I want to explore folds into these questions of making and sharing worlds, questions of imperceptibility and of the relations to everyday online implementations. I am thinking here of the ubiquitous mining of information about user habit and "lifestyle" routinely conducted by most large-scale web enterprises, including search engines (Hansell, 2006). The mainstay of the outcry against these automated profiling processes is that they violate users' privacy, constituting a form of Big Brother–style surveillance. I want to suggest, though, that privacy is not the primary issue at stake here. We should take note of the response made by executives of the data mining software companies employed by search engines when the issue of privacy violation by search engine profiling is raised: "Search behavior is the closest thing we have to a window onto people's intent" (Marshall, quoted in Hansell, 2006). This statement was made by the senior vice president of an advertising agency using data mining techniques. Here the individual can only be approximated and is anyway only secondary: "search behavior" is primary. And what is being "discovered" in this process of data mining is "behavior" or, in knowledge-discovery-speak, pattern. Data mining does not target the person but behavior as trend in a population. As an executive from Cingular Wireless, a U.S. telecommunications company, confirms, "You are no longer targeting people you think will be interested in your product. . . . We know based on your behavior that you are in the market, and we can target you as you bounce around the Internet" (Hansell, 2006). To cry out against these techniques in the name of privacy violation, then, is to miss the point, to fall short of the target. It is the population as an averaged trend behaving in this or that way, which is really at stake.

Data mining is a technique that belongs to knowledge economies modulated by the diffuse politics of biopower. Biopower consolidates and hones strategies for managing populations via techniques such as the statistical analysis and prediction of lifespan, habit, custom, and so on (Foucault, 1980b and 1991; Lazzarato, 2004). Foucault particularly linked statistical analysis to measures for the calculation of costs across averages: What would be the optimal amount to spend on such and such a measure?

What amount cannot be exceeded? (Foucault, 2007: 6) These techniques for managing populations according to a calculation of average costs (incurred by a corporation or likely to be spent by a niche market) now saturate "life" and are found everywhere. They are at the base of profiling browsing and spending behavior in the online environment for the purposes of calculating and predicting future spending patterns. Here the aesthetics and politics of data *under*mining become very sticky indeed. If we follow the line I have set up that connects Deleuze and Guattari's becoming imperceptible with an idea of undoing "the individual" and becoming "everybody," it might initially appear that this is not dissimilar to the energies driving the constitution of aggregated entities such as "lifestyle," "online spending patterns," and so on. Perhaps becoming imperceptible has slipped indiscernibly into just this very fading of "the individual" and toward, instead, that very massification of populations' behavior, which is at the very heart of contemporary forms of power. Perhaps too we might find some leverage in covering over our online tracks and traces so that we cannot be made perceptible to the data mining activities of search engine corporations such as Google Inc.

Hedging bets on these issues of discernment and indiscernibility, *TrackMeNot* (*TMN*) facilitates a fading away of the individual trails of online habits and patterns created through the course of daily net activity by again using the extension capacities of Firefox. Once installed, the *TMN* plug-in operates in the background of an individual user's online movements, setting off random search queries from a particular user's IP. These are issued *to* search engines themselves. On installation, the queries are initially provided as a list sourced from feeds of popular searches from sites such as the *New York Times*, Slashdot, and so on (Howe and Nissenbaum, 2009: 422). Over time, and as the browser starts and *TMN* is initiated, search "items" on these lists are substituted so that the list dynamically changes and updates. This prevents the search engines themselves from detecting a "static list" of search queries and becoming sensitive to this list. *TMN* also deploys other search "imitative" functionalities such as "burst-mode querying," which sets off a group of queries to a search engine in close temporal proximity to a genuine search by a user. The effect of all these simulations of "search" is to create much more information about a user's search engine interactions than fits the actual average searching habits or "pattern" of that user. As Howe and Nissenbaum, the plug-in's developers, poetically put it on the website, "With *TrackMeNot*, actual web searches, lost in a cloud of false leads, are essentially hidden in plain view" (2006). *TMN* is a search simulation engine, creating "behavior" from an individual's browser links and relations and thereby generating "non"-behavior. Essentially, *TMN* is generating a low signal-to-noise or a high noise-to-signal ratio, which makes the automated profiling or extraction of clear data/signals about user behavior by actual search

engines difficult. Data mining operates on the implicit assumption that users will leave traces in their data that can be *tracked*, providing clues to their online behavior. By aggregating enough of these traces from enough users, data mining promises to sift this tracking into a form that ultimately produces the pattern "behavior." *TMN* generates too much behavior, exceeding the calculation of the average optimal amount of querying the "normal" tracked web denizen might generate. The "user" becomes imperceptible, disappearing in a cloud of perceptibility.

Once a corporate entity such as Google is founded on the automation of search and is fed by the technologies of knowledge discovery, net critique and a critical, generative networked practice must also consider and play with such automatism. To data-undermine, then, is to radically automate and to automate radically as a careful ethical and aesthetic gesture. The hope remains, even if this endeavor fails, of creating patterns more poetic than those produced by the data miners.

Refraining

4 Going Viral: Contagion as Networked Affect, Networked Refrain

Viral goes viral

In 2010 Nick Bilton, who posts for the *Bits* (Business, Innovation, Technology, Society) blog of the *New York Times* online, asked an immanently networked question about contemporary network experience: "Has viral gone viral?" (2010). For Bilton, the fast-paced spread and exponential growth of such phenomena as the online media attention after Michael Jackson's death (where traffic to the *New York Times* online spiked at 5:20 pm on June 20, 2009) and the appearance of online platforms such as Chatroulette (where people are randomly connected to each other's webcams simply by clicking a button on the site), are evidence of the ramping up of generalized media contagion. By way of comparison, Bilton argues, social media sites such as Twitter and Facebook have taken several years to build user numbers and reputation. Chatroulette—which importantly requires no sign-up or login and functions purely on instant, random, switching and automated chat connections between people—now has an average of over 220,000 page views per day since its launch in November 2009 by Russian teenager Andrey Ternovskiy.[1]

In the decade and a half since Douglas Rushkoff used the term *virus* to describe the spread of segments, stories, clips, and sensational narratives through the then broadcast media at an "infectious" rate, the idea of "going viral" has indeed spread far and wide (Rushkoff, 1996: 7–16). The web is full of viral analysis—from technology bloggers such as Bilton to viral marketing sites and gurus who advise on viral networking methodologies and predict what *will* "go viral" online. And the web is full of things going viral: jokes, marketing campaigns for beer and, most of all, videos passed through video-sharing platforms such as Vimeo and YouTube. It seems that the more things go viral, the more they become both networked and virological; spreading itself spawns industries that parasitically host on spreading. Recursively and autopoietically, spreading generates more spread. Networked contagion, then, seems to operate in a

manner similar to the arraying, databasing and self-enclosing movements of computationally inflected, network experience that I have already described. It folds back on itself in order to replicate; it oozes via involution. And yet, such quantizing maneuvers generate something else, something novel, whether that is another platform, a new sensation, or even a twist in networking itself.

Bilton draws our attention to three characteristics in networked things going viral: speed of spread, quantity of views or users accessing something being spread, and the unpredictability of what will spread. The quicker and greater the spread *and* the quirkier, more localized its origin, the more viral its virology becomes. Rushkoff had already noted that a media virus displayed just such qualities of instantaneous and exponential spread. But he also placed more emphasis on the inventiveness of the media, technology, or message through which the "virus" caught our attention, got us hooked and infected. A media virus behaves exactly the same as a biological one, according to Rushkoff: a biological virus manufactures a sticky, outer protein shell to both protect its own genetic code and to attach itself to other molecules within a cell it has invaded as does the clever media virus: "The 'protein shell' of a media virus might be an event, invention, technology, 'system of thought,' musical riff, visual image, scientific theory, sex scandal, clothing style or even a pop hero—as long as it can catch our attention. Any one of these media virus shells will search out the receptive nooks and crannies in popular culture and stick on where it is noticed" (Rushkoff, 1996: 10). For Rushkoff, the virus itself—riding on the back of a decade dealing with frequent and hideous deaths from AIDS—had something dangerous about it. In the heady mix of 1990s media "hacktivism" and techno-utopianism, media viruses seemed to promise the possibility of spreading—using tactically placed and inventively crafted "media shells"—subversive elements throughout popular culture. In the hands of "metamedia" activists, media viruses would be a way to wage a countercultural war (Rushkoff, 1996: 290–293). For Rushkoff, then, going viral involved stickiness and riskiness. For Bilton, writing a decade and a half later, these more visceral qualities seem to have receded and the only residue of such risky behavior is that no one can pin the viral down.

Something that frequently eludes viral advisors in the "going viral" industry of websites such as BuzzFeed or viral marketers such as Ralph Wilson is the ability to predict what will take off.[2] Although the viral gurus sort, filter, and quantify what has gone viral, the next big thing remains difficult to predict. In looking at the kinds of online videos that circulate rapidly, attract the most views or downloads, and retain something ineffably quirky—that is, following for a moment Bilton's three qualities of things that do go viral—a certain style of online video heads up the pack. We find

short clips of deranged laughing babies, animals that act in excessively cute or malevolent ways, homespun webcam childlike singers with grown-up, gravelly voices, amateur dancers, and obsessive guitar players. They possess singularity—*a* baby is laughing, *a* teenager is singing, *a* child is delirious—and this is often reflected in their title, subject matter and moving image "styles." Importantly a shared singularity emanates from their everydayness. None of these traits is captured by the particular person singing, talking, or laughing. This is not a singularity of which a subject in front of the lens (or behind it for that matter) can immediately take possession. Such viral videos are generalizable: any child could have acted in such a way; anyone could have made a home music video; a camera just happened to be available. And this singular generality is just such videos' charm. Equally, none of the generality of the clips can be simply attributed to the pervasiveness of digital technologies or networks. That the digital camera phone or webcam already harbors certain kinds of aesthetic qualities—fixed medium camera angles that crop backgrounds and intimately compose the shot, low-quality lighting that softens contrast—is not determined by but rather brought to the fore through the moving image cultures of platforms such as YouTube. It is especially a quality of the everydayness of the videos that go viral. The ubiquity of digital cameras, the fact that they are in everyday usage, does not produce the hypervirality of these video clips. The atmosphere of everydayness, as a vital element of contemporary online moving-image culture, is generated and enabled in the singularity and networked movement of the clips themselves.

David after Dentist is an intimate and hilarious single-shot, handheld video of a small boy in the back of his father's car, free-falling through multiple moods and offering up existential musings after receiving gas from a visit to the dentist.[3] In his one minute and fifty-nine seconds of YouTube fame, David alternately blurts and screeches in a semidelirious state: "Is this real life?" "Will this last forever?" "You have four eyes." "Aaaarggh." What he says is funny, but the cascading movement of his voice up and down the scales of lucidity and delusiveness are funnier. *David after Dentist* is the adult camera tracing the movement of a child's delirium—a crossing over of usual roles (the child is high, the adult straight) and a crisscrossing between sense, sensation, and nonsense. We follow a sequence of a child's thought and imaginings, moving in and out of focus, in and out of nonsense, and this is what gives the piece its affectivity. The clip is short, but for David his present state might "last forever"—the present moment seems to play out as an intermezzo in two tempos. It's as if we experience, along with David but also outside David, with his father holding the camera, an everyday moment as it gains a morphology, as it becomes contoured.

4.1
Screenshot from the YouTube video *Chocolate Rain*, Tay Zonday, 2007. Creative Commons license: Attribution-NonCommercial-NoDerivs 2.5 Generic, http://creativecommons.org/licenses/by-nc-nd/2.5/

Chocolate Rain is a different kind of viral video (figure 4.1) but still partakes in this contouring of the everyday. It is a homemade music video shot, written, and sung by Tay Zonday, a young singer whose youthful looks belie his deep vocal chords.[4] Twenty-four seconds into the clip a subtitle appears across the screen, as Zonday pulls to the side of his microphone. "I move away from the mic to breath in," he gravely informs us, intercepting his unexpectedly gravelly adult melody line. The gesture is both unintentionally funny and also thoughtful, as if he must assist an imagined audience to understand his performance. In spite of the fact that the subtitle is created in "post-production," it has the feel of being integral to the moment of presentness in the clip, as if we must be made to understand and empathize with just this aspect at just this moment of Zonday's performance.

HaHaHa is perhaps the epitome of just such everyday viral videos.[5] A baby laughs demonically in short repetitive sequences for a total of one minute and forty-one seconds, in response to his father making sounds such as "bong" and "bing." The laughter is infectious but the virality of the video lies not simply in "catching" the laughter from the baby, although this certainly occurs. What is compelling about the viewing experience of this clip is that it sits on the cusp of a kind of emergence of something: the baby repeatedly approaches the cusp of becoming something else—a deranged adult perhaps? The laughter too seems to just reach the point where it

becomes musical. Its short refrains are punctuated by crescendos and decrescendos; it has a rhythmic feel. The parent's voice seems to become almost infantile. Everything approaches and then diffuses, fades away. Again, these moments are short, glimpses of some everyday occurrences but the baby's insistent laughter seems to draw the present moment out, as if it might keep going and going.

In these and similar "everyday" YouTube videos that have gone viral, two qualities permeate their styles and resonate for our viewing experience: a singularity, a *thisness* that belongs to the atmosphere of the entire clip rather than to someone or thing in it; and a drawing out, a contouring of this moment's duration as presentness. Not duration full of presence but rather a shaping of the temporariness, of the "in-the-now" of the everyday. We sense that there is a quality of *thisness* to these videos that is exacting—just this child doing just that after the dentist; just this young performer singing just such a way and making just that remark; just this baby laughing in just such a deranged manner. And yet these specific qualities remain frustratingly intangible. What is there to fix upon or to make substantial, in just this moment when one can declare that, after all, they are simply ordinary, simply everyday? What is it, then, that makes these clips circulate among millions of people online? Deleuze and Guattari suggest, "They are haecceities in the sense that they consist entirely of relations of movement and rest between molecules or particles, capacities to affect and be affected" (1987: 261). We respond to such haecceities, as Deleuze and Guattari call this quality of vague thisness that generates a response—that capacity to be affected by the everyday—by conjoining with them, by going viral, by associating with them contagiously. Something elusive moves and moves us; something not quite quantifiable is generated when these videos are uploaded and then circulate through networks. Something that is felt, shared, and spread through online audiences and networks. Something that does not yet have substance, even so, has force. As these viral videos *go viral*, they become an element at work in the individuation of networked affectivity. They enable a collective (heterogeneous) capacity to affect and be affected in online networks. They make the spread of networking contagious. In this and the next chapter I attend to the ways in which the conjunctions between singularity and generality, situatedness and vagueness, resonate through contemporary networking. They have become a kind of refrain for eking out the bare conditions for the experience, the aesthesia of contemporary networking. Across both these chapters we will begin to sense how the refrain, rather than the loop, best sketches *the variability in recursion* that is contemporary networked relationality.

In contradistinction to the pervasive sense of fear and panic that marks the affectivity of post-9/11 media cultures, Tony Sampson has observed that much of what spreads

in ordinary and often banal ways through networked culture, such as viral videos, is joyful (2011). Although clips such as *Chocolate Rain* and *Hahaha* make us laugh, it is not that these videos simply spread "joyfulness" or, as Sampson would have it, a "love" virus. Both fear and love are less affects, in the sense that I have been invoking the affective as a mover and enabler. Joy, fear, sadness, anger, and so on are at least tangible in feeling, if not in cause. They are nameable and enumerable, as Darwin noted when he listed the human "emotions" in his 1872 *The Expression of Emotions in Man and Animals*. Paul Eckman and Warren Friesen have since whittled Darwin's accumulation of emotions back to basics: happiness, fear, sadness, anger, surprise, disgust, contempt, and shame (Ekman and Friesen, 1986).

But the viral videos I have been describing are not so solid in content or expression. They are less categorically about, or generative of, a concrete finite feeling and more often comprise simply a sequence, even fragment, of rhythm and tempo. Their little ritornellos eke out a temporary circumscription around an everyday moment, making it memorable. This provides such moments with just enough duration, prolonging the present moment and shaping daily intensities and tonalities into something approaching but not quite the familiar. The psychoanalyst Daniel Stern, whom Guattari drew upon to articulate his conception of affect, distinguished between the Darwinian "categorical affects," which provide definitive, individuated emotions that can be distinguished from one another and what he called "vitality affects" (Stern, 1998: 54). These do not fit into such denominated emotions because they are moving, dynamic qualities of experience: *surging, fading away, fleeting, explosive, decrescendo, bursting, drawn out*—these are the kinetic terms he uses to momentarily put his finger on such experience (Stern, 1998: 54). For Stern, these affects are closely caught up with the tempo and rhythms of daily living—we experience them as we breath, fall asleep and wake up, get hungry, go to the toilet, and so forth. Although they are explicitly present in infancy—indeed the infant is mostly immersed in such vitality affects—Stern is also of the view that they impinge on all our daily comings and goings. Vitality affects might accompany a more categorical emotion such as happiness—we feel a "rush" of happiness when we see someone we love. But they can just as well accompany some action that has no distinct affect—the slight surprise that rises up from nowhere when we read the *Chocolate Rain* subtitle and watch Tay Zonday pitch away from his microphone to "breathe in."

Vitality affects are not expressions of emotion but rather are generalized affect-sensory movements that, ontogenetically, precede the capacity to categorically express "a" feeling. Stern likens them to the gestures performed by puppets. Puppets have no specific means to signal emotion but rather perform a total movement that is expres-

sive without definitively expressing some thing (1998: 56). The proximity of vitality affects to the coming and goings of everyday bodily movement gives a qualitative contouring to the transitions that comprise James's world of pure experience. For James, experience is most basically comprised of pure relations in transition: "What I do feel simply when a later moment of my experience succeeds an earlier one is that though there are two moments, the transition from the one to the other is *continuous*. Continuity here is a definite sort of experience" (1977: 198). Stern gives these transitional relations a contour, a durational detail, an envelope that defines their attack and decay, through which we can trace both their quality and their temporality. Vitality affects are affect as both processual and contouring—as *virally* passing. Their generality can be detected in the everydayness of viral videos insofar as these are expressive but do not express any particular content. These videos singularize expression via movement, not form and content. They deploy the crescendo/decrescendo of the baby's laugh; David lurching in and out of sense and nonsense; Tay Zonday's leaning into and out of the mic stand. General, vague, yet tremendously energetic, the everydayness of viral videos are compositions of vitality—transitory experience animating the collective life of networking.

Contouring networked vitality: refrain and territories in viral video

These instances of going viral are moments that have not been deliberately orchestrated by viral marketing campaigns. Instead, they erupt out of nowhere, gather momentum, and behave like the dynamics of nonlinear systems. Of course, it is the case that viral marketing also "goes viral" and also involves the production/contouring and capture of affect. But in such cases, the affect generated is given a definitive form: joy, sadness, surprise, wonder, and so on. It is categorically rather than vitally affective. By way of contrast, the catapulting of ordinary, everydayness in online video clips to the status of "gone viral" generates a vague emergent affectivity. Affect, here, is not yet "named"—it is on the move and something novel is emerging from it. This ordinariness, this vitality touches on something "outside" the network, if only momentarily. This something "outside the network" can be viewed from the perspective of energetics, as Matteo Pasquinelli has done, arguing that digital networks depend on an unacknowledged surplus of material and extensive vitalities such as living labor (2008: 54–64). Networks feed on this vitality; in effect, networks are viruses, or at least immaterial parasites, that require a corporeal host, a living multitude. In focusing thus far in this book mainly on the technical operations shaping network experience, I have sought to inflect the "flows" of networking—expressed through its graphs,

visualizations, links, and nodes—with quite specific choreographies: diagramming, databasing, auto- and allopoietic loopings which energize network ecologies. Conjoined to these, the networked *dispositif* deforms and is modulated; it does not simply consolidate regimes. It is moved, through such forces, to concatenate emergent socialities and novel aesthesias and to transversally connect to other abstract machines. These concatenations produce mosaics rather than pattern or form—a pragmatic plurality in which James's "lines of influence" between elements hold "the network together" (James, 1977: 407). Network analysis must also encompass the vitalities from which networks parasitically feed and which, as befits parasites, they must simultaneously sustain and nurture in order to survive.

This "something outside" could also be viewed from the perspective of the molecularities that subtend and pass contagiously through networks. Examples of the molecular vitalities of networks are experienced everyday on- and offline, often provoking immediate sensations and reactions. These arrive in the form of jokes, mash-ups, image and video links that do the rounds of email lists or social media sites. These then get picked up by "what's hot" sites and suddenly take off, attracting millions of views or downloads. Jonah Perretti has posited the existence of a multitudinous network that is parallel to the internet and composed of the inadvertent participants of what he calls the "Bored at Work Network" (Peretti, 2005). These are the people who make things "go viral" by forwarding, blogging, instant messaging, chatting, and generating the daily links for viral media. Peretti has been involved in many "contagious media" phenomena: forwarding the infamous NIKE sweatshop email, creating the website *Black People Love Us* that relayed the often offensive things whites say in "well-meaning ways" about blacks. He has since synthesized these projects into *The Contagious Media Project* site (Peretti, no date). But as befits the direct intentionality that marks this kind of "going viral," Peretti attributes the success of networked contagion to a categorically defined subjectivation of the disaffected worker—a kind of second, "gray," fiber-formed network personality. Most accounts of the viral quality of, especially, networked media emphasize the "user-led" nature of contagious distribution. Jean Burgess distinguishes this as the qualitative difference between viral marketing, which instrumentalizes viral media, and the "bottom-up" dynamics of viral video, which engenders instead a culture of inventive participation (2008: 101). Although positing something outside the network, these responses and interventions nonetheless consolidate a subject position of disaffection or "joyous participation," either of which aggregate to produce an alternate network.

Instead, I want to propose that we understand what networks feed off and hasten along—what we live and experience online in everyday, dynamic ways—from the

perspective of an affectivity that is not yet categorized or owned. When Guattari draws our attention to affect's movement, he notes its transitive character, its capacity to facilitate the passage between one thing and the next (1996: 158). It is little wonder, then, that many have noted the speedy and heightened spread of affectivity itself at work in viral media and networked communications (Gibbs, 2001; Rushkoff, 1996). But it would be useless to pose affect as the sensory outside to networked technics. In proposing a molecular approach to understanding the networked movement of "going viral," I hope, instead, to focus on the movements and mechanisms that conjoin networks and affects, for it is these contoured corridors, these transitions with singular qualities, that provide the means for contagious spreading.

I have previously outlined a less reductive sense of affect and its movements via Stern's notion of the vitality affects. But the mechanism through which this affectivity goes viral can be more precisely thought when brought together with Guattari's extended riff on the concept of the ritornello, or refrain (Guattari, 1996; Deleuze and Guattari, 1987: 310ff). The refrain is a repetitive sequence, "a being of sensation" (Deleuze and Guattari, 1994: 184), a composition of percepts and affects that catches on. It might be a short burst of birdsong, a facial trait, some rhythmically, returning mythic element. Guattari is particularly interested in the ways in which the refrain operates as an initial pulsation that enfolds affect onto itself, in the process etching the first contours of expressivity. This etching is not so inscriptive that affect is yet wholly individuated, thereby becoming "an" expression such as a particular emotion. Rather, affect is scribbled into communicability, insofar as "communication" here designates only a bundling or eking out that facilitates the passing of one thing (in) to another:

> The primary purpose of an Icon of the Orthodox Church is not to represent a Saint, but to open an enunciative territory for the faithful allowing them to enter into direct communication with the Saint. . . . The facial ritornello then derives its intensity from its intervening as a shifter—in the sense of a "scene changer"—in the heart of a palimpsest superimposing the existential territories of the proper body upon those of the personological, conjugal, domestic, ethnic, and other identities. (Guattari, 1996: 165)

The religious icon as refrain performs two functions. One is to open up territory for something to pass differentially—here, between the saint and the faithful. This, then, is what rhythmic expressivity produces: a territory of collective enunciation, heterogeneously differentiated elements put in relation. The refrain and collective enunciation precede full articulation or expression. They are components and aspects of communicability—"sign-particles" of communication (Genosko, 2002: 181). The other function of the icon is to actively facilitate the operation of the abstract religious

machine; that is, to enable religious incorporation, whereby the body of the congregation is literally enfolded into the institution of the church. This function is ritualized through the repetition of the refrain of the icon's face, which traverses bodies as well as other machines (juridical, economic, etc.). As Guattari notes, the icon's face transfers religious propriety to the individual churchgoers and to their relation with God, to nuptial and other domestic and national/ethnic aspects of the congregation's life: baptism, burial, the homogenizing of the congregation as Orthodox *Greek* or *Russian*, for example. The refrain of the icon's face is active across and between all these passages but its force changes both in amplitude and direction (reterritorializing, deterritorializing) as it joins with or recedes from the force of other abstract machines, such as state, nation, and community.

As Lone Bertelsen and Andrew Murphie have suggested, the refrain has (at least) three phases as it plays out as an event (2010: 142–145).[6] These do not unfold chronologically; rather, they constitute the multiplicity of the refrain's "eventness." The refrain works, in the first instance, to open up as much as establish a temporary and tentative marking of place. It does this not to spatialize or to claim space as its own but rather so that something might come to pass—the opening up and onto new potentialities. But this phase is very vague, very rough; initially the refrain is really only diagrammatic and marks a break and a jump as one thing passes to another (Deleuze and Guattari, 1987: 311). Considered from this initial phase, the vitality refrain of viral videos is just that momentary, diagrammatic sketching of everydayness: David's delirious "is this real life?"; Zonday's "I move away from the mic to breath in"; the baby's bursts of sonorous derangement in his laughter. But here we need to hold together both aspects of the diagram—its inventiveness and its coordinating forces. We must remember that viral videos do not simply mark out a "pure" affectivity for this sketching takes place within the territory of online networking, always also transversally concatenating with abstract machines of digitality, faciality, biopower, and so forth.

The second aspect, or phase, of the refrain noted by Bertelsen and Murphie is that new functionalities emerge or are redistributed with(in) the territories. This involves many heterogeneous components, but the function of the refrain here is to procure a mode of organizing and marking a territory. This is complicated since we are speaking not simply of a new aesthetic territory but also of a contouring that occurs within the territories of networking. For this might equally reorganize network components so that they consolidate territories such as the faciality of the online "celebrity" and/or it might push established networks toward deterritorialization and permit novelty to emerge:

Sometimes one goes from chaos to the threshold of a territorial assemblage: directional components, infra-assemblage. Sometimes one organizes the assemblage: dimensional components, intra-assemblage. Sometimes one leaves the territorial assemblage for other assemblages, or for somewhere else entirely: interassemblage, components of passage or even escape. (Deleuze and Guattari, 1987: 312)

The upload of the kind of videos I have been describing is both an opening up of the network to everyday vitalities and a simultaneous stretch of what Dimitris Papadopoulos, Niamh Stephenson, and Vassilis Tsianos term the regime of "life control" across the vital aspects of (online) life (2008: 138). But what Papadopoulos, Stephenson, and Tsianos also suggest is that life movements, vitalities, refrains—they describe these as "continuous experience"—historically actualize the regime of life control in specific ways. That is, they give it shape; they contour its modes of expression. It is not, then, simply a question of the regime of life control or biopower capturing or appropriating something that sits "vitally" outside it. Rather, biopower is modulated by "vital" experience and through this modulation becomes a specific and actualized *dispositif*. The everyday vitality of viral videos generates network movements and molecularities that crystallize differently depending on what happens to the refrain. Continuing Bertelsen and Murphie's trifold analysis of the refrain as event, then, its third aspect is to continue *to* refrain. It may do so by enclosing, repeating, and stamping out the territory and/or by conjoining with other new territories and novel components, concatenating to open up new possibilities for an aesthesia of everyday viral vitalism. As is quite often the case, though, the refrain becomes repetitive and reestablishes old ground: Tay Zonday becomes a YouTube celebrity; David's dad sells T-shirts with the slogan imprinted on them: "Is this Real Life?" Even so, the refrain performs a transformative task—between this territory/body and that, between the institution of the church and its congregation, between everyday vitalites and networked media. Something passes and one milieu is transduced into another. The scene has changed:

The form of a refrain is not, therefore, a stable distribution of "formed" affects. It is an erratic and evolving distribution of both coming into being and the power to affect or be affected. This is its power. The refrain is a particularly useful way of negotiating the relations between everyday infinities of virtual potentials and *the real (that is, not just theorized) operations of power*. Refrains enable modes of living in time, not in "states." (Bertelsen and Murphie, 2010: 148)

The refrain provides us with an understanding of affect as a movement in and of emerging semiosis rather than affect as either untrammeled chaotic flux or as categorical emotion. This movement does not necessarily turn affect toward signification per se, although a refrain that has been turned into an "emblem of recognition," such as

the icon or a passport photo, might well be an element in a regime of signs (Guattari, 1996: 162). But this is not the refrain's first function and it is never delimited by its place in such a regime. Instead, the refrain beats out the intervals of asignifying semiosis—semiosis before signification. It is a device that gets affect around, that singularizes it, that contours it and that ushers forth dynamics between milieus and planes—of the living and nonliving, of art and technics—and hence temporalities. It is not a carrier of meaning or signs but, as Bertelsen and Murphie argue, "a gathering of forces," and those forces come from elsewhere (2010: 145).

With respect to a consideration of the terrain of contemporary technically inflected networks, we should acknowledge this work done by refrains at the level of expressing everyday vitalities. This helps to get us past the network as primarily technical assemblage. It moves us past a pure "digitalism" (Pasquinelli, 2008: 58) but doesn't yet land us with "user-generated content" or "participatory culture" as all-too-human explanations of inhuman virologies. Like a virus crossing from replication to full-blown liveliness, the refrain skips merrily across betweenness. It moves us further than the looped recursivity of arraying as the propulsive technics of network experience and out onto the mosaic plane of the affectivities that likewise catalyze networking.

If we consider going viral from the perspective of the refrain, this also means abandoning entirely the notion of viral networks or media as transmitters of messages and of the media virus as code. For that approach assumes an organized and directional syntax and semantics for code—in other words, code as a *regime* of signs. But it does not mean abandoning the idea of *coding*, as long as we understand coding at this level in its rhythmic dimension—as the way in which flows are punctuated in order to pass through networks. In going viral, networked refraining gathers the forces of everyday vitalities and makes them pass—transduces them through the network. We need to attend to the work of the refrain—the way that, for example, short sequences of video repeat themselves, passing along networks, or how they perform a transduction that results in the production of the existential territories that comprise networked experience. We need to attend to the relations between the technical speeds and exponential growth phenomena of networking on the one hand, and the everydayness of networking (and its humans) on the other.

Viscosity of affect and speeds of the viral

But we can retain certain aspects of Rushkoff's "media virus," especially its more visceral qualities, such as its "stickiness," for these tell us something about viral passing. Guattari too observed that affect is sticky, clinging to subjectivity—as much to the

one who "utters" as to the one who is addressed (1996: 158). The movement of affect, then, does not consist solely in passing sensation along from node to node, person to person, media platform to platform. It is also gluggy and pulls at things—strands of toffee stringing out from and catching at one another. Guattari names affect's viscosity "glischroid," recalling a psychiatric term used to characterize the epileptoid personality structure (1996: 158). From the early through to the mid-twentieth century, psychiatry and psychoanalysts developed a personological conception of epilepsy as a particular kind of character trait that could accompany someone prone to seizures or could develop into a pathology. The glischroid character or sticky personality could not help but repetitively engage in extended interpersonal transactions, and these might also lead to irritability and aggression. In such personological analysis, these traits could be generalized beyond the epileptic seizure and apply to a variety of communicative situations: "Viscosity is a tendency for prolonged interpersonal contacts; talking repetitively, circumstantially; and pedantically; and not ending visits after a socially appropriate interval" (Engel, Pedley, and Aicardi, 2008: 2105). By the mid-twentieth century, the psychological conception of the viscous type had developed into neuropsychological theories that linked temporal lobe epilepsy with a psychopathology of "viscosity." The glischroid "type" oversteps normative sociality by being too engaged, too caught in the "interpersonal"—that space in which things pass between people—for periods that extend beyond the "appropriate" duration of social interaction. Irritability, then, passes to others as they endure the glischroid type. Becoming overly socially engaged, the social encounter in effect breaks down and crosses back into an affective outbreak of sticky irritability. Rushkoff also lights on stickiness as a way of making viral media take hold—something "sticky enough" to get people's attention so that it spreads throughout the system (Rushkoff, 2002: 53). But he is more interested in how this allows viral media to build speed of transmission. This misses the differential tempo of spreading, the ways in which intensities build, in turn arriving at thresholds where transitions occur and then speed gathers: social quickly goes antisocial; smooth goes sticky; viral goes viral. Contagion, it seems, is constituted by differential speeds and thresholds. The assumption that online media move at consistently rapid speeds when going viral misses the variability of networking, the plurality of its mosaics. It misses the sense in which viral spread also resists "transmission" and catches things in vortices or where prolonged periods of media engagement might also "threaten" the bonds of sociability.

Spreading, then, involves differentials of speed, movement, and intensification, detectable when we consider its molecularity rather than when we focus on transmission. Spreading is not just a lightning bolt penetrating through the network, but a

build, a bifurcation and passing across thresholds: "It is characterized by the existence of threshold effects and reversals in polarity" (Guattari, 1996: 158). Sticky affectivity is a kind of sensibility and sensitivity that passes around the social but not via some intentional person-to-person communication dyad. Rather, movement happens at infrapersonal speeds and dimensions. As Brian Massumi puts it, viscous affect is the "life-glue" of the world's matter (2002: 227). Yet in a glischroid encounter, affect passes in too sticky a manner, repetitively and pedantically building toward "outbreak," which threatens to unglue the social, if only momentarily. If affectivity is the dimension already prior to the space or field of interpersonal communication, then it is tenuous to build it up territorially, for it might well consist largely of a sea of glug. Contagion might just as easily ooze, flee from us or throw us into encounters in which we get stuck as spread like wildfire.

In picking up on the relationships among temporal lobe epilepsy, the glischroid, and affectivity, Guattari also signals another kind of circuitry through which affect passes—the neurological. This is not of course to suggest that Guattari was advocating for some kind of neural correlates as the basis for the production of affect. Indeed, he certainly wants us to think without such notions of ground with respect to affect; rather it positions or orients and opens up spaces of and for communication. Nonetheless, this small gesture toward the neurological might also provide some new directions for where we might take affect with respect to viral media and networks. Rightly or wrongly, affect has been theorized in relation to the sensory, to the body and to passion in much nonrepresentationalist theory (for example, Sedgwick and Frank, 2003). Going viral and a more general consideration of the virology of networks have also been understood with reference to the biological (Rushkoff, 1996; Thacker, 2009). As Jussi Parikka has suggested, most thinking about the virus in relation to technology—from computer viruses to the conception of networked systems as environments—mobilizes a "becoming-biological" of the digital (2007: 120–121). But this also amounts to an increasing creep of biology into becoming the foundation for everything that moves either actually or virtually. It can be seen, then, as a kind of reclamation of vitality by the system of "life" and indeed an instantiation of biopower. By underscoring affect's stickiness in relation to the *neural*, I want to suggest two things. First, affect urgently needs to be thought of in relation not so much to the biological and to biopower as to the neural and to noopolitics. I do not mean here to oppose the biological and the neurological but rather to shift our understanding of networked affect away from its biopolitical mobilization and organization toward consideration of the ways in which affect increasingly functions in new political and medial configurations of "nerves" in contemporary networked experience. In the next chapter, I will show how networking has come to play a vital part in what I see as an emerging

paradigm of perception that sees human thought and action emanating from the indistinction between artificial neural networks and neurobiological processes. For the moment though, I want only to signal the place affect increasingly plays in areas associated with the neural in contemporary network experience. Second, I want to suggest that a certain sticky residue of something vitally affective does get taken up by some of the YouTube videos that go viral. This is a residue that sees a vitality affect move through the networked field, reinvigorating it rather than being reassimilated to its biopolitics. This vitality remains elusive to the biopolitical network *dispositif*; it has not yet been entirely quantified and made predictable as such. Yet it continues to ripple through and shape it.

It is worthwhile noting the variable speeds and thresholds of the spread and movement of affect, as these tend to be ignored in accounts of media virus and networked contagion. If we are to believe bloggers such as Bilton, viral marketing gurus and much networked theory, networked contagion is marked by instantaneity—the real time of digital delivery. And it is this speed of viral spread that changes social interactions so that openness, uptake, and sharing with random strangers, all of which characterize the frenzy of socialities emerging in platforms such as Chatroulette, become the norm. All of these virally networked modes of engaging do share something with epidemiological vectors operating in biological viral contagions. But we would do well to remember stickiness here too, the residue of an affectivity moving in gluggy undulations and circulating through online videos such as *David after Dentist* and *Chocolate Rain*. Going viral has at least a double temporality: the fast, and "quantifiable" virology of informatic transmission and the movement of affective traces via network refrains. Both of these tempos are at work in contemporary media contagions; both are different formative modulations of affect as contagion. Networked contagion has multiple speeds and is multipolar—too fast to be caught and pinned down, too soupy and vague to be clearly cognized. It is technical and depends on machine times *and* it reaches outside to something soupy that cannot be thought digitally but is nonetheless felt vitally. Contagion in networks is the going viral of affect, reconstituting the transitivity of the viral as that which "over" passes, keeping things excessively networking, making them in excess of the norms of communication in the social encounter, making them stick yet passing too stickily.

The three Cs: control, contagion, and communicability

In the 2011 film *Contagion* by Steven Soderbergh, the blogger Alan Krumwiede (played by Jude Law) works at networked speeds, spreading "news" online about the outbreak of a mysterious fatal virus in Minneapolis (and simultaneously in Hong Kong and

London) over the Thanksgiving weekend. Two tempos interweave in the movie: the speed of information and the speed of disease infection. Krumwiede's blog posts initiate and stoke viral media contagion across networks—from his posts we move to conspiracy theories, to overhyping of the spread and effects of the virus, to his Twitter updates on everything viral. Fighting both the biological virus and panic, the film builds a main narrative thread in which doctors, contracted by the Centers for Disease Control and the World Health Organization, must deploy epidemiological methods and protocols to track and map the source of infection in order to find a cure. Viral *information* is constantly threatening to outstrip the slower pace of disease control. The biological virus also spreads quickly, but it is specific. It moves through people and populations in particularly traceable ways: within the intimacy of familial relations in the home environment; in the public school system, where it passes from child to child; via air travel; through crowds of people; via direct airborne contact and touch. These are all situations in which there is tangible and proximate contact between large numbers of people or where conditions allow for incubation. It affects members of populations in specific ways depending on their demographic, their proximity to others, their recent itineraries. The point about biological infection is that its "communicability," its capacity to pass from carrier to carrier, requires specified periods of time from incubation to infectiousness and can only actualize under certain kinds of physical and climactic conditions. By way of contrast, "going viral" in electronic and networked media seems unfettered in terms of transmissibility. What goes viral throughout media may be elusive, but "going viral"—the communicability of media and networks—is configured as free flowing.

Scott Burns, *Contagion*'s scriptwriter, at times conflates and at other times distinguishes between media and biological infection in an effort to show that the third infection that overtakes the global population in the film—panic—emerges not simply on biological grounds but also through media rumor and sometimes misleading information, rapidly firing across networks in a Web 2.0 era. There is a moment close to the beginning of the film where the two virologies conflate: a handheld video of a man convulsing on a bus and dying from the mystery virus threatens to *go viral* online. This threatens to inflate public panic not simply about the biological effects of the virus but also about a rumored conspiracy to contain and cover over its real horror and transmissibility. The biological virus feeds the media virus and thus the panic virus. Yet what Burns conflates is not simply biology with media and affect but rather modes of communicability. The specific modes of contact and transmission through which viral disease passes are conflated with the supposedly unfettered flows of media communication. The merger of actual disease communicability with modes of con-

temporary networking and communication and with the spread of affect suggests that we have shifted into a more generic arena for thinking through the viral. This signals a shift away from Foucault's "epidemic experience and consciousness" (1973) with its specification of event, time, and place for disease spread into some other disease-media-affectivity milieu. This milieu is the pandemic.

A decade and a half ago, the film *Outbreak* (Wolfgang Petersen, 1995) became a box office hit. It too dealt with viral spread, but its targets of concern were how to isolate issues of species-to-species and nation-to-nation contamination via the protocols of disease quarantine. As the Ebola-like virus is carried from a village in Zaire to a town in the middle of the United States by a monkey, the question of how to contain the spread using extreme stealth and military measures—firebomb the U.S. town of Cedars Creek or obtain classified military information about a vaccine—become core in fighting a first-world outbreak. *Outbreak* sits on the edge of two conceptions of the viral: the first is a dawning acknowledgment of the breakdown of species barriers coupled with the globalization of this breakdown; the second is the strategy of containment, which belongs to a milieu for disease in which barriers can be drawn around diseases and specifications can be made. What changes in the popular depiction of viral contamination between 1995's *Outbreak* and 2011's *Contagion*? The obvious answer would be that the twinned development of networked media with globalized information, commodities and population flows means that containment, as a strategy, is no longer feasible. The "enemy" is now not a military conspiracy that must be redressed—the secret mistake or cure that has been secreted or "contained" by government and must be revealed by the good doctors. The enemy in 2011 is, rather, the uncontainable nature of virology—biological or informatic. The solution lies not in containment or countercontainment but in beating down untrammeled contagion through rational forces, forces that materialize in *Contagion* through the Centers for Disease Control and the World Health Organization. Such forces will be mustered in the form of epidemiological knowledge and protocols prompting a "race against time" in the face of media, panic and infectiousness.

But something else has changed, and this goes to the heart of going viral. We have shifted from outbreak and the politics of containment to contagion and the culture of spreading. Subsequently, we have also finished with an epidemiology of disease and entered a generalized condition of the pandemiological. In fact, the biological virus and the networked virus in *Contagion* are not simply operating at different tempos; they are also operating at different scales, along different perceptual axes, and onto-genetically via different modes of individuation. Additionally, there is a merger from virus to going viral, from entity to process. This is achieved synecdochically as we

pass, in *Contagion*, from a representation of the symptoms of the disease in a video clip to the spread of the clip-disease as the moving image goes viral via the network. Yet even though these transit from one to the other there remains a world of difference between actual virus and going viral.

In the *Birth of the Clinic*, Foucault observed that the conception of disease as epidemic emerged *epidemiologically* in the eighteenth century as an event specifically situated in time and place (1973: 22–25). Contagiousness is itself not so much of interest in the birth of epidemiology; rather, the where and when disease happens is of chief concern. Foucault suggests that while a specific disease is understood to be repeatable, an epidemic, by dint of its time and place of outbreak, is unique. How the disease is transmitted is not at the core of the birth of a "medicine of epidemics," that is, epidemiology (Foucault, 1973: 24). Instead, the question is, What form does the process of disease take such that it can be generalized across a population but remain specific to a place and time? What is at stake is both a generality and a particularity. The disease is understood through a collective consciousness of multiple viewpoints—medical, institutional, political (that is, the police)—that check and cross-check its outbreak points, its movements, its qualities, "a medical consciousness whose constant task would be to provide information, supervision and constraint all of which 'relate as much to the police as to the field of medicine proper'" (Foucault, 1973: 26). Epidemics and epidemiology, then, are born out of a particular political consciousness that in the eighteenth century amassed through the birth of totalizing clinical experience. The epidemic ushers in both the clinical experience and a form of knowledge that isolates specific facts—times, dates, places—in a mass or totality such as the population. The epidemic and epidemiology are imbricated in a politics that seeks to secure the movements of disease across populations. The epidemic is tied to a politics that proceeds via strategies of control and containment over a mass.

So what has changed in the decade and a half between the movies *Outbreak* and *Contagion* and the ways they differently handle viral movement? A double shift has occurred: we have moved away from epidemiology as the milieu that contours consciousness of disease outbreak and spread—epidemiology as traceable back to the unique event that can then be contained. Instead what is of primary focus is contagion itself. The crucial point is the general vagueness of contagion: its spread to everything and anything, its nonspecificty, its communicability. The other aspect of the shift is that as contagiousness spreads through everything, the viral becomes something much less biological, insofar as biological disease should be something specified nosologically. Instead, the viral designates a general tendency toward communicability itself. The viral is what passes from one thing to another rather than what develops out of

the specificity of disease-based circumstances. This is so even, as we shall discover a little later, for a new pandemic conception of the biological virus. The key is not *what* is spreading or *what* agency is controlling and communicating the spread. What becomes crucial for contagion is movement *between*, passing from this to that—transitivity. It is less, then, that media, communication, and networks have become biological and more that the viral's quality of nonspecificity makes it many things or processes at once. Going viral comes to signal a condition in which the biological, the communicative, and the affective all pass between one another. Communicability, rather than communication, is key to this miasma. James has something to say about the experience of transitivity, which, he argues, is complex and, especially for our purposes, nonsubstantive: "When things pass backward and forward repeatedly from 'm' to 'n' this does not engender habituation but rather registers as the 'shock' of their difference; the more imperceptible in difference, the more is this 'shock' registered" (James, 1992: 236–237).

Shock is not found *in* "m" or "n" but rather is generated in a passage *between*. For James, the key issue is difference in transition. Communicability is not, then, an experience of a numbing boredom building up through repeated imitation. Instead, it generates microsensibilities: infinitesimal changes in which the movement from this to that involves sharp sensory registration across various planes. We lose this in many analyses of going viral, especially ones that light only upon this generalized state of communicability. James reminds us to pay attention to the *how* of the passing.

The public health domain also displays a series of interesting changes with respect to this transcommunicability of the viral across registers. In the last decade the concept of the pandemic has been revived here. It has taken on a different sensibility with respect, especially, to predicted influenza A outbreaks (strains and mutations of both the H1N1, "swine," and H5N1 "avian" flus) by organizations such as WHO, the Centers for Disease Control and Prevention, the European Commission, and the National Influenza Centers as well as by prominent virologists. From 2003 to 2009 the use, definition and circulation of "pandemic" particularly intensified as public health authorities attempted to come to grips with the movements and mutation of a number of new influenza A strains. In 2003 the virologists Robert Webster and Elizabeth Walker published an article in *American Scientist Online* with the tremulous title, "The world is teetering on the edge of a pandemic that could kill a large fraction of the human population" (2003: 122). This article detailed the outbreaks of avian flu in Hong Kong between 1997 and 2001, indicating how each outbreak specifically began in domestic birds and spread devastatingly in some cases (in 1997, for example) to the human population or in other cases was contained through swift measures to kill

the bird populations (in 2001, for instance). In 2005 and in response to the spread of avian flu strains, WHO revised its 1999 guidelines for preparing and responding to pandemic influenzas.[7] It recommended the introduction of a six-phase system to track the development of, and to prepare and respond to, a pandemic (WHO, 2005: 7). In 2007 the Centers for Disease Control released its Pandemic Severity Index, assigning categories of, mainly, influenza outbreak from moderate (category 1) to severe (category 5) or pandemic (CDC, 2007). The index analogously uses the hurricane warning system to develop a community warning system and prompt action in response to pandemics. In June 2009, having predicted a severe pandemic event for several years on the back of evidence of severe avian flu outbreaks, the WHO got itself into some hot water. It declared that the outbreak of "swine flu," rather than avian flu, had gone to pandemic status (Chan, 2009). But the subsequent lack of severity of the symptoms, death, and spread of swine flu effectively left the WHO struggling over what in fact constituted the conditions of a pandemic.

As a number of people have observed, the rhetoric accompanying and affect attached to public health, media, and populations' responses to these potential pandemics come amid the preemptive logic of post-9/11 culture and politics (Massumi, 2010; Stephenson and Jamieson, 2009; Muntean, 2009). This logic of affective threat generalizes to the point where the virus, in pandemic phase, loses any sense of specificity: "Threat is from the future. It is what might come next. Its eventual location and ultimate extent are undefined. Its nature is open-ended" (Massumi, 2010: 79). But what I am interested in here is the emergence of not just threat but of *pervasiveness* as the condition in which we biologically, communicatively, and affectively inhabit a perpetually unfolding moment. Pandemicism involves a becoming-abstract, a deterritorialization of disease and, consequently, the joining up of disease with all and any other modes of transmission. During the height of the 2009, swine flu (H5N1 strain) pandemic declaration, virologists began to admit they were confused: "It is really quite hard to figure out what is and what is not a pandemic," declared the epidemiologist Dr. David Morens (Morens in Altman, 2009). In the confusion over not only what constituted a pandemic (in spite of the "clear" six-level staging process) but which influenza strain—swine versus avian—was actually going to become pandemic, the WHO has received criticism from the medical profession.[8] As one prominent doctor in preventative medicine declared, "We, the public health community, ought to be chided about the confusion. . . . We ought to be able to do a better job in communicating in an understandable way" (Schaffner in Altman, 2009). The development of "pandemicism" lies precisely in a "going viral," an everywhereness, a generalizability of viruses. This excessive, glischroid extension of communicability leads to epistemo-

logical and communication breakdown. The very nature of disease cannot be properly explained. But the disease cannot be communicated because of its pervasive communicability. In the virus "going viral," we also move beyond a becoming-biological of the social and of the media toward an excessive communicability. The inability to communicate effectively publicly by those who should know better is subtended by the sticky excess of bio-medial-affective communicability.

Communicability, sociality, vitality: toward contagion as immanent movement

There has been renewed interest in the ideas of contagion and imitation found in the work of nineteenth-century sociologist Gabriel Tarde. Tarde provides a logic for the emergence of the social, which emanates not, as he puts it, from the utilitarian economics of mutual service nor from the juridical framework of contractual obligation but from association. The social as association accumulates steadily as a formation via imitation: "Society may therefore be defined as a group of beings who are apt to imitate one another, or who, without actual imitation, are alike in their possession of common traits which are ancient copies of the same model" (Tarde, 1903: 68). For Tarde, sameness and repetition spread via contagions. The history and development of societies are composed largely via contagion-imitations from the modeling and copying of flints to the spread of local dialects (Tarde, 1903: 17). Tony Sampson suggests that Tarde's work on contagion offers us a way to account for a crossing from bio to socio insofar as he accounts for the social as a relational assemblage, consisting in just that traversal of bio-medial-affect I have detailed above (2011). Anna Gibbs has also drawn on Tarde's work on imitation suggestion and sympathy, suggesting we open corporeally and cerebrally via muscles, nerve, and fibers to the bodies and ideas of others (Gibbs, 2008: 135). Additionally Nigel Thrift shows how we might update Tarde's concept of "imitative rays," a somewhat instrumentalist determination of how imitation spreads via mechanisms such as print media (2008: 29). All these recent approaches are committed to thinking the biosocial transversally; thinking contagion in the contemporary moment precisely because, as all authors argue, spreading spreads across such distinctions.

But, crucially for Tarde, the social as such gives us groupings that have congealed by way of associations. These agglomerations have formed as a result of the work of imitation but then become assemblages, which involve not just institutional elements but corporeal components such as habits. The social, as Latour has suggested in his reading of Tarde, is not a more complex form of sociality but rather, in its congealing, a mode of standardization (Latour, 2002: 122). We should not create divisions or levels

between the micro and the macro vis-à-vis society, as if the latter were a complex formation that has emerged out of microinteractions. Yet Tarde does differentiate between sociality and society in terms of *process*. There are processes that are immanently dynamic and *molecular*, and there are processes that have congealed and are *standardized*: "A society is always in different degrees an association, and association is to sociality, to imitativeness, so to speak, what organization is to vitality, or what molecular structure is to the elasticity of the ether" (Tarde, 1903: 69–70). Pure imitation, then, taking us to the threshold of this standardization, of course runs through the social as its lifeblood. Yet imitation is infrasocial or, to borrow an idea from Guattari, the asignifying generation of conditions that are presocial (Guattari, 2008: 63). The "social" is a crystallization of imitation, and that process occurs via the infrasocial of *sociality*. Not yet structured into associations, sociality is more like a force-movement whose pure immanence can be detected, according to Tarde, in the densest proximity of peoples to one another and in the most temporally immediated conditions: "It would consist of such an intense concentration of urban life that as soon as a good idea arose in one mind it would be instantaneously transmitted to all minds throughout the city" (Tarde, 1903: 70). *Sociality* is intensive imitation—"ground-matter," biomass, ether and molecularity of *society*. Tarde sees sociality as a kind of matter-flow coursing through but also ontogenetically preceding the social as standardized assemblage. The social as formation "kneads" this stuff, organizing and grouping it into associations. Whereas sociality is intensive sticky molecularity, the *social* comprises an extensive field of organized imitation.

Tarde understands sociality by analogy with the molecularity of matter and ether not in order to biologize it but rather to get at its immanent, dynamic plasticity—its processuality. Imitation and its contagions are first and foremost intense dynamisms not biological entities. Like a biomass, sociality moves and spreads through both imitation and adaptations of imitations. As Latour has also suggested, imitation is a processual movement, marking the ways in which elements congealing via sociality stick to and copy each other and pass this on: "Imitation, that is, literally, the 'epidemiology of ideas.' . . . The term 'imitation' may be replaced by many others (for instance, monad, Actor-Network or entelechy), provided these have the equivalent role: of tracing the ways in which individual monads conspire with one another without ever producing a structure" (Latour, 2010: 149). Tarde's conception of sociality is (analogously) close to the contemporary notion of communicability, which has shown up in the pandemic approach to public health, in the going viral of networked media, increasingly in the analysis and commentary of contemporary social-political movements for change, and in the contagious cascading collapse of financial institu-

tions during the 2008 global financial crisis. Indeed financial analysts have increasingly evoked the notion of contagion to account for crises from the Asian crisis of 1997 to the global financial crisis of 2007–2008 (Kolb, 2011: 3–10).

Yet the virality or contagion of all such "events" does not simply lie in their speed and immediacy—qualities associated with the spread of globalized communication networks. Viral marketing, for example, also deploys strategies of pervasively spreading vaguely coded branding. It relies on the low intensity of networks—"small pieces loosely joined"—where people simply spread the "experience" of a product from one to the next. They "communicate" its virality, in other words. Matthew Fuller and Andrew Goffey suggest that viral "spread" as a mode of "communication" may be less about instantaneity than it is about generating an atmosphere of "everywhereness" (2009: 154–155). What spreads under viral communication is not a message but rather a sense of being in the "flow" of messaging, in the process of semiosis. For Fuller and Goffey, viral marketing is not "viral enough" since it always falls short of a pure mediality, a pure flow of intensive media matter, and instead needs to capture such flows in the form of niche markets. Here, communicability is territorialized by communication through a mode of standardization—capturing markets. Yet something of the plasticity of the "flow" through which the contagion does its indiscriminate spreading remains in the experience of contemporary networked media. Going viral signals a general sociality or communicability in the environment. We live in a deterritorialized "zone," the communicability of which provides the social and communication's matter-movement yet whose distribution also outstrips these. If googlization, which I considered in chapter 2, is an attempt to reterritorialize and own the "spread" of networking, going viral is its riposte, flooding out the tendency toward monism.

Tarde undertakes a speculative attempt to come to terms with the molecularity of the social so as to not reduce it to mere collections of associated individuals (Tarde, 1899/2000: 19–20). As Thrift puts it, we should not categorize the work of imitation as "social" per se because its effects, diffusions, and formations are precisely not of "the category," not of the thing that has become a social fact: "What we can see is a constant adaptive creep which has its own momentum and cannot be cataloged as a social category or force since it is happening continuously, as a background of contagion which acts equally as a foreground" (2008: 86). Imitation, repetition, and adaptation are ongoing differential processes modulated by forces of homogenization; repetition is also modulated by adaptive change. More often than not, contemporary networked experience produces conjunctions—between the molecular and the molar, sociality and the social, communicability and communication, asignifying and signifying semiosis, biomass and bodies, affect and emotion. And that is why we should pay

particular attention to the molecular work of elements such as refrains, which can alert us to the shaping and experience of these very transitions.

To return, then, to the refraining vitality of YouTube gone viral videos such as *David after Dentist*. We should remember that what passes from YouTube subscriber to subscriber here is not just some generalized "spread" but rather something peculiar, quirky, and elusive—something that sticks. While there is much in the media that gets hyped, gets repeated, and becomes drearily popular (cementing rather than refraining), things also pass because they are refreshingly sticky. Such YouTube videos affect others—people laugh, catch the vitality, recognize the everydayness, repeat the refrain and move it along via online networks. There is corporeal and incorporeal movement going on. I want to suggest, though, that the transmission of such viral videos is generated through an affective-socio-technical relationality that is multiconstitutive, comprising but not limited to the sensing of vitality about the clip itself, the singular shaping of this via a refrain, the packaging of the refrain as networkable through a very specific online platform and, finally, its multiplication via a multitude of networking mechanisms. What we have is a conjunction of heterogeneous affective, technical, and imitative (of the order of sociality) elements: the vital and the multiple, the indivisible plastic (vitality affect) and the discrete technical element (computational network). In other words, we can generate a diagrammatic perspective—recalling chapter 1, we could say more specifically a "mechanogrammatic" perspective—on going viral as a "machine of expression." In turn, this gives us a way of understanding such distributed machines of expression as collective enunciations (Guattari and Roelnik, 2008: 43) of networked aesthesia.

Massumi gives us a molecular analysis of visual motifs (2011a: 43–44). The decorative architectural motif—a plaster of paris branch of leaves statically swaying, a still bunch of grapes hanging—is both frozen and repeated across the stucco plaster ceiling. It suggests the potential for movement. As the eyes visually follow the motif down a wall, it feels as though movement is about to occur. As Massumi suggests, the body is capacitated but the frozen motif does not allow the release of such potential:

The form naturally poises the body for a certain set of potentials. The design calls forth a certain vitality affect—the sense we would have, for example, of moving our eyes down a branch of rustling leaves, and following that movement with our hands. But that life dynamic comes without the potential for it to be actually lived. It's the same lived relation as when we "actually" see leaves, it's the same potential. But it's *purely* potential. We can't live it out. We can only live it *in*—in this form—implicitly. (2011a: 43)

The vitality affect as refrain is slightly different: the refrain, as we recall, both opens up the space for transmission as well as shaping something so that it becomes repeat-

able. The vitality affect of *David after Dentist*'s "Is this real life?" or *Hahaha*'s deranged crescendo/decrescendos of baby laughter opens up and is opened up in the context of networked, distributed territories. Both the space (extensivity) and temporality (intensivity) of transmission are densely immediated. This is just like Tarde's city, where an idea is taken up, imitated in all directions, and constitutes part of the ongoing event that is the associative forming of sociality. Instead of the body being potentialized but with nowhere to go, as is the case for the visual motif, vitality is both potentialized and spreads everywhere in the networked refrain. There is no frozen terrain here; multiple relational territories proliferate transversally. In such "going virals," bodies and brains are communicably networked and concatenated into new "machines of expression." They open up new territories, which pose the possibility for rethinking the relations between sociability and the social, communicability and communication.

5 Nerves of Data: Contemporary Conjunctions of Networks and Brains

Distributed neurologies/neuro-networking

Imitation seems to haunt, or at the very least accompany, digital computation. During the 1980s and '90s, memetics were all the rage. The cultural concept of the meme as an imitative "carrier" of culture was initially expounded in the work of the evolutionary biologist Richard Dawkins when he compared it to the gene (1989: 192). A meme is understood to be a rapidly replicating transfer of ideas, behaviors, or skills that typically takes hold across populations. In the hands of Susan Blackmore, memes became memetics, a full-fledged theory of cultural production and reproduction (1999). During the 1990s many digital producers and theorists believed that the internet facilitated memetic spread and uptake of not only ideas but also of rich media, such as digital images, sound, movies, and so on (see Heylighen, 1996: 48–57). The previous chapter focused on "going viral" as a peculiarly contemporary mode of imitation in which, especially, everyday ephemera such as babies laughing and homespun pop songs become refrains, replicated and distributed as video clips via media-sharing platforms such as YouTube. Both the "contagions of imitations" of memes and viral media—to use Tarde's phrase (1903: xviii)—are indebted to the communicability of networks. What is at stake in networks' virality is less an analogy with biology than the general pervasiveness of a plastic, dynamic, and sticky communicability, a force of relationality that is not yet full *communication*, in which process, movement, and circulation take precedence, albeit at differential speeds.

Imitation abounds across networks, then, and in this chapter my focus turns initially away from the internet. In the neural "network," by contrast, another kind of imitative presence has been popping up. "Mirror neurons," located initially in an area called F5 in the premotor cortex of macaque monkey brains, have been thus named because they "fire" both when acting *and* observing hand and mouth actions in others—that is, other monkeys and human experimenters (Rizzolatti et al., 1992).

Working on the relations among motor events, cognition, and perception in the 1980s, a group of Italian neuroscientists were surprised by the phenomenon of neural firing in the macaque brain while watching another undertake the hand action of grasping. Neuroscientists began to speculate about such phenomena in human subjects and to use less invasive methods to test neuronal response (Buccino et al., 2001). Combining a range of in vivo brain imaging technologies such as positron emission technology (PET) and functional magnetic resonance imaging (fMRI), neuroscientists seemed to discover similar evidence of a "mirror neuron" system located in a homologous area of the human brain responsible for motoricity—Broca's area (Arbib et al., 2000). These findings have fueled scientific speculation on whether learning, language, and other "social" behaviors might actually be based on neural correlates.

At first glance, positing mirror neurons as the seat of both primate and human intersubjective (that is, social) behavior smacks of substantialism. And yet over the past two decades research into mirror neurons has increasingly deployed, at the very least, a "systems approach" (Arbib et al., 2000) and, at the more radical end, an articulation of neural architecture as fully distributed (Damasio and Meyer, 2008: 167–168). Unlike Dawkins-inspired memetics, which reifies imitation by drawing an analogy between memes and genes, mirror neurons might be rendered *ontogenetically relational*, firing in one and the other, monkey or human, through action-perception interchange. Mirror neurons catch action, perception, and cognition in a "betweenness," a concatenation of cognition and movement. This indeed is radical territory for the neuro- and life sciences, suggesting that relationality may precede the division between the brain that acts and the brain that observes the brain that acts. Yet we should recall that James was already suggesting something similar more than a century ago. Self and other's feelings and cognitions were to be understood as differences in degree of feelings of relation rather than differences in kind: "What is the difference between *your* feeling cognized by me and a feeling expressly cognized by me as *mine*? A difference of intimacy, of warmth, of continuity, similar to the difference between a sense-perception and something merely imagined" (1992: 1013, n9, emphasis in original). Here the idea of degree connotes again the foregrounding of betweeness as relational; how degrees of betweenness constitute the relations between feeling and thinking.

Many of the problems and issues raised by contemporary neuroscience build on this genealogy of a distributed, relational, and *networked* diagramming of the brain-mind-world-self assemblage that is suggested by James's attention to relations as the real stuff of experience. But networking and, especially, online networked technologies have also become intertwined with the neural in ways that both take up and move with this relationality—this distributed diagram of affect, perception, and cognition—

and seek to exploit and capture it. This "capture" comes in the form of an orienting of computational-neural networks toward prediction, especially toward attempts to predict behavior in markets, populations, consumers. Part of networked entities and corporations' growth and use of data mining systems that learn from and model data—that is, systems deploying machine learning—to predict future directions relies on artificial intelligence research that began in the 1990s. During this period, when we were, on the one hand, experiencing an explosion in the life sciences and artificial life, artificial intelligence (AI) research was engaged in a raft of "practical" applications for industry and for the military (Johnston, 2008: 386). "Smart applications" were tried and tested, such as electronic fraud detection, voice and face recognition, and data mining systems. This research is imbricated in generating and deploying a distributed, networked architecture that still owes a debt to the genesis of neural networking in Warren McCulloch and Walter Pitts's conception of the movement of the brain's electrochemical impulses through neural circuits as a form of biological computation (1943: 99–115). Importantly, McCulloch and Pitts drew a formal analogy between the activity of neurons acting in neurophysiological networks in order to receive and transmit electrical signals and the "activity" of logical propositions and their networks of relations: "The 'all or none' law of nervous activity is sufficient to insure that the activity of any neuron may be represented as a proposition. Physiological relations existing among nervous activities correspond, of course, to relations among the propositions; and the utility of the representation depends upon the identity of these relations with those of the logic of propositions" (1943: 117). In fact, McCulloch and Pitts shed less light on the brain's activities than they did on a mode of thinking computationally beyond simple input-output models of information processing. Their paper gave impetus to the modeling of *artificial* rather than biological neural networks and initiated research into questions of learning and adaptation in AI. What this analogy between physical and artificial neurons facilitated was a kind of backward and forward mapping that has also entwined and harnessed computational models of thinking to the activity of (idealized) neural correlates (Piccinini, 2004: 176).

As John Johnston has argued, this enmeshing of the neurobiological with the computational has continued to provide an AI research direction that differs from an emphasis on language, general intelligence, and symbolic processing (2008: 386–388). As they now feature in AI, neural networks have become largely nonbiological and increasingly interlinked with branches of statistics and data analysis. Machine learning now finds itself at home in the internet and in databases. In part, this is due to the fact that large enough datasets and, especially with the development of shared online platforms, enough instances of distributed parallel processing networked nodes can

"collectively" combine to create a kind of vast quasi-AI. Or at least this seems to be the dream of networked corporations such as Google, as we can glean from another infamous Eric Schmidt-ism: "In five years, Google will have built 'the product I've always wanted to build—we call it 'serendipity,' he said, adding that it will 'tell me what I should be typing'" (quoted in Mills, 2006).

From one angle, it appears that deployment of machine learning techniques across, especially, online applications signals that biological neurality may have fled the scene of such models. Yet Google's search aspirations rest precisely on a *reterritorialization* of mind/intelligence in which a raft of machine learning techniques, from data mining to dataset training, claim the territory of noncognitive dimensions of brain and thought. In the form of "serendipity" or "prediction," these become the resource on which to build artificial neural networks. I suggest that networked media really are returning to the neural as they explore techniques for machine learning. What they hope to territorialize via creating an AI that can, for example, "read" large datasets or supply the next keystroke, is a kind of intelligence that exists interstitially in the nebulous "between" spaces before conscious (human) thought fully emerges. This chapter discusses the ways in which the potential of relationality—which for James emerges through the betweenness of thoughts, actions, subjects and objects in the world—gets channeled into a resource for methods of predicting where networking will go and what it will do. At the close of chapter 1, I drew out a tension between diagram and model of the network, suggesting that in modeling networks over attending to their diagrammatic forces, we take the path of taming potential. Potential then becomes prediction—what *will* happen next. In this chapter, I suggest that tension over distributed betweenness, that which remains not fully known yet nonetheless real and experienced, on the one hand, and the taming of such experience by techniques of prediction, on the other, now suffuses the neural politics of networks. The harnessing of networks by machine learning leads us to models of prediction rather than pursuing McCulloch and Pitts's more suggestive "relations among propositions." Even so, I think that the engagement with the "neural" of networks should not be dismissed out of hand; there remain many meshes of "neural" and "network" that suggest possibilities for reinserting the radical betweenness that James offered us.

A good example of this "predictive" trend and attempt to capture the vagueness of relational potential is the development and implementation of Google's *Prediction API* tool. This tool forms part of the networked corporation's self-conscious development from "search" toward artificial intelligence and marries cloud computing with predictive AI. As Schmidt has claimed, "We're still happy to be in search, believe me. But one idea is that more and more searches are done on your behalf without you needing to type. I actually think most people don't want Google to answer their questions. . . .

They want Google to tell them what they should be doing next" (Schmidt quoted in Jenkins, 2010).

Both *Prediction API* and the shift to prediction as the ultimate goal for Google search are indicative of a disposition toward capturing and reterritorializing the radical potential of distributed (neuro)architectures. Like any API, the heart of this application is source code that allows for certain kinds of communication functions to occur on or between components of a database. In the case of its *Prediction API*, these functionalities allow for pattern matching and machine learning. But there is a twist—Google releases this data mining/prediction tool to users on the condition that their data is stored on Google servers.[1] Effectively, data becomes *less* distributed and more concentrated within the proprietorial grasp and confines of particular networked corporations, a move typical of the shift toward cloud computing. That data stored on Google servers also becomes the testing field for a tool with machine-learning-enabled application, which is likewise Google's property. This is a definitive step along the line of the user-generated content supply model of webonomics. Google distributes its tool "freely" to users so that its tool can learn, indeed "self-organize," and consolidate others' data or content for the company. The network is parasitically developing its "cognitive" capacities from the data labor of its users.

The broader move away from search per se toward prediction of what "users" desire before they even know what they want signals a more insidious foray into staking a claim on the nonconscious and affective terrain of precognition and all its betweenness. Networked media is turning toward systems, tools, and processes of what I call "neuro-perception," that is, a paradigm of perception that sees human thought and action emanating from the overlay of artificial neural networks on neurobiological processes. But there's more than a turn here; there's a staggering leap. How have we traveled from McCulloch and Pitts's analogy between relations and propositions to Google's prediction? How has searching morphed into a form of AI that claims to anticipate your next move? And what implications does this assemblage of "machine-us" intelligence, riding the slippery slope of the predictive, have for the molecularity of perception that James was so eager to preserve in foregrounding its betweenness? And how does the slide from potential to prediction conjoin with molar sociotechnical assemblages?

Brain terrain

Before I enter into these entanglements, I want to note that it is not only networked R & D that has recently turned toward the neural but also cultural theorists and commentators. A range of writers has taken up the mirror neuron hypothesis, arguing

diversely that such neurosocial phenomena suggest a complex web of imitation emerging transversally across the biological and the social (Stafford, 2007; Thrift, 2008; Sampson, 2011). Crucially, incorporating the neural into accounts of the infrapersonal, the personal (subjective), and the interpersonal (social) means that the relational web of affect, perception, and cognition has come to occupy center stage for cultural and aesthetic analysis. But there has also been a turn *against* networks that seeks to prove with neurobiological evidence that the internet and other digital media rot our brains. Thought, focus, attention—especially of the so-called "iGeneration" of 18- to 24-year-olds—and the synapses themselves have increasingly been characterized as deteriorating, in a state of crisis or under attack, targeted by economies, techniques, and cultures of fragmenting and accelerating media (Carr, 2010a, 2010b; Greenfield, 2009; Wolf, 2007). Computational culture's revving up–dumbing down tendencies effect a significant shift, according to Nicholas Carr, away from depth and substance toward the flatlands of surface insignificance, which he calls "the shallows": "Our online habits continue to reverberate in the workings of our brain cells even when we're not at a computer. We're exercising the neural circuits devoted to skimming and multitasking while ignoring those used for reading and thinking deeply" (Carr, 2010b). For those at the alarmist end of the turn to the neurological in media analysis, the software and hardware of media technologies are turning our "wetware" to mush, transforming our nerves of steel to nerves of data.[2]

The turn against networked media turns away from brain and mind as relational. Subsequently, a distinctly cartographic approach to the brain as chartable territory returns, especially evident in the summonsing of neuroimaging techniques (fMRI, for example) to incontrovertibly "map" neural activity, structure, and change. In Carr's analysis of networked media's effects on our neural circuits, he uses a 2008 neurosociological study as evidence of, "what the Internet is doing to our brains" (2010a: 120–126). Gary Small, the psychiatrist to whose study Carr defers, conducted a series of experiments with both "naive" and "savvy" web users, using before and after fMRIs as visual indices of structural neuroanatomical change due to exposure to web browsing. The brain of the naive user is, at the beginning of the study, relatively "unwired" for the web. The savvy participants' initial fMRIs indicate, on the other hand, that an area at the left front of the brain, the dorsolateral prefrontal cortex, showed intense neural activity. By way of contrast, those who had little exposure to web surfing showed up as having much less neural activity in the comparable area. After 5 days of 5 hours daily use of Google to conduct web searches, the naive brain's "wiring" lit up differently—incontrovertible evidence that neuroanatomical change has taken place due to networked media engagement. In a voice poised between wonder and

terror Carr remarks, "The human brain is almost infinitely malleable" (2010b). Yet as with all before-and-after shots, change itself can only be inferred. What is captured and mapped is the visual fact that change has happened, indexed to the implication that seeing these colored, "lit-up" areas of the fMRI renders change through neuroanatomical restructuring. Although seemingly affirming qualities such as plasticity, this line of thinking espouses a strong view of mind to brain locationalism.

This also signals a panicky flight away from contemporary media and networks into the arms of neuroscientific evidence. Such a flight partially concurs with Bernard Stiegler and Katherine Hayles's concerns with the digital and networked capture of the attention spectrum, especially in young people (2010; 2007). Hayles identifies a current generational cognitive change in 8- to 18-year-olds, which she terms the shift from deep to hyper-attention (2007: 187). Deep attention is characterized by sole focus on one media object—for example, reading a book—whereas hyper-attention typically involves shifting one's attention around multiple media: listening to the iPod while doing email while submitting a homework assignment and texting one's friends. According to Hayles, this is both typical of the "younger" generation and intricately connected to learning and cognitive disorders such as attention deficit disorder and attention deficit hyperactivity disorder (2007: 188ff). Her tone is not moralistic or nostalgic, and she certainly makes the case that computer games might also engage their users in long periods of "deep" attention and absorption (2007: 198).

Stiegler offers a grimmer view. He is concerned with a broader socioeconomic-cultural shift—the overall thrust of contemporary technicity in which an entire system for capturing and modulating not simply bodies but our total spectrum of attention has developed: "The solicitation of attention has become the fundamental function of the economic system as a whole, meaning that biopower has become a psychopower" (Stiegler, 2010: 103). This is now particularly the case for contemporary "youth" who, across an entire generation, have lost their attentional capacities. Technicity, understood within the parameters of Stiegler's *Time and Technics* project, is a historically specific systematizing of technical objects whose organizing principle resides in the acceleration of time (Stiegler, 1998: 23). Temporality itself is commandeered by this techno-logic such that future thought, life, and tendencies must be "programmed," calculated, and invested in. In short, the future—*anticipation as an existential territory*—is reterritorialized by capital (Stiegler, 1998: 42).

Teletechnologies—through which, for instance, online digital games are played—are examples, in Steigler's eyes, of how the dynamic of human-technics both simultaneously engages and generates a temporality (of ever-present immediacy), resulting in a dysfunctional ethico-aesthetic horizon. For Stiegler, then, future activity has

already been captured by "psychopolitical" forces, which commandeer the affective-cognitive potential of anticipatory feelings for the performance of, for instance, the split-second decision making that drives global financial markets. This same domination of temporality by a (non)thinking-acting, which sees attention as a "zone for investment," also drives the teletechnological occupation of intensive temporality or duration. Stiegler goes some way to giving us an understanding of the move by networked corporations such as Google from search to prediction, that is, from a (relatively) open and extensive scanning of the future by searching it to an intensive enclosure of a zone before it even occurs by predicting it. Stiegler urges us to rapidly invent a "noopolitics"—a politics to combat the neural forces at work in the contemporary attention economy. His noopolitics both critiques the destitution of attention and the colonization of time by psychopower—a psychopolitics—and hopes to transform psychopower into an ethics and practice of care for mind (Stiegler, 2010: 92–93). But as I argue below, this turn against networked media fails to understand the meshwork that neural and network have become. It fails to detect the diagrammatic force of the neural's relations with the networked mechanogram. It positions technologies such as neural imaging outside the field of power while at the same time it fails to detect the radical potential of distributed neural architectures. We need to trace how the molecular and molar dimensions of the neural have become coextensive with the (social) field of network power.

From noopolitics to noopolitik and back

In 1999 RAND Corporation researchers John Arquilla and David Ronfeldt had already identified an emerging trend in international relations and military strategy that they termed *noopolitik* (1999: 29). Arquilla and Ronfeld believed that the U.S. government and military should expand and run with this trend that emerged out of the growth of the noosphere, the emerging informatic arena, which also included political and economic alliances and contestations (1999: 28). Noopolitik should be considered a strategic and crafted move on the part of powerful "knowledge-based" institutions: "Noopolitik is an approach to statecraft, to be undertaken as much by nonstate as by state actors, that emphasizes the role of soft power in expressing ideas, values, norms, and ethics through all manner of media" (Arquilla and Ronfeldt, 1999: 29).

According to Arquilla and Ronfeldt, the last few decades of the twentieth century had brought about significant change in the fabric of international relations at the level of players, media, and technological infrastructure (1999: 35). The global interconnectivity facilitated by information technologies, which facilitates flows of finan-

cial, political, and media information, conjoins with the rise of a "new" civil society in which nonstate actors (NGOs) play a significant role. NGOs operate less like previous liberal corporate players, with a top-down approach to international relations, than like nodes in networks, monitoring, reporting upon, and disseminating information about government, military, and corporate agencies via their networks. The "noosphere," then, is this mesh that actively senses the information environment—a metanetwork that collectively exercises a noopolitics.

Noopolitics, then, needs to be considered more broadly as the widespread exercise and operation of information as a field of power relations that pervades all levels of society. As we shall see, Lazzarato makes a similar point in refining Foucault's terms *biopower* and *biopolitics* (Lazzarato, 2002). Both biopolitics and noopolitics can be understood—by advisors to the U.S. military and radical political theorists and sociologists such as Foucault and Lazzarato—as the immanent, dynamic, and differential fields out of which a specific strategy of power, be it biopower, psychotechnologies, or noopolitik, is able to operate.[3] This is quite different from Stiegler's distinction between psychopower and noopolitics, in which the former is deemed an apparatus of capture whereas the latter plays a transformative role. Ultimately, Stiegler's sketch of the politics of the noo does not take into account the conjunctions and disjunctions that concatenate, as Lazzarato puts it, "patchworks into networks" (2006b: 180). Or, to return to the dynamism I have underlined as immanent to networking, the ways in which the *dispositif* of psychopower emerges fully networked out of the diagrammaticity of the soft, loose, and plastic networking that is noopolitics. Noopolitics is, as we shall see below, a set of plastic forces for neuroperceptually networking—an emerging diagram that concatenates brains and informatic technics. Out of such a "neurogram," new forms of subjectivation emerge—the production of a mind that can be data mined for its own future behavior, for example. It is the radically empirical *processual* dimension out of which new bio-noo-assemblages crystallize and consolidate plastically modulating power relations.

A decade and more on from Arquilla and Ronfeldt's "advice," it seems the active adoption of "noopolitik" as a U.S. state-sanctioned strategy has only just caught on. In the aftermath of the 2003 U.S. invasion of Iraq, on-the-ground military personnel found themselves untrained for the protracted occupation that ensued. Computer simulation training has long been an element of U.S. military training, with the use of computational flight simulators beginning in the 1960s and becoming widespread by the 1980s. However, the widespread use of computer *gaming* as, first, a U.S. military public relations exercise and, later, a training simulation for military personnel was via *America's Army* (*AA*), released in 2002. Yet the game environment and play is

anything but noopolitical, insofar as Arquilla and Ronfeldt describe this aspect as relying on soft power, the appeal of values to set an agenda and persuasively win over opposition, and promoting shared values and belief systems (Arquilla and Ronfeldt, 1999: 40–41). *AA* is instead a first-person, online shoot-'em-up game based around team play in simulated combat situations.

In the last two or three years, the U.S. Army and government have changed tack with respect to the design and development of military computer simulation environments, a result, no doubt, of the state of perpetual war in which they find themselves. Although *AA* is still an active combat—what is now called a "kinetic combat"—training and recruitment environment, a new phase of computer simulations is now active and in development. One of the main gaming/simulation environments now used for the U.S. military is *UrbanSim*, developed by the Institute of Creative Technologies (ICT) at the University for Southern California and funded largely by the U.S. military (ICT, 2010). *UrbanSim*, with its echoes of the *SimCity* series developed by Electronic Arts, deals with the "nonkinetic" aspects of military situations:

Bosack [project manager at the Institute of Creative Technologies] and his team then built the game's characters as autonomous agents that react not just to specific actions, but to the climate created by a player's overall strategy. Members of a tribe, for instance, want jobs, but they won't work if they don't feel safe. Instead, they might join the insurgents. Patrolling neighborhoods, meeting with tribal elders, and creating more economic opportunities—tactics straight from counterinsurgency manuals—can reduce the likelihood of that outcome in the game. (Mockenhaupt, 2010)

UrbanSim uses what is known in software development as "under-the-hood" components. Quite literally the simulation is an umbrella for different information architecture components, using several AI technologies. *UrbanSim* borrows a previously modeled educational AI tool for simulating social interactions in multiuser environments called *PsychSim*.[4] This component allowed a belief system for the nonplayer agents or population to be modeled and stored in the game's engine by creating a reusable library of "behavior entities" that could be called up and combined variably (McAlinden et al., 2009: 4). The other AI component technology working in tandem with the *PsychSim* tool is *UrbanSim*'s story engine, which generates events in which "players" have to quickly modify their actions and responses (McAlinden et al., 2009: 4).

Importantly, the developers of *UrbanSim* describe the environment as a "learning package" that will allow military commanders to instruct their staff in complex and dynamic military situations after the offensive and defensive operations of initial combat have concluded (McAlinden et al., 2009: 2). Prior to executing simulated

scenarios in the *UrbanSim* practice environment, the "player" or "learner" as s/he is at this stage, undertakes the first part of the training package—eight tutorials labeled the "UrbanSim Primer" (McAlinden et al., 2009: 3). The developers call this "cognitive preparation" as, via practice examples and accessing recorded interviews with military commanders, the player/learner gains the conceptual knowledge for the complex tasks in the simulation environment proper. There is also another AI component incorporated here as the player's practice examples are evaluated and s/he is given feedback. The "Primer" sets the stage for the simulation as "educational," keeping cognitive learning activities formally at a distance from the action of the game.

This does not mean that the *UrbanSim* environment is disembodied. But what is different about *UrbanSim* as a military training environment is that the gamer's action and body are first "primed" for the game play via "cognitive preparation." The "Primer" provides an environment, which trains the player in "readiness"—an affective state—to then play out scenarios. The AI components, then, mesh with the precognitive aspects of human experience in a chronology that mimics the same relations laid down between the biologically and artificially neuro in Google's *Prediction API*. *UrbanSim* realizes a highly specified embodied dynamic for training in computational environments in which future moves and scenarios are isolated and then honed to become a "behavior"—something recognizable by a machine intelligence and which can be modulated for future actions and situations. The point is not to act on impulse, to shoot to kill, but rather to modulate readiness in isolation from action. *UrbanSim* and Google's switch to prediction over search share a tactic: break the looping continua of betweenness that thread through neural pulsation and thought, affect, and action by cutting into the distributed, nonlinear temporality of networked neural architectures. Serious gaming and networked technologies, riding the back of the last two decades of military-industrial AI research, are targeting the incorporeal interstices and intervals of brains networking. They burrow in at a molecular level, inserting intervals that demarcate boundaries between what we feel and what we know, harnessing potential so that it is constrained to play itself out as readiness and predictive capacities.

From noopolitics to neuropolitics

The various turns toward and against both the neurological and against contemporary technicity by network and media theorists, neuroscientists, and networked corporations proffer a garden of crisscrossed forking paths. Distributed and pervasive architectures for both brains and technically inflected networks equally involve de- and

reterritorializations. Neuroscientific material artifacts such as fMRIs become twilight indices of "the neural"—proof that something untoward is happening to our brains. The neurological turn toward visible, circumscribed territories and away from pervasiveness or the neurological turn toward relationality and away from cartographies of the neural, are both attempts at handling the imperceptibility of contemporary conjunctive experience. Yet imperceptibility is the contemporary experience of inhabiting networks that are intensely circumscribed by techniques such as customization and that disperse extensively into an ether of cloud computing. This imperceptible experience is itself conjunctive—situated vagueness.

Neurological turns also carry along with them an attitude and approach, incurring either a politics that is willing to engage with or one that simply cannot abide by this concatenation of the pervasive and the circumscribed. We need to ask specific questions about the *neural* micropolitics at play in proposing distributed versus located brain architectures. Equally, we need to figure out the conjunctions and relays of such architectures with the molar dimensions of neuroperceptual corporatism bent on sequestering attentional capacities, such as anticipation, for technologies of prediction. How does attention get captured? What are the technics of this capture? What indeed might a more networked or ecological understanding of and approach to media and to the media artifacts of neuroscience bring to understanding the capturing, sequestering, and inflecting of attention? William Connolly's nomenclature of "neuropolitics" (2002: 12) is ultimately more useful than Stiegler's noopolitics because it gets at the transversal and dynamic meshwork of all the components at stake in thinking through what he terms *brain-body-culture networks*.

Neuropolitics is at work in the ways neuroscience diversely contributes to, deploys, and is deployed in generating certain transversal entities such as brains, "youth," or "internet users." A neuropolitics is operating when Carr declares that fMRIs indicate a rewiring of our brains as a result of internet use, calling on the indexicality invested in brain imaging and equally cementing a neuroanatomical locationalism. But as I will indicate, neuropolitics is also an engagement with the ways in which temporality is configured via brain and networked architectures. Branches of neuroscience can also open up brains and minds to the virtualities of neural events. Hence it is important to singularize what the effects and stakes are in various neural architectures and processes: do they support, generate, and constitute novelty, inventiveness, indeterminacy? A neuropolitics, then, can be understood as a way to keep thought, neurons and networks open to uncertainty, to the novel and hence to change.

If we return to mirror neurons, we can see how debate over their explanatory status in human learning raises a number of issues about the (micro)politics of networks

within neuroscience. For Antonio Damasio and Kaspar Meyer, networked, distributed architectures must be at the heart of the mirror neuron system for it to make sense. They criticize the substantialism present in both scientific and public reception of mirror neurons, as if simply naming a set of cells in this way substitutes as an explanation for how imitative neural behavior actually functions (2008: 167). Damasio and Meyer propose that sensory neural signals are distributed across areas of the brain through what they call "convergence-divergence zones" (CDZs). These might localize around a sensation occurring close to, for example, the visual cortex and would bring together all the diverse signals that occur locally when visual perception is happening. But they would also be found in nonlocalized higher-order sections of the brain and would be capable of dealing with differential sensory signals converging on them from local CDZs (2008: 168).[5] When a monkey opens a nut, it hears it cracking, sees it opening, and feels the shell split. Neurons fire in different sensory areas, but the experience as process—hearing-seeing-feeling the crack—is transversally a continuous, multisensory experience (Damasio, 1989: 26).

The nonlocal CDZs have two functions: they coordinate the multisensory inputs as they are happening and they reactivate future responses to similar experiences. So, for example, if a monkey hears a nut being cracked, an entire neural network is triggered across the brain, (re)activating visual and kinesthetic memory traces of past nut-cracking sessions. Damasio and Meyer propose that mirror neurons might function like nonlocal CDZs. Their connections to other CDZs and their ability to collect and distribute signals based on learned experience, allow the brain to reconstruct an action from only part of the story. A whole neural network underlies the understanding of action, rather than a mirror neuron (2008: 168). Damasio and Meyer offer us something crucial from neuroscience. This lies partly but not exclusively with the distributed, networked brain architectures they deploy. The crucial dimension for us to draw on in these neuroscientific, distributed configurations is that of temporality. A distributed temporality immanent to neural signal processing—of future actions being relational events processually (re)assembled by brains in vivo—offers us a different kind of neuropolitics. Here futurity is less something to be predicted or anticipated and more something always unfolding differently. By inference, the monkey who hears a nut being cracked becomes "ready" for—*anticipates* action that it will perform—only *amid* its multimodal assemblage of dispersed sensory traces and times. There is no trajectory in which anticipatory potential lies in wait to motivate present cognitive schemas that would then call upon past, "learned" memories. There is no "primary" affect-percept-cognition that we could call "anticipation" resting upon the learned behavior that was modeled in the first instance by discrete cells called mirror

neurons located in Broca's region of the brain.[6] And herein lies the distinctive neuropolitics at work in positing a processual brain. Action is an event in which networking, relationally and retroactively, generates cognition out of what *is* in process, reinventing what *was* and hence what *will be*. This is micro-neuropolitics, working at the most molecular of levels, mitigating the capture of neural futurity, of the brain's virtualities, as some bounded affective and cognitive territory we can tame and turn into a predictable territory.

Acting up, on the "nous"

This micro-neuropolitics conjoins with a genealogy of thinking activity, especially mental activity, as an event. Action understood as event has only one function, which is, Massumi reminds us, to singularize: "Neither potential nor activity is object-like. They are more energetic than object-like. . . . For the basic category they suggest is just that: occurrence. Neither object nor subject: event" (2011a: 5–6). Henri Bergson analyzes such a mode of understanding the recollection of multiple images from a single image in, for instance, photographic memory. How, he asks, does one image, one sound, one idea, singularly and in a nonabstract manner call forth its associative percepts or concepts? He furnishes us with the concept of a "dynamic scheme": "I mean by this, that the idea does not contain the images themselves so much as the indication of what we must do to reconstruct them" (1920: 196). Bergson is careful not to lay out the "scheme" as if it were a map of memories that showed us where to go to retrieve our recollections. Instead, he suggests we think of how chess players dynamically call up the moves played in previous games and from these unfold their next moves (1920, 198). They do not, he says, carry a mental representation of each move played but instead carry a sense of the forces or capacities of the pieces and the interrelation of forces between pieces. The dynamic scheme engaged in the mental effort of recollecting involves a sensing of "reciprocal implication"—the ways in which chess pieces affect and are affected by one another's capacities (Bergson, 1920: 199). And feeling this dynamic sense of reciprocal implication gives us an organization of mentality as potential action unfolding in the future. But—and this is where the Bergsonian dynamic schema differs sharply from the neuroperceptual organization of potential into predictive or anticipatory schema—the schema remains virtually dynamic and thus actualizes differently on every occasion: "Each game appears to the player with a character entirely its own. It gives him an impression *sui generis*. 'I grasp it as a musician grasps a chord,' so one of the players described it. And it is just this difference of physiognomical expression, so to say, which enables the player to keep

several games in mind without confusing them" (Bergson, 1920: 198). The point of playing chess, Bergson is also implying, is not to be made ready to play any chess game nor is it to be able to predict the outcome of the game. The point of playing the game, and of the embodied/intellectual effort associated with learning in general, is to play the game *as it unfolds* and toward whatever it will become, in the context of a learned sensing acquired through the different games already played.

Bergson's dynamic schema is not simply the dynamic of forces internal to an individual memory and its effort to recollect. It lays out the dynamics of memory itself, conceived as ongoing relations between thinking and acting. Remembering occurs by cascading through actualized memory planes of perceptions and conceptions, revisiting the plane of all potential or virtual memories engaged in the generation of that one actualization (Bergson, 1920: 195). Making memories and recalling them takes intellectual effort and this effort *is* attention. Bergson is careful to distinguish between the mere sensation of alertness from attention as this felt labor of thought (1920: 186–187). Attention is not, then, a domain that can be grabbed, localized, and sequestered as Google's *Prediction API* and Steigler's critique of psychopower both assume. Attention is an attending *to*, tracing how something singularly unfolds relationally. This singularization occurs dynamically in relation to previously grasped actualizations and with the sense that the singularity of the unfolding—playing a chord, playing chess, surfing the web—always takes place in a present also littered with virtualities that potentially shift "the game" elsewhere. A distributed neural architecture needs to lean on a radical conception of thought as event, of mentality as occurrence, of the nonlinear and dynamic (re)assembly of intensive duration. Such an architecture stays close to a Jamesian conception of experience, which is not simply about taking on board the reality of relations but living amid the genuine uncertainty that experience bestows: "The conjunctions are as primordial elements of fact as are the distinctions and disjunctions. In the same act by which I feel that this passing minute is a new pulse of my life, I feel that the old life continues into it, and the feeling of continuance in no wise jars upon the simultaneous feeling of a novelty" (James, 1912: 95). Chance is, instead, what the pragmatist takes up, affirming that another action could always have occurred. Here chance does not take the place of determinism but is a rallying cry against it (Stengers, 2009: 15). To be a pragmatist is to make an effort to act with things as they occur—to affirm that action always retains spaces of hesitancy, and hence the potential for change, for another pathway to have occurred. As we shall see below, understanding action as event may now mean we need to surrender to and let go of the claims that an attention economy makes upon us. These claims—to stay attentive and focused and, moreover, to stay linked to nodes in the

network—normalize and determine the kinds of activities and modes of living that have reached their apotheosis in "the networked society." We need to concatenate action-thought in ways that acknowledge networking as indeterminate rather than predictable.

Drawing on such a genealogy of thinking *thinking* via ideas such as Bergson's attending to and James's pragmatic nuancing of chance preserves the virtuality of "attention" as a thoughtful capacity. It facilitates a way of understanding attention as something a brain does relationally as it stays in touch with the forces and capacities of others, other things, and its other (infra)dimensions. That such activity can only take place amid the uncertainties that life poses admits a very different way of conceiving mentality than those homogenizations that drive current attentional regimes.

From neuropolitics to noopolitics and back again

As Lazzarato reminds us, the development of a politics that is aware of the molecular modulations upon attention and its dynamic temporal schematization is nonetheless essential: "Memory, attention and the relations whereby they are actualized become social and economic forces which must be captured in order to control and exploit the assemblage of difference and repetition" (2006b: 185). For him there are three fundamental regions where the techniques of power in a society of control are strategically exercised: a broad cultural and scientific understanding of brain functioning as flows and connections of neural activity; teletechnologies, from the telegraph to the internet, which intensify action at a distance; and the production of publics—subjectivations that are precisely the coordination of collectivities operating at a distance (Lazzarato, 2006b: 180). But what is of equal importance in this three-way relation between brains, teletechnologies, and publics is that all are conceived as operating across and within an "elastic milieu" (2006b: 181). Lazzarato is drawing on Tarde's conception of publics dynamically constituted by and then modulating the emerging teletechnologies of mass print media. Since then, dynamism and plasticity have come to increasingly characterize brains, technics/media, and publics as corelated entities. But dynamism and plasticity are also qualities of our relational milieu, which diagrammatically holds together these regions.

From Bergson's dynamic scheme to a field of politics that dynamically diagrams brains, technologies for modulating attention and publics—we have crossed the threshold from (micro)neuropolitics and traveled back to the terrain of noopolitics. This is a noopolitics that delineates an embedded networking of our neuroanatomies with our technics, our neurotechnics with our thinking, and our minds thinking neuro-

technically together as dispersed publics: a diffuse, pervasive atmospherics of software, soft thought, and soft control. Power continues to modulate life and to function biopolitically. But its supplementary target is the brain-mind, the incorporeal dimension of bodies: "One could define the new relations of power, which take memory and its *conatus* (attention) as their object, lacking a better term, as 'noo-politics'" (Lazzaratto, 2006b: 186). And yet, in the midst of ubiquitous computing, of collective intelligence, of crowd sourcing, there remains a lurking sense—a carryover from Bergson-James, even so—of the force of indeterminacy. Lazzaratto's configuration of the noopolitical as an elastic milieu conserves something that evades capture because it takes its notion of the political as transversal, always edging up to an outside: "We must begin instead from the power of the multiplicity" (Lazzaratto, 2006b: 171). This is quite different from Stiegler's characterization of a noopolitics, which involves transforming current industrial psychotechnologies by giving them new kinds of regulation: "reengaging an editorial system"; areas of research development and reinvigorating sectors; "engaging families, elementary and secondary schools, and colleges and universities" in a thoroughgoing "European" effort to attend to care of the mind (Stiegler, 2010: 69). Here, noopolitics comes *after* the devastation wrought by the forces of industrial psychotechnologies. It's a cleanup job.

Yet it is out of multiplicity that power captures and transforms things: intellectual effort is reduced to alertness; open-ended search is bit by bit replaced by predictive techniques; mimesis as a field of interacting relations is pinned down to a patch of mirror neurons. What kind of multiplicity, then, pertains to and is targeted by psychopower? Not one that consists simply of the chaotic molecularity of neural processes, nor one that ontologically or historically exists prior to psychotechnologies and psychopower. A multiplicity cannot function as pure outside but is always also caught up within the field of the political, within diagrams of power. Refining the Foucauldian distinction between politics and power, Lazzarato says that biopolitics can be thought of as strategic coordinations of the entire spectrum of forces engaged in power so as to extract a surplus from life as such (2002: 103). Biopolitics arranges and coordinates all of life's relations, including those between man and woman, employee and employer, doctor and patient, student and teacher, and so on (Lazzaratto, 2002: 103). Biopolitics must therefore also engage the *dynamics* of these force relations—between struggle and acquiescence—as these come to pervade all of life.

Biopower is a formation of biopolitics, involving the crystallization of this dynamic such that institutions, discourses and an entire *dispositif* are set in place in order to extract a surplus from all of life's political dimensions. Biopolitics is ontogenetically (processually) necessary for biopower to emerge but biopower can also only modulate

this dynamic. For as a dynamic manifold, biopolitics also involves the creation and generation of life, power and politics, and in this the possibility that life might be lived, resisted, and played out in a myriad of different modes. Herein lies biopolitics' multiplicity that pertains to, that is targeted by but is not itself the outcome of, biopower: "Biopower coordinates and targets a power that does not properly belong to it, that comes from the 'outside'" (Lazzarato, 2002: 103).

Analogously, we might invert Stiegler's distinction and suggest that psychopower targets noopolitics, modulating forces that come neurally, cognitively, and affectively, from outside of psychopower. We would still need to think through this outside immanently, that is, as immanent to the relational, dynamic field that is noopolitics. We must understand the field of noopolitics as one that supplements biopolitics. Noopolitics does not simply extend biopower to areas of cognitive production and energy such as memory and attention while regulating the corporeal dimensions of the self and population; it also changes the ways in which the coordination of life's dynamics, its relations of forces, is exerted, giving it a new arc. This involves the ways in which brains are coordinated to affect and be affected by one another in dynamic relations of power. The way that "mind" or "intelligence" is constituted as a collectivity via means of technical extraction is noopolitics in process. An algorithm for search in which results are furnished due to the "collective intelligence" of web pages linked or pop songs constructed by crowd-sourcing samples of music coordinates the multiple intensities of crowds' generativity, together with new modes of publishing and distributing, and the extraction of cognitive labor. But as Lazzarato argues, "the public"—the dispersed crowd and moreover the multiallied crowd—is a tripartite element of the contemporary noopolitical field. The general public is no longer a sphere or homogeneous entity; rather, it is a dispersion of networked minds. Publics now dynamically shift technologies of psychopower and indeed play a role in the ongoing invention of technics. Technically modulated publics—which include "clients," "customers," "mobs," "members," and so forth—are an emerging multiplicity.

On the one hand, we need to find a different mode for constituting the "neuro" so as to keep its affectivities open; we need to pursue a "critical neuroscience."[7] We need to work at the reductive prescription of the neural to "substrate" and revive neurality's diagrammatic potentialities. One aesthetic strategy might be to diagrammatically approach the neural image as it circulates through cultural, social, and juridical contexts. This would loosen neuroimaging's capture by psychopower and would also question its use as a substrate for incontrovertible rewiring by cultural speculators such as Carr. On the other hand, we need to attend to the relation between publics and teletechnologies, since these are being consolidated through the con-

junction between intelligence and algorithm. The differentiating, dispersed public of contemporary networked cultures needs to be kept open to dynamic reformation. Let's take up both these directions by proposing that what is needed is a transversal noopolitics.

Toward a transversal noopolitics 1: a diagrammatics of the brain-image

In Daniel Margulies and Chris Sharp's video installation *Untitled* (2008), changing patterns of luminescence and color patches skip and undulate across an fMRI animation of a brain (figure 5.1).[8] The video is a selection from an fMRI mapping of a subject who, just prior to the scan, was asked to meditate upon a passage from Immanuel Kant's *Critique of Judgment* concerning knowledge and perception and, while the fMRI scan was in process, listened to Igor Stravinsky's *The Rite of Spring*. Reflection and perceptual experience—usually held apart at least by Kant and the rationalist and cognitivist tradition of thinking "mind"—here dance together in shifting waves. Which color traversing and "lighting up" an area of the brain corresponds to reflective thinking, and which to sensory input? It is impossible to discern the separate modalities and locations in the brain. To complicate things, the installation offered the viewer the chance to read the same Kantian text and listen to Stravinsky's riotous piece through a set of headphones while also viewing the video of the animated fMRI. The

5.1
Daniel Margulies and Chris Sharp, screen shot from *Untitled*, 2008, copyright the artists. Image courtesy of the artists.

artists aimed to let "viewers . . . perform and identify with the experiment by viewing on the screen an imagery that might be similarly going on in their own brains."[9]

What appears to be the uncomplicated representation of the neural imaging of the neural correlates of thought, perception, and emotion is suddenly set into feedback and feed-forward motion. To begin with, there is no textual annotation of the fMRI sequence in the installation, as would normally accompany a medical set of fMRI scans—either on the image itself or as a radiographer's accompanying report. And unless audience members are very knowledgeable about neuroanatomy and can read fMRI scans, identifying a correlation between "lit" areas of the brain and either cognition or perception would be unlikely. Creating a choreography across the brain's cross-sections in response to two distinct activities seemingly located in different brain areas—in general, the frontal lobes deal with thought, language, and words; the temporal lobes with sound, listening, music, and associated memories—the artists present a moving brain rather than a brain correlated and fixed.

The opportunity to "identify" with this video of brain choreographies by undertaking the same cognitive and perceptual activities as the original experimental subject is a red herring. For that viewer is also engaging at least one extra sensory activity by watching the video. Surely this modality would also have to show up as an activated area in any in vivo neural imaging? Additionally, might observing the video of a similar activity in which they are likewise engaged activate the mirror neuron system of the observer, providing further lit-up areas? And, as if that were not enough, the viewer is literally being asked to imagine the relation between images in front of them and imaging inside of them, adding another layer of thinking and lighting up to their engagement. As it turns out, then, the viewer is multimodally engaged: thinking, sensing, and imagining. What different choreography of neural imaging, then, would an fMRI of a viewer's brain generate to the one being screened before them? The point here, of course, is that the viewer is never able to simply "identify" with the images of the brain on the screen; there is always at least one other dimension of brain activity engaged because the viewer is another brain doing other things while also engaging with the brain of another. Viewers' brains—their thoughts, perceptions, emotional responses, and imaginings—create other unknown neural elements in the installation, generating a sense that neural activity can never be simply pinned down and correlated visually. It is always located somewhere else, always dispersed throughout an assemblage of sensory, thinking, and collective brain relations. Margulies and Sharp's installation raises the question of the current epistemic status accorded to neuroscientific imaging. If fMRIs cannot easily provide access to evidence of the neural correlates of thought, perception, and emotion, how can they be used indexically with

such ease across a range of arguments from ballasts about the effects of digital media to the intentionality of individual subjects before, during, or after committing crimes?[10]

What does an fMRI actually visualize? Nothing quite so simple or complex as processes of wiring and firing or unfolding intentionality. The areas of "color" converted from the original grayscale image are a "capture" of cerebral hemodynamic response—we are looking at the surplus of oxyhemoglobin (oxygenated blood) remaining in the veins as a ratio of the increase to decrease of cerebral blood flows. Active neurons require both glucose and oxygen in order to fire, and an fMRI traces the movement of blood transporting the glucose and oxygen necessary for firing through the vascular system. Not unusually for any form of neuroimaging, *what* is being imaged is up for question. Are we seeing the trace of the activity of neurons themselves, for example, or are we seeing the trace of activity caused by neurotransmitters, which likewise require cerebral blood flow? Furthermore, although the spatial resolution of the fMRI is remarkable, its temporal resolution is relatively poor, with an estimated 4- to 5-second period needed for image capture due to the rate of blood flow response on which it depends. It is therefore not a direct measure of neuronal activity—which typically occurs at the submillisecond level—and it is neuronal activity that is networked and distributed. Moreover, the question of correlation between the indices that psychologists use to measure human perceptual, emotional, and social phenomena such as responses to online media and social interaction and the indices used to measure neural responses via neuroimaging have come under scrutiny. Neuroimaging studies that seek to proffer evidence that "happiness" is located in area X of the brain have suffered from excessively high correlations between these indices (Vul et al., 2009)—so high as to suggest that usual scientific error margins, sample number for the study, and "noise" in imaging data issues are being ignored in order to "prove" the validity of neural correlation hypotheses. Yet another argument concerning neuroimaging use in the areas of social and emotion/perception studies is that looking for emotional response in a certain area of the brain means only that area of the brain is studied for evidence of that response and only certain responses by neurons are deemed appropriate for analysis (Kriegeskorte et al., 2009: 535). Correlation occurs in a circular fashion and ahead of the actual data itself. This is like trying to find evidence for the way the internet changes our minds by looking only in the area of the brain where you expect to find it.

What we certainly are *not* seeing in those color patches lighting up in fMRIs are neurons, wires, circuits, networks being remade.[11] Before asking what, we should ask how an fMRI visualizes. We should be clear on one thing—an fMRI is not a visually generated image. In fact, in order to become image, what is required is the conversion

of nonvisual data into an imagistic space. Like MRIs, fMRIs measure the combination of magnetic signals emitted from hydrogen nuclei in water from the area of the body being imaged (magnetic resonance). Magnetic field gradients are captured by the scanning process and their frequencies and rate of change are related to the position where the signal is picked up by the scanner. The magnetic signals captured—emitted over time usually as the cerebral blood flow is changing in response to stimuli—are composed of a series of sine waves, with individual frequencies and amplitudes. These frequencies and amplitudes are computed using a process called the Fourier transform, which converts signal from the time domain into the frequency domain. The frequencies are then separated out and their amplitudes are plotted as an image. A number of manipulations in the Fourier transform space that allow for smoothing of the final image data, elimination of noise via, for example, high-pass filters and so forth, take place before the image of an fMRI is generated. What is being scanned and then what is done computationally to the signal captured are fundamentally nonvisual; the image/s we eventually see are of rate of change as a function of time. What we are looking at, then, is first and foremost a temporally imputed imagescape. As Joseph Dumit has shown in the realm of PET imaging, functional brain imaging at its constitutive level should not be confused with morphological images of the brain, even though such images appear to generate a sense of the brain's morphology (1999: 189).

When we look at an fMRI, we should remind ourselves too of what is involved in the visual processing aspects of such images of cerebral change. The areas of "color" we often see are converted from grayscale in the original imaging (after the Fourier transform has processed the data into smoothed images), and these map a "capture" of cerebral hemodynamic response. We see the surplus of oxyhemoglobin remaining in the veins, measured as a ratio of the increase to decrease of cerebral blood flows. Active neurons require both glucose and oxygen in order to fire and an fMRI traces the flow of blood transporting glucose and oxygen through the vascular system necessary for firing. But are we seeing the trace of the activity of neurons themselves, for example, or are we seeing the trace of activity caused by neurotransmitters, which likewise require cerebral blood flow? An fMRI cannot distinguish the two substantially—it is a mapping of oxygenated blood flow, that is, of processes, not substances. These remain areas of neuroscientific dispute. But we can be sure that what we are not seeing in those color patches is a neuron, a wire, a circuit, a network. We are looking at a mathematically inflected (ratio of increase to decrease), recolored afterimage selected out of dynamic processuality.

The more the fMRI becomes visual artifact (and especially when it is framed as "an" image or even two comparable images), the less visually indexical it can be said to be,

given that its initial data comprises signal generated by radio waves. As "an" imaging of the brain, then, we need to understand the final startling brain "images" of so-called located emotions or as evidence of rewiring less as units being imaged than as (data) sets made up of cross-processed signal in which the relations between data variables such as frequency, amplitude, and position are maintained. At this level, fMRIs recall the diagrammatic qualities of the Peircean icon, which I raised in chapter 1: "A diagram . . . is nevertheless in the main an Icon of the forms of relations in the constitution of its Object" (Peirce, 1933: 531).

But the fMRI corralled into "demonstrating" structural change—as with Carr's deployment of Small's studies of structural change in web surfers' brains—has become indexical and lost its virtuality. It has lost the potential for the brain to again change in response to . . . less exposure to the web, exposure to noise in the street, change ad infinitum. Losing a relation to the virtual means it also loses its relations to the very materialities asserted by neuroscience as immanent to brains: plasticity and dynamism. As indexical image, it also loses the dynamic temporal schematization of thought-action-perception that the Bergson-James genealogy of thinking about brain-mind provides us. What we need, then, is a way to perceive such neuroimages dynamically, as filaments of the complexity of neuro-affective-perceptual-cognition as this complexity comes *technically* to light. As dynamic, as diagrammatic, as machinic, the fMRI might alternatively be made to cast both light and shadows on, as much as be constitutive of, the twists and involutions of the current neuropolitics of networked media that seeks to capture, via prediction, the indeterminacy of futurity.

Recalling the trajectory from Peirce through to Guattari and Virno that I drew in chapter 1 concerning the diagram, fMRIs used in neuroimaging of social behavior, emotion, and perception might be viewed more fruitfully if we conceive of them along diagrammatic rather than cartographic axes. This would mean they would hold less an indexical than a deterritorialized imitative relation to the functioning brain. This way of framing fMRIs used for sociocultural situations accords them a chronologically paradoxical status; they become diagrams *for* the brain, not *of* it. They become an imaging of the relationality of machine-brains—not what is happening in the brain but rather how brains and neuroimaging co-compose each other. As we will see in the next chapter, similar co-compositional experiments are being set up by contemporary aesthetic practice as it networks neurons, robotics, and "fine art" as a "syn-aesthetics." What are at stake are diagrams—not direct indices—for the future of the way we want to imagine networks of brains, thought, and technics. Such assemblages should suggest escape routes from the aggregating and preemptive forces of the current neurally fueled desire to preimage and map out the future.

Toward a transversal noopolitics 2: networked media amid publics

Margulies and Sharp's installation suggests one configuration for the ways in which the noopolitical milieu of brain-technics and public can become more elastic and dynamic: circuits of action, reflection, and imagination and their temporalities differentially connect the subject's brain to neuroimaging to the brain in situ and experiencing. So too do we need to chip away at congealed notions such as the "iGeneration," which, according to neurally inspired media theorists, has become the prime target of psychopower. If for psychopower the problem of the public is how to hold together subjectivities acting upon one another at a distance, then the potential for a different kind of noopolitics might well lie with the public's propensities toward dispersion and transformation (Lazzarato 2006b: 181).

Sweeping characterizations of generations as a mode of organizing the relation between population and media are implicit in both Stiegler and Hayles's critiques of contemporary psychopolitical regimes. Yet these characterizations are out of step with the actual logic of contemporary media. We should remember that this logic is not simply technical but also economic—one in which, as Stiegler's work suggests, the market and marketing play key roles. But contemporary digital techno-logic does not just function to create "markets" and hence consumers; rather, it modulates "the" market by multiplying it into *markets* and extending it across the entire spectrum of life, from the corporeal to the cognitive. This produces a constant segregating effect on categories such as consumers, dividing "the" market into ever increasing pockets or niches of customization. Chris Anderson called this emerging business model of networked market economies "the long tail": "This is the difference between push and pull, between broadcast and personalized taste. Long Tail business can treat consumers as individuals, offering mass customization as an alternative to mass-market fare" (2004).

Although much has been made of the economics of the long tail and of the networked technologies that co-constitute it, less has been said about its subjectivations. If markets are becoming more ubiquitous and yet more differentiated, might not this differentiating tendency also create a more heterogeneous populace? Tiziana Terranova has argued that the segregating, dissociative logic and affectivity of teletechnologies, which perform and facilitate action at a distance, may also generate new kinds of publics who could resist the agglomerating maneuvers of attention capture regimes (2007: 140–141). Terranova considers the formation of publics as "events" (142), characterizing contemporary crowds quite differently than Stiegler and Hayles's do in their homogenizing concept of population.

In the aftermath of Anderson's analysis of networked media as "pull" media, Terranova notes that the internet actually produces phenomena of both massification *and* segregation. Certain blogs or YouTube videos garner exponential hits, while other sites produce differentiated and segregated audiences. This push-pull combination is in fact much more typical of online media publics, which form and disperse temporarily around networked phenomena. The noopolitical capture of attention and affect by teletechnologies can, on the one hand, create publics that might appear more like the "masses" of broadcast media. On the other hand, these dispersed, forming and reforming publics can also capture media. This emerging noopolitics charts a differentiating will to power that is immanent to the techno-logic of contemporary systems of technical objects. Networked publics might temporarily constitute new kinds of "collectivities" or "counter-weapons" (Terranova, 2007: 142) of resistance to the implicitly militarized, noopolitik of digital communications packaging rolled up into, for instance, *UrbanSim*. We move from a notion of "the" public toward provisional publics.

This kind of provisional collectivity might just as readily generate exit points as entry portals for overcoded online spaces. An example can be found in the media events generated by the *Web 2.0 Suicide Machine*, a "piece of socio-political net-art" (McNamara, 2010) created in Moddr (2009), a new media laboratory in Rotterdam.[12] The "machine" is, at its back end, a "python script," a programming language frequently used for web applications, running on Moddr's server. The script can launch a browser session for a user that allows them to automate the process of disconnecting from social media networks. Participants submit their login details for social media sites such as Facebook, MySpace, Twitter, and LinkedIn, and the session erases online traces of all participants' content and contacts in their online social networks. Moddr approach technical objects as reusable and repurposable. Rather than straight "remix," projects such as *Web 2.0 Suicide Machine* can be seen in terms of what Matthew Fuller has termed "critical software" (2003: 23) and is a contemporary iteration of Guattari's metamodeling. Critical software exposes the normative forces that operate across software's multiple scales. The *Web 2.0 Suicide Machine* does this by exposing social media's biopolitical grip on networking at a molar level and on personal data at a molecular level. But it also gestures toward new modes of collective aesthetic creation. The metamodeling tendencies of critical software suggest an inventive or transformative noopolitics that is all the while digital. It undoes the synchronization of digital technologies with a digital "program," suggesting, in opposition to Stiegler, that the digital is not necessarily tied to a program for psycho-control.

What I want to suggest is that such critical software practices circumvent the otherwise normative forces of software. But this is not simply because their code is different. In the case of the *Web 2.0 Suicide Machine*, the code conjoins with a small—in comparison to usual web "hit" statistics—"public" of social media "suiciders." But this small provisional public is a multiplying, conjoining one, distributed via nonhuman network forces that we see at work in the logic of push-pull media. The *Web 2.0 Suicide Machine* featured in an episode of the popular animation series *South Park*, in which the character Stan Marsh joins Facebook but then uses the *Web 2.0 Suicide Machine* to "unfriend" himself.[13] Following this logic of publics and media that make up networked assemblages, the relatively small provisional public of suicide machine users transversally comes to reassemble with a much larger public assembled around a television series. This kind of multiscalar assembling hints at the transformative potential of conjunctions between networked and broadcast media. This new provisional multimembership "public" in turn blogs, tweets, and chats about the *South Park* episode and the "suicide machine," sending yet more people (who are also members of other publics) to the website. New collectivities form that meld push and pull media, hackers and fans, artists and mass audiences.

It is through the transversality of contemporary digital media that we can discover a differentiating aesthetic in which the potential for multifarious noopolitical configurations and strategies lies. Rather than embodying a technics oriented toward the capture of attention, the "suicide machine" embodies a letting go—a surrender to the code "machine" and, consequently, walking away from the molecular and molar management of data life and bodies invested in by network corporations such as Facebook and Google. But the *Web Suicide Machine* is no piece of jokey net art. It quite literally "kills" your online life if you surrender to it. Networked machines have real socioaesthetic consequences; the "life" they ask us to address however is not one captured and predicted but rather the ones we might collectively wish to build in the future. More than simply sundering one's online life, such projects beckon toward an aesthesia that finds humor and joy in unlikely machinic assemblages forged in the conjunctions between provisional networks, inventive coding, and dispersing publics.

Synthesizing

6 Toward Syn-aesthetics: Thinking Synthesis as Relational Mosaic in Digital Audiovisuality

Curating syn-aesthetically

Much of this book has been about shifting networks away from the cartography of link-nodes and loosening the thinking of networked experience from the imperatives to expand, connect, and capture intensive and extensive territory. I have emphasized the relational dimensions of network technics, aesthesias, and proto-socialities, especially by drawing attention to diagramming tendencies in network experience. This relationality is sometimes immanent to the software, infrastructure, and informatics of networks—areas I concentrated upon in the first three chapters of this book. At other times, it has been important to examine networked relationality transversally by seeking out areas of thought, culture, and creation as broader collective phenomena—viral video, for instance—or by looking at the ways in which the relationality of networks helps us understand the radical implications of distributed neural architectures.

The last section of this book seeks to take the reimagining and rethinking of network aesthesia somewhere else and to draw out the ways in which certain artistic practices—practices that take the experience of relation as fundamental for novel aesthetic creation—also participate in these processes of reimagining and rethinking the network. My choice of artists and practices is not driven by work that has been made for the net. I am not concerned with current developments in web design and aesthetics, with online participatory cultures, or with tracking a new "movement" of network art. Rather, I am interested in the ways in which certain movements of networks—conjoining, transiting, clustering and intensifying, and, most importantly, synthesizing—come to generate novel aesthetic experience. That is not to say that this section moves "offline." Instead, I demonstrate just how pervasive the movements of networks have become for contemporary experience. It is as if computationally inflected artistic practice has inhaled the network *dispositif*, but what it exhales

becomes something altogether more enchanting, more scathing, and more insightful. Such practice moves us toward a syn-aesthetics, and more radically toward a *syn-aesthesia* of networks.

If we were to curate an exhibition that drew out this networked relationality across a number of unconnected artworks—out of place, out of time, and out of theme yet *transversally* conjoined—we might select the following works:

1. *telefunken* (2000), Carsten Nicolai. Nicolai's work across sound, vision, signal, noise, and their ecologies provides different working methods and processes for synthesis and for generating a syn-aesthetics. In *telefunken*, digital signal crisscrosses media players: instead of an image signal coming out of a video player, a CD player is hooked up to a television monitor. Audio tracks playing on a CD in a gallery space visually generate the movement, pulse, and pace of white lines across television monitors. Nicolai calls this connection of CD to TV "erroneous," giving us an insight into something else at work in digital syn-aesthetics (Nicolai and Olbrist, 2002: 78). For Nicolai, digital signal does not simply flow from one machine to another; rather, the idea is to see what happens if an error across signal, and in connectivity, occurs. This is not simply "the error" as it appears in avant-garde art making in, for example, the Dadaist movement. It is the error as a fundamental problem encountered in the digital milieu, which comprises the forces, patterns, and processes of signal generated in and out of code, passing in and out of electronic materialities. The error in *telefunken* launches a bank of signal flows, which mesh and self-organize, resolving themselves compositionally. A digital ecology temporarily forms—the installation *telefunken*, consisting of cross-processed audio (CD) and image (televisual) signal that rests on the mistaken synthetic conjunction of media players. Here synthesis is not so much the resulting unity of an installation that smoothly transcodes modalities and signal as it is a processual meshwork of players, modes, and digitalities.

2. *MEART—the semi-living artist* (remote, networked, neural, and robotic assemblage), 2002–2006, Steve Potter's Laboratory, Atlanta, and SymbioticA Lab, Perth. In a neuroscience laboratory at the Georgia Institute of Technology, Atlanta, a "brain" is growing. Across the world in another laboratory, a robotic limb is built, capable of manipulating pens and pencils and "drawing." The brain—in actuality, cultured rat neurons—and the limb meet across a network, where information gathered as the cells are stimulated, is sent across the internet and received by the robotic arm. MEART is a distributed artist: an assemblage of biological, mechanical, electronic, digital, and networked technologies. The artists and collaborators call it a "semi-living" artist (Catts and Zurr, 2002: 366; Ben-Ary in Voth, 2003: 8) because it conjoins the born and the made as a new entity, a new event or state that synthesizes the living and nonliving, the manu-

factured and the grown. Yet unlike many previous attempts to create such syntheses, from cyborgs to artificial life, MEART remains as disjoined as it is connected, its neural biological components in one place generating creative "thought," its mechanical, electronic body somewhere else making "art." The project asks us to explore not only what constitutes an artist (is an artist simply a machine for making art, for example?) but also *of what* is an artwork made? MEART's dense, spidery drawings look rather like links without nodes, network lines that have been repeatedly overlaid to produce thick meshes that do not join (see figure 6.1).

There are peaks and troughs, clusters and intensities—but no *pattern*. Instead, the drawing is an artifact of a convoluted synthesis of transductions. These start with a video camera in a gallery that captures an image of a visitor, transcodes this image data and sends it as packages online to the neuroscience lab across the world. The cultured rat neural cells grow over a multielectrode array (MEA), which can both stimulate the cells with the information it receives from the original portrait video image and then record the results of such stimulation. This data is then sent back to the robotic arm in a gallery, which draws a spidery "portrait" its "brain" has "seen."

6.1
Drawing from *The Portrait Series (Phase III)*, MEART, 2004, copyright. Image courtesy of Guy Ben-Ary on behalf of MEART.

Perhaps, then, what constitutes the art here is, as the project's collaborators say, "the ability to link together diverse inputs" (MEART, 2011). The question, however, of what art might be under such transductive network conditions turns on just how that linking can operate to preserve diversity.

3. *St Gervais* (live audiovisual performance) 2010, Yannick Jacquet and Thomas Vaquié.[1] Jacquet is an artist who cofounded AntiVJ, a group of European artists and a visual label. AntiVJ collaborate with electronic musicians, DJs, and live music performers to create installations and performances that are usually digital but not constrained to the confines of the screen. In *St Gervais*, Jacquet was expressly concerned with the architecture and interior spaces of the Temple de Saint-Gervais, the Geneva church in which the audiovisual performance took place. Although its architecture is Gothic, the interior walls of the church were stripped bare during the Reformation in the mid-sixteenth century and the walls whitewashed in line with the severe iconoclasm of Calvinism. Since 2005, the Temple de Saint Gervais has been part of Espace Saint-Gervais, which brings together music, cinema, and spiritual events. How these elements might be brought together experimentally—using projection mapping for the light component of the VJing with live music performed on the organ and digital electronic music and signal—becomes the unfolding preoccupation of *St Gervais*. Projection mapping is a relatively new video mapping technique, which allows video signal to be projected onto irregular surfaces such as buildings. The video can be wrapped onto the shifts in shape that make up the architectural surface. Projection mapping generates a more dynamic interplay between the architectural surface and the video signal/content than simply projecting *onto*, producing a sense that architecture and image contribute to a "mapping" of each onto the other. AntiVJ has been a pioneering exponent of such techniques, which have now become widely used among VJs. *St Gervais* is exemplary of the forging of such digital audiovisual experiences, which dynamically synthesize the cross-processing of light/image by electronic music signal and the spatializing of this architecturally to produce a novel syn-aesthetic environment.

None of these works really fits together in the exhibition: Nicolai's installation formed part of a show of his works in a gallery; Potter's and SymbioticA's labs contributed to a remotely networked neurorobotic art research project; Jacquet and Vaquié's produced a live performance for a site-specific space. The first and last engage elements of audiovisual cross-processing of signal, but only one (*St Gervais*) is performative and architectural. The neurorobotic project seems out of place in this exhibition, but it does take place through networking and involves the transduction of signals and their processing *across* locations and technologies. It is also "live," to some extent, *and*

performative. This syn-aesthetic exhibition, then, comprises only the uptake of minor elements from each of the works, the resynthesis of these across each other, and the generation of an emergent mosaic work, which gathers fleetingly as the edges of all the pieces lap at one another. This virtual relationality can be sensed only by feeling networking as a mosaic in the making; only by providing spaces for that relationality through a syn-aesthesia; and only by rethinking synthesis, especially of the senses, differentially. In chapter 4, I suggested that the refrain contours vitality affects giving them the first scribblings toward expressivity. Syn-aesthetics works as a relational machine of expression, assembling affect cross-modally. *Digital* syn-aesthetics develops this machine of expression through cross-processing signal in contemporary audiovisual works, mixing these up with other machinic elements such as the neuro and the robotic. But we must be careful not to reduce either cross-modal transfer or cross-processing signal to each other. Differential arrangements of sense and signal will also prove to be important.

The amodality of cross-processing in digital audiovisuality

Of course we could take a more reductive view and assert that what all these works have in common is an exchange of modalities, technologies, and signal effected by transcoding all information inputs and outputs as digital code. Digital code would then provide the "computer layer" of transactions in such works, which, according to Manovich (2001: 46), is the level of meaning that makes sense to the various technologies operating in such "cross-processing" assemblages. And yet it is clearly the case that in all these works, digital signal is not the only signal at work: Nicolai's television receives digital but outputs analog signal; MEART encompasses a number of forms of digitally generated, encoded, and decoded data but at each point deals with different kinds, not just degrees, of digital information; *St Gervais* involves the live performance of an organ, which might be considered an early *analog* proto-synthesizer. There are at least two layers, not one digital "ground," in all of these assemblages through which technologies and machines understand and exchange signal.

Although digital transcoding does take place, it is clear that works like these, which increasingly occupy the stage of contemporary inventive networked and audiovisual experimentation, are concerned more with transduction than transcoding. Indeed, transduction is crucial for understanding the transmission and resynthesis/reassemblage of multifarious signals in such artworks at the level of the machine. This is because at the level of human experience and participation in such works and their environments, transduction is experienced as relation—of something alongside

something else, of something passing into something else, and so on. The syn-aesthetics of this direction in audiovisuality and in other forms of networked assemblages generates the experience of modal and temporal *transition*.

In keeping with James's insights on the reality of such experience of relation, we should also keep in mind that transitions are not things but processes—changes. We experience not change itself but rather *changing*. This is especially important to remember when we are dealing with syn-aesthetic experience or, rather, the experience of audio-visual-neuro-robotic-live-recorded-architectural etcetera modalities, technologies, components, and signal. James suggests that we do not experience the quantity or quality of a sensation in and of itself; rather, we attend to its ratio, its relation, to other sensations we are experiencing at the same time (1977: 27). James points to both experience of sensation processually and the capacity to abstract the experience *as* relation. This is quite different from furnishing a ground, layer, or unifying means through which differing sensations or signals merge. Hence I have deliberately chosen to nominate such processual abstraction of relation as experienced by either machines or humans in these art practices and work as syn-aesthetic rather than synesthetic. As I will suggest later in this chapter, synesthesia has all too readily been drawn into reductive analogies with the digital transcoding of signal, and digital signal has likewise been used to provide a foundation for thinking synesthesia. What I want to do is keep the conjoining—the "-"—open.

In chapter 4, I introduced the concept of "vitality affects" from Stern's work (1998: 54) in order to come to terms with the everyday affectivity of viral videos. For Stern, vitality affects involve mainly fleeting experience of processes such as bursts, intensifications, decays, sustains, and fades; that is, they provide an ongoing experience, in the lives of humans, of transition. As it turns out for Stern, the processual experience of vitality affects is accompanied in both infants and adults by the ability to abstract while transitioning, while relating. This ability to abstract relationality in and from process Stern calls "amodal perception": "Like dance for the adult, the social world of the infant is primarily one of vitality affects before it is a world of formal acts. It is also analogous to the physical world of amodal perception, which is primarily one of abstractable qualities of shape, number, intensity level, and so on not a world of things seen, heard or touched" (1998: 57).

Amodal perception is neither perception (the processes of looking or listening, for example) nor sensation (the physical feelings that occur when looking at or when listening to something). Furthermore, amodal perception does not involve emotion per se. But it does lend support to and fringe into all these different systems. Amodal perception is a yoking together of different modalities so that, for example, something

experienced visually might also become synthesized as the same experience of the thing perceived tactilely. The modal experience of one thing transitions into a different modal experience of the same thing. And, yoked together, an experience is "abstracted" amodally as a shape *and* a degree/intensity of pressure, for example. The temporal structure of infantile amodal perception is dominated by a continuous yet virtual present in which, yoking sight with the touch of some thing, a kind of déjà vu takes place (Stern, 1998: 53–54). The continuous present is experienced as having just emerged from the past—the past being constituted simply as a specific modal experience of a thing called upon as that modality transfers to another modality. Stern also suggests that a latent sense of a nonspecific future of where this experience will move toward also arises in this continuous present.

According to Stern, amodal perception is a process independent from perception, sensation, and emotion and has its own dynamic form. More recently, he has introduced the term *form of vitality* (2010: 92). Vitality forms are dynamic; that is, they occur temporally. And they occur not simply in the microneural processes, subjective and intersubjective dimensions of human experience, but also in cosmic dimensions of nonhuman experience, such as space-time and, importantly for this chapter, in temporal aesthetic experience: "being vital . . . has to do with all of these things, of having force behind it, and going somewhere, and being able to move with a temporal structure" (Stern, 2010: 92). Vitality forms, then, involve force, direction, and temporal unfolding. All these elements are present in amodal perception: the yoking together of modalities is force; the transitioning of modalities into each other and their abstraction into relations of shape, intensity, and so on, is direction; the present latent with past and future virtualities is temporal structure.

Amodal perception is emergently contoured by a form of vitality specific to infant experience, yet it continues to play a part in "adult" temporal aesthetic experience. It is especially active as a form dynamically organizing syn-aesthetic experience. In VJing, for example, image and sound are often yoked together in asynchronous temporal relations that foreground the transitions comprising the digital "real-time" cross-processing of signal. The VJ, for example, performs with a laptop, and the two speeds at which these different "performers" compose can often create glitches in the entire temporal structure of the VJ set. The multitude of actions a VJ sets off in their VJing software can cause software loops and recursive responses in the laptop. Stutters, compounding filters, and the wresting of control away from one interface input to another (trackpad to preset input, for example) are common experiences in VJing. This "glitch in time" might generate either a smooth or disjunctive synthesis of image and music, but it nonetheless foregrounds the experience of transition itself as

hallmark of the aesthesia of VJing. Mark Amerika has called this the "asynchronous realtime of VJing" (2007: 24). Interestingly, he describes such experiences is terms proximate to Stern's understanding of the experience of vitality affects: "One's sense data becomes stretched or shortened into durational shapes and smears that are at once dislocated and spatialized" (2007: 27). Clearly the dynamics of forms of vitality that organize the amodal perception occurring across syn-aesthetic experiences do not depend on transcoding signal or totalizing predetermined understandings of synesthesia.

Against syn-aesthetics: the total artwork

The notion pervading the *Gesamtkunstwerk*, the total artwork, is the "future past"— Richard Wagner's "artwork of the future" (Wagner, 2001)—to which digital multimedia has likewise chosen to align itself. Wagner has been very much at home in digital culture, having been invoked genealogically in order to theorize the origins of and future directions for multimedia (Packer and Jordan, 2001). Like the *Gesamtkunstwerk*, multimedia seemed to offer the dream of total experience (albeit upon the rather constrained stage of the computer desktop) by synthesizing the various elements of audio, visual, text, and graphic files with interactive gesture, all orchestrated via digital code. Wagner has become the genesis of a particular imaginary for the way digital code operates—not only aesthetically but also as worldview. The total Wagnerian or multimedia artwork involves a practice of fusing all aspects of the aesthetic (or all sensory modalities) under the aegis of a kind of "metaform." As Packer and Jordan see it, opera was Wagner's totalizing metaform; the metaform of the digital is the interactive interface in which call-response gestures orchestrate the fusing of all sensorially varying media (2001: xvii–xviii).

For Wagner, the architectural space for the staging of future dramatic art should facilitate a complete exchange of the artist with the audience, such that one becomes (in the sense of changing places existentially) a living, breathing instantiation of the other:

Thus the spectator transplants himself upon the stage, by means of all his visual and aural faculties; while the performer becomes an artist only by complete absorption into the public. Everything, that breathes and moves upon the stage, thus breathes and moves alone from eloquent desire to impart, to be seen and heard within those walls which, however circumscribed their space, seem to the actor from his scenic standpoint to embrace the whole of humankind; whereas the public, that representative of daily life, forgets the confines of the auditorium, and lives and breathes now only in the artwork which seems to it as Life itself, and on the stage which seems the wide expanse of the whole World. (Wagner, 2001: 186)

The connection between the total artwork and the metaform of interactive multimedia gives the operations of computation a particular status. It accomplishes more than simply giving the digital interface a binding or synthesizing function. It sequesters the process of binding the varying elements and substantializes it. Interfacial synthesis becomes the pregiven ground upon which multimediated sound, image, text, and so on magically melt into one another. The role of the computer in the Wagner-multimedia genealogy is to stage the immediate and transparent passing of all transcoded sensory elements into one another such that synthesis miraculously occurs. The coded environment breathes as the contemporary incarnation of a whole that has transcended its own modalities. Wagner's fusion of the arts allowed a passing of the heterogeneous into the homogeneous via the elevation of an epic musical form—tragic opera—to metaform, becoming the vital breath that united elements, senses, and functions. Deleuze and Guattari note the romantic passage from the aesthetic to the political in the following way: "The problem is truly a musical one, technically musical, and all the more political for that. The romantic hero, the voice of the romantic hero, acts as a subject, a subjectified individual with 'feelings' but this subjective vocal element is reflected in an orchestral and instrumental whole that on the contrary mobilizes nonsubjective 'affects' and that reaches its height in romanticism" (Deleuze and Guattari, 1987: 341). How might multisensorial experiences become something other? How might they keep moving and maintain their vital dynamic form, where elements of sound, color, gesture, proprioception are given lines that sometimes exchange, meld, and yet depart from each other in order to open up new worlds for the felt? How might synthesizing continue to open up a space in which thought runs off along these lines as well, becoming eccentric, wild, and fleeing? Thought about the exchange of sensations but also thinking generated in the very act of sensory exchange. Must the synthesis of heterogeneous elements collapse into a totalized digital world? What room in this to imagine how to synthesize different aesthesias?

The question, and it is one engaging the efforts of many contemporary artists and thinkers, is how to affect that passage or, put differently, how to pass affectively so as to maintain the passage's movement rather than collapse the movement of one thing into the other. Wagnerian affect is soaring, immediate, and complete—a total passing of art into the public and of public life into the aesthetic. For Wagner this must occur through dramatic music—that form in which music connects theater, language, architecture, dance, and visuality. This total offering up of the arts in the dramaturgical *Gesamtkunstwerk* was to provide the opportunity for audiences to connect directly to all senses at once and hence, in Wagner's view, to nature (2001:

188–193). Music in Wagnerian opera was intended to provide a mobilizing force for unification and it is in this that a particular kind of metasynthesis is found. But the question of passing as the transitive process of relation is passed over here in favor of totalization.

The return of synesthesia

Something riotous (not soaring) has been going on in the digital and electronic audio-visual domain over the past decade. In the work of Carsten Nicolai, Robin Fox, Ryoichi Kurakawa, and others, in festivals such as the yearly Cimatics audiovisual extravaganza or the Mapping Festival held annually in Geneva, featuring non-screenbound audio-visuality, in VJing and in the curation of digital art into exhibitions such as "See This Sound," the senses are getting a work around.² Weaving its way through these various events and performances is a concept that intermittently pops up: synesthesia. Thought about the synesthetic has traversed both artistic composition and scientific approaches to human perception—artists and writers such as Rimbaud, Rimsky-Korsakov, Scriabin, Messiaen have been labeled as possible or actual neuro-synesthetes (van Campen, 1997; Harrison and Baron-Cohen, 1997). Twentieth-century artists such as Kandinsky and Cardew have suggested the conjunction particularly of the visual and the sonic—making art one sensory modality that necessarily calls up the other.

But there is a more specific discussion of synesthesia as a phenomenon of contemporary audiovisual spaces, as if, somehow, the digital and perception have become necessarily compossible. This hinges on the idea of a fundamentally connective analogy, sometimes implicit, sometimes explicit, between the neural and the digital. Although this connection opens up a number of interesting possibilities around the concept of plasticity, it also suggests a slide into the reified model of brain wiring, which I warned against in the previous chapter. Prominent neurological conceptions of the synesthetic and models of the movement and flows of data through software and information architecture such as the database converge. For example, Christopher Cox's analysis of Nicolai's *telefunken* draws together synesthetic experience with digital/electronic signal:

Exploring the synaesthetic possibilities of the electronic signal, "telefunken" instructs the listener to run its audio signals through a television set. . . . To speak like Kant or Heidegger, one might say that "telefunken" calls our attention to the transcendental field of the television, the conditions of possibility for any given image or content. In place of the ordinary empirical content of television—the endless flow of images and representations—"telefunken" gives us simply electrons, pixels, light, line, and frame. (Cox, 2002: 15–16)

Yet it is not just that the synesthetic and the digital converge. The process of audiovisual synthesis taking place in the installation is drawn into the epistemological and ontological space of the Kantian *a priori*. This seems to be architecturally problematic—a problem for how digital aesthetics might want to spatialize and compose. Accorded the status of a structuring architecture, which would condition the space of perception-experience, synthesis comes to occupy a similar place as the *Gesamtkunstwerk*. Must it? There may be another way to think the "meta" in metasynthesis. Before attempting to do so, however, it is useful to explore further this twisting together of the neural and the digital by visiting more recent work on synesthesia in both the perceptual and aesthetic.

When it investigates the cause of actual synesthetic experience (that is, involuntary consistent perceptions of colors with sounds and so on), neuroscience deploys concepts such as "cross-wiring" in the brain (Ramachandran and Hubbard, 2001: 8–12). Signal transmitted through wires becomes the founding architecture upon which sensory experience is etched, as if microprocesses and microprocessing could be similarly generated from electric-architectural unities. Contemporary research in the neurosciences generally accepts synesthesia as an anatomically based phenomenon of human perception located in a neurobiological architecture. Although there is variation in the ways in which synesthesia manifests in perception—colored-hearing, colored-graphism, visual-smelling, and so forth—neuroscientists agree that synesthesia involves an involuntary and repeated invocation of one sensory modality by another in response to a perceptual stimulus (Cytowic, 1997: 23; Ramachandran and Hubbard, 2001: 4). Neurological research into synesthesia can be "sorted" into two prevailing approaches: one based on the idea that ordinary neural "pruning" in human development fails to occur, leaving in place an originary synesthetic brain; the other based on the idea that different sensory modalities and their functions are located in separated areas or modules of the brain, which are "cross-activated" in synesthetes.

There are two main competing neurological hypotheses for synesthesia: crossmodal transfer (CMT) and neonatal synesthesia (NS). One derives from the other but makes more radical neurological claims. The CMT hypothesis is slightly older and was developed as a result of work by Meltzoff and Borton, who posited that infants have the ability to recognize objects in more than one sensory modality (1979). So, for example, something that a baby has only touched can nonetheless be visually recognized by it. The process involved in this infantile experience involves the transfer of sensory "data" across modes—haptic to visual. Visual recognition is here understood as something that must exist prior to intermodal processes. The process is possible

because of the infantile brain's cognitive ability to abstract representations from objects. It is this capacity for abstraction that points to where joining—the "syn"—of all the sensory modalities occurs. The CMT hypothesis rests on the proposition that synesthesia is primarily a function of inherent cognitive capacities for abstraction and representation in the human brain. We should note the difference between this form of abstraction and the one Stern presents us with: here we are dealing with *cognitive* abstracting capacities. Stern is quite adamant that cross-modal transfer is noncognitive and is organized by forms that have their own affective, vital dimensions (Stern, 1998: 47ff).

The more recent NS hypothesis, supported by neurologists such as Harrison and Baron-Cohen (1997) and Ramachandran and Hubbard (2001), asserts instead that synesthesia is a primary and originary state of infantile perception as opposed to, say, cognition. Up until about the age of four months, the state of organization of the infant's brain does not differentiate sensory input in this model of understanding the perceiving infantile brain. Instead, the NS hypothesis claims, the neural architecture is cross-modal, or "cross-wired." Neurological development from this period on, then, initiates the process of "normal" differentiation into separate sensory modalities. Some human brains do not fully differentiate, leaving original "cross-modal" pathways active. In these cases, adult synesthesia will persist, and a person may experience the typical "symptoms" of involuntary call-up of colors in conjunction with hearing certain sounds. The NS hypothesis rests on the notion that an originary totality of perception can be sought in an undifferentiated neonatal neurobiological architecture.

In the CMT model, cognitive abstraction makes sensory cross-modality possible; in the NS model complete nondifferentiation supports movement between sensory pathways. There is a fundamental symmetry, then, between the competing hypotheses even though they differ as to the developmental emergence and neurosystemic location (cognition versus perception) of synesthesia. In other words, at the heart of both understandings of the synesthetic lies the "ground" of an originary unity of the individual brain—either fundamentally perceptual or cognitive. But it is precisely such unity that requires explanation. For in fact what we are seeking is an understanding precisely of the sensory, perceptual, or cognitive activities of unification (or rather of joining) by investigating synesthesia in the first place. This brings us to the problems posed by classical models of ontology, which, as Gilbert Simondon pointed out, attempt to explain processes via their outcomes (1992). Hence the "unity" of synesthesia (emergent outcome) becomes an explanation for how it is that the senses join or cross. Synesthesia, however, is processual—the conjoining of sound and color is

Toward Syn-aesthetics

both conjunctive *and* an individuated percept (and, as we will see from Simondon below, a percept that individuates). The question at hand is how to think perception as neither structure embedded in the mind nor the end product of a set of activities:

> In the living being, *individuation is brought about by the individual itself,* and is not simply a functioning object that results from an individuation already accomplished, comparable to the product of a manufacturing process. The living being resolves its problems not simply by adapting itself which is to say by modifying its relation to a milieu (something a machine is equally able to do)—but by modifying itself through the invention of new internal structures. . . . *The living individual is a system of individuation, an individuating system and also a system that individuates itself.* (Simondon, 1992: 305, emphasis in original)

Perception in a living being, following Simondon, might be thought as a mediating process that is both a bringing together but, in this very conjoining, individuates. Perception conjoins the human's sensory potentialities with its milieu and brings a world to which it is already parametrically tuned. Humans, for example, cannot see "infrared" in the color spectrum and can usually hear between 20 and 20,000 Hz. Perception thus depends on a "preindividuated" set of human potentialities and limitations. But this bringing-into-relation of the human organism with a milieu is itself already relational and processual. This bringing-into-relation *is* the very work of perception as it actively contours the relational architecture of the sensory-motor apparatus. This apparatus is less a machine or even system and more an internal resonance—an infolding of resonances that have metastabilized. In a human (and many other living organisms) this resonance is the sensorium as individuating continuum—a modulating relationality of all five, six, seven or more of the senses to one another. This is what Massumi has called the senses' already existing "perfusion," the intersensing or coattraction of the senses as "almost" there, a virtuality (2002: 156–157). This must always already have been the senses' relational mode of existing in order for them to individuate (and which was itself already an individuation *and* the "preindividual" of the senses as plurality).

Now, this diagram of a relational sensory perception-architecture does not "solve" the neurological question of synesthesia in terms of accounting for its neurobiological causes.[3] But it does provide a kind of plasticity for thinking synesthesia as process that both coheres and differentiates and that takes us away from the metaphor of "hard wiring" that traverses both the neural and digital accounts of the synesthetic. Perhaps the issue is the kind of architectures we use to think and make neurological and digital relations. Synesthesia as both neurological condition and as digital aesthetic experience, then, needs to be unthought as a unified architecture of hardwired pathways

for signal flow. It might then be thought anew as a relational architecture, as Massumi has suggested (2002: 191–192). Here synthesis of image and sound, such as happens in the midst of a particularly freewheeling VJing set, composes an emergent syn-aesthetics recursively drawing on and refreshing a field of varied continuities of lines of sensory expression that fan out between artist, art, and audience: "These bodies pass through the all encompassing image-sound mix and can also *become part of the image-sound mix* in an electronic mesh of robust synesthetic happenstance. The bodies become screens and sound boards as well as social engines to remix the performance energy into a poetically tinged playing field of *networked potential*" (Amerika, 2007: 51–52). Mark Amerika alludes to both mesh and potentiality as differential, as a "tinged playing field" for contemporary audiovisual digital experience. If we are to deploy a digital syn-aesthetics, we must be willing to allow both the "syn" and the "aesthesia" resonant, modulating activities and architectures. But this also necessitates giving up the Wagnerian idea of the artwork as total experience, where it seems to have shifted since losing its objecthood.[4] New subjectivations must follow from this—not only for "the artist" and "the viewer" but also for "art." We cannot approach the digital as exemplary of synesthetic experience if by this we mean that interfacing with digital art presents us with a totality of sensory engagement. I will return to this below when I think through current artistic experiments in cross-processing digital signal syn-aesthetically.

Synthesizers, control, and the relational

Deleuze and Guattari posit the difference between romantic and modern (contemporary) thought as a difference in approach to the question of synthesis (1987: 342–343). Romantic philosophy requires a formalizing synthetic identity for thought, which makes matter intelligible across all difference, organizing it as a continuity: the a priori synthesis. Modern/contemporary philosophy must instead elaborate thought's materiality differentially, in order to harness forces that are not in themselves thinkable. Likewise thinking through contemporary artistic experience must find something novel in its materialities that do not speak to an identity in matter. Visual art passes through the image in order to render other forces—the nonvisual, for example—as can be sensed in the fleshy sounds of Francis Bacon's painting. Sound art and modern music (Boulez, Cage, and so on) connect the sonorous with its materiality and cosmology, which, according to Deleuze and Guattari are its nonsonorous molecularity. These are forces such as electromagnetism—forces that subtend sound but are not actually sonorous themselves.

Interestingly, there is both a machine and a process in the sonic realm, which, for Deleuze and Guattari, precisely achieves this nonromantic mode of synthesis—the synthesizer: "By assembling modules, source elements and elements for treating sound (oscillators, generators and transformers), by arranging microintervals, the synthesizer makes audible the sound process itself, the production of that process, and puts us into contact with still other elements beyond sound matter" (1987: 343). It is the parametric operation of the synthesizer that uses one force—for example, the force of a wave being pushed through different ranges of voltage frequency—against the force of another element of sonic matter, that makes the synthesizer a relational apparatus. Synthesis thus shifts away from its function as the unifying ground it held in, for example, Kant's judgments, toward a new shifting terrain of differential forces. This terrain is always diagramming, as sonic and nonsonic elements consistently relate to each other in the making of what Deleuze and Guattari describe as a field of "generalized chromaticism" (1987: 95).

According to Deleuze and Guattari, Kant's synthesis occurs as a cognitive response to sensory information. It is the organizing capacity of cognition, which accords this sensory information "form" as mental representation. But it would be a mistake, they suggest, to similarly accord the synthesizer—that mid-twentieth-century musical invention—such an a priori function. It does not organize and represent its various data inputs from some a priori space of "code." Instead, it allows the differing inputs (sensory elements) to form relationally via their various sonorous forces; that is, the attack and decay of a note or sequence of notes might be isolated, tweaked, and used recursively or as a force on another input. The synthesizer is not a meta-apparatus in the sense of being a transcendent organizer of sonic elements into form (either reproducing an individual sound or formally producing "music"); the synthesizer is a new kind of instrumental assemblage, comprising the dynamics between sonorous and nonsonorous elements, sonic and infrasonic forces. It is born out of an era of experimentation with sound as a materiality riven through with nonsonorous forces.

The sticking point in all this is the digital. Deleuze and Guattari's "discovery" of the asignifying semiosis of the synthesizer arrives on the cusp of the release of the digital synthesizer into the music market. Quite apart from where it ends up—unsurprisingly, in the New Romantic melodies of Duran Duran, Ultravox, and Boy George during the 1980s—the digital synthesizer becomes an instrument for solving what is both a technical and political problem. This was already occurring during the 1960s but was not quite apparent then at the level of musical and aesthetic production. Most synthesizers in the 1960s and through the late 1970s were still large and customized, sitting in a small number of avant-garde recording studios, such as those of the

Cologne Recording Studio used by composers like Stockhausen.[5] Indeed, it is quite possible that by solving the problem in the specific way that it was solved, digital synthesis was able to rejoin its old neighbor, the synthetic a priori.

Modular systems dealing with the organization of electronic systems were on the rise during the 1960s. Together with hardware such as transistor devices, entire systems for electronic sound synthesis could be packaged in smaller, more transportable units that were customized but mutually compatible (Manning, 2004: 101–105). Filters and oscillators could be put together to synthesize the one sound simultaneously. Previously, sound synthesizers featured sliders and knobs, where the electronic signal was processed at one point, synthesized, and then passed down the signal line to the next point of synthesis, so, for example, first oscillated, then filtered. Now the system could be designed so that an external set of voltage characteristics could control the signal outside its passing from one process to another. This allowed a secondary set of interconnections to produce the control information for any of the individual modules, creating the beginnings of a metadata or "control" layer of data, which acted on the signal and allowed it to be processed in a way specific to the forces of those actions (that is, the particular set of voltage characteristics).

So far we have, in effect, what passes as Deleuze and Guattari's nonsonorous forces (voltage) affecting and modulating the sonic. And indeed the resulting sonority perhaps rendering audible something that is inaudible—changes in electrical current as it is conducted through the materiality of the transistor. Notably, voltage-controlled synthesizers are analog, that is, continuously variable, in terms of the signal and in terms of the ways in which one electronic signal acts on another. But there are elements of the design and the hardware that also make this kind of synthesizer a precursor to digital instruments—specifically its use of modular design and of transistor devices. Importantly too this very design of a control line for passing signal through the system is cybernetic insofar as it sets up an architecture for one pass or feed of information to pass or feed into another layer of information. But it is more than cybernetic once the control layer becomes digital, effectively allowing many more operations on operations and, what is more, allowing these operations to shift from the status of force to that of execution. In the digital synthesizer, the control layer is not itself a force but rather becomes removed from the actions of forces, from forces' affectivities (the way forces affect and are affected). In becoming executable (executive, perhaps) it turns algorithmic: "Synthesis techniques are central to the idea of digitally generated sound. The computer or other digital synthesis hardware must be instructed in some fashion to produce the sound. A synthesis technique is a set of rules for ordering and controlling those instructions" (Strawn, 1985: 1). We could of course imagine

algorithms as something different from operations that execute functions of code and see them instead as new condensations of forces. As Adrian MacKenzie has suggested, algorithms are complex condensations of code and sociality in which what is "ordered" is already subjected to a certain epistemic setting into place, an "ordering" of things by their place and time (2006: 44).

We should think carefully about the interrelations of the digital synthesizer's architecture, its relation to its own analog voltage-controlled predecessor and to its milieu of information theory and culture. In particular, it is the culture of military research and development in digital computation that holds the key as to what happens to synthesis in the digital synthesizer. Paul Edwards has carefully outlined a setting in place of a triangle of command, communication, and control governing the sociotechnical ensemble in the emergence of digital computation during the post-World War II period of American military research. Digitality itself is not an obvious or necessary technology to be deployed in this setting but is sought after because it delivers a certain militarily ordered zeitgeist that he describes as a rationally controlled "closed world" (1996: 43–73). All our elements of computational hardware, software, interface, and system design come to us out of this sociotechnical ensemble that has been and continues to be military research. This includes the digital synthesizer. This is not to say that the analog synthesizer's components are not also adjuncts of what was once military electronic research. But the crucial difference lies with an architecture that replaces the force-materiality relation (still possible even in the voltage-controlled analog synthesizer) with an instruction-signal relation, in which instructions are to be carried out on codified sounds. In other words, in which sonorous matter is synthesized a priori from the control line of code.

Cross-processing signal or the analog compositionality of digital synthesis

In an interview about the performance *St Gervais*, Vaquié, who composed the electronic music for the performance, suggests the ways in which the organ becomes an element in *St Gervais*'s audiovisual production. Compositionally it contributes to the performance architecturally more than at a visual or sonic level. It is as if the organ becomes a kind of analog architectural force of composition out of which both the digital music and graphics emerge: "The organ is an instrument that permits this kind of visual performance because it's imposing. There is something rather architectural, which allows the visual work to be pushed a little further" (Vaquié in Jacquet and Vaquié, 2011). At times, through the projection mapping, the organ seems to architecturally emerge out of itself. Then the video image shifts sideways across the space,

almost sitting alongside the actual organ, displacing it. The projection shifts back into image again rather than a becoming-architectural, since it no longer correlates or overlays the actual organ. There is an oscillation in the moving image between organic emergence and inorganic stuttering and collapse as we realize the image itself is just a digital shadow of the architectural thing again. Here we have something nonvisual being imperceptibly drawn out of the visual field as a mode of synthesizing through conjunction. As Vaquié remarks, the organ also becomes a sonic instrument in the composition of the overall electronica achieved: "Behind the organ there is a whole mechanism, with many control knobs allowing one to choose from different types of sounds such as whistles, cymbals, bells . . . so this is an instrument that can be played with. You are able to regulate the sound in time. This is an approach you find in electronic music composition" (Vaquié in Jacquet and Vaquié, 2011). In *St Gervais*, another composer's music—Arvo Pärt's *Annum per annum*—is played on the organ. But the organ itself, analog proto-synthesizer that it is, becomes the meta, architectural layer through which both image and sound cross-process each other. The organ is an analog modulator of the digital elements of the performance, a nonaudiovisual force through which they spatialize and temporalize.

Such modulations occur throughout contemporary audiovisual events and practices. Ryoichi Kurokawa's digital cross-processing audiovisual sculptures and performances crop up in festivals, clubs, art galleries, and music video. He is a VJ less interested in image for music than in experimenting with what we might call relational sculpture. The term *relational sculpture* is my paraphrasing of the term *animated sculpture*, which Manning uses to analyze David Spriggs's sculptures (2009: 143–150). She suggests that these "sculptural objects" draw us in to the "seeing" of the force of visual perception as we move around them, expecting but not quite making out bodily forms within their glass cases. The sculpture itself is not animated; rather, it is the relation that the relational sculpture-viewer assemblage triggers between visual perception and movement that composes the animation. An animation of the virtual in/of perception. Similar, perhaps, to what Olafur Eliasson has said in relation to the aesthetic problematic that animates his work—the seeing of seeing or the sensing of sensing (Eliasson in Eliasson and Gilbert, 2004).

In Kurokawa's work, questions of relationality are equally foregrounded. Along with works of a number of other artists who VJ or who produce audio visual performances where audio signals initiate, trigger, and deform visuals in real time (and vice versa), Kurokawa's work is frequently described in synesthetic terms (Neissen, 2006). Although operating as separate modes, the aural and visual aspects of the work appear to persistently elicit each other so as to produce a synthesis of visual listening or aural visuality.

We sense this solicitation in a video Kurokawa directed for electronic musician ditch's track "mysterious hoze." But it is not one in which audio and visual modalities dissolve in an apotheosis of transparency. Instead, the emphasis on the choreographic force and relation of audio to video signal creates an animated sculpture unfolding temporally. As if an electronic materiality—a cross-woven signal arising out of the interplay of sonic and visual forces—were also giving us a temporal structure of the electronic event. A kind of time-image of digital signal—a "heautonomous" cross-processing (Deleuze, 2005: 274ff).[6]

Kurokawa initially builds a synchronicity between the techno beat of the soundtrack and the rhythms of the drawn blobs and shapes that protract and contract in the screen space. The visuals seem to directly emerge and take form from the persistent beat of the dance track. But one minute and forty seconds into the sound, the visual drops off and out of time with the beat to become a quivering tentative ring. Momentarily it lacks any pulsation driving its formation. We shift gears away from the synchronous unity of audio and visual modes to their disjunction, the departure of their edges from each other. Our aural attention shifts elsewhere from the driving techno-unity of the track to hear the understated entry of a jazz-inflected guitar riff. Would we hear this variation as anything other than simply melodic if an electronic heautonomous syn-aesthetics had not entered the mix? Perhaps an informed listener would be able to discern the multifarious universes of reference that always inflect contemporary electronic dance music. But what Kurokawa brings visually to the sonic pulse is a departure from the inevitability of beat, which might dominate if the visuals simply reinforced the rhythm. Instead, the audio signal's intervals and inflections open up by generating a flickering relation with the image. The ear is visually oriented toward the sonic differentiation held virtually in the music.[7]

Kurokawa has passed between the audio and visuals to open up a plane of conjunctive potential for the electronic. No longer is "mysterious hoze" only a driving dance track; it also comprises other universes of reference, such as jazz (of which of course dance music is aware, but which can become drowned out by a dominant beat). Visual and aural are no longer synchronously mapped onto each other but become intensive relational universes mapping and unmapping each other. In Kurokawa's live audiovisual performance/sculptures too there is a building together and a falling apart of sonic and visual intensities. Rather than arising from the pregiven of synesthetic signal, what is worked *at* is a sounding out of the molecular consistency at which sensory modalities are able to transit into one another and to become conjoined.

Cross-signal processing of digital signal—for example, the use of digital sonic signal to trigger, produce, and modulate transformations and formations of visual signal in

practices such as VJing—is an area that has already attracted some attention as an example of a different kind of syn-aesthetics. Mitchell Whitelaw has argued that the transcoding of sound and image in the work of contemporary Australian artists Robyn Fox and Andrew Gadow can be understood in terms of cross-modal binding (Whitelaw, 2008b: 259–276). Here the sound-image produced in these digital audiovisual environments might be thought as a cross-modal "object," which both points to the underlying digital signal and to a domain of correlation between modalities. Correlations (co-relations) Whitelaw suggests are part and parcel of perceptual experience—edges and limits in a given perception that suddenly make it shift from sensation to meaning. Sher Doruff has also suggested that neural synesthesia does not need to function as ground for the digital; nor, we should add, must "signal" across wires legitimate a correlative neurology of synesthesia (2007). Doruff puts forward the idea of a transdisciplinary *synesthetic practice*. A practice of intercomposing bodies, signals, and machines where sensory modalities are not the starting points of relation and fusion is not the necessary outcome of their commingling. Rather, an image-sound sensed is a contraction of audiovisual practices, emerging out of the resonances set off by digital aesthetic generative architectures for sound, gesture, proprioception, image, electronic signal, and so on. Mark Amerika puts it another way, suggesting that VJing as a lifestyle practice of writing the image into existence involves processing (or transferring) the energies of sensation and perception *before* we cognitively organize them: "As any philosophically engaged VJ will tell you, the brain's readiness potential is always on the cusp of writing into being the next wave of unconscious action that the I—*consciousness par excellence*—will inevitably take credit for. But the actual avant-trigger that sets the image *écriture* into motion as the VJ jams with new media technology is ahead of its—the conscious I's—time" (2007: 71). We are back in the terrain, then, of Stern's precognitive amodal perception.

Interestingly, the programming environments for much cross-signal audiovisual processing in software such as MAX/MSP/Jitter deploys a "patch bay" diagram, in which signal flow is directed in and out of processes such as filtering.[8] A number of VJing packages such as GridPro alternatively use a kind of array interface in which signals are sent places via circuitous routes in order to interact with one another. So, although there are plenty of algorithms working away to crunch the signal and executing effects, what seems to have been left out of view in the cross-processing environment is the architecture of the control line. This is not to say that there isn't data instructing other data what to do. Is this the reappearance of a metaform, the digital as command-control-communication synthesis, in the guise of metadata?

Perhaps ... and yet metadata is also simply data about data.[9] Or, put another way, data exerting a singularly informatic force upon other data—in-forming data about data. This "other data" can likewise become metadata, and so on. In fact, this does happen in a cross-signal programming environment when a number of parameters (or "patches," which are small and discrete code modules) all wrangle for their place in a sequence of executable events. It is often not clear in a live audiovisual cross-signal processing situation which signal, which data is telling which other data what to do. Setting up a number of sequential patches can result in recursions that cause or stall the working together of data, resulting in "erroneous" or unexpected interactions and the invention of new image-images, image-sounds, sound-sounds, and sound-images, as I suggested earlier. Signal's micromovements become compositional, and not simply in the hands of the composer/artist. From an array of micropasses, signal flutters, stutters, and modifies signal. As Whitelaw suggests, signal in cross-processed audiovisual aesthetic objects is not a case of simple transmission of information from A to B: "Signal here refers to a pattern of differences or fluctuations, a flux that, like data, must always be embodied but which, again like data, can be readily transduced between one embodied form and another. [Robin] Fox's laptop does not send sound to the oscilloscope, or in fact to the audio amp; it sends signal, a pattern of fluctuating voltage" (2008b: 271).

It seems, then, that in these types of signal cross-processing events we revisit the analog voltage-controlled synthesizer, where continuous variables or flux patterns between voltage and sonorities contract into emergent sonic sensations. But then we have shifted the design away from a separate control line, the voltage-controlled synthesizer's command-control cybernetic heritage. In the ways audiovisual artists and VJs are using digital cross-processing, modules are constantly shifting around; they never acquire ground, and they never ascend to the full status of the "control" line. In cross-signal processing audiovisual events, especially in live and somewhat aleatory circumstances, digital synthesis sheds its tendency to reach toward the synthetic a priori. The sensibility that finds lines of expression through cross-signal processing is no longer a causal one, nor is it fixed in place or line. Rather it *becomes* visual-sonification/sonic-visualization, diagramming a resonating, moving architecture. Not structural but relational. Not synthesized seamlessly but conjunctively transitional. Something that builds rather than "the" built. The network or meshwork of signal in such a syn-aesthetics generates a mosaic of interlinked codings, functioning diagrammatically, multiplying and generating new relations between modalities and, transversally, across technologies and abstract machines: the cybernetic machine, aesthetic machines of romanticism, modernism, digitalism and ... novel machinic formations?

7 The Thingness of Networks: Invasion of Pervasiveness versus Concatenated Contraptions

Two aesthesias for things and networks

1. The wireless orb sits slightly to the back, on top of your desk (that's the one made of wood, not liquid crystals), and every so often a different hue pulses through it.[1] The undulating waves of color and light send delicate declarations into the room: stocks are up, stocks are down; storm approaching, sky clearing. Lately, the LCD desktop screen has become too busy, too crowded with tweets, status updates, spreadsheets, waves, buzzes, download bars, and dancing icons to fit in "peripheral" information such as the financial market movements or weather drifting in from the outer reaches of the globe. So you ordered this wireless orb, an ambient device, that softly and discretely lets you know what is happening at the edges of your world. Your world, in which the immediacy of pulsing screen-based data bleats at you noisily. Better, then, to let the background—those invisible, indirect forces like "the market" or "climate"—slither in and out occasionally and in a diffuse manner.

That orb was fun—an attractive and appropriate *objet* for the contemporary office, but it was a bit . . . well, useless. It didn't really do enough. It retreated to the very back right-hand corner of the desk where it oops! fell and crashed to the floor into a million frosted liquid crystal and silicon pieces, all entangled with its power cord. It was time to update that background ambience anyway, so you bought a Nabaztag (Armenian for "rabbit") a really cute plastic "bunny," 23 centimeters tall.[2] Your little deskbound "anibot" is quite agile. It's WIFI-enabled and can send and receive MP3s, texts, and streams from the internet. Better still, it can speak these to you or, if you are still ambiently inclined, it can use indicative lights. But since it's a bunny and since it's connected, won't your bunny want to connect with all the other bunnies out there too? After all, you are constantly updating with your friends via social media, so you wouldn't want to deprive your bunny from participating in the internet of rabbits, would you?

So you will need to register your rabbit, which you eagerly get up to do on December 26 (your girlfriend mixed up her Christmas and Easter gifts!). Halfway through filling in the online form, the page crashes. You press the back button and some annoying dialog box appears asking if you want to resend the information. You have no option if you want to register your bunny, so you press "OK." But then you are taken back to the beginning of the registration process and all the information you had previously entered is lost. Never mind, start again; you can't wait to connect your rabbit and all the other rabbits around the world! But the same thing happens . . . what is going on?! A few hours later you light upon the Nabaztag blog and someone posts that the central servers have crashed with all these partially registered, partially connected rabbits the world over . . . well, trying to connect. You persevere, and finally, after much time ministering to the networked life of your desktop rabbit, your bunny can finally share pictures of itself that look remarkably similar to all the other bunnies on Facebook. But the voice-enabled services it promises remain fairly minimal, and the transmission time from server to desktop rabbit is so slow. All these things your wired bunny promises, and yet it takes you more and more time to get it to do them.

Your bunny is busily, if somewhat intermittently, wired. But really you want it to just connect to the things around it in a more or less useful and less demanding way upon your own time. So you have to buy the next generation Nabaztag:tag, which sounds a bit like things are doubling up, doesn't it? The really great thing is that this has a chip inside it using radio frequency identification (RFID) that allows it to "read" other RFID-enabled objects. Okay, what good is that? Well, if your house keys are also RFID-enabled (and Violet, the company that manufactures your bunny, can also sell you an RFID key ring) and you lose them, bunny can track them if they are within a reasonable radius and tell you where they are. Bunny and keys have connected, then, in a rather small and localized internet of things. That's better now—the bunny social media sites and tweets were making you a little busy (on top of maintaining your own sites as well). Now that the bunny can do something useful again, it can recede into the background and all those bunny friends, blogs, and streams of information bleating at you should eventually just fade away.

Hang on, there's a new one out just this month! It's called Karotz—that's a much easier name to read and pronounce. And now it just about does everything in a completely integrated way, as it has "processor, memory, RFID reader, WiFi antenna, webcam"; so, all in all, "Karotz will have his own on-board intelligence, new electronic components, and useful and funny applications" (Karotz blog, 2011). Now it can connect to my applications online, connect to its own applications and sites online, and connect to other things that can connect to it in your home. But there's a lot

The Thingness of Networks

going on the top of your desk again, even if it's not taking up so much physical or screen space; somehow it's colonizing mind space. You're going to have to keep track of all these things going on everywhere. You need a new device to keep track of things, using a higher level of connectivity that tracks all your connections to things and networks. You keep feeling that, although things are everywhere, the everywhere keeps reconfiguring and upgrading and requires ever-increasing levels of attention. And so there you have it—the recursive creep that is an "internet of things," that is, an everywhereness commonly called pervasive media. This is networked anesthesia.

2. A computer sits in the middle of a metallic-topped wooden desk, a pair of stereo speakers on each of its sides facing into the room. A wooden chair slides out from under the desk (see figure 7.1). This setup, shoved against the wall, seems functional rather than seductively ambient—no ergonomic office furniture, no colorful lights or

7.1
Lungs, YoHa, 2005. Database, computer hardware and software, speakers, desk, and chair. Installation shot, copyright the artists. Image courtesy of the artists.

low-level beeping sounds of electronic domesticity. The screen scrolls automatically across and down through fields and lines of code; white text moves repetitively against a black background. The machine is doing the dirty gray work of computing, crunching through thousands of data records detailing the names, age, and height of victims who worked in the Nazi forced labor camp of the Deutsche Waffen- und Munitionsfabriken (the munitions factory) at Karlsruhe during World War II. From each record, a calculation of the amount of cubic liters of air each person took in their last breath—their "vital lung capacity"—is extracted. These are then summed together and algorithmically transformed to create a sonification of this data. Instantly the data becomes embodied force as a loud scream/breath propels itself through the speakers acting at cross-purposes to the dull functionality of the space. This noise is felt—sound waves are vibratory—as a heavy data entity, a totality of expiring vital force from the 4,500 mainly Ukrainian Jews, homosexuals, dissidents, and other "undesirables" found in the data records. These original "lungs" were forced to work in the munitions factory, slave laboring in a war that was quite literally built on the will to exterminate them. This force conspires to exhale through the artificial "lungs" bestowed upon a reinvigorated desktop system, which has ordinarily functioned as just a utilitarian workstation. But the desktop has now become a software/hardware *contraption*, a fantastic machine that carries forward something extracted from the living labor of the past into the hushed tones of the contemporary media art museum. Such contraptions are conjunctive devices, productive of an aesthesia of networks.

Both scenarios are actual configurations of objects and information flows, not imaginary musings; they are real arrangements of the relations holding together things and networks. Yet the making of relationality here—the bringing-into-experience of the reality of relations—in each scene is quite different. Karotz and its host of humming, connected predecessors is a typical arrangement in our contemporary "internet of things," an increasing infoscape connecting devices with one another, allowing them to transact across and as networks. Also known as embedded, ubiquitous, and pervasive computing, the experience of such networking is often couched within an ambient aesthetics—an everywhereness that retreats (Fuller and Harley, 2011: 39). Such devices go about their networking quietly—serenely even—promising never to distract us by their background presence. And yet this fading away is likewise accompanied by a creeping sense of low-level "thereness"; the price of such serene devices lies with the human cognitive and affective labor spent as we collectively attend and administer this presence. The experience of the nonhuman and human conjoining generated through such scenarios, then, is likely to result in a slow numbing of any novel possibilities for differently nuanced relations. I suggest, alternatively, that in the second

scenario, raised by the artwork titled *Lungs* created by YoHa in 2005, a quite different aesthesia for networks arises.[3] This work pays careful attention to how software, hardware, bodies, and temporalities are to be brought into relation. Indeed, its mode of bringing-into-relation affords us an experience of the join itself, suggesting something altogether different for contemporary devices. *Lungs* is nothing short of a fantastic contraption, a gadget that does not orchestrate surrender to the background but rather unfolds and tries to reassemble differently the underbelly of machinic assemblages. Here, as with the audiovisual possibilities for a differentiating synthesis I raised in the previous chapter, we might also encounter a syn-aesthesia of networks.

The desk, the chair, the computer, and the speakers formed part of an exhibition, inside a media arts museum that is now located in the halls where the forced extraction of labor performed under slave conditions earlier fueled the German war effort during the 1940s. The installation could be said to be site-specific, for it uncovers the layers of a building that have operated to cement over the unwanted and buried histories of a place. Here, where art, beautifying the ugliness of industrialism's dirty past, now sits, this contraption cries out about the violent atrocities that took place. The desktop artwork is specific about this place and its history, yet it also speaks to a wider, more problematic relationship between aesthetics and geographical/historical sites deriving from German post-World War II culture. Art after this time has had a troubled relation to the historical sites of Nazi horror, functioning sometimes as a salve, a memorial, and even operating a mild effort toward denazification.

Different buildings and cities have either covered over or left exposed their relations to Nazi events. In Vienna, for example, Rachel Whiteread's Judenplatz Holocaust memorial, or "Nameless Library," sits starkly in the middle of the old Jewish square. Rising almost 4 meters high, it is a massive concrete casting of library shelves with their books turned outward, hiding their identificatory titles and resisting an easy engagement. It invokes an association with the People of the Book, Jews, but also looks like a bunker. It is brutish and massive yet remains evocative, via contradictory associations, of a people, an event, a time. As an artwork it attempts to refuse aestheticization. Documenta, the contemporary art festival held every 5 years in the West German industrial city of Kassel, on the other hand, was conceived especially in order to "reconcile" Germany with a Europe from which it had been shut out and off since at least the 1930s to late '40s. Here art has taken the role of functioning redemptively in relation to history, politics, and place. It attempts to regenerate, using culture as means to repatriate ugly histories.

But the computer, speakers, desk, and chair, the database and embodied sonification, the munitions hall and the art and media museum create a different experience

of relationality from either an aesthetics of refusal or repatriation. Instead they fashion a network of things incongruently conjoined. There is certainly no cover-up (or covering-over) going on here. But there is also something much more than an aesthetic strategy of site specificity being pursued. *Lungs* singularly joins things in order to generate a certain mode of networking. What is being worked at and upon are exactly those conjunctions through which things can be brought together. How are things to be hooked up, and what are the potential conjunctions of a device? asks this piece. Harwood refers to these kind of works, which *Lungs* initiated—a series also including *Tantalum Memorial*, made with Richard Wright in 2008, and *Coal-Fired Computers*, made with Jean Denmars in 2010—as contraptions (2010). A contraption hails from the underside of the network *dispositif*, adopting a technics of disassembling rather than of gluing together. It folds the relations that usually imperceptibly support the smooth functioning of a regime of power outward rather than in on themselves. Yet it also puts into operation a mode of machinic composition. A contraption chugs away at unpacking, blowing up, and letting off steam, unraveling and picking over the conditions under which things have been stitched up:

In the art space, or more usually on the boundaries of art, the works are contraptions made up of situations, peoples, geographies, networks, technicalities that bring the historical, social, economic, political into proximity with each other to create a moment of reflection and imagining.

The constituent parts usually operate in many contexts at the same time, technical journals, political groups, Congolese telephone networks, radio stations, Universities, schools, museums, curatorial practice, urban regeneration. (Harwood, 2010)

Such fantastic machines scratch away at our scabs and show up our socioaesthetic scars, asking: How might we think the complexity and ecology of the relations between things differently? What would happen if we rearranged elements so that they said something different, something novel? If data exhaled a scream that could be heard for a mile around, instead of sitting silently and anonymously as dusty records in an archive, would database experience become something novel? What happens when we deliberately and carefully mix up this with that?

"Two parts, themselves disjoined, may nevertheless hang together by intermediaries with which they are severally connected, and the whole world may eventually hang together similarly, inasmuch as *some* path of conjunctive transition from which to pass from one of its parts to another may always be discernible" (James, 1977: 220). If we follow James through his conceptions of both the world as "multiverse" (1977: 412) and of thinking as an activity of "noetic pluralism" (1977: 264–265), we can see that both things in the world and the thinking of things can come together in a

"concatenated" rather than merely aggregated mode. This allows both the actual and the virtual relations between things, and between things and us, to form both actualized and potentialized pathways for movement. Experimental artworks such as *Lungs* aim to induce a way of making, thinking, and unfolding connections among things as just such a tracing and activation of movement—an experiencing of their relations as a "concatenated knowing" (James, 1977: 265). The point is not to bring everything together so that it smoothly pulses, transmits, and glows informatically. Instead, contraptionist approaches both interrogate the conjunctions presumed to be there and furnish new pathways for moving from one thing to the next.

Lungs produces the conjunctions—some latent, some actually needing to be generated—that allow transitions between the archive and the database; between dead data and screaming corporeality; between software and the materialities of social relations and political events; between dry records and living labor; between the past and its contraction by, and exhalation out into, the air of today: "Such determinedly various hanging together may be called *concatenated* union" (James, 1977: 221). *Lungs* determinately hangs stuff together in a capricious manner, concatenating their variable union, so that we are able to unfold that fabrication, that contraption, which is the relationality of things. Instead of an ambient device, we discover a machine expressing the thingness of networks.

Making things relational

"Making Things Public: Atmospheres of Democracy," the exhibition put together by Bruno Latour and Peter Weibel at ZKM in 2005, was a major curatorial attempt to foreground things and their relations—*to* each other, *between* oscillating poles of aestheticization and politicization, *to* the public, and to the *institutions* of public life.[4] It aimed to unleash contemporary concatenations of art, science, and politics. By dint of chronology and preoccupation and also because of its specific inclusion of works such as *Lungs* and other networked pieces by artists, "Making Things Public" implicitly took aim at the assemblage that emerged in network theory and design during roughly the same period and has continued to gain momentum—an internet of things. On the face of it, an internet of things simply describes the expanding electronic interconnectivity of ordinary objects that might, like the orb, be made to do extraordinary things, such as transmit the latest online breaking news headlines and global political machinations gleaned from its connectivity to the internet. As we shall see, Latour's mobilization of things and relations via a loose concatenation of aesthetics, sciences,

and politics also puts an end to their homogenization and stratification by such assemblages as pervasive computing.

The dull utopianianism of a coming society in which everyday, utilitarian objects and furniture would seamlessly transmit data to one another was detailed in beige tones in Mark Weiser's 1991 article "The Computer for the 21st-Century" (1991). Railing against the dominant discourse of, and ventures into, the virtual reality technologies of the 1980s and '90s, Weiser espoused what he called "embodied virtuality": physical objects would become both embedded with digital technologies and network-enabled, expansively networking the concrete world:

> When almost every object either contains a computer or can have a tab attached to it, obtaining information will be trivial: "Who made that dress? Are there any more in the store? What was the name of the designer of that suit I liked last week?" The computing environment knows the suit you looked at for a long time last week because it knows both of your locations, and, it can retroactively find the designer's name even if it did not interest you at the time. (Weiser, 1991: 104)

But the actual implementation of such a vision for networking has required less office design and more scaling-up of logistics. Pervasive computing's growth has benefited from tracking military equipment and supplies throughout recent periods of globally distributed warfare. In 2003 the U.S. military, with the world's largest supply chain, spelled out a plan to make mandatory the use of RFID tags on all pallets, cases, and pellets from its suppliers by 2005 (RFID News, 2003). This meant that Weiser's more benign plan for getting things to "talk" to one another on an everyday basis receded, as ubiquitous computing was realized first and foremost by tracking armaments and supplies through massively distributed databases.

Neither the war effort attachment of RFIDs to supplies nor the bland futurism of an internet of office objects is what Latour has in mind when inciting us to make things and their relations the centerpiece of a reinvigorated formulation of publics and politics: "If the *Ding* designates both those who assemble because they are concerned as well as what causes their concerns and divisions, it should become the center of our attention: *Back to Things!* Is this not a more engaging political slogan?" (Latour, 2005: 23). Instead of futuristic scenarios, Latour urges us to go back to "things," as if they somehow conjured a less determinately modern past. But this is no simplistic return to a less complex age: the more we rediscover thingness, the less we find ourselves inhabiting an environment filled by objects as such. Instead, as an apparatus such as *Lungs* suggests, taking on thingness implies we also enter a topological landscape of contraptionist ecologies. Things for Latour, or contraptions for YoHa, are not simply physical objects or machines, which we engineer and in which we embed our

plans, maps, models, and circuits of connectivity. Like the refrain, they are gatherers of forces, but forces that are much further along the process of actualization than they are in the refrain. As things, they have become "matters-of-concern," transformed by differential social and political interests and processes from mere "matters-of-fact" (Latour, 2005: 19). Operating in a contingent manner, things assemble *relations*; indeed, they are relational assemblages, remembering all the while James's exhortation that we treat experienced relations as real (1912: 42). The project "Making Things Public" is discursively and pragmatically concerned with the ways in which today more than ever thing-oriented objects assemble relations, sometimes maintaining their processuality or more usually codifying the relations into recognizable pattern. If, for James, "the relations that connect experience must themselves be experienced" (42), in the contemporary moment we give this relational generativity the name "ecology": "Modern visitors, attuned to the new issues of bad air, hazy lights, destroyed ecosystems, ruined architecture, abandoned industry, and delocalized trades are certainly ready to include in their definition of politics a whole new ecology loaded with things" (Latour, 2005: 17). Such ecologies are contraptionist because they gather together components that are proximate and contingent rather than seamless and flawlessly connected. This is a very different mode of assembling than neatly arranging objects as parts that sit within a deliberate and preordained system. We are neither propelled toward a future of glowing, humming ambience nor stationed within a logistical system of easily quantifiable supplies.

We might remind ourselves of Bateson's critique of scientistic ecological thought and his alternative view of ecology as that dimension in which things are composed of systems (networks) of "communicative" interactions (Bateson, 1978: 470–481). Things in interaction, and so networked together, cannot be quantified and reduced to x amount of pollutant or be calculated as possessing a specific "biomass." The human, for instance, is not an object "in" the environment; rather, human-environment is a coupling that, already a network/relation, generates a network/relationality of interactions (Bateson, 1978: 459, 464ff). These interactions, in turn, generate communicative patterns, many of which consolidate into embodied habits—modes of acting and thinking about the world—becoming the major factors in ecological degradation. But the interactions also and, most importantly, are differential; that is, their dynamics affect their differences, generating new patterns or *information*. It is these differences that could be said to be the things—the matters-of-concern—in the system, insofar as it is these that produce change in the system, as it too changes, relationally, with them. Moreover, for Bateson, any "coupling"—teacher-pupil, alcoholic-alcohol, society-norm—generates (and is generated by) ecologies.[5] Ecologies, then, are precisely

those relational phenomena in which things cannot be quantified or reduced to their objecthood, matter-of-factness, or units (of supply, connected devices):

When you narrow down your epistemology and act on the premise "What interests me is me, or my organization, or my species," you chop off consideration of other loops of the loop structure. You decide that you want to get rid of the by-products of human life and that Lake Erie will be a good place to put them. You forget that the eco-mental system called Lake Erie is a part of your wider eco-mental system—and that if Lake Erie is driven insane its insanity is incorporated in the larger system of your thought and experience. (Bateson, 1978: 460)

Guattari's uptake of Bateson's conviction—that pathological object-oriented epistemologies are at the core of the drive to quantify ecological thinking—opens up the idea of ecology to the transversality at the core of networking movements: "In order to comprehend the interactions between ecosystems, the mechanosphere, and the social and individual Universes of reference, we must learn to think 'transversally.' Just as monstrous and mutant algae invade the lagoon of Venice, so our television screens are populated, saturated by 'degenerate' images and statements" (Guattari, 2008: 29). The transversal attitude, approach, and movement of thinking thingness, as a thing's *mutant and real* relationality, is precisely what Latour and YoHa incite us to practice via "contraptionist" ecologies.[6] The transversality immanent to contraptionism confabulates in a manner similar to James's radically empirical mosaics (James, 1912: 86). Similarly, the mosaic is not an environment in which "things" are embedded and from which, consequently, things can be extracted. Ecologies, mosaics, networks—all are formed in transitory movements of conjoining and disjoining, as these forces disparately assemble and dissemble worlds.

Latour makes a throwaway remark about this radical public sphere—this "object-oriented" democracy in which things gather all manner of concerns together—being analogous to the development in computer science of object-oriented programming (2005: 14). Although he may not have been fully aware of the implications of such an analogy, it is important, in the context of the emphasis I have placed on the technics of networks and computation throughout this book, to see what such a comparison draws out for his notion of "things." Object-oriented programming is applied to a wide range of computer languages, and over the last thirty years its definition has broadened so as to include virtually any program in which computation is performed on "objects" (Mitchell, 2003: 277). An object here is a particular kind of data structure whose scale can be small or large (a single integer or an entire database) and that "compiles" its elements or attributes (behaviors) with its methods (subroutines or functions). These behaviors are called up when messages are sent to the object. For example, the database can look up and retrieve information about a variable if a

message is sent to it. The specific data structure of an object makes it a particular class of object. As a member of a class, an object can generate other instances of this class, and these instances will inherit its data structure. The first point to note about object-oriented objects, then, is that they are composed of relations that hold together the data elements and their methods.

The second point we should be aware of is that when an object receives a message, how its method or function executes depends on how the object has been/is being implemented. Different objects respond differently to the same message. This is known as "dynamic look-up" and, in effect, means that the object "decides" how its functions are implemented in situ, that is, as the program or code is running (Mitchell, 2003: 280). The object-oriented object is not controlled by a static external variable or pointer but executes its functions amid a field of methods (attributed relations) and a field of messages (dynamically executing relations). We could say, then, that to a limited extent object-oriented programming encapsulates a microecological/contraptionist mode of computation: it approaches objects not as units but as entities with dynamic, relational capacities and contexts. This is probably as far as we should push Latour's casual analogy. But it is worth drawing out some of these comparisons, because it takes us in a direction radically removed from the current instantiations and utopic visions of an internet of things. The latter sits squarely within a view of the autonomous object, node, or unit embedded in a sea of connectivity. Objects and nodes come first, then connections follow; whereas, for a contraptionist ecology, things, even classes, are permanently contracting, mingling, extracting. Things, then, are individuations of and individuated by relations. Going back to things, especially computationally inflected networked things, in the Latourian sense means making things relational.

Making things trackable

We can begin to sense that feeling our way through the thingness of networks is altogether different from designing or ushering in an internet of things. But the two poles of things being discussed here—an ecological actualization of the materiality of networking, and the increasing computational interconnectivty of everyday objects—do share something in common. In both, the solidity of stuff melts away. For an internet of things, what ultimately counts is not the device but rather the data generated by and about it. As Bruce Sterling notes, this has led to the production of an entirely new class of objects in the world, which he calls "spimes" (2005: 11). When it comes down to it, spimes are "pure data"; they begin and end their lives as

information, and this is what makes them entirely trackable and completely accountable from cradle to grave. The spime is still by and large attached to a physical thing in the world—RFID tags, for instance, are embedded in military supplies. And yet there are quite clearly entire object fields that are becoming increasingly objectless, if we still think of objects as material instantiations. The entire publishing industry is in crisis because, for better or worse, physical books are in the process of becoming antiquated. Electronically, "a book" is more or less a kind of tag whose visual and semiotic conventions are used only to keep its contents and formatting standardized. For example, I receive a PDF file of potential "book covers" to select in an online anthology series for which I am one of the editors. I wonder: Except for either the interface dependencies we metaphorically maintain as older media formations change or simply for nostalgia, why do I need a *cover* for a book that will only exist to be read and accessed via a screen? As if passing sequentially from a cover image to a text file would reveal the mystery of the words contained . . . within? There is no "within" in such a relational data world; there is, however, "withness." And as James reminds us, withness is the barest of conjunctive relations, unfolding in time (1912: 57).

For Sterling, ceding the materiality of object to the transactions of the data sphere means that this new category of spimes emerging can no longer be primarily understood as objects with attributes. Instead, an object is only that which secondarily materializes via the work done by relations: "The SPIME is a set of relationships first and always, and an object now and then" (Sterling, 2005: 77). But does this mean that, like the contraptionist ecologies of Latour and YoHa, relation and process are likewise given primacy in our data-based, object-oriented world? Yes, but then very quickly no: "In the very midst of the continuity our experience comes as an alteration. 'Yes,' we say at the full brightness, '*this* is what I just meant.' 'No,' we feel at the dawning, 'this is not yet the full meaning, there is more to come'" (James, 2008: 115).

For James, "thisness"—the forces of things that make them just something, that *are* their force of individuation—and the ongoing dynamism of their relationality, *both* comprise the "pulses of experience" (2008: 115–117). Where this is also the case for contraptionist ecologies, it is not the case for Sterling's data sphere, where, as I argue, relations lose their indeterminate dynamicism and ultimately what gives them oomph.

Data and networks, as I have argued throughout this book, are intensively accidental—contesting, contingent, conjunctive—yet extensively regulated fields. They gain consistency in flux and are persistently modulated by control mechanisms such as formats, standards, and protocols. Relationality and thingness coalesce, differ, and struggle for the upper hand, both making up the "pulse" of their experience. We must

take this pulse in any instance when we want to determine an aesthesia of networks, that is, just how the thisness or individuation of networks is to be sensed. In such a confluent space and atmosphere, we should be careful to keep an eye on what is understood by relations. For what Sterling means by relations in fact boils down to transactions. The transactions that spimes generate occur between already constituted entities, such as databases, users, GPS satellites, RFID tags, and readers. And it is this sending and receiving, entering and retrieving, that is a form of transactionalism, which results in the formation of a network of trackable objects. In other words, if a spime is a set of relations, it is so because the set itself is delimited by what is transacted between nodes of a network. A set of transactions, then, even considered as a set of relations between things, is an aggregate of individualized connections and subtractions in much the same way, as I suggested in chapter 2, that Google Earth is an aggregate of search and data transactions between individual users and automated engine. But transactions are reduced forms of relationality—the residue of the relational minus the potential for the novel.

Here betweenness is no longer variegated by degrees, as it is in some of the connectionist neurological thinking I examined in chapter 5. Instead, it has become a coordinated space guaranteeing what is to take place amid objects. It is never given, then, as a real element of network experience itself; that is, it is not produced relationally. Rather, it holds as either something to be generated by pregiven entities or as a realm already ontologically constituted prior to the dynamic experience that is networking. James discusses this deployment of relation in which finite things exist as self-contained entities (or sets) and relation is that which must transcendentally connect them, calling such an ontology "intellectualism" (James, 2008: 120). Experience, for him, consists of bits in which, like a grain of sugar, differentiated qualities, such as crystallization and sweetness, are always already in relation. Relations are not the extensive connections between things but the intensive conjunctions that make up the thing's very (ontogenetic) reality. Massumi takes aim at the continuation of such "intellectualism" in contemporary formulations of interactivity (Massumi, 2011a: 21). The same could be said for networked experience. Relation is not the links that hold between nodes; nor is it what bestows on the nodes the quality of distinction (for example, when the spime comes to be seen as a "set" of relations). Relation is already operative in the technicity of networking, in the *diagramming*—looping, refraining, synthesizing—of networks. It both generates a field—an array, for example—and is coextensive with this field, assembled as the (network) *dispositif* of sociotechnical machines, codings, institutions, discourses, emergent and proto-forms of organizations, protocols, and so forth.

Ambient territories and life administration

The operativity of networked "things," whether lit-up orbs or spimes, can nonetheless upset attempts to control relationality even as these deploy such mechanisms as class, link, or ground. Both networked things and the movement of networking have transversal tendencies. Consider RFIDs, for example, which shift two ways, not simply embedding readable data into physical objects via data tags but also requiring the "reading" of these tags via another object, a reader that can pick up data signal. There is no clear distinction between these two entities. RFID tags can be both passive and active (RFID FAQ, 2002–2011). A passive tag will simply have data encoded and stored on it that can be read; an active tag carries a power source, such as a battery, with it and so can either constantly broadcast or activate its data to be broadcast to a reader. But in order to activate such a broadcast, the active tag must function like a reader, detecting via an antenna or wand the proximity of another signal to which it will broadcast. An active tag, then, is already a tag-reader transaction; its networkability is constituted precisely out of this relationship.

The interchangeability between tags and readers within trackable data technologies is an essential dimension of their mode of networking and extends to a wide variety of situations. For instance, in one context a human with a mobile phone might hold the phone's screen over a physical object with an attached or embedded tag. The object appears onscreen, overlaid with a cascading stream of animated images. Here the object is the tag, the human-phone assemblage the reader. But just as Weiser dreamt in 1991, humans can easily become exactly like objects in this ambiently intelligent environment, functioning simply as data to be detected by a reader. His company of the future would tag its employees so that receptionists, or now more probably managers, would know where people were in the workplace (Weiser, 1991: 98). This delegation of human to the status of data set is an increasingly commonplace occurrence, experienced in places such as public washrooms, with their sensor-activated flushing toilets detecting the buttocks-to-seat distance coordinates as a set of human evacuation data relations, as well as in the complex design for human-computer interaction rendered by sensor-driven new media artworks. Unlike the seemingly liberatory effects of interactivity or online participation, in which human users became both consumers and producers of media content, pervasive computing simply assigns a temporary "position" to either people or things as it continuously retrieves, reads, stores, and relays information.[7]

Even if this mundane interchangeability of networked, data-based environments points us toward the duller side of ambience, it nonetheless induces panic. This panic

is an all-too-human response to the radically inhuman concatenations that pervasive network experience holds up for us. The interchangeability between tagging and reading that networks such as RFIDs support only belies a much more fundamental interchange—the fact that for the computational assemblage, such as a database and its network, "we" have become "it": "At a particular moment from a database point of view, you will have more in common with your car than with your neighbor. For some idiot savants a green toothbrush is terribly different from a red toothbrush, a very different thing altogether" (van Kranenberg, 2008: 18).

We could say, then, that one answer to the question of how networks experience is facilely provided by the internet of things in its negation of human agency. Making things trackable includes making humans things; ipso facto, networks come (in)to experience inhumanly. The human morphology is as synthesized a form of data as any other shape. Interestingly—and affectively resonating with the pandemicism of viral media that I discussed in chapter 4—fear proliferates when we enter an arena of pure mediality or communicability. In the internet of things, distinctions are muddied between sender and receiver, encoder and decoder, data and human, as everything transmits to everything else across the network: "In a mediated environment, it is no longer clear what is being mediated, and what mediates" (van Kranenberg, 2008: 12).

Rob van Kranenberg's critique of the ambient "intelligence" fostered by an internet of things raises the question of the loss of human agency that such an environment of pure mediality generates. Here, the networked device and the technical relations with which it should engage us—tinkering with, fiddling around, and patching up, for example—are blanketed by intelligent design. We have, van Kranenberg argues, ceded our relations with stuff to software control, and matters-of-concern no longer concern us. Creating and interconnecting ambient things means that we have given up our actual, embodied, pragmatic *relations* with the stuffness of things: "If as a citizen you can no longer fix your own car—which is a quite recent phenomenon—because it is software driven, you have lost more than your ability to fix your own car, you have lost the very belief in a situation in which there are no professional garages, no just in time logistics, no independent mechanics, no small initiatives" (van Kranenberg, 2008: 23). In this atmosphere that is a generalized communicability of networks—a complete media environment in which mediation between humans and nonhumans has retreated into the ambient background, leaving only mediality—there are two possibilities for the human. Either we make panicked attempts to reinstate the disjunction between things and us, or we try for relational reinvention.

Reinstating a discontinuity between things and us has recently emerged by reclaiming the foreground from the pervasive background; in other words, reterritorialization.

Take, for example, research into pervasive media sponsored by the Joint Research Centre, a network of research institutes funded by the European Union.[8] Such research declares that the problem with a future pervasive ambient intelligence is that all the familiar human cultural boundaries—between work and leisure, between the public sphere and privacy—disappear (Beslay and Hakala, 2005). As I suggested, what we are facing here is the interchangeability that data transactions thrive on and hence the convergence of everything, including humans, into the data network. The panicky response wants to cut this flow. New boundaries, in fact *territories*, that function digitally must be generated so that a *digital private sphere* can be cordoned off, managed, and augmented appropriately, amid this atmosphere of indiscriminate communicability: "By digitising this personal domain, but also its boundaries, the vision of digital territory offers the opportunity to introduce the notion of territory, property and space in a digital environment" (Beslay and Hakala, 2005: 2).

As it turns out, what these researchers have in mind is an exhaustive extension of the Nabaztag:tag-Karotz scenario, in which all personal, private, and customizable data becomes an administered territory, a digital "bubble" that surrounds, engulfs, and protects the digital data/person from trespass. As we can well foretell, people must become managers of their own personal data—accumulating, analyzing, and selecting what data is collected for and about them and their devices. They must become metamanagers of life's communicability, preserving theirs and others' digital territory, as if they were indeed living life in a cloud of digital bubbles:

> The concept of a bubble can be used to control the communication of the bubble; that is to say, both incoming and outgoing data flows. . . . In the case of access rights to a mainframe computer, these rights can have different levels, for example, administrator, user or visitor, providing them with different system functions. The owner of a bubble can act as the administrator for the access rights. (Beslay and Hakala, 2005: 2)

With territory comes subjectivation—the rise of the bubble person as administrator of data-life. Yet this sounds suspiciously similar to the role of the database administrator (whom I examined in chapter 3), whose function, with respect to the database and its users, is to select the operations and decisions that enable data to be put into informatic exchange. We already experience, all too keenly, the anesthetic upshot of such endless processes of data-life administration: sorting playlists on our mobile listening devices; setting and resetting filters for our email inboxes; syncing all the various incoming and outgoing data storage and retrieval devices we possess. But the point I am making here is slightly different; in effect, the instantiation of a digital bubble as securitization of the private digital data sphere only ends up rendering the personal *as* database and, then, personal experience *as* database administration. In

trying to disjoin, we have turned "us" into "it" again. Proliferating digital bubbles with an eye to providing a means of discrimination between data territories likewise assumes that inhuman elements—data, databases, networks—exercise or exude human capacities, such as governability, discrimination, or discretion. Yet the logic of the ambient pervasive computing environment inevitably recedes into an interconnected background of transactionalism.

Toward a syn-aesthesia of things and relations

Instead, we might respond by trying to live amid all these deterritorializations thrown up by pure mediality and chaotic communicability: viral media, noopolitics, the amodal in-betweenness of novel audiovisual environments, and so forth. For rather than dull hums and noisy glows, here we also find passages and crossings between us, data, and things that offer concatenations as (in)determinately varied assemblies. We already respond as we try out just such novel processes and modes of collective reinvention. Yet reinvention is not a solo project and not just for the human, for we will always be reinventing in relation with things. Although these modes of invention are already taking place, certain kinds of artistic practice—the building of contraptions and the unraveling of the ways their assemblage has lent support to a network *dispositif*—reinvent the thingness of things. By reconfiguring dominant modes for bringing computational hardware, software, bodily organs, and affectivity into relation, *Lungs*, for example, conjoins, contrives, and devises differently. The contraption plays a role in repotentializing data.

We also need new ways of reactivating the relationality of networks. This book has been precisely about many of those collective aesthetic moments and strategies, which engage with just such hopes: from diagramming the network into a mosaic of singularly collective cross-modal rhythms in the installations of Natalie Bookchin to the vitality affects of online viral videos; from opening the self-enclosed search universe of Google to allopoietic forces to data-undermining military-industrial-academic networks; from considering the radical temporality of distributed neurally networked architectures to the disjunctive syn-aesthetics of contemporary audiovisual performance. Here, at the book's close, I want to loop back to my initial investigation of networks' diagrammatism by looking at what kind of aesthesia is generated as relational networking between people and (informatic) things is differentially diagrammed. What is at stake is the radical opening up of the network as a relational field of communicability in which, while neither things nor humans are seen as worlds apart, neither are they reduced to the sameness of a world composed by data administration.

A field of inquiry opens up, away from the internet of things, in the vicinity of the thingness of networks.

An example of such inquiry, in which such networking raises the potential for a variably relational hanging-together of communicability, can be seen in the art, design, and research practices of the collaborative known as spurse.⁹ Unlike the loose conception of "collective" that holds together anarchic groupings of artists and designers, spurse focuses on actually generating novel kinds of collective action by creating situations in which humans collaborate with both other humans and nonhumans: "Spurse is a research and design collaborative that catalyzes critical issues into collective action. Through a playful transformation of conceptual and material systems, we develop problems worth having and worlds worth making, engaging across scales and complexities of all things human and nonhuman, organic and non-organic" (spurse, 2011a). This sounds a lot like a Latourian research program, and to an extent elements of actor-network theory pervade such an approach—the constituting of action, engagement, and environments via entanglements between humans and nonhmans being the most crucial. Yet Latour himself has criticized the "network" in actor-network theory, arguing that the transformative potential of *networking*'s transductions has been lost in an age now dominated by *networks* (Latour, 1999: 15). Rather than map the network of actors and their relations, practices—conceptual, ethico-aesthetic, technical, political, and social—that generate novel relations, novel fields, and experimental aesthesias are required. Spurse's practices do not propose a new network or collective but focus instead on processes of generating and intervening rather than shaping a formation itself. At the same time, they do emphasize the nonhuman-human relations that need generation. Let's call these instead collectivities, with the proviso that such collectivities are not deemed new "research networks." Instead, we can return to the Jamesian mosaic with a Guattarian nuance; they are loosely joined but rigorously generated relationalities of peoples, projects, and productions—assemblages that provoke collective *infrapersonal* modes of enunciation. They too belong to contraptionist ecologies because they do not create a semiotic break between expression and formation but allow each to conjunctively transition to the other—"a 'machine' that concomitantly determines the action of the cosmic and molecular fluctuations, of real and virtual forces, of sensible affects and corporal affects, and of incorporeal entities such as myths and universes of references" (Melitopolous and Lazzarato, 2010: 54).

The idea of such collectivities is not to constitute a network from technologies nor from things to people; rather, the idea is to reconstitute, via creative research, "the

network." The work of collectivities such as spurse—or for that matter an increasing range of "labs," spaces, and concatenations focusing on "research-creation" (Thain, 2009)—is to invent new kinds of network protocols: ethico-aesthetic ones.[10] Rather than analyze the "logic" of networks, such programs for research and practice ask, How do we/can we compose ourselves as collectivitities/networks? What novel discoveries can we make about our/the world's relations of betweenness, withness, toness, andness?

Spurse develops and collaborates on diagrams, which, rather than finished aesthetic outcomes, its members see as things to think through and with, relationally. Nonetheless such collectively produced diagrams do become things too—things that travel, feeding forward into new situations and processes to be used by others. The diagram is a process and a production but never a product—it indicates lines of force in collaborations and ethico-aesthetic pathways to new situations. Diagrams become inhuman elements of the collectivity, and the collectivities come to generate diagrammatically, taking care of such aspects as speeds, intensities, movements that change the qualities of an environment. This is networking as processual and deeply interested in the protocols that might scribble new processes of relating to, in, and of the world into being. This bears similarity to a number of artists exploring digital audiovisual cross-processed signal, who, I suggested in chapter 6, were developing temporary ecologies out of the disparate forces and materialities of electronic media. What they and their signals cross-diagram are temporary digital ecologies in which synthesis operates both con- and disjunctively. All such novel attempts to diagram, to bring-into-experience an aesthesia of networks, work at and via processes of spatializing and temporalizing that are attentive to the textures of transitions.

Creating networking through collective diagramming, which also requires creating novel processual protocols, gives rise to a living, lively, collective syn-aesthesia. The diagram in spurse's work is both pragmatic and abstract—a means for generating thought and an image for getting thought around and making it active. As Iain Kerr, one of spurse's core members, states, "In spurse we use diagrams as a key tool in most of our projects. We do not imagine the diagram is the outcome—a final work of art. It is rather a tool to understand to move through processes and levels of abstraction toward interventions in systems" (Kerr, 2011). Spurse diagrams imperceptibly, in order to get at processes—emergences, shifts, and unfoldings—that cannot be pictured but might be sensed as diagrams (Kerr, 2008: 108). Spurse often works collaboratively with communities, institutions, and situations. In 2004 for example, they facilitated a project commissioned by the Maine Arts Commission with communities living and

working along the Maine coastline: *Mapping the Working Coasts: An Investigation into the Working Coasts of Maine*.[11] This project was an attempt to trace change that had been occurring on the working waterways of the Maine coastline as accessibility to the local coastline has been displaced by housing developments and tourism. The project worked in process over several months, with spurse members sailing up and down the coast interviewing, drawing, and traveling with coastal community members. But the maps and diagrams created with those coastal workers and dwellers were less visualizations than means to refuel discussion—collective reimaginings of how new types of dwelling and habitation might be realized. The diagram/map/image here becomes something to process and deal with change—those hard-to-detect yet immanently felt transitions through which environment and habitus become something different and often something alien to their inhabitants.

The diagram tracings that took place throughout this project as a boat sailed up and down the coast (and became a working "research-creation" vessel for conducting interviews, workshops, and drawings) also catalyzed thinking for spurse: "The archives generated became part of a spurse exhibit on rethinking sustainability and another on new drawing/diagramming logics" (spurse, 2011b). The diagram, then, is not simply a tool for extraction or an artifact of extractive processes—"data mining" processes, for instance. It is a technique for feeding back into the community and feeding forward to others. Manning calls these "relational techniques" (2009: 2). The diagram is less a drawing, less "art," than a contraptionist device in the sense that I have been using this idea throughout this chapter. The material diagram on paper carries forward something drawn out of incorporeal processes. It straddles both technique and process, furnishing us with a different kind of technics—a technics for concatenating the instrumental with the catalytic. Yet this is also a gentle technics, one that nurtures and is attentive to the actualization of relation, understanding that what is extracted is never exhausted and that the diagram always holds other potential unfoldings. It does not try to synthesize relations into a final aesthetic, social, or political outcome. Instead, it solicits and follows the diagram's virtuality, the diagram's force—the force of the edge.

I began this book with another image—the mosaic as William James's thought-image of the radical empiricism of real relationality. And for James, the mosaic was all about the force of the edge. As the outer edge of one event—transitions of thought, sensation, nature, practice, belief from one state to the next—conjoins or differentiates it from the inner edge of the next, some *thing* emerges, processually. This thing or rather *thingness* is an expanding pool of relationality. The edge is the mosaic's force; it drives the patterning rather than the other way around. The diagram, resonating

with such thought of the mosaic, is becoming a new image for relational thought and practice. This is especially so when it is deployed syn-aesthetically in projects researching, intervening into, and catalyzing novel networks and ecologies. It has become a device *for* imperceptibility, for relaying the force of the edge where technologies join with interventions—where the assemblage is disassembled and its contraptionism laid bare. Here the diagram becomes a machine for expressing the relational thingness of networks; here an aesthesia of networks edges into perception.

Notes

Introduction

1. Deleuze and Guattari define the diagrammatic as that which plays a piloting role in not only thought and perception but also in life, action, change, history, and so on (1988: 142). Anything indeed that involves the movement of the relational elements of an assemblage toward ongoing change involves the work of the diagram. The diagrammatic resides in the virtual dimension—it engages the potential for its elements to actualize as they interrelate and interact, but this potential might have any number of varying actual outcomes. In the example of the topological time slice of internet server connectivity, this image is an actualization, then, rather than a diagram in the full sense I am evoking here. But it certainly is imbued with diagrammatic elements—the potential that it may actualize differently—as is any actualization.

2. I have elsewhere written about the way in which Lombardi's work propelled the FBI into full investigation of the relations of the 9/11 attacks to Bin Laden (Munster, 2005).

3. I will also be drawing upon contemporary understandings of perception as action rather than cognition, drawing on work by Alva Noë (2004), Brian Massumi (2002), and Erin Manning (2009).

4. Guattari often slips among his various terms, which run from the "infra-personal" to the "molecular" to "processes of singularization." Although all these belong to the same plane, they are differently nuanced. The "molecular" describes the plane and its machinic fluxes; the infra-personal denotes that this plane does not belong to individual experience as such but rather describes experience as process before individuation; relation, transition, and processes of singularization are more events through which molecularity proliferates and finds a point of rest or expression. These events may or may not be human-made (Guattari and Rolenik, 2008: 172).

Chapter 1

1. For example, RapidShare, the popular file hosting site, has created a "room" to go to for entertainment while waiting for uploading or downloading: "Welcome to the Anti-Waiting Lounge! We all know that Waiting sucks. So we here at RapidShare have made a few games to keep you entertained when there is no option but to wait" (RapidShare, 2010).

2. Such combinations are proclaimed via a predictive computer science conjoined to economic rationalism in the form of, for example, Moore's law. This is the declaration that integrated electronic circuitry will exponentially decrease in size and expense at least up until around 2015 (Moore, 1965: 114–117). There is, similarly, Nielson's Law, a formulation that high-end internet users' bandwidth exponentially increases by 50% every 21 months (Nielsen, 1998).

3. Cohen announced the release of the protocol and set up a link to it via a message in a Yahoo group. This message and active link is still archived and available to view under the message heading "decentralization: Implications of the end-to-end principle." Available at http://finance.groups.yahoo.com/group/decentralization/message/3160.

4. Kleinrock's thesis proposal was also published within the context of broader team research on information processing and circulated in 1961 and 1962 at MIT via the Research Laboratory of Electronics' quarterly progress reports, which updated and reported on all research being undertaken by the lab throughout the year (Cunningham, Kleinrock, et al., 1961; 1962).

5. The report is mentioned in an interview between Davies and Martin Campbell-Kelly (Davies, 1986).

6. Morris Kline provides a good explanation of the role of tensors and functives in topological geometry (1972: 1122–1127).

7. Peirce's explication of how an image becomes a symbol is useful for understanding how data visualization always functions *nonindexically* rather than via the indexical relation it supposedly has to "real" objects in the world: "A man walking with a child points his arm up into the air and says 'There is a balloon.' The pointing arm is an essential part of the Symbol without which the latter would convey no information. But if the child asks, 'What is a balloon?' and the man replies. 'It is something like a great big soap bubble,' he makes the image a part of the Symbol" (Peirce, 1998: 274–275). The image as index is always secondary to the production of symbols but the symbol is also located within a context (the pointing arm) and so is not simply arbitrary. Making data into image using computation—symbolic languages coupled with algorithmic processes—deploys a semiotizing process in which indexicality is not primary. I return to the relationship between Peirce and data in chapter 3.

8. *Mass Ornament* is a high-definition video installation. It was first shown as part of the 2009 *COLA* commissions, at the Los Angeles Municipal Art Gallery, Barnsdell Park, Los Angeles, May 14–July 12. Documentation by Bookchin of the installation can be viewed via *Vimeo*. Available at http://vimeo.com/5403546.

9. *Laid Off* (2009) is part of a larger work, titled *Testament*, by Bookchin, which is ongoing and made up of a series of multichannel videos all sourced from online video "confessions." *Laid Off* is held in the collection of the Los Angeles County Museum of Art, Los Angeles, California.

10. In the English translation of Giorgio Agamben's essay "What Is an Apparatus?," Foucault's original French is translated as follows: "The apparatus itself is the network that can be established between these elements" (Agamben, 2009: 2). Agamben's translators, David Kishik and Stefan Pedatella, note that some English translations of other authors' texts were amended in

order to take account of Agamben's "distinctive" Italian translations. Between the original Foucault text (a conversation between Foucault and a number of French psychoanalysts) and the English and Italian translations and uses, networks and their theorization have also developed. It is not surprising that Agamben now understands the "apparatus" as a network rather than a system. I have used Agamben's text because it marries the question of the apparatus to the contemporary discussions and politics of networks. For the original French conversation, see Michel Foucault, "Le jeu de Michel Foucault. Entretien avec Colas," *Ornicar: Bulletin périodique du champ freudien* (July 10, 1977): 62–93.

11. Eugene Thacker, for example, takes what he calls a diagrammatic approach to the entangled relations that have emerged between contagion (living, material modes of proliferating) and transmission (nonliving, informatic, immaterial pathways of circulation), in contemporary networked culture. Although he takes up both Deleuze and Foucault's transversality, he argues that a diagram does not so much follow the becoming of networked events as signals or "demos" what has already (disjunctively) become within a given context. Thacker's insights about the conjoining of the living and nonliving are extremely pertinent to a contemporary analysis of the bioinformatics of contemporary networking. But by narrowing down the diagram to its demonstrative function he also misses its virtuality and energetics (Thacker, 2005).

12. James discusses this distributed architecture for experience in detail in the paper "The Knowing of Things Together" (1977: 157n18).

Chapter 2

1. Quotation from a "Frequently Asked Questions" page from the forum *Google Earth Community* (2005). This was an online forum that Google itself often directed search queries to although it was never part of the Google corporation. In 2005 Google automatically redirected searches about Google Earth to this page implicitly authorizing the information found there. Google Earth Community now hosts a variety of forums on issues connected with the use and application of Google Earth. Google Earth now has its own FAQ, which states that Google Earth strives to obtain high resolution although this will depend on the area being imaged and the source data obtained. This caveat is the closest Google Earth admits to censoring or being politically sensitive to imaging some data. See "Understanding Google Earth Imagery," *Google Earth* website. Available at http://support.google.com/earth/bin/answer.py?hl=en&answer=176147.

2. Orkut is Google's social networking platform and was also launched in 2004. Initially it dominated as a social media site over Facebook and others in Brazil and India. There are a number of speculations about why Orkut succeeded in Brazil but not, for example, in the U.S. When it launched in 2004, web traffic of several million users slowed its speed down to a crawl. U.S. users found it too slow but Brazilians, used to poor speeds, stuck with it, became familiar, and kept using it. But in 2010, Facebook usage had increased in India with over 20, 873,000 users as of July, compared with 19, 871,000 for Orkut (ComScore.com, 2010).

3. *The Googlization of Everything* is an ongoing book/blog written by Siva Vaidhyanathan (and others) and is published online in collaboration with the Institute for the Future of the Book

(2007 ongoing). It was also published as a hardcopy book (Vaidhyanathan, 2011). The book critically analyzes networked on- and offline life in a post-Google era, focusing on the ways in which Google as a search enterprise has affected the way we relate to each other, the way knowledge is disseminated and produced and the ongoing relations that emerge between networked corporations and institutions. Central to Vaidhyanathan's analysis is that Google has managed to invade and control most of the web and, more than this, that it exercises a kind of governance effect where it subtly exhorts us to do as it wishes. Google therefore operates via soft power. However, not all commentators agree with this viewpoint and in fact some business analysts have pointed to the amount of Google products that have simply trailed along: "Google's problem isn't a string of failures, then, but rather the middling performance of many products that survive" (Bloomberg Businessweek, 2006).

The problem with Vaidhyanathan's analysis is not that it is wrong, but that it leaves little room for feeling out the heterogeneous and disjunctive aspects that comprise Google as an assemblage of a complex networked ecology. I hope that by tracing out this ecological networked approach we might find more fissures and tentacles that reach toward other ways of relating with and to Google than to predominantly view it as symptomatic of a society of control.

4. *Autoscopia* was commissioned by the National Portrait Gallery of Australia as part of the virtual exhibition "Doppelgänger." The exhibition ran on Portrait Island in the environment Second Life from October 23, 2009, to April 23, 2010. *Autoscopia* (Clemens, Dodds, and Nash, 2009) continues to exist as a website that returns "portraits" based on user-entered names, pictorially composed through online generated search results. Clemens and Nash (2011) have also written a paper that addresses a number of conceptual aspects of *Autoscopia* and the status of the digital image in network culture. During the course of writing about *Autoscopia* I corresponded with Adam Nash, to whom I am grateful for feedback and for extra insights about the piece. He informed me that *Autoscopia* also deploys search engines such as Intellus and ZoomInfo, which are often used by corporations and government agencies to run background information checks on people. Nash commented that the reason they had decided to include these to run in *Autoscopia*, was precisely because such search facilities represented what the artists see as the "dark" side of online search, or "hinternet" (email correspondence, June 3, 2011).

5. See, for example, the review "Google Earth 3.0" (Dragan, 2005).

6. The term "sociable media" was initially used by network theorists to describe all forms of media in which multiuser participation constituted the media environment (Donath, 2006). Interestingly, the notion of "sociable" gives a more descriptive sense of what social media platforms say people do when they use Facebook, Twitter, and so forth; that is, that people are using these networked platforms in a "convivial" manner.

7. Robert Nirre made an early and similar observation about the web in general. Nirre was concerned with the ways in which networking got rid of spatiality by eliminating distance and hence *spaces* for people to congregate. I am less concerned about this earlier debate around space, communications, and habitation than I am with the elimination of *sociality* as a dimension for the Google Earth *zeitgeist* (see Nirre, 2004: 260–268).

8. Google Earth Community, which is a series of forums devoted to different threads about Google Earth, can be found at https://productforums.google.com/forum/#!forum/gec. For Google Earth Hacks, see http://www.gearthhacks.com/.

9. See, for example, the assertion made by Indian president A. P. J. Abdul Kalam on October 16, 2005, that developing countries had been deliberately chosen by Google Earth to be mapped with high-resolution images (Kalam in Sharma, 2005).

10. <*AbstractView*> (Polak and van Bekkum, 2010) was launched when Google Earth 5 was operating. It was this version that allowed the Street View "spheres" to be shown via a plug-in. Since then this option has been disabled. I am very grateful to Esther Polak for a lively discussion that has ensued between us about her and van Bekkum's intervention into new cartographic media (email correspondence, August 22, 2010–May 22, 2012). Polak sees this work as a kind of cinematography of Google Earth, which she nominates as less a visual and more a spatial medium. She also interestingly suggested to me that, given the disabling of the spheres option, <*AbstractView*> had already become a media archeological work about Google Earth.

11. For two different views on this, see the official Google account on the Google blog authored by Marissa Mayer (2005), the Google director of consumer web products, and Noam Cohen (2007).

12. See the *Google Will Eat Itself* website (UBERMORGEN.COM, 2005–2007). Alessandro Ludovico is the publisher of the Italian new media art, culture, and hacktivism magazine *Neural*. Paulo Cirio is an artist working "beyond media art," as he explains his practice on his website, available at http://www.paolocirio.net/. The *GWEI* site was active from 2005 to 2007 insofar as it sought to actively increase monies earned via the AdSense program. While no longer active in this way, it nonetheless still accrues earnings from AdSense automatically.

13. A "Solidarity Link Action" was initiated by Geert Lovink via the "nettime" and "spectre" mailing lists on March 24, 2007, and was announced on Bruce Sterling's *Beyond the Beyond* blog on *Wired* on March 25, 2007. Available at http://www.wired.com/beyond_the_beyond/2007/03/more_interventi/.

14. Teran notes in documentation for the project, that "if the longitude and latitude coordinates are included with a video when publishing it on YouTube, then this video automatically appears on a Google Earth map and connects it to a physical location" (2011). However, like Polak and van Bekkum's experience of using Google Earth, aspects of the platform have changed since she made the work. Google filtered out many of the YouTube videos that Teran originally found and so many of the videos no longer appear on Maps. Teran built her own data mining software to be able to continue her line of work. I would like to thank the artist for these points of clarification (email correspondence, May 9, 2012).

Chapter 3

1. The other model for database design that emerged via the work of Charles Bachman, a software engineer working at General Electric during the 1960s and '70s, was the network model. It

allowed sets of data or records to be linked in a many-to-many manner and encouraged the programmer to become a "navigator" at a low level through the machine representation of the data. Its failure to be widely implemented seems to have more to do with the fact that IBM had already adopted wide-scale use of hierarchical database models and the switchover would have been too expensive. Many of the ideas around multiple variable returns for queries that became a feature of relational databases were also of concern to Bachman (Bachman, 1973).

2. For the original paper, see Edgar F. Codd, "Derivability, Redundancy, and Consistency of Relations Stored in Large Data Banks," *IBM Research Report*, San Jose, California RJ599 (1969). In this chapter I refer to the published paper of 1970.

3. Cloud computing is still an evolving architecture, but at its most basic it involves the provision of services such as email, social media, database retrieval and storage, and gaming from a pool of providers across the web to individual users/consumers. An example of cloud computing is the use of a Gmail (Google mail) account, where someone accesses and sends all email messages by logging into an account on a Google mail server rather than onto an account dependent on the IP address of their own desktop computer. The U.S. National Institute of Standards and Technology provides the following standard definition, which it acknowledges is an evolving beast and which is regularly updated: "Cloud computing is a model for enabling convenient, on-demand network access to a shared pool of configurable computing resources (e.g., networks, servers, storage, applications, and services) that can be rapidly provisioned and released with minimal management effort or service provider interaction" (Mell and Grance, 2009).

Cloud computing is necessarily amorphous because it is a combinatorial architecture of both distributed and centralized connections, structures, and protocols. Increasingly, large networked corporations such as Facebook must invest in huge physical data storehouses to maintain "the cloud"; that is, to store all their individual user's data. From the user point of view, accessing Facebook, then Gmail, then switching to an online game may create a sense of an easily distributed "everywhereness" to cloud computing. From the viewpoint of the networked service provider, more centralized platforms, storage spaces, and standardized protocols must be generated in order to facilitate and of course cement market share.

4. *ShiftSpace* is an extension to the Firefox browser initially developed by Dan Phiffer and Mushon Zer-Aviv (2006–2011). *MAICgregator* is a Firefox extension developed by Nicholos Knouf (2009a). *TrackMeNot* was developed by Daniel Howe and Helen Nissenbaum (2006).

5. For a good description of how neural nets and decision trees are used in data mining, see Edelstein (2005: 11–17). For a critical analysis of the development and history of AI and machine learning, see Johnston (2008: 287–336).

6. For an example of a text from the 1990s that furnishes an early analysis of data mining as a knowledge discovery method, which reveals pattern in data, see Fayyad, et al. (1996: 37–54).

7. This work is now available at http://wwwwwwwww.jodi.org.

8. Here I am drawing on the ongoing projects of the *Bureau of Inverse Technology* (BIT), an art-research collective, to conjure up a sensibility that develops via inverse engineering and available at http://bureauit.org/. Since 1991 BIT has been using off-the-shelf software and hardware reen-

gineered to encourage objects and systems to produce outcomes perversely alternative to the purposes for which they were originally built. In undertaking this inversion process, the original technical systems and objects reappear with their stakes and constraints openly declared and acknowledged. Further information about BIT and documentation of their numerous projects from 1991 onward can be found at their website.

9. *Ad-Art* was developed in conjunction with Eyebeam, New York, and is available at http://add-art.org/. It extends the ethos behind "ad blocker" Firefox extensions, which have been massively downloaded and used to replace web banner adds with blank space. *Ad-Art* instead asks curators to select two to three weekly ranges of "banner-sized" images that replace web ads with art instead.

Chapter 4

1. Because people do not sign up for Chatroulette, there is no way to actually count its user numbers, as one can with social media networks such as Facebook and Twitter. However, using a Firefox extension such as SiteLogiq, it is possible to run automated web analytics on any domain. SiteLogiq frequently runs web analytical reports on popular sites such as Chatroulette (2012).

2. The website BuzzFeed, which reposts web news items, phenomena, and snippets and then allows users to "vote" on what will go viral ahead of time, is in effect generating a metaviral effect. In fact, BuzzFeed is a kind of media experiment in generating contagious media as emergent and is at once self-reflexive and part of the viral phenomenon. It also develops widgets and applications that allow its community to track things going viral: "Our viral optimization engine tracks and optimizes for virality" (BuzzFeed, 2011). See also the Contagious Media Project website, where founder Jonah Peretti explains the philosophy behind creating BuzzFeed (Peretti, no date). Ralph Wilson, on the other hand, is a web-marketing guru, whose viral advice is heartfelt rather than tongue-in-cheek (2000).

3. *David after Dentist* was a homemade video, originally shot in 2008 and uploaded to YouTube on January 30, 2009, by the subscriber "booba1234," David's father. By March 2012, it had over 107 million views/downloads and had spawned a website (http://www.davidafterdentist.com/), and David's father was selling T-shirts and stickers with "Is this Real Life?" printed on them. The video is available at http://www.youtube.com/watch?v=txqiwrbYGrs.

4. Tay Zonday's *Chocolate Rain* was first uploaded to YouTube on April 22, 2007. As of May 2012 it has had over 79.6 million views (Zonday, 2007). Zonday also has had his share of instant celebrity, has won Webby and YouTube awards, performed with Beyonce and has made appearances on *South Park*, among a myriad of media performances. For further information about Zonday, see his website, http://tayzonday.ning.com/

5. *Hahaha* was uploaded by the YouTube subscriber "BlackOleg," presumably the baby's father, on November 1, 2006, and as of August 2011 had over 180 million views. The video has been removed from YouTube due to a copyright claim.

6. Bertelsen and Murphie also refer to Stern's conception of vitality affects in their analysis of the *Tampa* incident in Australian politics in 2002, in which a Norwegian ship, the *Tampa*, rescued and held refugees off the coast of Australia who were seeking political asylum. They argue that the appearance of the *Tampa* as "a red ship" on the horizon of the Australian coast functioned as a refrain and gathered and reorganized territories in Australian politics. Their reference to Stern's conception of vitality affects is similar to mine insofar as the vitality affect contours the temporality in which a refrain's affect gains momentum. However, within the context of the viral videos I am analyzing, I am keen to follow further aspects of vitality that Stern deploys, especially those rhythmic movements of affect that are close to the rhythms of living/life. This is precisely what these kind of viral videos refrain and, hence, how they come to conjoin life to/in the network.

7. The document titled "WHO Checklist for Influenza Pandemic Preparedness Planning" is still available from the "Global Alert and Response" section of the WHO website (2005). The most recent document revises the 2005 version (2009).

8. See the criticism of WHO in the editorial by Fiona Godlee (2010), who criticizes WHO for creating a deliberate panic by misrepresenting the 2009 swine flu outbreak as pandemic and assisting the profits of pharmaceutical companies. See also Margaret Chan, director-general of WHO, writing in response to this (2010).

Chapter 5

1. Google's *Prediction API* is to date still in a testing phase. Information about the tool is available at https://developers.google.com/prediction/docs/getting-started.

2. The neural turn in network and media analysis only gets stranger. A 2011 neuroscience study concluded that there was a direct correlation between the size of areas of the brain connected to social-cognitive functions—the amygdala—and the size of online social media networks of individual users—for instance, the number of friends one had in Facebook (Kanai et al., 2011). Thus while Carr has concluded that the internet impairs the brain, neuroscience remains divided on the issue. The correlationalist hypothesis is clearly malleable and dynamic.

3. This is probably not a coincidence. Arquilla and Ronfeldt (1999: 53n27) make reference to Foucault's work on discourse in their elaboration of the relation between narrative and soft control. It is highly likely they were also familiar with his work on power and resistance.

4. *PsychSim* was developed in 2003–2004 by the Center for Advanced Research in Technology for Education also at the University of Southern California, where the Institute for Creative Technologies is located.

5. Other neuroscientists offer similar possibilities with respect to the notion of distributed spatiotemporalities. For example, Ramachandran's work on phantom limbs suggests that this experience produces sensation in places where there is no anatomy by activating adjacent regions of sensation and activity in brain and body (Ramachandran and Blakeslee, 1998).

I am not necessarily endorsing Damasio and Meyer's entire neural architecture, in which, for example, CDZs are understood to house "instructions" for coordination (2008: 168). There are implicit traces of a command-control model of neural architecture lurking here, which indeed would not be necessary for a relational and ontogenetic conception of neural functioning, as I hope to show. It should also be noted that a range of neuroscientific and neurpsychological studies of mirror neurons in humans deploys system- and network-based approaches to the architecture of the brain. Even Rizzolatti's research into human mirror neurons describes these as a system, although the emphasis on the evidence of brain imaging in his and fellow researchers' studies also tends to support anatomical localization of mirror neural activity to particular regions (Rizzolatti and Craighero, 2009). Other neuropsychologists who have focused on the relations between language comprehension, speech gestures, and mirror neurons emphasize the interactional and relational systems involved in, for example, understanding the speech gestures of another, even when neuroimaging evidence of Broca region activity is evident: "We argue by analogy with our previous research that it is interaction among these areas, rather than processing associated with Broca's area per se, that constitutes the mirror or observation-execution matching system associated with processing speech-associated gestures" (Skipper et al., 2007: 264).

6. Neuroanatomically, Broca's region is the posterior inferior frontal gyrus in both the left and right hemispheres of hominid brains. The areas are difficult to localize but are generally associated with a range of language tasks, including speech, comprehension, and action recognition and understanding.

7. Critical neuroscience is an interdisciplinary approach and network of mainly neuroscientists and social scientists with some philosophers and artists that is based in Germany (including researchers from Max Planck Institute for the History of Science in Berlin, the Institute of Philosophy in Marburg, and the Institute of Cognitive Science in Osnabrück). Its aim is to engage the expectations of neuroscientific research and practice critically in order to examine where the potential and promise fall short of or play out insidiously in policy, clinical practice, and ethical debate. Its network also extends to Canadian, American, and Brazilian scientists and researchers. Further information about the network, its events, publications, and researcher profiles can be found at "Critical Neuroscience," available at http://www.critical-neuroscience.org/.

8. This work was shown as part of the exhibition "Brainwave: Common Senses," at Exit Art Gallery, New York, February 16–April 19, 2008. A description of the installation and an excerpt of the video by Daniel Margulies and Chris Sharp can be viewed online (Margulies and Sharp, 2008).

9. This comment appeared as part of an artists' statement on a website that is no longer active. Daniel Margulies and Chris Sharp, "Artist Statement," 2008, Neurocultures.Org: Neuroscience and the Arts website, http://www.neuroculture.org/videogallery.html (accessed March 22, 2011).

10. U.S. courts are increasingly testing the possibilities of using neuroimaging as evidence of both criminal intention and as evidence (usually offered in defense) of various psychopathologies. The admissibility of such images is much contested since they require expert interpreters (see Dumit, 2004: 109–133).

11. Some recent neuroscientific thinking has begun to suggest that units such as neurons or circuits are not sufficient to provide correlative bases for neural activity. Scott Kelso, for example, charts the way in which a concept of "metastability" has begun to pervade recent neuroscience (2010: 117–138). The metastable mind is one in which cognition, for instance, occurs as a dynamic activity in which the brain's role is to coordinate relations between autonomously acting, self-organizing areas/activities and integrated brain-networked-wide action at the same time. The implication is that the unit at stake is not the individual neuron but rather the human being as a system coupled with its environment. This is not to say that one cannot read a neural image but rather that the modes of reading the image and how the image sits in relation to a sequence of images in time and across time might require reevaluation. In some ways this is always understood at a clinical level since a neurologist treating a patient will always compare sets of neural images over time to look for deterioration or improvement of damage or a lesion, for example. What I have been arguing, however, is that this is not the way such images are interpreted in other social and cultural contexts, where one image or set of images from a single study is often interpreted indexically.

12. Moddr is a media laboratory that runs out of WORM, a Rotterdam artist collective (see http://moddr.net/moddr_/). As alumni from the renowned Media Design master's degree at Piet Zwart Institute, Rotterdam, their aim is to modify and reengineer existing media and technologies. Their aesthetic is thus informed by a DIY hacker perspective but with a desire to reformulate within the context of Web 2.0 logics and technologies.

13. This occurs in the "You have 0 friends," episode 1404, *South Park*, and originally aired in America on April 7, 2010. See http://www.southparkstudios.com/guide/episodes/s14e04-you-have-0-friends.

Chapter 6

1. *St Gervais* was performed during the Mapping Festival, 2010, a festival of live audiovisual performance and installation held since 2005 in Geneva. The piece was performed in a Protestant, formerly Calvinist church, Temple de Saint Gervais. Geneva is known as the birthplace of Calvinism, whose architecture and interiors espoused a creed of iconoclasm.

2. The Cimatics festival has been held for seven years, staged by the Cimatics Platform (http://www.cimatics.com), an international organization based in Brussels that supports and exhibits audiovisual art. It started as a VJing festival in 2003 but has expanded to include an array of audiovisual sculptural and kinetic events, master classes, and performances. The Mapping Festival (http://mappingfestival.ch) began in 2005 and is held annually in Geneva, Switzerland. It promotes audiovisual environments, performances, and installations, which move beyond the screen. "See This Sound" was an exhibition that historically examined the interrelations of sound and image via electronic and digital media arts. These were looked at from the varying viewpoints of media, perception, and culture and from a range of theoretical frameworks. It ran from August 28, 2009, to January 10, 2010, at the Lentos Museum in Linz, Austria.

3. My aim is not to provide an explanation for synesthesia as a neurological phenomenon; however, this does raise the issue of why it is that synesthesia when thought neurologically requires a causal explanation as such. If, for example, an ontogenetic approach were to be adopted by neurologists (following Simondon), synesthesia might simply sit within a continuum of human perception as one potential mode through which perception individuates. Synesthesia would already be part of the ontogenetic field of human perception—one of its potentialities. To a certain extent, the concept of neuroplasticity (that the brain is in a constant relation of neurobiologcal formation with its milieu), which is now becoming more accepted within the neurosciences, holds out the possibility that a more ontogenetically inclined mode of thinking might permeate this field. If the brain is process rather than entity—suggested by the neuroplastic notion that neurobiological change can and does consistently occur—then this might also suggest that perception too is no longer an "outcome" caused by certain wirings of the neural pathways. For a good and accessible overview of neuroplasticity, see Norman Doidge (2007).

4. I am here referring to Western art theoretical debates of late modernism in which Michael Fried positioned minimalism as a new art "position" breaking with both representationalist and modernist/medium-specific concerns, especially as evidenced in mid-twentieth-century painting. For Michael Fried, minimalist sculpture, in particular, was concerned with the wholeness and indivisibility of the object (see Fried, 1988). In turn, this issue about the objecthood of the minimalist work of art was also countered and debated by the equally strong conceptual art movement of the 1950s and 1960s. Lucy Lippard's *Six Years: The Dematerialization of the Art Object* (Berkeley: University of California Press, 1997) remains a key text in this debate. Lippard politicizes the assertion of objecthood in minimalism and (white, middle-class, chiefly male) American art criticism of the period.

However, the debate moved into somewhat different territory during the 1990s, with the emergence of both "environments" that were art works, such as virtual reality art, and the dominance of video installation at biennales and festivals and the art criticism of Nicolas Bourriaud's "relational aesthetics" (see Bourriaud, 1998). Bourriaud emphasizes notions such as participation and interaction as key aspects of twenty-first-century art: neither object nor concept are crucial; instead, the experience counts. In many ways, it is this aspect of the digital environment that returns the digital artwork to Wagner's *Gesamkunstwerk*.

5. The Studio for Electronic Music was founded by Hans Hartmann, the director of West German Radio in Cologne in 1953. Members of the Groupe pour Musique Concrète, which included Stockhausen, used it to experiment with electronic sound using various analog and early digital synthesizers (see Stockhausen, 2004: 370–380). Deleuze briefly writes about the difference between analog and digital synthesizers, arguing that whereas analog synthesizers are "modular," digital synthesizers are "integral" (Deleuze, 2003: 116). What is integral about the digital synthesizer is the way in which it integrates all operations on sound and by sound, making it pass through binary codification. I do not think that Deleuze's distinction between the two kinds of synthesizers actually holds historically since it is the analog voltage-controlled synthesizer that introduces a control line operation on its modules. Likewise, digital synthesizers use a modular design. It is the case that a *cybernetic* model of codification is at work in both the analog

voltage-controlled synthesizers and early digital synthesizers. Deleuze further argues in this text that it is modulation (which can be seen in the example of the subtractive synthesis of frequencies in analog synthesizers) that characterizes the analog. It should, however, be noted that in a much later text Deleuze argues that modulation is characteristic of *control* societies, which characteristically are also codified digitally. I think he later realized that it is not the digital nor the analog per se that are at stake but the question of the command-control model that is immanent to the logic of first-order cybernetics (Deleuze, 1992: 3–7). My thanks to Troy Rhoades for directing me to Deleuze's remarks on analog and digital synthesizers.

6. The term *heautonomy* is borrowed from Deleuze's work on the time-image in avant-garde cinema, in which he uses it to refer to the disjunction achieved between the acoustic and the visual in the films, for example, of Marguerite Duras (Deleuze, 2005: 247ff). Duras's cuts between sound and image deterritorialize the self-identity of the sonic and the optical, which in classical and narrative-based cinema tends toward the affirmation of a unification of the two. In VJing or music videos created by electronic audiovisual artists such as Kurokawa, the disjunction is not so much a "shock" as it is in avant-garde cinema as a modulation of the coherence that a repetitive bass track sets up.

7. I am making something of an assumption in my analysis of this video. From what I know of the way in which Kurokawa works, he uses both audio and video signal as generative forces on each other. So, for example, he may produce an audio track, which he will then use to cross-process video material. He might also then take this material and feed it back to affect the audio signal. My assumption in the analysis of this music video is that given he has been provided with the audio by another artist, he would have used the audio signal generatively to produce the pulses and intensities we find in the visuals. For further information about Kurokawa's working methods, see Kurokawa in Niesson (2006).

8. For general information about the MAX/MSP/Jitter environment, see the Cycling'74 website, available at http://cycling74.com/products/max. In particular, the page on "control" is interesting. As will be seen from a typical segment of a MAX patch on this page, although the software proclaims its ease of control, this is because, as it says, "everything is connected to everything." See http://cycling74.com/products/maxmspjitter/control/. Effectively, then, control is less about a command line algorithm in this environment than it is about the capacity for anything to become a controller, that is, for any module of the customized environment to modulate any other module.

9. The concept of metadata has been around for about forty years and was first coined and then trademarked as Metadata by Jack E. Myers in 1973. In general, computer and information scientists and librarians agree that it is data about other data and that it is linked associatively to that other data both temporally and spatially, as, for example, with "tags" that provide keyword semantic descriptions of web content. In general computational terms, metadata handles and locates this "other data" in a more efficient way so that the bulk of the other data does not have to be processed. Its position is not entirely clear, though, as other data can become metadata too, and from the point of view of computational processing, metadata *is* just data. For a good overview of the emergence of the term, see Bellevue Linux Users Group (2006).

Chapter 7

1. The Orb is a device built by the company Ambient Devices and was first released in 2003. It is preset to track the Dow Jones Industrial Average and glows from green to red as the stock market moves up and down. See http://www.ambientdevices.com/about-us/consumer-products.

2. The Nabaztag is a "smart object" shaped like a rabbit, developed and manufactured by the company Violet and first released in 2005. The device was beset by a number of technical problems, including server connectivity and slow network data transmission times. During the Christmas period of 2006, as a huge number of customers tried to register their rabbits, with the Nabaztags operating as clients to their central company servers, service disruptions caused the registration process to break down. This meant that a number of customers created multiple half-completed registrations, also causing data corruption of the files. Violet, the name of the startup responsible for the product, responded to this on the Nabaztag blog with a press release titled "Press release from Violet, Paris Tuesday, December 26, 2006." The blog is no longer available but can be accessed as a cached version archived on the Wayback Machine using the following URL: http://web.archive.org/web/20070104232121/http://blog.nabaztag.com/2006/12/paris_tuesday_d.html. Violet went bankrupt in 2009 and was bought out by Mindscape. A third-generation rabbit, Karotz, was released in 2011. See http://store.karotz.com/en_US/.

3. *Lungs* was created by YoHa—the collaborative name for the duo Matsuko Yokokoji and Graham Harwood—in 2005. It was first exhibited as part of the show "Making Things Public: Atmospheres of Democracy," Zentrum für Kunst und Medientechnologie (ZKM), Karlsruhe, Germany, March 20–October 3, 2005.

4. An archive of the exhibition, participating artists, and image and video documentation can be found at http://on1.zkm.de/zkm/stories/storyReader$4581. A catalog and reader accompanying the show has been published (see Latour and Weibel, 2005).

5. Bateson uses the term *system* to describe these complex coupling/interaction assemblages (Bateson, 1978: 470ff). However, the idea of systems in Bateson has lost its nuances since, paradoxically, cybernetics has become more widespread. This is of course because a certain cybernetic machine—that of command, control, communication—has overcoded its other propensities. The system is what works, is efficient, and embeds "things" in their place. For Bateson, however, it is clear that systems are multideterminate, composed of levels of interactions and interactions between levels, heterogeneous and evolutionarily emergent. In fact, this leads him to sometimes substitute the idea of the network for that of the system:

It is characteristic of this complex network of determination of ideas (and actions) that particular links in the net are often weak but that any given idea or action is subject to multiple determination by many interwoven strands. We turn off the light when we go to bed, influenced partly by the economics of scarcity, partly by premises of transference, partly by ideas of privacy, partly to reduce sensory input, etc.

This multiple determination is characteristic of all biological fields. Characteristically, every feature of the anatomy of an animal or plant and every detail of behavior is determined by a multitude of interacting factors

at both the genetic and physiological levels; and, correspondingly, the processes of any ongoing ecosystem are the outcome of multiple determination. (Bateson, 1978: 476)

6. Contraptionist ecology shares much with what Michael Godard and Jussi Parikka call "unnatural ecologies," in their exploration of recent contributions to the field of media ecology:

Media ecology is itself a vibrant sphere of dynamics and turbulences including on its technical level. Technology is not only a passive surface for the inscription of meanings and signification, but a material assemblage that partakes in machinic ecologies. And, instead of assuming that "ecologies" are by their nature natural (even if naturalizing perhaps in terms of their impact on capacities of sensation and thought) we assume them as radically contingent and dynamic, in other words as prone to change. (Godard and Parikka, 2011)

I also include, within the sphere of recent theorizations of ecologies, Jane Bennett's wonderful and radical formulation, after Latour, of a public sphere in which nonhumans really do *matter*: "It seems that the appropriate unit of analysis for democratic theory is neither the individual human nor an exclusively human collective but the (ontologically heterogeneous) public coalescing around a problem" (Bennett, 2010: 108).

7. An example of the hype surrounding the "emancipatory" conflation of users and producers via human-computer, and especially in online interaction, can be seen in *Time* magazine's declaration that "You" are the 2006 person of the year:

It's a story about community and collaboration on a scale never seen before. It's about the cosmic compendium of knowledge Wikipedia and the million-channel people's network YouTube and the online metropolis MySpace. It's about the many wresting power from the few and helping one another for nothing and how that will not only change the world, but also change the way the world changes. (Grossman, 2006)

Here not only have "you" become active and generative of media and culture, but "you" have become plural, all of which assumes, rather stupidly, that neither activity nor plurality previously constituted humanness to any such degree.

8. I am referring to the article written by Laurent Beslay and Hannu Hakala (2005), who are members of the Institute for Prospective Technological Studies, Seville, part of the European Union's Joint Research Centre, a network of seven research institutes across the EU. This is not to say that all research coming out of this network carries the same concerns for rescuing the human from the interchangeable transactionalism of pervasive media. But it is unsurprising that the EU should sponsor research that advocates human rights in the information age, such as the right to privacy.

9. Spurse is a collaborative consultancy of ten core members whose expertise crosses design, architecture, urban practices, computer systems development, historical research, community facilitation, and engineering. Their noncore members and other collaborators number up to another sixty people, depending on the suite of current projects. Their membership structure and working practices are rigorously researched and developed rather than being organizationally loose, as are many art and design collectives. Further information and extensive documentation of their projects can be found at http://www.spurse.org.

10. The term *research-creation* is here used in the sense put forward in issue 1 of the journal *Inflexions*. This sense is explicated in Alanna Thain's editorial for the issue: "Research implies an

attentive posture, an openness to what is already happening, an expanded perception of what we are already participating in" (Thain, 2009). Such an expanded field for research, which ties it relationally to practices of creation, has been rigorously worked on by The SenseLab since 2004 when it was initiated by Erin Manning in Montreal. The SenseLab has led to the *Inflexions* journal and a range of other ethico-aesthetic research events. See http://senselab.ca/.

11. For further information about this project, see the documentation at http://www.spurse.org/projects/working-waters/. See also Community News (2004).

Bibliography

Abiteboul, Serge, Richard Hull, and Victor Vianu. 1995. *Foundations of Databases*. Reading, Mass.: Addison-Wesley.

Agamben, Giorgio. 2009. *What Is an Apparatus? and Other Essays*. Trans. David Kishik and Stefan Pedatella. Stanford: Stanford University Press.

AlexK. 2006. "Why Does Germany Suddenly Look Different?" *Google Earth Hacks Forum*, March 24. Available at http://www.googleearthhacks.com/forums/showthread.php?t=5935&page=1&pp=15

Altman, Lawrence. 2009. "Is This a Pandemic? Define 'Pandemic.'" The Doctor's World. *New York Times* online, June 8. Available at http://www.nytimes.com/2009/06/09/health/09docs.html

Amerika, Mark. 2007. *META/DATA: A Digital Poetics*. Cambridge, Mass.: MIT Press.

Anderson, Chris. 2004. "The Long Tail." *Wired* 12.10. Available at http://www.wired.com/wired/archive/12.10/tail.html?pg=4&topic=tail&topic_set=

Arbib, Mark, Aude Billard, Marco Iacoboni, and Erhan Oztop. 2000. "Synthetic Brain Imaging: Grasping, Mirror Neurons and Imitation." *Neural Networks* 13 (8–9): 975–997.

Arquilla, John, and David Ronfeldt. 1999. *The Emergence of Noopolitik: Toward an American Information Strategy*. Santa Monica, Calif.: RAND Corporation.

Bachman, Charles. 1973. "The Programmer as Navigator." *Communications of the ACM* 16 (11):269–285.

Barabási, Albert-László. 2002. *Linked: The New Science of Networks*. New York: Basic Books.

Barabási, Albert-László, and Reka Albert. 1999. "Emergence of Scaling in Random Networks." *Science* (October 15):509–512.

Baran, Paul. 1990, "Interview with Paul Baran." Judy O'Neill, March 5, Menlo Park, Calif., Charles Babbage Institute, University of Minnesota, Minneapolis. Available at http://special.lib.umn.edu/cbi/oh/display.phtml?term=Baran&search=Submit

Baran, Paul. 1964. "On Distributed Communications." Memorandum, RM-3420-PR, August, Santa Monica, Calif.: RAND Corporation. Available at http://www.rand.org/pubs/research_memoranda/2006/RM3420.pdf

Bateson, Gregory. 2002. *Mind and Nature: A Necessary Unity*. Cresskill, N.J.: Hampton Press.

Bateson, Gregory. 1978. *Steps to an Ecology of Mind: Collected Essays in Anthropology, Psychiatry, Evolution and Epistemology*. St. Albans: Paladin Books.

Bellevue Linux Users Group. 2006. "Metadata Definition." *The Linux Information Project*. Available at http://www.linfo.org/metadata.html

Benkler, Yochai. 2006. *The Wealth of Networks*. New Haven: Yale University Press.

Bennett, Jane. 2010. *Vibrant Matter: A Political Ecology of Things*. Durham: Duke University Press.

Bergson, Henri. 1920. "Intellectual Effort." In *Mind-Energy: Lectures and Essays*, trans. H. Wildon Carr, 186–230. New York: Henry Holt.

Berners-Lee, Tim, and Robert Cailliau. 1990. "World-Wide Web: Proposal for a Hypertext Project." Worldwide Web Consortium, original memorandum. Available at http://www.w3.org/Proposal.html

Bertelsen, Lone, and Andrew Murphie. 2010. "An Ethics of Everyday Infinities and Powers: Félix Guattari on Affect and the Refrain." In *The Affect Reader*, ed. Melissa Gregg and Greg Seigworth, 138–157. Durham: Duke University Press.

Beslay, Laurent, and Hannu Hakala. 2005. "Digital Territories: Bubbles." Draft paper, 1–11. Available at http://cybersecurity.jrc.ec.europa.eu/docs/DigitalTerritoryBubbles.pdf

Bilton, Nick. 2010. "Has Viral Gone Viral?" BITS weblog. *New York Times* online, March 29. Available at http://bits.blogs.nytimes.com/2010/03/29/has-viral-gone-viral/

Blackmore, Susan. 1999. *The Meme Machine*. Oxford: Oxford University Press.

Bloomberg Businessweek. 2006. "So Much Fanfare, So Few Hits." *Business Week* online, July 10. Available at http://www.businessweek.com/magazine/content/06_28/b3992051.htm?campaign_id=search

Bogue, Ronald. 2003. *Deleuze on Music, Painting and the Arts*. London: Routledge.

Bookchin, Natalie, and Blake Stimson. 2011. "Out in Public: Natalie Bookchin in Conversation with Blake Stimson." In *Video Vortex Reader II: Moving Images Beyond YouTube*, ed. Geert Lovink and Rachel Sommers Miles. Amsterdam: Institute of Network Cultures.

Bosteels, Bruno. 2001. "From Text to Territory: Felix Guattari's Cartographies of the Unconscious." In *Deleuze and Guattari: Critical Assessments of Leading Philosophers*, ed. Gary Genosko, vol. 2, 881–910. London: Routledge.

Bourriaud, Nicolas. 1998. *Relational Aesthetics*. Paris: Les Presses du Réel.

Bibliography

Bricken, Meredith. 1991. "Virtual Reality: No Interface to Design." In *Cyberspace: First Steps*, ed. M. Benedikt. Cambridge, Mass.: MIT Press.

Brin, Sergey, and Lawrence Page. 1998. "The Anatomy of a Large-Scale Hypertextual Web Search Engine." Seventh International World-Wide Web Conference, April 14–18, 1998, Brisbane, Australia. Available at http://ilpubs.stanford.edu:8090/361/

Bruno, Christophe. 2006. "Interview with Christophe Bruno, Media Interventionist." *Neural* magazine (English edition), 25:43.

Buccino, G., F. Binkofski, G. R. Fink, L. Fadiga, L. Fogassi, V. Gallese, R. J. Seitz, K. Zilles, G. Rizzolatti, and H. J. Freund. 2001. "Action Observation Activates Premotor and Parietal Areas in a Somatotopic Manner: An fMRI Study." *European Journal of Neuroscience* 13 (2):400–404.

Bucksbarg, Andrew. 2008. "VJing and Live A/V Practices'. *VJTheory*. VJTheory.net: Realtime Books. Available at http://www.vjtheory.net/web_texts/text_bucksbarg.htm

Burgess, Jean. 2008. "All Your Chocolate Rain Are Belong to Us: Viral Video, YouTube and the Dynamics of Participatory Culture." In *Video Vortex Reader: Responses to YouTube*, ed. Geert Lovink and Sabine Niederer, 101–110. Amsterdam: Institute for Network Cultures.

Bush, Vannevar. 1945. "As We May Think." *Atlantic Magazine* online. Available at http://www.theatlantic.com/magazine/archive/1969/12/as-we-may-think/3881/

Buzzfeed. 2011. "Make Your Ideas Viral." Buzzfeed Inc. Available at http://www.buzzfeed.com/signup

van Campen, Cretien. 1997. "Synaesthesia and Artistic Experimentation." *Psyche* 3. Available at http://journalpsyche.org/ojs-2.2/index.php/psyche/article/view/2358/2290.

Carr, Nicholas. 2010a. *The Shallows: What the Internet Is Doing to Our Brains*. New York: W.W. Norton.

Carr, Nicholas. 2010b. "The Web Shatters Focus, Rewires Brains." *Wired*, May 24. Available at http://www.wired.com/magazine/2010/05/ff_nicholas_carr/all/1

Catts, Oron, and Ionat Zurr. 2002. "Growing Semi-Living Sculptures: The Tissue Culture & Art Project." *Leonardo* 35 (4):365–370.

Centers for Disease Control and Prevention. 2007. "Hhs Unveils Two New Efforts to Advance Pandemic Flu Preparedness." Press release, Department of Health and Human Services, United States Government, February 1. Available at http://www.cdc.gov/media/pressrel/2007/r070201a.htm

Chan, Margaret. 2010. "WHO Director-General's Letter to BMJ Editors." June 8, Media Centre, World Health Organization. Available at http://www.who.int/mediacentre/news/statements/2010/letter_bmj_20100608/en/index.html

Chan, Margaret. 2009. "World Now at the Start of 2009 Influenza Pandemic." World Health Organization, media release. Available at http://www.who.int/mediacentre/news/statements/2009/h1n1_pandemic_phase6_20090611/en/index.html

Childs, David L. 1968. "Description of Set Theoretic Data Structure." Technical Report, College of Engineering, University of Michigan. Available at http://deepblue.lib.umich.edu/handle/2027.42/4163

Clemens, Justin, Dodds Christopher, and Adam Nash. 2009. *Autoscopia* website. Available at http://www.autoscopia.net/

Clemens, Justin, and Adam Nash. 2011. "Take a Good Hard Look at Yourself: *Autoscopia* and the Networked Image." In *New Imaging: Transdisciplinary Strategies beyond the New Media*, ed. Su Baker, Melanie Oliver, and Paul Thomas, 39–49. Column 7. Sydney: Artspace.

Codd, Edgar F. 1970. "A Relational Model of Data for Large Shared Data Banks." *Communications of the ACM* 13 (6):377–387.

Cohen, Noam. 2007. "Google Halts 'Miserable Failure' Link to President Bush." *New York Times* online, January 29. Available at http://www.nytimes.com/2007/01/29/technology/29google.html?_r=1

Community News. 2004. "Mapping the Working Coasts: Using Art to Understand the Waterfront." *Maine Arts Commission Magazine*, Fall. Available at http://www.spurse.org/projects/working-waters/

Comscore.com. 2010. "Facebook Captures Top Spot among Social Networking Sites in India." ComScore Inc. press release, August 25. Available at http://www.comscore.com/Press_Events/Press_Releases/2010/8/Facebook_Captures_Top_Spot_among_Social_Networking_Sites_in_India/%28language%29/eng-US

Connolly, William. 2002. *Neuropolitics: Thinking, Culture, Speed*. Minneapolis: University of Minnesota Press.

Cox, Christopher. 2002. "From Synapse to Signal." *Autopilot,* catalogue, 14–17. Berlin: Die Gestalten-Verlag.

Crampton, Jeremy W. 2010. *Mapping: A Critical Introduction to Cartography and GIS*. Oxford: Wiley-Blackwell.

Crampton, Jeremy W. 2003. *The Political Mapping of Cyberspace*. Chicago: University of Chicago Press.

Cunningham, J. E., F. Uri Gronemann, T. S. Huang, J. W. Pan, O. J. Tretiak, W. F. Schreiber, S. Asano, J. Ziv, L. Kleinrock, and D. N. Arden. 1962. "Processing and Transmission of Information." *Research Laboratory of Electronics Quarterly Progress Report*, Massachusetts Institute of Technology, April 15: 156–160. Available at http://hdl.handle.net/1721.1/53693

Cunningham, J. E., F. Uri Gronemann, T. S. Huang, J. W. Pan, O. J. Tretiak, W. F. Schreiber, S. Asano, J. Ziv, L. Kleinrock, and D. N. Arden. 1961. "Processing and Transmission of Information." *Research Laboratory of Electronics Quarterly Progress Report*, Massachusetts Institute of Technology, July 15: 162–163. Available at http://hdl.handle.net/1721.1/53595

Cytowic, Richard. 1997. "Synaesthesia: Phenomenology and Neuropsychology." In *Synaesthesia: Classic and Contemporary Readings*, ed. Simon Baron-Cohen and John Harrison, 17–42. Oxford: Blackwell.

Da Costa, Pedro Nicolaci. 2011. "Global Economy Week Ahead—Revolution and Some inflation." *Reuters Africa*, February 13. Available at http://af.reuters.com/article/egyptNews/idAFN11176067 20110213?sp=true

Damasio, Antonio. 1989. "Time-Locked Multiregional Retroactivation: A Systems-Level Proposal for the Neural Substrates of Recall and Recognition." *Cognition* 33:25–62.

Damasio, Antonio, and Kaspar Meyer. 2008. "Beyond the Looking Glass." *Nature* 454:167–168.

Daniel, Caroline, and Maija Palmer. 2007. "Google's Goal: To Organise Your Daily Life." *Financial Times*, Financial Times.com, May 22. Available at http://www.ft.com/cms/s/2/c3e49548-088e-11dc-b11e-000b5df10621,dwp_uuid=e8477cc4-c820-11db-b0dc-000b5df10621.html#axzz1BL6wN8lo

Davey, Nicholas. 2007. "Aesthetics." In *The Edinburgh Companion to Twentieth Century Philosophies*, ed. Constantin V. Boundas, 615–628. Edinburgh: Edinburgh University Press.

Davies, Donald W. 1986. "D. W. Davies interviewed by M. Campbell Kelly." National Physical Laboratory, Charles Babbage Institute, University of Minnesota, Minneapolis, March 17: 1–34. Available at http://www.cbi.umn.edu/oh/display.phtml?id=116

Dawkins, Richard. 1989. *The Selfish Gene*. Oxford: Oxford University Press.

Deleuze, Gilles. 2005. *Cinema 2: The Time-Image*. London: Continuum.

Deleuze, Gilles. 2003. *Francis Bacon: The Logic of Sensation*. London: Continuum.

Deleuze, Gilles. 1994. *Difference and Repetition*. Trans. Paul Patton. New York: Columbia University Press.

Deleuze, Gilles. 1993. *The Fold*. Trans. Tom Conley. Minneapolis: University of Minnesota Press.

Deleuze, Gilles. 1992. "Postscript on the Societies of Control." *October* 59 (3):3–7.

Deleuze, Gilles. 1988. *Foucault*. Minneapolis: University of Minnesota Press.

Deleuze, Gilles, and Félix Guattari. 1994. *What Is Philosophy?* London: Verso.

Deleuze, Gilles, and Félix Guattari. 1987. *A Thousand Plateaus*. Trans. Brian Massumi. London: Athlone Press.

ditch. 2007. "mysterious hoze." With Rioychi Kurokawa, video director. Music video. Available at http://www.youtube.com/user/opdisc#p/a/u/1/_eqBT6YbXBs

Doidge, Norman. 2007. *The Brain That Changes Itself: Stories of Personal Triumph from the Frontiers of Brain Science*. New York: Penguin.

Donath, Judith. 2006. "Sociable Media." In *Berkshire Encyclopaedia of Human-Computer Interaction*, 627–633. Great Barrington, Mass.: Berkshire Publishing Group.

Doruff, Sher. 2007. "Extreme Intervals and Sensory Fusions: The Hinge." Conference proceedings, Mutamorphosis: Challenging Arts and Sciences, Prague. Available at http://mutamorphosis.wordpress.com/2009/03/01/extreme-intervals-and-sensory-fusions-the-hinge/

Dragan, Richard V. 2005. "Google Earth 3.0." Review, *PC Magazine*, June 28. Available at http://www.pcmag.com/article2/0,1895,1831854,00.asp

Duchenout, Nicholas, and Robert J. Moore. 2004. "The Social Side of Gaming: A Study of Interaction Patterns in a Massively Multiplayer Online Game." In *Proceedings of the 2004 ACM conference on Computer Supported Cooperative Work*, 360–369. New York: ACM Press.

Dumit, Joseph. 2004. *Picturing Personhood: Brain Scans and Biomedical Identity*. Princeton: Princeton University Press.

Dumit, Joseph. 1999. "Objective Brains, Prejudicial Images." *Science in Context* 12 (1):173–201.

Edelstein, Henry. 2005. *Introduction to Data Mining and Knowledge Discovery*. Potomac, Md.: Two Crows Corporation.

Edwards, Paul E. 1996. *The Closed World*. Cambridge, Mass.: MIT Press.

Ekman, Paul, and Warren Friesen. 1986. "A New Pancultural Facial Expression of Emotion." *Motivation and Emotion* 10 (2):159–168.

Eliasson, Olafur, and Chris Gilbert. 2004. "Interview with Olafur Eliasson." *BOMB*, 88. Available at http://www.bombsite.com/issues/88/articles/2651

Engel, Jerome, Timothy A. Pedley, and Jean Aicardi. 2008. *Epilepsy: A Comprehensive Textbook*. Vol. 1. Philadelphia: Lippincott Williams & Wilkins.

Fayyad, Usama, Gregory Piatetsky-Shapiro, and Padharaic Smyth. 1996. "From Data Mining to Knowledge Discovery in Databases." *AI Magazine* (Fall):37–54.

Foucault, Michel. 2007. *Security, Territory, Population: Lectures at the Collège de France, 1977–1978*. Ed. Michele Senellart, trans. Graham Burchell. New York: Palgrave.

Foucault, Michel. 1991. "Governmentality." In *The Foucault Effect: Studies in Governmentality*, ed. Graham Burchell, Colin Gordon, and Paul Miller, 87–104. Chicago: University of Chicago Press.

Foucault, Michel. 1980a. "The Confession of the Flesh." In *Power/Knowledge: Selected Interviews and Other Writings*, ed. Colin Gordon, 194–228. New York: Pantheon Books.

Foucault, Michel. 1980b. "The Politics of Health in the 18th Century." In *Power/Knowledge: Selected Interviews and Other Writings*, ed. Colin Gordon, 166–182. New York: Pantheon Books.

Foucault, Michel. 1973. *The Birth of the Clinic: An Archaeology of Medical Perception*. London: Tavistock.

Fried, Michael. 1988. "Art and Objecthood." In Fried, *Art and Objecthood: Essays and Reviews*, 148–172. Chicago: University of Chicago Press.

Fuller, Matthew. 2010. "Pits to Bits, Interview with Graham Harwood." Matthew Fuller personal website. Available at http://www.spc.org/fuller/interviews/pits-to-bits-interview-with-graham-harwood/

Fuller, Matthew. 2003. *Behind the Blip: Essays on the Culture of Software*. New York: Autonomedia.

Fuller, Matthew, and Andrew Goffy. 2009. "Towards an Evil Media Studies." In *The Spam Book: On Viruses, Porn and Other Anomalies from the Dark Side of Digital Culture*, ed. Jussi Parikka and Tony Sampson, 141–159. Cresskill, N.J.: Hampton Press.

Fuller, Gillian, and Ross Harley. 2011. "The Protocological Surround: Reconceptualizing Radio and Architecture in the Wireless City." In *From Social Butterfly to Engaged Citizen: Urban Informatics, Social Media, Ubiquitous Computing, and Mobile Technology to Support Citizen Engagement*, ed. M. Foth, L. Forlano, C. Satchell, and M. Gibbs, 39–54. Cambridge, Mass.: MIT Press.

Galloway, Alex, and Eugene Thacker. 2007. *The Exploit: A Theory of Networks*. Minneapolis: University of Minnesota Press.

Genosko, Gary. 2002. *Felix Guattari: An Aberrant Introduction*. London: Continuum.

Gibbs, Anna. 2008. "Panic? Affect Contagion, Mimesis and Suggestion in the Social Field." *Cultic Studies Review* 14 (2):130–145.

Gibbs, Anna. 2001. "Contagious Feelings: Pauline Hanson and the Epidemiology of Affect." *Australian Humanities Review*, September. Available at http://www.australianhumanitiesreview.org/archive/Issue-September-2001/gibbs.html

Gibson, William. 2010. "Google's Earth." *New York Times* online, August 31. Available at http://www.nytimes.com/2010/09/01/opinion/01gibson.html?_r=6

Godard, Michael, and Jussi Parikka. 2011. "Editorial." *Unnatural Ecologies, The Fibreculture Journal*, 17. Available at http://seventeen.fibreculturejournal.org/

Godlee, Fiona. 2010. "Conflicts of Interest and Pandemic Flu." *British Medical Journal* 340:2947.

Goodwin, Jacob. 2005. "Inside Able Danger: The Secret Birth, Extraordinary Life and Untimely Death of a U.S. Military Intelligence Program." *Global Security News Magazine*, September. Available at http://www.gsnmagazine.com/sep_05/shaffer_interview.html

Google. 2010. "Understanding Google Earth Imagery." Google Earth website. Available at http://earth.google.com/support/bin/answer.py?answer=176147

Google. 1999. "Google's New GoogleScout Feature Expands Scope of Search on the Internet." Google Press Center website. Available at http://www.google.com/press/pressrel/pressrelease4.html

Google Earth Community. 2005. "Google Earth—Common Questions." Google Earth Community forum. Available at http://bbs.keyhole.com/ubb/ubbthreads.php?ubb=showthreaded&Number=89366

Google Inc. 2011. "Google Corporate." Google Corporate website. Available at http://www.google.com/corporate/

Gouchenour, Philip H. 2006. "Distributed Communities and Nodal Subjects." *New Media and Society* 8 (1):33–51.

Graham, Stephen. 2009. "The Urban 'Battlespace.'" *Theory, Culture and Society* 26:278–287.

Granovetter, Mark. 1973. "The Strength of Weak Ties." *American Journal of Sociology* 78 (6): 1360–1380.

Greenfield, Susan. 2009. "Screen Culture May Be Changing Our Brains." Interview with Kerry O'Brien for the 7:30 Report, Australian Broadcasting Commission, March 19. Transcript available at http://www.abc.net.au/7.30/content/2009/s2521139.htm

Grossman, Lev. 2006. "You—Yes, You—Are TIME's Person of the Year." *Time Magazine US* online, December 25. Available at http://www.time.com/time/magazine/article/0,9171,1570810,00.html

Guattari, Félix. 2008. *The Three Ecologies*. Trans. Ian Pindar and Paul Sutton. London: Continuum.

Guattari, Félix. 1996. *The Guattari Reader*. Ed. Gary Genosko. Oxford: Blackwell.

Guattari, Félix. 1995. *Chaosmosis: An Ethico-aesthetic Paradigm*. Trans. Paul Bains and Julian Pefanis. Sydney: Power Publications.

Guattari, Félix. 1974. *Molecular Revolutions: Psychiatry and Politics*. New York: Puffin.

Guattari, Félix, and Suely Rolnik. 2008. *Molecular Revolution in Brazil*. Trans. Karel Clapshow and Brian Holmes. New York: Semiotext(e).

Hansell, Saul. 2006. "Marketers Trace Paths Users Leave on Internet." *New York Times* online, August 15. Available at http://query.nytimes.com/gst/fullpage.html?res=9C0DEFD9173EF936A2575BC0A9609C8B63&sec=&spon=

Hansen, Mark. 2006. *New Philosophy for New Media*. Cambridge, Mass.: MIT Press.

Hare, R. M. 1981. *Moral Thinking: Its Levels, Method, and Point*. Oxford: Oxford University Press.

Harrison, John E., and Simon Baron-Cohen. 1997. "Synaesthesia: An Introduction." In *Synaesthesia: Classic and Contemporary Readings*, ed. Simon Baron-Cohen and John E Harrison, 3–16. Oxford: Blackwell.

Harwood, Graham, with Anthony Iles. 2010. "In the Mud and Blood of Networks: An Interview with Graham Harwood." *MetaMute*. Available at http://www.metamute.org/en/articles/interview_with_graham_harwood

Hayles, N. Katherine. 2007. "Hyper and Deep Attention: The Generational Divide in Cognitive Modes." *Profession* 1:187–199.

Heylighen, Francis. 1996. "Evolution of Memes on the Network: from Chain Letters to the Global Brain." In *Memesis: The Future of Evolution*, ed. Ingrid Fischer, 48–57. Ars Electronica catalogue. Vienna: Springer.

Hofman, Heike. 2003. "Mosaic Plots and Their Variants." In *Handbook of Data Visualisation*, ed. C. Chen, W. Härdle, and A. Unwin, 619–642. Berlin: Springer.

Holmes, Brian. 2008. "Counter Cartographies." In *Elsewhere Mapping: New Cartographies of Networks and Territories*, ed. Janet Abrams and Peter Hall, 20–25. Minnesota: University of Minnesota Design Press.

Howe, Daniel C., and Helen Nissenbaum. 2009. "TrackMeNot: Resisting Surveillance in Web Search." In *Lessons from the Identity Trail: Anonymity, Privacy and Identity in a Networked Society*, ed. Ian Kerr, Carole Lucock, and Valerie Steeves, 417–440. Oxford: Oxford University Press.

Howe, Daniel C., and Helen Nissenbaum. 2006. *TrackMeNot* website. Available at http://mrl.nyu.edu/~dhowe/TrackMeNot/

Jacquet, Yannick, and Thomas Vaquié. 2011. "St Gervais Interview." *AntiVJ Vimeo* online video channel. Available at http://vimeo.com/channels/5119

James, William. 2008. *A Pluralistic Universe*. Rockville, Md.: Arc Manor.

James, William. 1992. *Writings: 1879–1899*. New York: Library of America.

James, William. 1979. *Some Problems in Philosophy*. Cambridge, Mass.: Harvard University Press.

James, William. 1977. *The Writings of William James: A Comprehensive Edition*. Ed. J. J. Mc Dermott. Chicago: University of Chicago Press.

James, William. 1912. *Essays in Radical Empiricism*. New York: Longmans, Green.

Jansz, Jeroen, and Lonneke Martens. 2005. "Gaming at a LAN Event: The Social Context of Playing Video Games." *New Media and Society* 7 (3):333–355.

Jenkins, Holman. 2010. "Google and the Search for the Future." *Wall Street Journal*, Wall Street Journal Digital Network, August 10. Available at http://online.wsj.com/article/SB10001424052748704901104575423294099527212.html

Johnston, John. 2008. *The Allure of Machinic Life: Cybernetics, Artificial Life, and the New AI*. Cambridge, Mass.: MIT Press.

Kahn, Richard, and Doug Kellner. 2005. "Oppositional Politics and the Internet: A Critical/Reconstructive Approach." *Cultural Politics* 1 (1):75–100.

Kanai, Ryota, Bahador Bahrami, Rebecca Roylance, and Geraint Rees. 2011. "Online Social Network Size Is Reflected in Human Brain Structure." *Proceedings of the Royal Society, Series B: Biological Sciences*. Available at http://rspb.royalsocietypublishing.org/content/early/2011/10/12/rspb.2011.1959.full?sid=bdc5f98b-ea8a-4cb3-a864-15af80cb24f9

Karotz blog. 2011. "Karotz Points His Ears Straight Up in March 2011!" Karotz weblog. Available at http://blog.karotz.com/?p=1545&lang=en

Kelso, J. A. Scott. 2010. "Metastable Mind." In *Cognitive Architecture: From Biopolitics to Noopolitics—Architecture and Mind in the Age of Communication and Information*, 116–141. Rotterdam: 010 Publishers.

Kerr, Iain. 2011. "Systems and Things Diagrammed." Iain Kerr personal website. Available at http://iainakerr.com/iainkerr/spurse_dia.html

Kerr, Iain. 2008. "Notes on Immanent Assemblages." In *Useful Pictures*, ed. Adelheid Mers, 108–109. Chicago: Whitewalls.

Kleinrock, Leonard. 2005. "Kleinrock on Nomadic Computing: *Ubiquity* Interviews Leonard Kleinrock (Inventor of Packet-Switching)." *Ubiquity* 6 (25):12–19. Available at http://www.acm.org/ubiquity/interviews/v6i25_kleinrock.html

Kline, Morris. 1972. *Mathematical Thought from Ancient to Modern Times*. Vol. 3. Oxford: Oxford University Press.

Knouf, Nicholas. 2009a. *MAICgregator* website. Available at http://maicgregator.org

Knouf, Nicholas. 2009b. "Mining the Military-Academic-Industrial Complex in a Poetic-Serious Fashion." *MAICgregator* website. Available at http://maicgregator.org/statement

Kolb, Robert. 2011. "What Is Financial Contagion." In *Financial Contagion: The Viral Threat to the Wealth of Nations*, ed. Robert Kolb, 3–10. Hoboken, N.J.: Wiley.

Krebs, Vladis. 2002. "Uncloaking Terrorist Networks." *First Monday* 7 (4) (April 1). Available at http://firstmonday.org/htbin/cgiwrap/bin/ojs/index.php/fm/article/view/941/863

Kriegeskorte, Nikolaus, W. Kyle Simmons, Patrick S. Bellgowan, and Chris I. Baker. 2009. "Circular Analysis in Systems Neuroscience: The Dangers of Double Dipping." *Nature Neuroscience* 12:535–540.

Kurokawa, Rioyichi. dir. 2007. "mysterious hoze." Music video, music by ditch, op. disc label. Available at http://www.youtube.com/user/opdisc#p/a/u/1/_eqBT6YbXBs

Kurokawa, Rioyichi, and Bertram Niesson. 2006. "Rioyichi Kurokawa: Perspective and Nature [Interview]." *Digimag*, September 17. Available at http://www.digicult.it/digimag/article.asp?id=627

Lanier, Jaron. 2010. *You Are Not a Gadget: A Manifesto*. New York: Knopf.

Latour, Bruno. 2010. "Tarde's Idea of Quantification." In *The Social after Gabriel Tarde: Debates and Assessments*, ed. Matei Candea, 145–162. London: Routledge.

Latour, Bruno. 2005. "From Realpolitik to Dingpolitik or How to Make Things Public." In *Making Things Public*, ed. Bruno Latour and Peter Weibel, 14–41. Cambridge, Mass.: MIT Press.

Latour, Bruno. 2002. "Gabriel Tarde and the End of the Social." In *The Social in Question: New Bearings in History and Social Science*, ed. Patrick Joyce, 117–132. London: Routledge.

Latour, Bruno. 1999. "On Recalling ANT." In *Actor Network Theory and After*, ed. John Law and John Hassard, 15–25. Oxford: Blackwell-Wiley.

Latour, Bruno. 1993. *We Have Never Been Modern*. Cambridge, Mass.: Harvard University Press.

Latour, Bruno, and Peter Weibel, eds. 2005. *Making Things Public: Atmospheres of Democracy*. Cambridge, Mass.: MIT Press.

Lazzarato, Maurizio. 2006a. "The Machine." *Transversal*, 11. Available at http://eipcp.net/transversal/1106/lazzarato/en

Lazzarato, Maurizio. 2006b. "The Concepts of Life and the Living in the Societies of Control." In *Deleuze and the Social*, ed. Martin Fuglsang and Bent Meyer Sorenson, 171–190. Edinburgh: Edinburgh University Press.

Lazzarato, Maurizio. 2004. "General Intellect: Towards an Inquiry into Immaterial Labour." *Multitudes* 4 (Summer). Available at http://multitudes.samizdat.net/General-intellect

Lazzarato, Maurizio. 2002. "From Biopower to Biopolitics." *Pli. Warwick Journal of Philosophy* 13:99–113.

Lazzarato, Maurizio. 1996. "Immaterial Labour." In *Radical Thought in Italy: A Potential Politics*, ed. Michael Hardt and Paulo Virno, 133–147. Minneapolis: University of Minnesota Press.

Liailina, Olia. 2007. "Vernacular Web 2.0." New Network Theory conference, Institute of Network Cultures, University of Amsterdam, June 28–30. Also available at http://www.contemporary-home-computing.org/vernacular-web-2/

Licklider, J. C. 1963. "Members and Affiliates of the Intergalactic Computer Network." Memorandum. Available at http://www.kurzweilai.net/memorandum-for-members-and-affiliates-of-the-intergalactic-computer-network

Lovink, Geert, and Ned Rossiter. 2005. "Dawn of the Organised Networks." *Precarious Labour, The Fibreculture Journal,* 5. Available at http://journal.fibreculture.org/issue5/lovink_rossiter.html

Luhmann, Niklas. 2008. "The Autopoiesis of Social Systems." *Journal of Sociocybernetics* 6 (2):84–92.

Mackenzie, Adrian. 2012. "Sets." In *Devices and the Happening of the Social*, ed. Celia Lury and Nina Wakefield, 219–231. London: Routledge.

Mackenzie, Adrian. 2010. *Wirelessness: Radical Empiricism and Network Media*. Cambridge, Mass: MIT Press.

Mackenzie, Adrian. 2007. "Protocols and the Irreducible Traces of Embodiment: The Viterbi Algorithm and the Mosaic of Machine Time." In *24/7: Time and Temporality in the Network Society*, ed. Robert Hassan and Ronald Purser, 89–108. Stanford: Stanford University Press.

Mackenzie, Adrian. 2006. *Cutting Code: Software and Sociality*. New York: Peter Lang.

MacNamara, Paul. 2010. "Facebook Unleashes Lawyers on Web 2.0 Suicide Machine." Buzzblog weblog. Available at http://www.networkworld.com/community/node/53078

Madrigal, Alexis. 2010. "Inside the Google Books Algorithm." *Atlantic Magazine* online, November 1. Available at http://www.theatlantic.com/technology/archive/2010/10/inside-the-google-books-algorithm/65422/

Manning, Erin. 2009. *Relationscapes: Movement, Art, Philosophy*. Cambridge, Mass.: MIT Press.

Manning, Peter. 2004. *Electronic and Computer Music*. Oxford: Oxford University Press.

Manovich, Lev. 2001. *The Language of New Media*. Cambridge, Mass.: MIT Press.

Marguiles, Daniel, and Chris Sharp. 2008. "Untitled." Online video, available at https://vimeo.com/9871689

Maturana, Humberto R. 2002. "Autopoiesis, Structural Coupling and Cognition: A History of These and Other Notions in the Biology of Cognition." *Cybernetics and Human Knowing* 9 (3–4): 5–34.

Maturana, Humberto R., and Francisco J. Varela. 1988. *The Tree of Knowledge: The Biological Roots of Human Understanding*. Boston, Mass.: Shambala.

Maturana, Humberto R., and Francisco J. Varela. 1980. *Autopoiesis and Cognition: The Realization of the Living*. Dordrecht: Riedel.

Massumi, Brian. 2011a. *Semblance and Event: Activist Philosophy and the Occurrent Arts*. Cambridge, Mass.: MIT Press.

Massumi, Brian. 2011b. "Conjunction, Disjunction, Gift." *Transversal*, "Inventions" issue, http://eipcp.net/transversal/0811/massumi/en

Massumi, Brian. 2010. "The Future Birth of the Affective Fact: The Political Ontology of Threat." In *Digital and Other Virtualities: Renegotiating the Image*, ed. Griselda Pollock and Antony Bryant, 79–92. London: I. B. Taurus.

Massumi, Brian. 2009. "Technical Mentality Revisited: Brian Massumi on Gilbert Simondon." With Arne de Boever, Alex Murray, and Jon Roffe. *Parrhesia*, 7: 36-45. Available at http://www.parrhesiajournal.org/past.html#issue07

Massumi, Brian. 2002. *Parables for the Virtual: Movement, Affect, Sensation*. Durham: Duke University Press.

Massumi, Brian. 1997. "Deleuze, Guattari, and the Philosophy of Expression." *Canadian Review of Comparative Literature* 24 (3):751–783.

Mayfield, Ross. 2005. "Social Network Dynamics and Participatory Politics." In *Extreme Democracy*, ed. Jon Lebkowsky and Mitch Ratcliffe. Lulu.com publishers

Mayer, Marissa. 2005. "Googlebombing 'Failure.'" The Official Google Blog, September 16. Available at http://googleblog.blogspot.com/2005/09/googlebombing-failure.html

McAlinden, Ryan, Andrew S. Gordon, H. Chad Lane, and David Pynadath. 2009. "UrbanSim: A Game-Based Simulation for Counterinsurgency and Stability-focused Operations." Workshop on Intelligent Educational Games, 14th International Conference on Artificial Intelligence in Education, Brighton, England, July 7. Available at http://people.ict.usc.edu/~gordon/sble.html

McCormack, Derek. 2010. "Thinking in Transition: The Affirmative Refrain of Experience/Experiment." In *Taking Place: Non-representational Theories and Geographies*, ed. Ben Anderson and Paul Harrison, 201–220. London: Ashgate.

Bibliography

McCulloch, Warren S., and Walter Pitts. 1943. "A Logical Calculus of the Ideas Immanent in Nervous Activity." *Bulletin of Mathematical Biology* 52 (1–2):99–115.

McLuhan, Marshall. 1997. *The Essential McLuhan*. Ed. Eric McLuhan and Frank Zingone. New York: Routledge.

MEART. 2011. "The Project." MEART website. Available at http://www.fishandchips.uwa.edu.au/project.html

Mejias, Ulises A. 2010. "The Limits of Networks as Models for Organizing the Social." *New Media and Society* 12 (4):603–617.

Melitopolous, Angela, and Maurizio Lazzarato. 2010. "Machinic Animism." In *Animism*, ed. Anselm Franke, vol. 1, 45–56. Berlin: Sternberg Press.

Mell, Peter, and Tim Grance. 2009. "The NIST Definition of Cloud Computing." National Institute of Standards and Technology website. Available at http://csrc.nist.gov/groups/SNS/cloud-computing/

Meltzoff, Andrew N., and Richard W. Borton. 1979. "Intermodal Matching by Human Neonates." *Nature* 282 (5737):403–404.

Mills, Elinor. 2006. "Will Search Keep Google on the Throne?" *CNET News* online. Available at http://news.cnet.com/Will-search-keep-Google-on-the-throne/2100-1032_3-6070774.html

Mitchell, John C. 2003. *Concepts in Programming Languages*. Cambridge: Cambridge University Press.

Mockenhaupt, Brian. 2010. "SimCity Baghdad." *Atlantic Magazine* online, January/February. Available at http://www.theatlantic.com/magazine/archive/2010/01/simcity-baghdad/7830/

Moddr. 2009. *Web 2.0 Suicide Machine* website. Available at http://suicidemachine.org/

Monge, Peter R, and Noshir S. Contractor. 2003. *Theories of Communication Networks*. Oxford: Oxford University Press.

Moore, Gordon E. 1965. "Cramming More Components onto Integrated Circuits." *Electronics* 38 (8):114–117.

Mullins, Craig. 2002. *Database Administration: The Complete Guide to Practices and Procedures*. Indianapolis: Addison-Wesley Professional.

Munster, Anna. 2009. "The Henson Photographs and the 'Network Condition.'" *Continuum: Journal of Media and Cultural Studies* 23 (1):3–12.

Munster, Anna. 2005. "Why Is Bioart Not Terrorism? Some Critical Nodes in the Networks of Life." *Culture Machine*, 7. Available at http://culturemachine.net/index.php/cm/article/view/31/38

Muntean, Nick. 2009. "Viral Terrorism and Terrifying Viruses: The Homological Construction of the 'War on Terror' and the Avian Flu Pandemic." *International Journal of Media and Cultural Politics* 5 (3):199–216.

Murphie, Andrew. 2010. "Deleuze, Guattari, and Neuroscience." In *The Force of the Virtual: Deleuze, Science, and Philosophy*, ed. Peter Gaffney, 277–300. Minneapolis: University of Minnesota Press.

Neufeld, M. Lynne, and Martha Cornog. 1986. "Database History: From Dinosaurs to Compact Discs." *Journal of the American Society for Information Science American Society for Information Science* 37 (4):183–190.

Nicolai, Carsten. 2000. *Telefunken*. Installation: cd player, cd, Sony Hiblack Trinitron Television, dimensions variable.

Nicolai, Carsten, and Hans Ulrich Obrist. 2002. "Hans Ulrich Obrist in Conversation with Carsten Nicolai." *Autopilot* catalogue, 74–82. Berlin: Die Gestalten-Verlag.

Nielsen, Jakob. 2001. "Designing Web Ads Using Click-through Data." *Alertbox* website, September 2. Available at http://www.useit.com/alertbox/20010902.html

Nielsen, Jakob. 2000. *Designing Web Usability: The Practice of Simplicity*. Indianapolis: New Riders.

Nielsen, Jakob. 1998. "Nielsen's Law of Internet Bandwidth." *Alertbox* website, April 5. Available at http://www.useit.com/alertbox/980405.html

Niessen, Bertram. 2006, "Ryoichi Kurokawa, Perspective and Nature." *Digimag* 17, September. Available at http://www.digicult.it/archivio/digimag_17eng/articoli/audiovideo_bertramniessen.html

Nirre, Robert. 2004. "Spatial Discursions. Flames of the Digital and Ashes of the Real: Confessions of a San Francisco Programmer." In *Life in the Wires: The CTheory Reader*, ed. Arthur and Marilouise Kroker, 260–268. Victoria, Canada: New World Perspectives/CTheory Books.

Noë, Alva. 2004. *Action in Perception*. Cambridge, Mass.: MIT Press.

Nunes, Rodrigo, and Ben Trott. 2008. "'There Is No Scope for Futurology; History Will Decide': Félix Guattari on Molecular Revolution." *Turbulence* 4. Available at http://turbulence.org.uk/turbulence-4/there-is-no-scope-for-futurology/

O'Reilly, Timothy. 2005. "What Is Web 2.0: Design Patterns and Business Models for the Next Generation of Software." O'Reilly weblog. Available at http://www.oreillynet.com/pub/a/oreilly/tim/news/2005/09/30/what-is-web-20.html?CMP=&ATT=2432.

Packer, Randall, and Ken Jordan. 2001. *Multimedia: From Wagner to Virtual Reality*. New York: Norton.

Papadopoulos, Dimitris, Niamh Stephenson, and Vassilis Tsianos. 2008. *Escape Routes: Control and Subversion in the Twenty-First Century*. London: Pluto Press.

Parikka, Jussi. 2007. *Digital Contagions: A Media Archaeology of Computer Viruses*. Oxford: Peter Lang.

Pasquinelli, Matteo. 2008. *Animal Spirits: A Bestiary of the Commons*. Amsterdam: NAI Publishers.

Pasternack, Alex. 2008. "Beijing Olympics: The Buildings." *Bloomberg Business Week* online, July 30. Available at http://www.businessweek.com/innovate/content/jul2008/id20080730_080833.htm?chan=innovation_architecture_architectural+showcase

Peirce, Charles Sanders. 1998. *The Essential Peirce: Selected Philosophical Writings, 1893–1913*. Vol. 2. Bloomington: Indiana University Press.

Peirce, Charles Sanders. 1933. *Collected Papers*. Ed. Charles Hartshorne and Paul Weiss. Vol. 4. Cambridge, Mass.: Harvard University Press.

Peirce, Charles Sanders. 1932. *Collected Papers*. Ed. Charles Hartshorne and Paul Weiss. Vol. 11. Cambridge, Mass.: Harvard University Press.

Peirce, Charles Sanders. 1870. *Description of a Notation for the Logic of Relatives*. Cambridge, Mass.: Welch, Bigelow and Company.

Peretti, Jonah. No date. "Contagious Media Experiments." *Contagious Media* website. Available at http://www.contagiousmedia.org/.

Peretti, Jonah. 2005. Interview by J. Chung. Arts and Events, *Gothamist* website. Available at http://gothamist.com/2005/06/04/jonah_peretti_director_of_rd_at_eyebeam.php

Petersen, Wolfgang, dir. 1995. *Outbreak*. Warner Bros. Productions, USA.

Phiffer, Dan, and Mushon Zer-Aviv. 2006–2011. *ShiftSpace* website. Available at http://www.shiftspace.org

Piccinini, Gualtiero. 2004. "The First Computational Theory of Mind and Brain: A Close Look at McCulloch and Pitts's 'Logical Calculus of Ideas Immanent in Nervous Activity.'" *Synthese* 141:175–215.

Polak, Esther, and Ivar van Bekkum. 2010. <*AbstractView*> website. Available at http://www.abstractview.tv/

Ramachandran, Vilayanur, and Sandra Blakeslee. 1998. *Phantoms in the Brain*. London: Fourth Estate.

Ramachandran, Vilayanur S., and Edward M. Hubbard. 2001. "Synaesthesia—A Window into Perception, Thought and Language." *Journal of Consciousness Studies* 8 (12):3–34.

RapidShare. 2010. "Anti-Waiting Lounge." *Rapidshare* website. Available at http://rapidshare.com/#!lounge

RFID FAQ. 2002–2011. "What's the Difference between Passive and Active Tags?" *RFID Journal* online. Available at http://www.rfidjournal.com/faq/18/68

RFID News. 2003. "Military Edict: Use RFID by 2005." *RFID Journal* online, October 3. Available at http://www.rfidjournal.com/article/view/604

Rizzolatti, Giacomo, and Laila Craighero. 2004. "The Mirror Neuron System." *Annual Review of Neuroscience* 27:169–192.

Rizzolatti, Giacomo, G. di Pellegrino, L. Fadiga, L. Fogassi, and V. Gallese. 1992. "Understanding Motor Events: A Neurophysiological Study." *Experimental Brain Research* 91:176–180.

Rogers, Richard. 2009. "The Googlization Question: Towards the Inculpable Engine?" In *Deep Search: The Politics of Search beyond Google*, ed. Konrad Becker and Felix Stalder, 173–184. Piscataway, N.J.: Transaction Publishers.

Rushkoff, Douglas. 2002. "Open Source Reality." In Richard Metzinger, *Disinformation: The Interviews*, 50–59. New York: Disinformation Company.

Rushkoff, Douglas. 1996. *Media Virus: Hidden Agendas in Popular Culture*. New York: Ballantine Books.

Sabisch, Petra. 2011. *Choreographing Relations: Practical Philosophy and Contemporary Choreography*. Munich: epodium Verlag.

Sampson, Tony. 2011. "Contagion Theory beyond the Microbe." *CTheory: Theory, Technology and Culture* 34:1–2. Available at http://www.ctheory.net/articles.aspx?id=675

Sedgwick, Eve Kosofsky, and Adam Frank. 2003. *Touching Feeling: Affect, Performativity, Pedagogy*. Durham: Duke University Press.

Serfaty, Viviane. 2004. *The Mirror and the Veil: An Overview of American Online Diaries and Blogs*. Amsterdam: Rodopi.

Sharma, Dinesh C. 2005. "Indian President Warns against Google Earth." *CNET News* online, October 17. Available at http://news.com.com/Indian+president+rails+against+Google+Earth/2100-1028_3-5896888.html

Shirkey, Clay. 2008. *Here Comes Everybody*. London: Penguin.

Simondon, Gilbert. 1992. "The Genesis of the Individual." In *Incorporations*, ed. Jonathan Crary and Sanford Kwinter, 297–319. New York: Zone Books.

SiteLogiq. 2012. SiteLogiq website. Available at http://sitelogiq.com/

Skipper, Jeremy I., Susan Goldin-Meadow, Howard C. Nusbaum, and Steven L. Small. 2007. "Speech-Associated Gestures, Broca's Area, and the Human Mirror System." *Brain and Language* 101:260–277.

Slyck. 2001–2011. "Slyck's Guide to BitTorrent." Slyck website. Available at http://www.slyck.com/bt.php?page=1

Spurse. 2011a. "spurse." spurse website. Available at http://www.spurse.org

Spurse. 2011b. "Working Waters." spurse website. Available at http://www.spurse.org/projects/working-waters/

Stafford, Barbara Maria. 2007. *Echo Objects: The Cognitive Work of Images*. Chicago: University of Chicago Press.

Stalbaum, Brett. 2006. "An Interpretive Framework for Contemporary Database Practice in the Arts." Paper presented at the College Art Association 94th annual conference, Boston. Available at http://rhizome.org/discuss/view/20448/

Stengers, Isabelle. 2009. "William James: An Ethics of Thought?" *Radical Philosophy* 157 (September/October):9–19.

Stephenson, Niamh, and Michelle Jamieson. 2009. "Securitising Health: Australian Newspaper Coverage of Pandemic Influenza." *Sociology of Health and Illness* 31 (4):525–539.

Sterling, Bruce. 2005. *Shaping Things*. Cambridge, Mass.: MIT Press.

Stern, Daniel. 2010. "The Issue of Vitality." *Nordic Journal of Music Therapy* 19 (2):88–102.

Stern, Daniel. 1998. *The Interpersonal World of the Infant*. New York: Karnac Books.

Stiegler, Bernard. 2010. *Taking Care of Youth and the Generations*. Stanford: Stanford University Press.

Stiegler, Bernard. 1998. *Time and Technics 1: The Fault of Epimetheus*. Stanford: Stanford University Press.

Stockhausen, Karlheinz. 2004. "Electronic and Instrumental Music." In *Audio Culture: Readings in Modern Music*, ed. C. Cox and D. Warner, 370–380. New York: Continuum.

Strawn, John. 1985. "Overview." In *Foundations of Computer Music*, ed. Curtis Roads and John Strawn. Cambridge, Mass.: MIT Press.

Surowiecki, James. 2004. *The Wisdom of Crowds: Why the Many Are Smarter Than the Few and How Collective Wisdom Shapes Business, Economies, Societies and Nations*. New York: Doubleday.

Tarde, Gabriel. 2000. *Social Laws: An Outline of Sociology*. New York: Batoche Books.

Tarde, Gabriel. 1903. *The Laws of Imitation*. New York: Henry Holt.

Taylor, Mark C. 2003. *The Moment of Complexity: Emerging Network Culture*. Chicago: University of Chicago Press.

Teran, Michele. 2011. *Buscando al Sr. Goodbar* weblog. Available at http://www.ubermatic.org/blog/?p=225

Terranova, Tiziana. 2007. "Failure to Comply: Bioart, Security and the Market." *Transversal*, "Art and Police" issue. Available at http://eipcp.net/transversal/1007/terranova/en

Thacker, Eugene. 2009. "The Shadows of Atheology: Epidemics, Power and Life after Foucault." *Theory, Culture and Society* 26 (6):135–153.

Thacker, Eugene. 2005. "Living Dead Networks." *Fibreculture Journal* 4. Available at http://four.fibreculturejournal.org/

Thain, Alanna. 2009. "Affective Commotion." *Inflexions* 1. Available at http://www.senselab.ca/inflexions/volume_4/n1_thainhtml.html

Thatcher, Margaret. 1987. Extract from a transcript of the original interview with Douglas Keay, "Aids, Education and the Year 2000!" *Woman's Own*, available at http://www.margaretthatcher.org/document/106689

Thrift, Nigel. 2008. "Pass It On: Towards a Political Economy of Propensity." *Emotion, Space and Society* 1:83–96.

UBERMORGEN.com. 2005–2007. *Google Will Eat Itself* website. Available at http://www.gwei.org/index.php.

Vaidhyanathan, Siva. 2011. *The Googlization of Everything (and Why We Should Worry)*. Berkeley: University of California Press.

Vaidhyanathan, Siva. 2007–. *The Googlization of Everything (and Why We Should Worry)*, online collaborative publication, Institute for the Future of the Book. Available at http://www.googlizationofeverything.com/

Van Kranenberg, Rob. 2008. *The Internet of Things: A Critique of the Ambient and All-Seeing Network of RFID*. Network Notebooks. Amsterdam: Institute of Network Cultures. Available at http://networkcultures.org/wpmu/portal/publications/network-notebooks/the-internet-of-things/

Varela, Francisco J. 1999. *Ethical Know-How: Action, Wisdom and Cognition*. Stanford: Stanford University Press.

Virno, Paolo. 2009. "Natural-Historical Diagrams: The 'New Global' Movement and the Biological Invariant." *Cosmos and History: The Journal of Natural and Social Philosophy* 5:1. Available at http://www.cosmosandhistory.org/index.php/journal/article/view/129/238#footnote-524-2-backlink

Voth, Danna. 2003. "Rat Neurons, Robotic Arms, and Art." *IEEE Intelligent Systems* 18 (5):7–9.

Vul, Edward, Christine Harris, Piotr Winkielman, and Harold Pashler. 2009. "Puzzlingly High Correlations in fMRI Studies of Emotion, Personality, and Social Cognition." *Perspectives on Psychological Science* 4 (3):274–290.

Wagner, Richard. 2001. "The Art-Work of the Future." In *The Wagner Library*, ed. Patrick Swinkels. (Originally published in English in *Richard Wagner's Prose Works*, vol. 1, trans. William Ashton Ellis, 1895.) Available at http://users.belgacom.net/wagnerlibrary/prose/index.htm

Walker, Jill. 2002. "Links and Power: The Political Economy of Linking on the Web." In *Proceedings of Hypertext 2002*, 78–79. Baltimore: ACM Press.

Watson, Janell. 2008. "Schizoanalysis as Meta-modeling." *Models, Metamodels and Contemporary Media* issue, *Fibreculture Journal*, 12. Available at http://journal.fibreculture.org/issue12/issue12_watson.html

Webster, Robert G., and Elizabeth J. Walker. 2003. "The World Is Teetering on the Edge of a Pandemic that Could Kill a Large Fraction of the Human Population." *American Scientist* online, 91(2):122. Available at http://people.scs.carleton.ca/~soma/biosec/readings/influenza/influenza.html

Weinberger, David. 2002. *Small Pieces Loosely Joined.* New York: Basic Books.

Weiser, Mark. 1991. "The Computer for the Twenty-First Century." *Scientific American* 265 (3 September): 94–104.

White, Colin. 2004. "In the Beginning: An RDBMS History." *Teradata magazine*, September. Last available at http://www.teradata.com/t/page/127057, May 20, 2010. No longer available online.

Whitelaw, Mitchell. 2008a. "Comment on 'Array Aesthetics (Olympic Edition)'." *the teeming void* weblog. Available at http://teemingvoid.blogspot.com/2008/08/array-aesthetics-olympic-edition.html?showComment=1290816162270

Whitelaw, Mitchell. 2008b. "Syneasthesia and Cross-Modality in Contemporary Audiovisuals." *Senses and Society* 3 (3):259–276.

Willis, Holly. 2009. "Natalie Bookchin on YouTube." *KCET: infinitely more* website, Southern California Public Broadcasting Service online. Available at http://www.kcet.org/socal/voices/natalie-bookchin-on-youtube.html

Wislon, Ralph F. 2000. "The Six Simple Principles of Web Marketing." *Web Marketing Today* website. Available at http://www.wilsonweb.com/wmt5/viral-principles.htm

Wolf, Maryanne. 2007. *Proust and the Squid: The Story and Science of the Reading Brain.* London: Harper.

World Health Organization. 2009. "Pandemic Influenza Preparedness and Response." Influenza section, World Health Organization website. Available at http://www.who.int/influenza/resources/documents/pandemic_guidance_04_2009/en/

World Health Organization. 2005. "WHO Checklist for Influenza Pandemic Preparedness Planning." Global Alert and Response, World Health Organization website. Available at http://www.who.int/csr/resources/publications/influenza/WHO_CDS_CSR_GIP_2005_4/en/

Zer-Aviv, Mushon. 2007. "Interface as a Conflict of Ideologies." Networking Loose Ends weblog, April. Available at http://mushon.com/blog/2010/03/23/interface-as-a-conflict-of-ideologies/

Zonday, Tay. 2007. *Chocolate Rain.* YouTube video. Available at http://www.youtube.com/watch?v=EwTZ2xpQwpA

Index

Abdul Kalam, A. P. J., 201n9
Abiteboul, Serge, 76
Able Danger operation, 87–88
Abstraction, 164
Abstract machines, 30, 108
Abstract View, 56–57, 201n10
Actor-network theory, 192
Adaptation, 121
Ad-Art, 92, 203n9
Advertising, 60–61, 65–66, 92, 94
AdWords, 60, 66
Aerial photography, 54
Aesthesia, 1, 5–10, 14–16, 53
Aesthetics
 ambient, 178
 new media, 9
 and novelty, 10
 and politics, 161
 and sociality, 53
 and synesthesia, 15
Affectivity, 103–107, 109–113
 categorical, 104
 and neural experience, 112–113
 and refrains, 109–110, 122–123
 viscosity, 110–113
 vitality affects, 104–105, 113, 122–123, 158, 160, 204n6
Agamben, Giorgio, 198n10
Aggregators, 89–92
Ai Weiwei, 30
Aicardi, Jean, 111

Aisthesis, 9–10
AlexK, 54
Algorithms, 64–65, 67, 169
Allopoietic systems, 50
Al Qaeda hijacker network, 3
Altman, Lawrence, 118
Amazon, 42
Ambient aesthetics, 178
Ambient intelligence, 189–190
America's Army (AA), 133–134
Amerika, Mark, 160, 166, 172
Amodal perception, 158–159, 172
Analog signals, 157, 168–169
Analog synthesizers, 172, 207n5
Anderson, Chris, 148–149
Anesthesia, network, 3, 14, 177
Animated sculpture, 170–171
Annum per annum, 170
AntiVJ, 156
Aporia, 53
Apparatus, 38, 198n10
Arbib, Mark, 126
Architecture, 30–31
Arquilla, John, 132–134, 204n3
"Array of Stations, An," 27–28, 30–31, 40, 74
Arrays, 28–31, 76
Art criticism, 207n4
Artificial intelligence (AI), 85–87, 127–128, 134–135

Artistic practice, 5, 153
 and audience, 160–161
 and data undermining, 83, 90
 and empiricism, 10
 and linking, 156
 novelty in, 10
 philosophy of, 166
 and reinvention, 191
 total artwork, 160–163
 and World War II atrocities, 179
Art research, 15
Assange, Julian, 47
Associations, social, 119–120
Asymmetry, 1–5
Attention, 14, 131–132, 136, 139–140
Audiovisual experience, 14–15, 156, 158
 and cross-processing, 171–173
 and film, 208n6
 and synesthesia, 162–163, 166
Automated operations, 89
Autopoiesis, 50
Autopoietic machines, 29–30, 49–50
Autopoietic naming, 46
Autoscopia, 47–48, 50, 200n4
Avian flu, 117–118

Bachman, Charles, 201n1
Bacon, Francis, 166
Banco Nazionale del Lavoro, Reagan, Bush, Thatcher, and the Arming of Iraq, c. 1979–1990, 3–4
Barabási, Albert-László, 12–13, 86
Baran, Paul, 11, 21, 22, 24, 26–31, 40, 41, 42, 73–74, 76
Baron-Cohen, Simon, 162, 164
Bateson, Gregory, 25, 68–69, 183–184, 209n5
Baumgarten, Alexander, 9
Behavior, online, 94, 96
Beijing, "Bird's Nest" stadium, 30
Ben-Ary, Guy, 154
Bennett, Jane, 210n6
Bergson, Henri, 138–141, 147

Berkeley, Busby, 33
Berners-Lee, Tim, 41
Bertelsen, Lone, 108, 109, 110, 204n6
Beslay, Laurent, 190, 210n8
"Betweenness," 187
Beyoncé, 203n4
Bilton, Nick, 99–100, 113
Bin Laden, Osama, 47, 197n2
Biology, 112
Biopolitics, 133, 141–142
Biopower, 94, 95, 112, 133, 141–142
Birth of the Clinic, 116
BitTorrent, 20–21
Black holes, 55
Blackmore, Susan, 125
Black People Love Us, 106
Blindness, 69
Bogue, Ronald, 9
Bookchin, Natalie, 9, 33–36, 47, 191, 198n8
"Bored at Work Network," 106
Borton, Richard W., 163
Bosack, Matthew, 134
Bosteels, Bruno, 69
Boulez, Pierre, 166
Bourriaud, Nicolas, 207n4
Boy George, 167
Brain
 Broca's area, 126, 138, 205n6
 and computational thinking, 127
 cross-wiring, 163–164
 diagrammatics of, 143–148
 effect of internet on, 130–131
 imaging, 126, 143–148, 206n11
 and mirror neurons, 125–126, 129–130, 136–137, 204n5
 and social media, 130, 204n2
Brin, Sergey, 41, 64
Broca's area, 126, 138, 205n6
Brooks, Richard, 71
Browsers, 83–84, 88
Buccino, Giovanni, 126
Burch, Hal, 1–2, 3, 5

Bureau of Inverse Technology (BIT), 202n8
Burgess, Jean, 106
Burns, Scott, 114
Buscando al Sr. Goodbar, 69–71
Bush, George W., 65
Bush, Vannevar, 41, 42
Business databases, 74–75
BuzzFeed, 100, 203n2

Cage, John, 166
Cailliau, Robert, 41
Camera phones, 101
Cameras, 101
Campbell-Kelly, Martin, 198n5
Cardew, Cornelius, 162
Carr, Nicholas, 14, 130–131, 136, 142, 147, 204n2
Cartesian product, 79
Cartography, 69. *See also* Mapping
Categorical affects, 104
Catts, Oron, 154
Chan, Margaret, 118, 204n8
Chance, 139
Change, 158
Chatroulette, 99, 203n1
Chess, 138–139
Cheswick, Bill, 1–2, 3, 5
Childs, David, 76
Chocolate Rain, 102, 104, 203n4
Cimatics festival, 162, 206n2
Cinema, 208n6
Circuit-switching networks, 23
Cirio, Paolo, 65, 201n12
Clemens, Justin, 47–48, 200n4
Click-through, 66–68
Clinical experience, 116
Cloud computing, 202n3
Coal-Fired Computers, 180
Codd, Edgar F., 76–80, 202n2
Code sequences, 67
Coding, 110
Cohen, Bram, 20, 198n3
Cohen, Noam, 201n11

Collective experience, 35–36, 40, 59, 192
 and networked publics, 149–150
 and refrains, 107
Collectivities, 192–193
Commercial knowledge, 87–88
Communicability, 114–121, 125, 191–192
Communication
 and communicability, 125
 and refrains, 108
 and viscosity of affect, 111
Communications systems, 21–24, 26, 31, 42, 74
Complexity, 5, 12
Computational arrays, 30
Computational networks, 7, 19, 127
Computational storage, 73
"Computer for the 21st-Century, The," 182
Computer gaming, 133–134
Computer simulations, 26, 133–134
Concatenation, 8, 11
 and algorithms, 64–65
 and knowing, 15, 181
 and relational database, 79
Conjunctions, 14–15
Conjunctive contraptions, 178–183, 191
Connectivity, 1, 6
 and concatenation, 8, 11
 creeping, 15
Connolly, William, 136
Contagion, 113–116
Contagion, 99–123
 and affectivity, 104–107, 109–113
 characteristics of, 103
 communicability, 114–121
 and imitation, 119–121
 and looping, 100
 as machine of expression, 122–123
 and molecularity, 107
 and refrains, 103, 107–110, 122
 speed of, 111, 113–114
 and viral marketing, 105–106, 121
 viral videos, 100–105, 108–109, 113, 122–123

Contagious Media Project, The, 106, 203n2
Containment, viral, 115
Contractor, Noshir, 26, 39
Contraptionist ecologies, 183–185, 192, 210n6
Contraptions, conjunctive, 178–183, 191
Control lines, 168–169, 172–173, 208n8
Convergence-divergence zones (CDZs), 137
Cornog, Martha, 74
Corporatism, 30, 41–42
Cosmic dimension, 93–94
Cox, Christopher, 162
Craighero, Laila, 205n5
Crampton, Jeremy, 23, 55
Creep, 15, 177
Critical neuroscience, 205n7
Critical software, 149–150
Critique of Judgment, 143
Cross-modal binding, 172
Cross-modal transfer (CMT), 163–164
Cross-processed audio, 154
Cross-processing, 157, 169–173, 193
Cross-wiring, 163–164
Cunningham, J. E., 22, 198n4
Customization, 148
Cytowic, Richard, 163

Damasio, Antonio, 126, 137, 205n5
Daniel, Caroline, 61
Darwin, Charles, 104
Data
 humans as, 188–189
 metadata, 42, 172–173, 208n9
 perceptible, 82
 as relation of relations, 80, 85–86
 spimes, 185–187
 tags, 188
 as topology, 85–86
 visualization of, 32, 83–84, 93
Databases, 73–79
 administrators and users, 78–79, 190
 business, 74–75
 conceptual/logical level of, 78
 and contraptions, 180
 design of, 201n1
 domains, 80
 hierarchical, 73–75, 81
 machine experience of, 77
 as mathematical relations, 79–80
 and media, 85
 as metastructure, 76–77
 and objects, 184–185
 and packet switching, 75–76
 personal as, 190–191
 and primary keys, 74
 queries to, 58, 75–76, 80, 85
 relational, 11–12, 74, 76–81, 85–86
 search, 11
 as tables, 80
 vulnerabilities of, 74
Databasing, 78–79
Datagrams, 22–23
Data management, 77–79, 81–84
Data mining, 5, 12
 and aggregators, 90
 and biopower, 94–95
 genealogy of, 85–88
 Google, 129
 and networking, 86
 obfuscation of, 84
 and perceptible data, 82
 and prediction, 87
 profiling, 94–95
 and search engines, 50, 94–95
 and tracking, 96
 and value, 87
 and visualization, 83
Data nonvisualization, 83
Data Protection Act, 52
Data undermining, 12
 and artistic practice, 83, 90
 and inverse engineering, 90–92
 metalayering, 92–93
 poetics of, 83–84, 96

and search simulation, 95–96
and web advertising, 92
and world-making, 93–94
Data visualization, 32, 83–84. *See also* Images
Data warehousing, 81
Davey, Nicholas, 10
David after Dentist, 101, 123, 203n3
Davies, Donald, 23, 198n5
Dawkins, Richard, 125, 126
Deep attention, 131
Deleuze, Gilles, 9, 10, 28, 30, 37, 56, 93, 95, 103, 107, 108, 109, 161, 166–168, 171, 197n1, 199n11, 207n5, 208n6
De Meuron, Pierre, 30
Denmars, Jean, 180
Desktop computer project, 177–179
Diagrammatism, 3, 19–43, 191, 197n1. *See also* Mapping; Mosaics
 arrays, 28–31
 and brain imaging, 143–148
 and collectivities, 193–195
 and difference, 68
 dispositif, 36–38, 86
 distributed communications, 21–24, 26, 31
 forms of, 3–4
 and functionality, 28
 link-node images, 2–3, 5, 12, 21, 25, 31
 mechanograms, 26, 29–31, 42, 78
 and noopolitics, 133
 and relations, 187
Diagrams, 19–26, 68
 and collective protocols, 15–16
 and *dispositif*, 38
 and fields, 37
 as icons, 24–26
 internet, 11
 and maps, 24
 and movement, 11, 29
 network, 3–5, 21–22
 patch bay, 172
Digital bubbles, 190–191

Digital cameras, 101
Digital multimedia, 160–161
Digital signals, 154, 157–158
 cross-processing, 157, 169–173
 and military research, 169
 and synthesis, 162–163
Digital synthesizers, 167–169, 207n5
Disease containment, 115–118
Dispositif, 8, 36–38, 74, 77, 86
Distributed communications systems, 21–24, 26, 31, 42, 74
Distributed mesh, 22
Distributed networks, 21–22
Documenta, 179
Dodds, Christopher, 47–48, 200n4
Doidge, Norman, 207n3
Domain, data, 80
Donath, Judith, 200n6
Doruff, Sher, 172
Dragan, Richard V., 200n5
Dragon Tattoo, The, 49
Duchenout, Nicholas, 61
Dumit, Joseph, 146, 205n10
Duran Duran, 168
Duras, Marguerite, 208n6
Dynamic look-up, 185
Dynamic schema, 138–139

Eckman, Paul, 104
Ecologies, 183–185, 192, 210n6
Edelstein, Henry, 86, 202n5
Edges, 32, 35, 39, 194–195
Edwards, Paul, 169
Electronic books, 186
Eliasson, Olafur, 170
Emotions, 104
Empiricism, 10
Engel, Jerome, 111
Epidemics, 116
Epilepsy, 111
European Union (EU), 210n8
Event horizons, 55–56

Events
 actions as, 138
 publics as, 148
 refrains as, 108–109
Experience, 5–10. *See also* Human experience
 collective, 40
 of emotion, 104
 infant, 158–159, 163–164
 infrapersonal, 197n4
 Jamesian theory of, 7–10, 39–41, 105, 139, 186–187
 machine, 77, 83
 molecular, 13, 38, 106–107, 197n4
 and mosaic, 32, 39
 network, 5–7, 89
 and relations, 7–9, 32, 35
 of search, 11, 61
 of sensation, 158
 of transition, 158–159
 transversality of, 12–14
Expression of Emotions in Man and Animals, The, 104

Facebook, 51
Farocki, Harun, 54
Fayyad, Usama, 85, 87, 202n6
Fear, 188–189
Fields, 37
File-sharing networks, 20
Financial networks, 3–5
Firefox extensions, 92, 95, 202n4
Flash software, 60
Flight simulators, 133
fMRI scans, 144–147
Form of vitality, 159
Foucault, Michel, 36–38, 94, 95, 115, 116, 133, 198n10, 199n11, 204n3
Fourier transform, 146
Fox, Robin, 162, 172–173
Frank, Adam, 112
Fried, Michael, 207n4
Friesen, Warren, 104
Fuller, Matthew, 77, 121, 149, 178

Gadow, Andrew, 172
Gehry, Frank, 31
Genosko, Gary, 25, 31, 107
Geographical information systems (GISs), 45, 55
Germany, 52, 54
Gesamtkunstwerk, 160–163
Gibbs, Anna, 13, 107, 119
Gibson, William, 46, 57
Gilbert, Chris, 170
Girl with the Dragon Tattoo, The, 49
Glischroid character, 111–112
Godard, Michael, 210n6
Godlee, Fiona, 204n8
Goffey, Andrew, 121
"Going viral," 13, 99–100, 115–117. *See also* Contagion
Gold Diggers, The, 33
Goodwin, Jacob, 87
Google, 128
 acquisitions, 45–46
 advertising, 60–61, 65–66
 AdWords, 60, 65
 and data acquisition, 129
 and data queries, 58
 and "Google-us," 57–58, 67–69
 and indexing, 41
 Orkut, 46, 199n2
 PageRank algorithm, 59, 63–65, 67–68
 and prediction, 132
 Prediction API, 128–129, 135
 privacy policy, 52
 search, 14, 42, 46–47, 49–50, 59–61
 and sociality, 55, 68
 and usability, 60–62
Google Bomb, 65
Google Books, 49–50
Google Earth, 11, 45–63
 accuracy of, 55
 allopoietics of, 69–71
 as autopoietic machine, 49
 and difference, 68
Google Earth Community, 52–53, 58, 61, 201n8

Google Earth Hacks, 53
and imaging, 51–55, 61
and mapping, 51, 55, 69
and national security, 53–54, 201n9
and online games, 61
and search, 46–47, 61, 63
and shared experience, 58–59
as simulation, 51
as social media, 52, 59
and social relations, 52–53, 55–56, 58, 61
solitary user of, 55–56, 62
Street View, 52, 56
and visibility, 54
visual appearance of, 45
and YouTube, 201n14
Google Earth Community forum, 199n1
Google Maps, 45–46, 52
Google Will Eat Itself (GWEI), 65–68, 201n12
Googlization, 46–47, 49–50, 121
Googlization of Everything, The, 199n3
Gothic architecture, 30
Grance, Tim, 202n3
Granovetter, Mark, 7
Graph theory, 32
Gray, Mathew, 50
Greenfield, Susan, 130
Grids, 31
Grossman, Lev, 210n7
Guattari, Félix, 4, 7, 10, 12, 28, 30, 31, 50, 68, 93, 95, 103, 104, 107, 108, 109, 110, 111, 112, 120, 122, 147, 149, 161, 166–168, 184, 197n1

Haecceities, 103
HaHaHa, 102–104, 123, 203n5
Hakala, Hannu, 190, 210n8
Hansell, Saul, 94
Hansen, Mark, 9
Hare, R. M., 62
Harley, Ross, 178
Harrison, John E., 162, 164
Hartmann, Hans, 207n5

Harwood, Graham, 77, 83, 180, 209n3
Hayles, N. Katherine, 131, 148
Headers, datagram, 22–23
Heautonomy, 208n6
Heemskerk, Joan, 88
Heidegger, Martin, 162
Herzog, Jacques, 30
Heylighen, Francis, 125
Hierarchical databases, 73–75, 81
Hirstein, William, 204n5
Hofman, Heike, 32
Holmes, Brian, 26
Howe, Daniel, 95, 202n4
HTML, 88
Hubbard, Edward M., 163, 164
Hull, Richard, 76
Human experience, 39. *See also* Experience
 and data sets, 188–189
 and environment, 183
 and machines, 83
Hyper-attention, 131
Hyperlinks. *See* Linking
Hypertext, 41

Icons, 24–26, 107–108, 147
Identity, 47–48
iGeneration, 130, 148
Image horizons, 55–56
Images
 brains, 126, 143–147, 206n11
 Google Earth as, 51–55, 61
 link-node, 2–3, 5, 12, 21, 25, 31
 network, 2–3, 5, 21–22
 recollection of, 138
 and social media, 51–52
Images of the World and the Inscription of War, 54
Imitation, 119–121, 125–126
Imperceptibility, 9–10, 95–96, 136, 195
 and data undermining, 90, 92
 and the perceptible, 82–84
Indexicality, 54, 198n7
Individuation, 165, 186–187

Infant experience, 158–159, 163–164
Influenza, 117–118
Information analysis, 83, 87–88. *See also* Knowledge
"Information Flow in Large Communication Nets," 22
Infrapersonal experience, 197n4
Institute for Prospective Technological Studies, 210n8
Interactive multimedia, 160–161
Interfaces, 19
International relations, 132–133
Internet, 8
 and brains, 130–131
 development of, 88–89
 diagramming of, 11
 map of, 2
 neuroscientific study of, 14
 rationalization of, 60
 and relationality of data, 86
 Web 1.0, 88–89
 Web 2.0, 89
Internet of things, 181, 185, 189
Inverse engineering, 90–92
Iraq, invasion of, 133
Irritability, 111

Jackson, Michael, 99
Jacquet, Yannick, 156, 169–170
James, William, 5, 6, 7–8, 10–11, 23, 25, 32, 35, 38–42, 47, 57, 65, 79, 92, 105, 106, 117, 126, 128, 129, 139–140, 141, 147, 158, 180–181, 183, 184, 186–187, 194, 199n12
Jamieson, Michelle, 118
Jansz, Jeroen, 61
Jenkins, Holman, 129
Job loss narratives, 35–36
Jodi.org, 88
Johnston, John, 127, 202n5
Jordan, Ken, 160

Kahn, Richard, 65
Kanai, Ryota, 204n2

Kandinsky, Wassily, 162
Kant, Immanuel, 10, 143, 162, 167
Karlsruhe labor camp, 178
Karotz, 176–178, 209n2
Keaton, Diane, 71
Kellner, Doug, 65
Kelso, Scott, 206n11
Kennedy, John Fitzgerald, 47
Kerr, Iain, 193
Keyhole Corp, 45
Kishik, David, 198n10
Kleinrock, Leonard, 22–23, 198n4
Kline, Morris, 198n6
Knouf, Nicholas, 83, 90, 202n4
Knowledge
 collective, 92
 commercial brokers of, 87–88
 and concatenation, 15, 181
 and data undermining, 90, 92
 indexing, 41–42
 Jamesian theory of, 41
 as mosaic, 38–43
 and noopolitik, 132
Krebs, Vladis, 3
Kriegeskorte, Nikolaus, 145
Kurokawa, Ryoichi, 7, 162, 170–171, 208n6

Laid Off, 35–36, 198n9
Lambert, Steve, 92
Lanier, Jaron, 15
Large-scale networks, 12–13
Larson, Stieg, 49
Latour, Bruno, 6, 119, 120, 181, 182–185, 186, 192, 209n4, 210n6
Law, Jude, 113
Lazzarato, Maurizio, 79, 86, 94, 133, 140–142, 148, 192
Leibnizian monad, 56
Li Xinggang, 30
Lialina, Olia, 89
Licklider, J. C., 19
Life administration, 190–191
Life control, regime of, 109

Index

Linking, 32, 59, 64–65, 156
Link-node images, 2–3, 5, 12, 21, 25, 31
Lippard, Lucy R., 207n4
Living machines, 49
Lombardi, Mark, 3–5, 197n2
Long tail, 148
Looking for Mr. Goodbar, 70–71
Looping, 11, 25, 29, 42–43, 100
Lovink, Geert, 55, 201n13
Ludovico, Alessandro, 65, 201n12
Luhmann, Niklas, 50
Lungs, 177, 178–181, 209n3

Machine learning, 13, 127–129
Machines
 abstract, 30, 108
 autopoietic, 29–30, 49–50
 and contagion, 122–123
 experience of, 77, 83
 living, 49
 and perception, 84
 and thingness, 181
Mackenzie, Adrian, 10, 64, 65, 67, 80, 169
Macromedia, 60
Madrigal, Alexis, 50
Magnetic signals, 146
MAICgregator, 83, 90–92, 202n4
Maine coastline, 194
"Making Things Public: Atmospheres of Democracy," 181, 183, 209n4
Manning, Erin, 28, 29, 82, 168, 170, 194, 197n3, 210n10
Manovich, Lev, 157
Mapping, 19–26. *See also* Google Earth
 and diagrams, 24
 and network design, 21
 as potential movement, 24
 and terrain, 24–25
Mapping Festival, 162, 206n2
Mapping the Working Coasts, 194, 211n11
Maps API, 46

Margulies, Daniel, 9, 143–144, 148, 205n8
Marketing, 87
 long tail, 148
 viral, 105–106, 121
Markets, 37, 62–63, 148
Markov chains, 64
Marshall, Jeff, 94
Martens, Lonneke, 61
Massively multiplayer online role-playing games (MMPORGs), 61
Mass media, 140
Mass Ornament, 33–36, 38, 198n8
Massumi, Brian, 4, 38, 41, 82, 112, 118, 122, 138, 165–166, 187, 197n3
Mathematical relations, 79–80
Maturana, Humberto, 49
MAX/MSP/Jitter environment, 208n8
Mayer, Marissa, 201n11
Mayfield, Ross, 7
McAlinden, Ryan, 134–135
McCulloch, Warren, 127–129
McLuhan, Marshall, 51
McNamara, Paul, 149
MEART—the semi-living artist, 154–157
Mechanograms, 26, 29–31, 42, 78
Media networks, 14
Mediated environment, 189
Media virus, 99–100, 115
Mejias, Ulises A., 42
Melitopolous, Angela, 192
Mell, Peter, 202n3
Meltzoff, Andrew, 163
Memes, 125
Memetics, 125
Memex, 41
Memory, 139
Mesh image, 22
Messiaen, Olivier, 162
Metadata, 42, 172–173, 208n9
Metaforms, 160–161
Metalayering, 92–93
Metamodeling, 10–12, 149
Metastability, 206n11

Metasynthesis, 163
Meyer, Kaspar, 126, 137, 205n5
Military funding, 90
Military intelligence, 87
Military research, 169
Military supply chain, 182
Military training simulation, 133–135
Mills, Elinor, 128
Minimalism, 207n4
Mirroring, 3
Mirror neurons, 125–126, 129–130, 136–138, 204n5
Mitchell, John C., 184–185
Mockenhaupt, Brian, 134
Moddr, 206n12
Modern art, 10
Molar model, 13, 38
Molecular experience, 13, 38, 106–107, 197n4
Monge, Peter, 26, 39
Monkeys, brains of, 125–126
Moore, Gordon E., 61, 198n2
Moore's law, 198n2
Moral propositions, 62
Morens, David, 118
Mosaic plots, 32–33
Mosaics, 23, 32–36, 192
 edges of, 32, 35, 39
 Jamesian, 194–195
 knowledge as, 38–43
 relational, 157
 and things, 184
Mullins, Craig, 78
Multielectrode array (MEA), 155
Multimedia artwork, 160–161
Multiplicity, 141–142
Munster, Anna, 37, 197n2
Muntean, Nick, 118
Murcia, 69–70
Murphie, Andrew, 108, 109, 110, 204n6
Music, 161–162, 166
Myers, Jack E., 208n9
"Mysterious hoze" video, 171, 208n7

Nabaztag, 175–176, 209n2
Nameless Library, 179
Nash, Adam, 47–48, 200n4
Nazi labor camp, 178–179
Neissen, Bertram, 170, 208n7
Neoliberalism, 62–63
Neonatal synesthesia (NS), 163–164
Network diagrams, 3–5, 21–22. *See also* Diagrams
Network experience, 5–7, 89
Network images, 2–3, 5
Networking, 4
 aesthesia of, 8–10
 criticism of, 130
 of data, 86
 and diagramming, 28, 193–194
 experience of, 7, 16
 and looping, 42–43
 and neuroscience, 126–127
 pervasiveness of, 15
 as process, 11–13
 relational, 191–192
 as topological surface, 4–5
 and waiting, 19–20
Network science, 37
Network topologies, 19
Neufield, M. Lynne, 74
Neural networks, 14, 125–150
 and affects, 112–113
 artificial, 127
 and attention, 131–132, 136, 139–140
 and brain imaging, 126, 143–147, 206n11
 and CDZs, 137
 and computation, 127–128
 and computer gaming, 135
 and digital signals, 162
 and imitation, 125–126
 and internet use, 130–132
 and machine learning, 127–128
 and neuropolitics, 136–138, 140
 and noopolitics, 132–134, 136, 140–143, 148–149

Index

and prediction, 127–129
and smart applications, 127
Neuroimaging, 145–147, 205n10
Neuro-perception, 129
Neuroplasticity, 207n3
Neuropolitics, 136–138, 140
Neuroscience, 14, 136
 critical, 205n7
 and networking, 126–127
 and social media, 130–131
 and synesthesia, 163–164, 172, 207n3
News data, 90
Nicolai, Carsten, 154, 156, 162
Nielsen, Jakob, 59–61, 198n2
Nielson's law, 198n2
NIKE sweatshop email, 106
Nirre, Robert, 200n7
Nissenbaum, Helen, 95, 202n4
Noë, Alva, 82, 197n3
Nonliving systems, 49–50
Nonstate actors, 133
Noopolitics, 132–134, 136, 140–143, 148–149
Noopolitik, 132–135, 149
Noosphere, 132–133
Novel art, 10
Novel perception, 9
Nuclear attack, 30

Obama, Barack, 47, 48
Object-oriented programming, 184–185
Objects, 9–10, 184–186
Obrist, Ulrich, 154
O'Dowd, George Alan (Boy George), 167
"On Distributed Communications," 21
Ontogenesis of sensibilities, 9
Ontology, 164, 207n3
Orb, 209n1
O'Reilly, Timothy, 89
Organ music, 169–170
Orkut, 46, 199n2
Outbreak, 115

Packer, Randall, 160
Packets, 22, 27–29, 35
Packet switching, 22–23, 27–28, 75–76
Paesmans, Dirk, 88
Page, Larry, 41, 64
PageRank algorithm, 59, 63–65, 67–68
Palmer, Maija, 61
Pandemics, 115, 117–118
Panic, 114
Papadopoulos, Dimitris, 109
Parasites, networks as, 105–106
Parent-child structure, 73
Parikka, Jussi, 112, 210n6
Pärt, Arvo, 170
Pasquinelli, Matteo, 105, 110
Pasternack, Alex, 30
Patch bay diagram, 172
Pedatella, Stefan, 198n10
Pedley, Timothy A., 111
Peer-to-peer (P2P) file-sharing networks, 20
Peirce, Charles Sanders, 24–25, 33, 79, 147, 198n7
Perceiving, 82
Perceptibility, 5–6, 82
Perceptible data, 82
Perception, 1, 5, 13
 amodal, 158–159, 172
 distributed, 40
 and the imperceptible, 9
 and individuation, 165
 machine, 84
 neuro-perception, 129
 and relations, 165
 and synesthesia, 163–164
Perretti, Jonah, 106, 203n2
Pervasive computing, 182, 188–191
Pervasiveness, 118, 178
Petersen, Wolfgang, 115
Phiffer, Dan, 92, 202n4
Piccinini, Gualtiero, 127
Pigott-Smith, Tim, 49
Pitts, Walter, 127–129
Play, 60–61

Polak, Esther, 14, 56–57, 201n10
Political networks, 3–5
Politics
 and aesthetics, 161
 and disease, 116
 and power, 133, 140–141
 and prediction, 132
 and teletechnologies, 131–132
Populations, managing, 94–95
Portraits, web, 47
Portrait Series (Phase III), 155
Post-neoliberal networks, 55
Potter, Steve, 154, 156
Power, 133, 140–141
Prediction, 42
 and data mining, 87
 and neural networks, 127–129
 and politics, 132
 and search, 14, 128–129
Preference utilitarianism, 62–63
Primary keys, 74
Privacy, 52, 94, 190
Product, Cartesian, 79
Profiling, 94–95
Projection mapping, 156, 169–170
"Proposal for a Digital Communication Network," 23
Psychopolitics, 132
Psychopower, 133, 141–142, 148
PsychSim, 134, 204n4
Public health, 117–118
Publics, 140, 142–143, 148–150
Public washrooms, 188
Publishing industry, 186
Puppets, 104–105
Python script, 149

Queries, 95
 database, 58, 75–76, 80, 85
 Google search, 14, 42, 46–47, 49–50, 59–61
Queuing, 19–21

Radical empiricism, 10
Radio frequency identification (RFID), 176, 182, 188
Ramachandran, Vilayanur, 163, 164, 204n5
Random surfer, 64
Random walks, 64
RapidShare, 197n1
Rationalization, web, 60
Reciprocal implication, 138
Recursion, 11
Redundancy, 73–74
Refrains, 103, 107–110, 183
 and affects, 109–110, 122–123, 157
 and collective experience, 107
 and communication, 108
 as events, 108–109
Relational database, 11–12, 74, 76–81, 85–86
"Relational Model of Data for Large Shared Data Banks, A," 76–77
Relational sculpture, 170–171
Relations, 153
 and aggregators, 90
 database, 79–81, 85
 Jamesian, 7–9, 12, 32, 35, 79, 91–92, 105, 126, 128, 158, 183, 187
 mathematical, 79–80
 and mirror neurons, 126
 and perception, 165
 relation of, 80, 85
 sender-message-receiver, 38
 sensation as, 158
 social, 52–53, 55–56, 58, 61
 and spimes, 187
 and things, 178–187, 189, 194–195
 and transactions, 187
 virtual relationality, 157
Religious icons, 107–108
Repetition, 121
Research-creation, 193–194, 210n10
Rhoades, Troy, 208n5
Riemannian geometry, 28
Rimbaud, Arthur, 162

Index

Rimsky-Korsakov, Nikolai, 162
Rite of Spring, The, 143
Ritornello, 107
Rizzolatti, Giacomo, 125, 205n5
Rogers, Richard, 46
Rolnik, Suely, 122, 197n4
Ronfeldt, David, 132–134, 204n4
Rossiter, Ned, 55
RSSs, 82–83
Rushkoff, Douglas, 99–100, 107, 110, 111, 112

Sampson, Tony, 13, 103–104, 119, 130
Scale-free networks, 13
Schaffer, Anthony, 87–88
Schaffner, Dr. William, 118
Schmidt, Eric, 61, 128–129
Scotland, 56
Scriabin, Alexander, 162
Sculpture, relational, 170–171
Search, 48–49
 as activation of utility, 61
 and advertising, 60–61
 behavior, 94, 96
 and bombing, 65
 and cartography, 50
 experience of, 11, 61
 Google, 14, 42, 46–47, 49–50, 59–61
 and googlization, 49
 and link value, 59
 and network potential, 42
 and prediction, 14, 128–129
 queries, 65
 and sociality, 60
 and web portraits, 47–48
Search engines, 50, 94–95
Sedgwick, Eve Kosofsky, 112
"See This Sound," 162, 206n2
Sensation, 9, 158
SenseLab, The, 210n10
Senses, 165
Set theory, 76
Sharing, 20–21

Sharma, Dinesh C., 201n9
Sharp, Chris, 9, 143–144, 148, 205n8
ShiftSpace, 83, 92–93, 202n4
Shirkey, Clay, 7
Signals, digital. *See* Digital signals
Signs, 109–110
 icons as, 24
 objects as, 9–10
Simondon, Gilbert, 164–165, 207n3
Simulations, 26, 51, 133–134
SiteLogiq, 203n1
Six Years: The Dematerialization of the Art Object, 207n4
Skipper, Jeremy I., 205n5
Skype session, 19
Small, Gary, 130
Smart applications, 127
Smith, J. D., 87
Sociable media, 51, 200n6
Social associations, 119–120
Sociality, 55, 60, 68, 119–120
Social media
 and brains, 130, 204n2
 and data undermining, 83–84
 disconnecting from, 149–150
 and Google Earth, 51, 59
 and images, 51–52
 and neuroscience, 130–131
 and Web 2.0, 89
Social networks, 7, 11, 51–52, 59
Social relations, 52–53, 55–56, 58, 61
Soderbergh, Steven, 113
"Solidarity Link Action, A," 201n13
Sound treatment, 167–168
South Park, 150
Spain, 69
Spatiality, 200n7
Speed of transmission, 111, 113–114
Spimes, 185–187
Spriggs, David, 170
Spurse, 192–194, 210n9
Stafford, Barbara Maria, 130

Standardization, 119–120
Stations, 27–28
Stengers, Isabelle, 139
Stephenson, Niamh, 109, 118
Sterling, Bruce, 15, 185–187, 201n13
Stern, Daniel, 104, 158–160, 164, 172, 204n6
St Gervais, 156–157, 169–170, 206n1
Stickiness, 110–113
Stiegler, Bernard, 131–133, 136, 139, 140, 148, 149
Stimson, Blake, 35
Stockhausen, Karlheinz, 168, 207n5
Storage. *See* Databases
Stravinsky, Igor, 143
Strawn, John, 168
Structural coupling, 49
Studio for Electronic Music, 207n5
Swarming, 20
Swine flu, 117–118
Symbols, 33, 198n7
Syn-aesthetics, 153–154, 157–159, 166, 172
Synesthesia, 14–15, 158, 162–166
 and digital signals, 162–163
 and neuroscience, 163–164, 172, 207n3
 and perception, 163–164
 as relational, 166
 unity of, 164–165
Synesthetic practice, 172
Synthesizers, 167–169, 172, 207n5
Synthesizing, 161, 163, 166–167, 173
Systems, 209n5

Table, database, 80
Tags, 188–189
Tampa incident, 204n6
Tantalum Memorial, 180
Tarde, Gabriel, 119–121, 123, 125
Taylor, Mark, 31
Technicity, 131, 194
telefunken, 154, 162
Telephone communications, 23, 75
Teletechnologies, 131–132, 140, 142–143, 148–149

Televisual signals, 154, 157
Templates, 89
Temple de Saint-Gervais, 156
Temporality, 131–132
Tensors, 28–29
Teran, Michelle, 69–70, 201n14
Ternovskiy, Andrey, 99
Terranova, Tiziana, 37, 148–149
Territories, 190–191
Testament, 198n9
Thacker, Eugene, 112, 199n11
Thain, Alanna, 193, 210n10
Thatcher, Margaret, 58
Thingness of networks, 15, 175, 182, 185
Things
 and ecologies, 183–184
 and machines, 181
 and mosaics, 184
 and relationality, 178–187, 189, 194–195
 trackable, 185–187
"Thisness," 103, 186–187
Threat, 118
Thrift, Nigel, 13, 119, 121, 130
Time and Technics, 131
Time magazine, person of the year, 210n7
Topological data arrangements, 85–86
Topological network images, 2–3, 21–22
Topological surface, 4–5
Total artwork, 160–163
Tracking, 96
TrackMeNot (TMN), 83, 95–95, 202n4
Transactions, 187
Transduction, 157–158
Transitions, 158–159
Transitivity, 117
Translocation, 25
Transversality, 12–14, 141, 150, 184
Tsianos, Vassilis, 109
Twitter, 48

UBERMORGEN.COM, 65, 201n12
Ultravox, 168
Universal good, 62–63

Index

University of Southern California, 90
Untitled, 143–144
UrbanSim, 134–135
Usability, 59–62
U.S. military, 182
Utilitarianism, 61–63
Utility, 61

Vaidhyanathan, Siva, 46, 199n3
Van Bekkum, Ivar, 14, 56–57, 201n10
Van Campen, Cretien, 162
Van Kranenberg, Rob, 189
Vaquié, Thomas, 156, 169–170
Varela, Francisco J., 49–50, 71
Verdú, Irene, 70
Vianu, Victor, 76
Video conferencing, 19
Videos, viral, 100–105, 108–109, 113, 122–123
Vienna, Judenplatz Holocaust memorial, 179
Viral analysis, 99
Virilio, Paul, 54
Virno, Paolo, 25, 147
Virtual relationality, 157
Virus, 99–100
 biological, 100, 113–116
Viscosity of affect, 110–113
Visibility, 54
Visual art, 166
Visualization, data, 32, 83–84, 93. *See also* Databases
Visualizations. *See* Images
Visual motifs, 122–123
Visual signals, 156
Vitality affects, 104–105, 160, 204n6
 and refrains, 109–110, 122–123, 157
 and viral videos, 158
Vitality forms, 159
VJing, 159–160, 162, 166, 172, 208n6
Vlogs, 35–36
Voth, Danna, 154
Vul, Edward, 145

Wagner, Richard, 160–161, 207n4
Waiting, 19–20
Walker, Elizabeth, 59, 117
Warfare, 182
Web. *See* Internet
Web 1.0, 88–89
Web 2.0, 89
Web 2.0 Suicide Machine, 149–150
Web browsers, 83–84, 88
Webcams, 101
Web pages, 88
Web portraits, 47–48
Webster, Robert, 117
Weibel, Peter, 181, 209n4
Weinberger, David, 8
Weiser, Mark, 15, 182, 188
"What Is an Apparatus?," 198n10
Where2, 45
Whitelaw, Mitchell, 30, 31, 172
Whiteread, Rachel, 179
Willis, Holly, 33
Wilson, Ralph, 100, 203n2
Wireless orb, 175
"Withness," 11–12, 33, 35, 186
Wolf, Maryanne, 130
World Health Organization (WHO), 8, 118, 204n7
World-making, 93–94
World War II photography, 54
World Wide Web. *See* Internet
Wright, Richard, 180

YoHa, 83, 184, 186, 209n3
Yokokoji, Matsuko, 83, 209n3
YouTube, 33, 68–71
 and Google Earth, 201n14
 viral videos, 100–103, 122

Zer-Aviv, Mushon, 65, 92, 202n4
Zonday, Tay, 102, 104–105, 108, 109, 203n4
Zurr, Ionat, 154